Dignity and Decadence

RICHARD JENKYNS was born in 1949 and educated at Eton and Balliol College, Oxford. He was a Fellow of All Souls College, Oxford, 1972–81, and Lecturer in Classics at the University of Bristol, 1978–81. He was elected a Fellow of Lady Margaret Hall, Oxford in 1981. His other books are *The Victorians and Ancient Greece* (1980; winner of the Arts Council National Book Award for Creative Non-fiction and the *Yorkshire Post* Prize for the Best First Work); *Three Classical Poets: Sappho, Catullus and Juvenal* (1982); *Classical Epic: Homer and Virgil* (1991); and, as editor, *The Legacy of Rome* (1992). He is now writing a book on Virgil.

DIGNITY
AND
DECADENCE

VICTORIAN ART AND
THE CLASSICAL INHERITANCE

Richard Jenkyns

Harvard University Press
Cambridge, Massachusetts
1992

Copyright © Richard Jenkyns 1991

Printed in Great Britain

10 9 8 7 6 5 4 3 2 1

ISBN 0−674−20625−8

Library of Congress Catalog Card Number:
91−75748

To Sophie

CONTENTS

PREFACE

I hope that readers of this book will forgive a few words about how it came into being. Some while ago I was invited to give the Ferens Fine Art Lectures at the University of Hull, the subject to be classicism in Victorian art. Though I had written a book about the influence of ancient Greece on the Victorians, I am not by profession an art historian; still, I decided to take up the challenge. Having given the lectures, I felt that it would be worth sharing the images which I had shown and my own thoughts about them with a wider audience. This book is the result.

The written word should be different from the spoken; yet I have not sought wholly to disguise the book's origins: after the party the ashtrays are emptied, but the scent of cigars lingers in the upholstery. I have set myself not a single aim, but a mixture of several. One has been simply to show the extent and variety of classical themes and images in the Victorian age, and to let the pictures speak for themselves. I have allowed myself to select and omit: I have ranged fairly widely, and that means, of course, that I have had to leave out a great many things which I would have liked to include, all the more since, to avoid mere generality throughout, I have often lingered disproportionately (it may seem) on a painting which I find revealing or a building which I enjoy or a mind which seems worth exploring. I have found space for things which I consider second-rate, third-rate or even worse where I have thought that they could tell us something about the character of the Victorian age, and I have also sought (which is quite another matter) to give some idea of the ordinary texture of nineteenth-century culture, including among the famous some humbler makers of the Victorians' visual world. These too include the good, the bad and the indifferent: there is excellence to be found among the obscure and vulgarity among the eminent.

In recent years books have appeared which have opened up to us whole new areas of the Victorians' visual experience; I think, for

example, of Mark Girouard's *The Victorian Country House* and Benedict Read's *Victorian Sculpture*. Where the lions have feasted, the jackals may take their fill; and I think that there may be some value in looking at the material from a less specialized point of view and trying to set the Victorians' art in a context. I have included painting, sculpture and architecture, and have adopted a somewhat different line of approach to each, partly from inclination, partly perhaps because the evidence points that way. In the case of painting I have concentrated on a comparatively small number of comparatively well-known names, with only brief indication of the extent to which they influenced other artists; I do not believe that a multiplication of minor figures would much affect the overall picture. On Victorian sculpture I doubt whether I have much to add to what others have said, and I must admit to finding much of it dull stuff, except in certain cases where it has ceased to owe anything significant to classical example; here my interest has been rather in the place of sculpture within Victorian culture and its effect on the imagination of painters and writers. Architecture has imposed the most drastic selectivity: of all these arts the most diverse in its character during the nineteenth century, the most universal in its effects. I would not have the knowledge, even if I had the space or the wish, to write a full and balanced account of the many Victorian architects who worked in the broad classical tradition; decent, second-rank men mostly, who inspire moderate respect rather than excitement. Instead I have tried to place Victorian architecture in a setting, asking how far it can be seen as part of a classical tradition and looking for the common currency of ordinary Victorian building.

My concern has been to look not only *at* Victorian art, but also *through* it at the world from which it sprang: it is an interesting task to take the outward and visible appearance of an age and ask what it can tell us about the preoccupations, conscious and unconscious, of the time. How far does the Victorians' art reflect their ideas and beliefs and the changes through which they passed? Simple answers are likely to be wrong answers; but the interrogation is worth while, none the less. Besides, the facts that we know about the Victorians are so many and various that they may confuse us by their multitude: we need a clue through the labyrinth. What I have done is to take one part of the Victorians' world – their visual

culture – and one aspect of that culture – its classical element – and tried to see where they lead us. I have discussed the relations between the Victorians' art and their literature; but since the classical influence on Victorian literature is immense and this is meant to be a book about visual art, I have usually had to be brief, of necessity, in what I have said about authors. Literature is treated very much more extensively in my earlier book, *The Victorians and Ancient Greece*. This also discusses, less fully, some aspects of the Victorians' visual art, and thus it overlaps with my subject here. In writing the present work, I concluded that if I were to avoid entirely those topics upon which I had touched before, I should distort the picture and enfeeble the argument, and so readers of the earlier book may occasionally feel a sense of *déjà lu*. As far as possible, though, I have aimed to break new ground.

I define the Victorian age in a fairly strict sense by the dates of the Queen's reign, 1837–1901. 'Periods' are always arbitrary constructions, and one which is defined by the deaths of one old man and one old woman may seem more than usually so. I used to suppose that it would be better to think in terms of two periods, the first stretching from 1830 to 1870, the second from 1870 to the First World War. I now suspect that a division into four periods would be at least as true to the dynamics of the nineteenth century: proto Victorian, 1820s to 1840s; mid Victorian, late 1840s to late 1860s; ripe Victorian, late 1860s to early 1880s; Edwardian, mid 1880s to about 1910. However, if the Victorian age is seen as a process rather than a solid lump of history, the Queen's dates may be as good limits as any. At all events, they are the limits that I have set myself. I have taken a fair amount of space to discuss the early nineteenth century, but I should stress that this has been in order to shed light upon the Victorian age itself. I have not sought to write another history of neo-classical sculpture, or architecture of the Greek Revival, topics which have been treated by expert hands, but tried to glean from these large fields such matter as may help to explain Victorian art and attitudes.

My first chapter attempts to sketch the Victorian setting, to raise some questions and to start some hares. Chapter Two considers how Victorian architecture relates to the classical schools of the eighteenth and early nineteenth century. Chapter Three looks at ideas about sculpture from two separate viewpoints: the first part

examines the odd place of sculpture in the Victorian imagination, while the second investigates the significance of the Pygmalion myth. Chapter Four returns to architecture, again with two quite different angles of approach. In the first section (which readers may perhaps find drier than most of the book) I have discussed Ruskin's complicated, uneasy engagement with Greek architecture, partly because he is so interesting in himself, but also because he tells us something about his time. The second section turns from theory to practice, and tests Ruskin's claims against the evidence of what the Victorians actually built, mainly by looking at one particular city. The rest of the book is concerned with the later part of the century. Chapter Five begins the enquiry into painting with some artists who enjoyed public honour and high esteem among a middle-class audience in their own time. The same period appears rather differently in Chapter Six, where the aesthetic movement is brought into play, and art becomes more entangled with literature. The later nineteenth century is in cultural terms a confused and perplexing period; Chapter Seven searches out a few strands in a complicated fabric and the place of a classical tradition within them.

I owe a large debt to all the curators and librarians who have lent their time and knowledge to the collection of illustrations, and I am grateful to the individuals and institutions that have allowed me to reproduce copyright material. My debt to those who have written before on nineteenth-century art and architecture is of course very great, though I cannot always pin it down. My warm thanks, for help and advice of various kinds, to Robert Baldock, Carol Heaton, Michael Liversidge, Christopher Newall, Stuart Proffitt, John Trelawny-Ross and John and Valerie Wilton-Ely.

LIST OF ILLUSTRATIONS

xiii

DIGNITY AND DECADENCE

The Victorian Setting

My dear Children,

Some of you have heard already of the old Greeks . . . Those of you who are boys will, perhaps, spend a great deal of time in reading Greek books; and the girls, though they may not learn Greek, will be sure to come across a great many stories taken from Greek history . . . You can hardly find a well-written book which has not in it Greek names, and words, and proverbs; you cannot walk through a great town without passing Greek buildings; you cannot go into a well-furnished room without seeing Greek statues and ornaments, even Greek patterns of furniture and paper . . .

With these words the Revd Charles Kingsley introduced *The Heroes* (1855), a collection of Greek myths retold for boys and girls, and they may stand here, like the text at the head of a Victorian sermon, to introduce this book. For my subject is the classical side of Victorian art and architecture, and Kingsley's claims raise the question of how large a subject it is. After all, when we first encounter the Victorians, we are taught that they were under the spell of the Middle Ages. We think of the Gothic Revival in architecture; in painting the word 'Victorian' conjures up the Pre-Raphaelites, whose name was a homage to the fifteenth century. If our interests are literary, we may think of Tennyson, whose *Idylls of the King* recreate the medieval romances of Arthur and his knights. If our concerns are historical and political, we may think of the guild socialism of William Morris and his friends, which gathered inspiration from a rather roseate view of how trades and crafts in the Middle Ages were organized.

Such is, or was, a conventional picture of Victorian culture. But in the case of literature opinions have changed, and it is recognized

that here the influence of the ancient world upon the Victorians was immense. To be sure, literature and the visual arts are different matters, and it is within literary culture that we would expect the influence of antiquity to have been strongest, for the simple reason that at this date most of those who were educated at all were educated chiefly in the Greek and Latin classics. It was a commonplace in the last century to say that men forgot most of what they had learnt at school or university, but it would be surprising if no traces of their education remained with them. Those fifteen years of Horace and Cicero, of ablatives absolute and questions expecting the answer no cannot have gone entirely for nothing. As the classical schoolmaster puts it in Kipling's *Regulus*, 'It sticks. A little of it sticks among the barbarians.' Or to turn from fiction to life, there is the observation of William Cory, among the finest of Victorian schoolmasters, that though much would be forgotten, at least 'the shadow of lost knowledge' would remain as a protection against many illusions.[1] Moreover, though many undergraduates were heroically idle, the universities always had their 'reading men', and it is chiefly among these that we find the future writers, thinkers and statesmen — that is, the men who produced the words which we read today. Many of the best Victorian writers and thinkers did not go to university — Dickens, Trollope, Mill, Grote, not to mention all those intellectual women debarred from higher education by their sex — but among those who did, we would expect to find classical ideas influencing the pattern of their thoughts.

Yet the fact of classical education cannot alone account for the extent of classical influence on Victorian literature. Ancient Greece, above all, was almost an obsession for many Victorians. Classical education had been going on for centuries, but this subjection to the spell of Hellas was comparatively new. Whatever its causes, it would be surprising if it had left the other arts untouched. We have heard Kingsley telling the children that the visible influence of ancient Greece is all around them in the fabric of their everyday lives: Greek buildings, Greek furniture, Greek patterns on the wallpaper. Was this true or was it special pleading?

Suppose we were to conduct an opinion poll, asking the passengers on the Clapham omnibus to name one object or building or monument to symbolize or sum up the Victorian age. I fancy that the most votes would go to the Albert Memorial (Plate 1). Designed

by Sir George Gilbert Scott, it dates from the plumb middle of Victoria's reign (1863–72), and very thoroughly Gothic it appears. And it is indeed more than a tribute to the dead prince, for it advertises the achievements of Great Britain. At the monument's four corners are deposited four masses of statuary, anchoring it to the ground as though it were a space rocket which might take off were there no weight of marble to keep it earthbound; they represent the four continents, reminding the British patriot that he is a citizen of the first world empire in history. Higher up, beside the columns that uphold the central canopy are four more groups representing Manufactures, Commerce, Agriculture and Engineering, and intimating that the industrial and agricultural revolutions were British inventions. Scott himself claimed that among the models for his Memorial were the reliquaries of the middle ages, shrines of

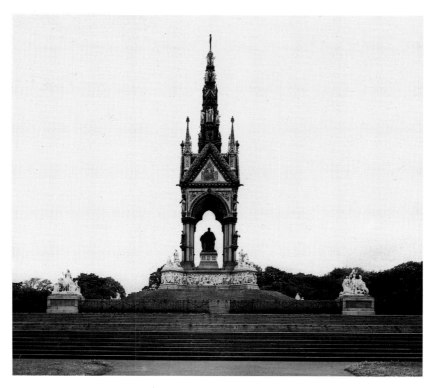

1 High Victorian shrine: the Albert Memorial, Kensington Gardens, London.

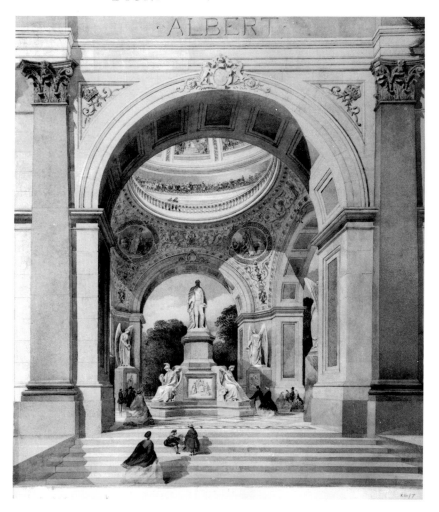

2 The Albert Memorial as it might have been: Sir Charles Barry's classical design.

jewels and precious metal for the bones or blood of saints and martyrs; but whereas medieval man was content with objects two or three feet high, this modern shrine has swollen to gargantuan size, like the power of Great Britain itself, which had expanded out of a small island into the largest empire ever known.

So the Memorial seems very British, very Victorian and — the sculpture apart — very Gothic. How well it seems to confirm the

idea of the Victorian era as one inspired by the Middle Ages. But from the Memorial's history a different picture appears.[2] The committee in charge of the project had asked seven architects to submit plans. One of them, Scott, was a champion of the Gothic style, but the other six were all in a broad sense classical architects. In the event two of these dropped out, and two other men were invited to take their place. Of the nine designs solicited and the seven submitted, Scott's was the only Gothic one. As we know, this was the one chosen; but the Memorial might easily have appeared as in Plate 2.

And since we find ourselves in Kensington Gardens, let us look closer. Around the monument's base runs a frieze depicting those judged to be the best poets, architects, sculptors and composers; 168 men and one woman. We are not surprised to see some prejudice in favour of local talent: Bird and Bushnell among the world's best sculptors, Benedict and Bishop among the composers. The front side is devoted to poetry, an art in which England has indeed excelled; surely we shall find Shakespeare in the central position. Not so: Dante and Shakespeare recline, like angels on an altarpiece, at the foot of the central throne; upon the throne itself sits Homer (Plate 3). It is an extraordinary tribute to the sway of Greece over the Victorian imagination that on this monument to imperial pride, of all places, Shakespeare should be subordinated to another.

3 Shakespeare defers to Homer: the great poets, by H.H. Armstead, on the Albert Memorial.

perhaps Armstead, the sculptor, felt the paradox, for he has made Homer rather more obviously Hellenic than he need have done. The footstool is archaeologically correct in its Grecian form; so too is the lyre, mutely dissonant with the medieval fantasy above.

No one will doubt that Greece and Rome had some influence on the Victorians' visual world; the extent of that influence is less certain. So let us, if only to clarify the issue, imagine a sceptic, doubtful whether the ancient world had much influence on Victorian art. 'Well,' he says, 'that part of the frieze is a tribute to literature, and we are agreed that literature is where we expect to find classical influence most prominent. Anyway, I can allow that in sculpture the classical tradition was particularly strong. But I am not yet persuaded that this tradition was more widely significant.'

Can we meet this objection? Let us next consider public buildings and travel to the heart of Liverpool, where we find St George's Hall (1841–56), designed by the brilliant but short-lived H.L. Elmes, perhaps the best secular building of its date in Europe (Plate 4). It stands at the top of a gentle hill, bestriding the high ground with a splendid confidence; like an ocean liner breasting the waves it rides the irregular terrain of St George's Plain, the rough cobbles rippling around its base. This building shows a four-hundred-year-old classical tradition in architecture, descended from the Renaissance, still continuing in the mid nineteenth century with perfect assurance; a tradition indeed, because Elmes uses the old vocabulary of classical forms without any embarrassment whatever, yet with freedom and originality. In some respects the Hall seems marked by a static monumentality; consider the ceremonious Roman dignity of the handsome portico, eloquent but not pompous, weighty without excess of heaviness. Consider the avenue of solemn columns along the flank; a composition which may recall the deep serious façade of Smirke's British Museum, which was going up in London at the same time (Plate 220). But whereas the Museum is merely grave and sober, the brilliance of St George's Hall is that it blends monumentality with a remarkable dynamism. It is exceptionally narrow for its length, but so well proportioned that no discomfort is felt. This slimness, together with the flatness of the roof profile and the straightness of the sides, where the colonnade is gathered in tightly to the main body of the building, creates a powerful thrust along its axis. The core of the Hall is a firm, simple oblong; but look

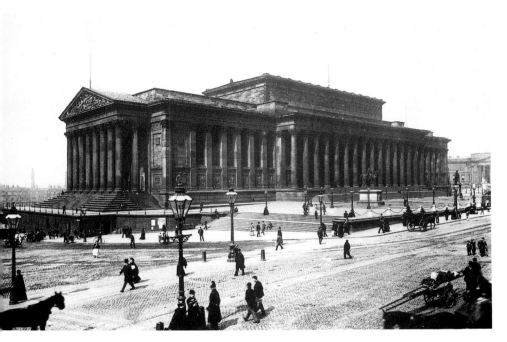

4 The centrepiece of
Liverpool's monumental heart:
Victorian classicism seen at its
finest in St George's Hall.

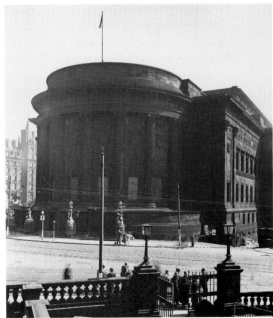

5 St George's Hall,
from the North.

how boldly the portico advances from that rectangular centre. And when we walk round to the back, the comparison to the stern of a ship is hard to resist (Plate 5). Further, Elmes has, more or less literally, let air into his composition. Let us return to the side façades. First look to the centre: an advantage of using columns is that they admit empty space into a composition: from one point of view, they make it more sombre by casting shadows which introduce areas of darkness into a façade; from another, they lighten it by breaking up the line of solid wall. Now look to the sides of the central colonnade. Here the flat expanses of wall contrast with the line of columns and yet echo them. Elmes has broken open the wall surface to create a group of square pillars with, again, an area of hollow space behind them. At first glance, the side of the building looks rather flat; on closer inspection we see that it is a composition in several planes: the line of free-standing columns forms one plane, the line of the wall another, the line of the inner wall half hidden behind square pillars a third. These subtleties modify the Hall's solidity; they give it a lightness, a buoyancy. It is a superb achievement; and though richly classical, it could belong only to the nineteenth century.

St George's Hall, one must admit, is in a class of its own; but let us see what else we can find merely by strolling round St George's Hall and discovering what our eyes light upon. The first thing to catch our attention is the Wellington Monument (1863), a Tuscan column with the Iron Duke on top. This type of monument descends from Trajan's Column in Rome, passing in the European tradition through Napoleon's Column in the Place Vendôme in Paris, the Duke of York's Column in London and, most famously, Nelson's Column in Trafalgar Square (1839–42). Nelson in London and Wellington in Liverpool show in Victorian architecture the continuance of a classical and European tradition.

Beyond the Wellington Monument our eye falls on two buildings of the 1870s (Plate 6): the Picton Library (1875–9), and the Walker Art Gallery (1874–9); two handsome buildings and – let us confess – unusually pure in their handling of classical forms for the period; perhaps the nearby St George's Hall imposed a sense of propriety. The Sessions House (1882) takes us unto the next decade (Plate 7); this is more typical of its period, more undisciplined in its treatment of the classical elements, coarser in detail. Further on we meet the

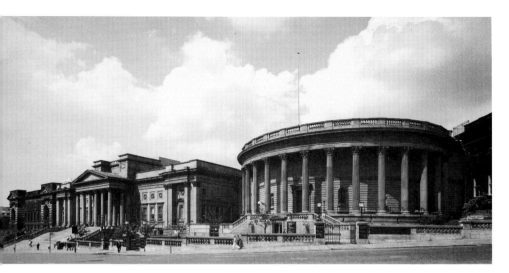

6 The central massif of the monumental range facing St George's Hall: the semi-circular facade of the Picton Library (by Cornelius Sherlock, 1875–9) with the William Brown Library (Thomas Allom, 1857–60) to its left. The Walker Art Gallery (Sherlock and Vale, 1874–7) is immediately to the right of the Picton Library.

Technical College (1896–1902); a different style here, but again typical of its period – the Edwardian or imperial baroque (Plate 8). This is still historicist architecture, but this time the primary historical allusion is patriotic, recalling Wren and his followers. Wren in turn had derived his style from various influences, above all the Roman baroque; so only at two removes or more does this late-Victorian style derive from antiquity. But it still belongs, in a jybroad sense, to the classical tradition; indeed the very indirectness of the Graeco-Roman influence shows the tradition's continuing vitality: it had been taken into the bloodstream of European architecture and was still developing even on the brink of the twentieth century.

We have now been through Queen Victoria's reign decade by decade, without even shifting our ground from St George's Plain. Liverpool's Victorian centre is unusually distinguished, but other industrial cities of the north followed its lead in putting up a classical town hall, usually in a ripely 'Italianate' style; Leeds and Bolton are good examples. The former case is particularly interesting in that the city fathers intended the building to represent their

9

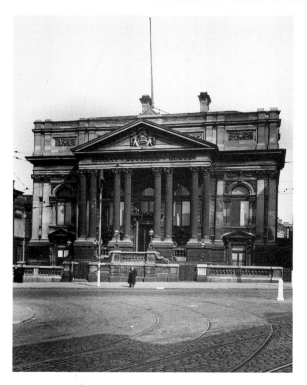

7 Liverpool, Sessions House (by F. and G. Holme, 1882–4): a looser handling of the classical elements, but still confident and enjoyable.

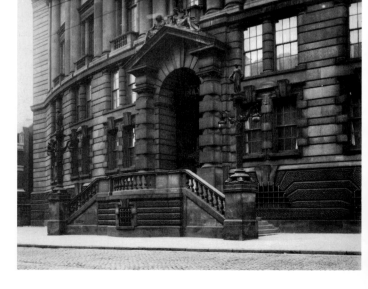

8 Liverpool, College of Technology (by E.W. Mountford, 1896–1902): imperial baroque (and an architect imported from London) as the Edwardian age draws near.

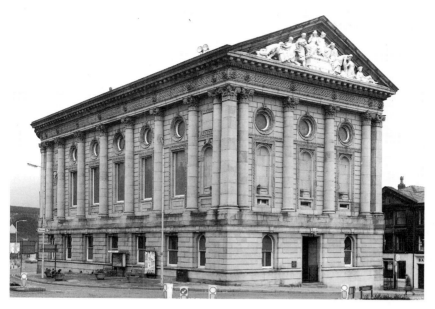

9 Mill-town temple to civic virtue: Todmorden Town Hall (by John Gibson, 1870). In the pediment, Yorkshire embraces Lancashire.

age to posterity, rivalling, as they hoped, the halls of medieval Flanders. Local philanthropy produced a noble temple to civic ambition even in the small Yorkshire mill town of Todmorden, deep in a Pennine dale close to the Lancashire border (Plate 9). The pediment contains allegorical female figures representing the two counties; Yorkshire has her arm around Lancashire's shoulder, no doubt to console her for not being Yorkshire.

'Very well,' the sceptic now replies, 'no doubt public buildings in the classical tradition were put up throughout the nineteenth century. But civic architecture is a distinctive case: it is meant to be pomp-and-circumstantial, and for this requirement a classical style did very well. But what of the buildings that the Victorians put up for their own pleasure?'

Let us then look at country houses. We shall start in the 1840s; and we shall start at the top. For their private use Victoria and Albert built Osborne House (1845–51; plate 10): an Italianate villa, its interior a petrified forest of marble statuary in the neo-classical tradition. True, they later built Balmoral in a more or less medieval

style, but it is this which is the special case. The house is Scots-baronial because it is in the Highlands; like the tartan wallpaper (horrid thought) the architecture is inspired by the spirit of the place rather than the spirit of the age: the *genius loci* demanded a style meet for Caledonia stern and wild.

And the classical style continued in country houses after the mid-point of the century. In the fifties Samuel Daukes created an Italianate palace for Lord Dudley at Witley Court (Plate 11), incorporating porticoes built by Nash in about 1800, and attached to the parish church of the 1730s; the harmony of the whole group testifies to a continuing, adaptable tradition of classical design. Brodsworth Hall is an example of classical style in the sixties, St Leonard's Hill in the seventies. By 1880 the Queen Anne Revival was well under way, the Gothic Revival was virtually dead for domestic purposes and the architecture of the home had abandoned the Middle Ages.

10 Royal Italianate: Osborne House, Isle of Wight (by Prince Albert and Thomas Cubitt, 1845–51).

11 A classical tradition: the Italianate palace of Witley Court, Worcestershire (by Samuel Daukes, 1850s) incorporates John Nash's portico (*c*.1800) and the parish church of *c*.1735 (seen top left).

Of course there were plenty of Gothic country houses built in the first half of Victoria's reign (seldom after the mid seventies); yet through the zenith of the Gothic Revival there was also a classical tradition continuing unabashed. The owners of country estates felt free to build in either style. If we turn from mansions to more everyday buildings, the classical tradition is still in evidence. What did the ordinary Victorian street scene look like? A stroll along the endless Italianate terraces of Bayswater or Kensington, past more Tuscan columns than were ever seen in Tuscany, provides an answer. The basic vernacular of Victorian London is a kind of debased classical.

What then has become of the Gothic Revival? Several things might be said. First, for a period of forty years or more, virtually every Anglican church — and there was a vast number of them — was designed in the Gothic style. Pugin, the John the Baptist of the Victorian Gothic Revival, was a Roman Catholic; but his ideas were quickly taken up by High-Churchmen, and the Cambridge Ecclesiologists were especially zealous in spreading his gospel. Schools and colleges, too, are usually Gothic at this time, partly because the grandest public schools dated from the Middle Ages, partly because of Oxford and Cambridge, and partly because founders and benefactors were more eager than ever to assert the religious

basis of education. A rare exception may confirm the rule: Welling-
ton College was built in a red-brick Wren style in the fifties (one
would think it twenty years younger), but the rejection of Gothic
signifies that the school's foundation is military rather than
religious. University College London had been established in the
1820s as a secularist and utilitarian alternative to Oxford and Cam-
bridge. In 1832 came the official counterblast: the foundation of
Durham University, placed with symbolic fitness in the midst of
one of Europe's grandest medieval monuments. Durham had been,
in Scott's words, 'Half church of God, half castle 'gainst the Scot';
now the castle would become a holy fortress defending Christian
education against the modern world's infidelity.

But though Anglican churches and colleges are usually Gothic,
we get a different picture from the Nonconformists, partly because
they reacted against the Established Church. Methodism had grown
out of Anglicanism, and the Methodists were more inclined to stick
to Gothic, but Baptists and above all Congregationalists were much
attached to classical forms and were still putting up handsome
porticoed façades in the mid century and even later. In Scotland
the scene is again different: the Church of Scotland – Presbyterians,
to be sure, but here the Establishment – tended to favour Gothic.
So did the Episcopalians, thus asserting their kinship with the
Church of England south of the border. The independent Calvinist
congregations sometimes went for the Greek Revival (Plates 214
and 215): again one supposes that the style was chosen to demon-
strate separateness.

With the Roman Catholics the story is different again, for they
fought an architectural civil war within their own ranks. On one
side were those who wanted to stress the modern Roman church as
the true descendant of the medieval English church. Loudest of
these was the convert Pugin; like many nationalists, he was half a
foreigner, his father being an expatriate Frenchman. The fifteenth
Duke of Norfolk built enormous churches at Norwich and Arundel
at his own expense; conscious of his family tradition of aristocratic
English recusancy, he too chose the Gothic style. Oxford, a city
which, in Arnold's words, still whispered the last enchantments of
the Middle Ages, got the Gothic St Aloysius, a large grim barn
designed by the inventor of the Hansom cab, which is not enchant-
ing and whispers nothing whatever. On the other side stood the

Ultramontanes, like Father Faber the Oratorian, who favoured an Italianate architecture which proclaimed their loyalty to the see of Rome; the best known example is Faber's own Brompton Oratory (built after his death). Yet ideology is not a certain guide: we might expect Newman to have been a Goth; in fact he advocated the Italian style.

These considerations suggest that in some Victorian buildings, at least, the style has a symbolic function. But where there are competing symbolisms, more than one style is needed for the different sides of the argument to be expressed. So the more one sees Victorian style as symbolic, the more one should expect to find the classical tradition present as part of the story. Here we must tread carefully: sometimes there is symbolism in the style of a nineteenth-century building, sometimes not. It would have been surprising if the secularist University College London, put up in the 1820s, had not been in the Greek style; fittingly, the architect, William Wilkins, changed to a Gothic style for his work at King's College Cambridge. But at Downing College Cambridge he was purely Greek again, and this time the choice of style seems to be entirely aesthetic. (These, incidentally, were the first university buildings on the campus plan, anticipating Jefferson and Latrobe at Charlottesville by some ten years.) The relation between architecture and the society from which it springs is not as simple as the historian might wish.

Besides its ecclesiastical importance, the Gothic Revival is probably represented in every sizeable English town by a substantial secular building: a town hall, hotel or railway station. It is also true that many of the most original architects of the time were Goths: Pearson, Bodley, Butterfield, Street, Burges. The biggest of them all in fame and size of practice was Sir George Gilbert Scott; not a great artist, but as a self-promoter in the very highest class. All these men took up the Gothic cause (though Scott, faced with the possibility of losing the commission for the Foreign Office, consented to run off a design in the Italianate style demanded by Lord Palmerston – one of his best buildings, as it turned out).[3] And much of the finest Victorian architecture did go into churches, where the Gothic style was dominant.

However, if we concentrate on the most prominent figures, we may be misled. In one sense, after all, brilliant men cannot be

typical, because most men are not brilliant. Ruskin is a case in point: a man of genius, but for that very reason not representative of ordinary taste. In some respects he was indeed influential, his most visible legacy being the mid-Victorian vogue for the Venetian Gothic; and he was among the inspirers of guild socialism. But in other matters, though he was admired, one may doubt whether he had much effect. He told his readers that Rembrandt and Murillo were disgusting, and the Victorians went on adoring them; he told them that their social system was wicked, and they went on thinking it rather a good thing; he told them to build Gothic houses, and though a few dons in North Oxford paid heed the people as a whole did not. And indeed, as we look at our own age, we may become sceptical of the real influence of prophets and polemicists.

We should also be cautious about taking an era at its own valuation. It is probably true that the Victorians tended to think of themselves as a medievalizing age, and perhaps they had some cause to do so. England is the oldest country in the world, the last surviving medieval state. The structures and institutions of France and the United States derive from the Enlightenment: they are late eighteenth- or early nineteenth-century. Germany and Italy are creations of the mid nineteenth century, Russia and Japan of the twentieth. But England's medieval organization has just gone on, evolving without any definite break, and such continuity has visible effects. Rights of property accumulate and cannot be dissolved; the pattern of streets is almost unchangeable. Haussmann was able to demolish wide areas of Paris and construct a nineteenth-century city of broad boulevards; in Britain that could not have been done. (People sometimes talk of Wren's plan for rebuilding the City of London after the Great Fire as an opportunity lost. Surely they are wrong. It was a visionary scheme, which could only have been realized by compulsory purchase and the buying out of innumerable property rights, things which the seventeenth-century British state had no mechanism for bringing about.) Hence the view that English taste is essentially quaint, countrified, picturesque, while the genius of France (and maybe of other countries too) is grand, urban and classical: making avenues, building palaces and setting up triumphal arches are essentially un-British activities. Sir Nikolaus Pevsner argued this line with charm and ingenuity in *The Englishness of English Art*, and there is truth in it; but not the whole truth. The

British may seem deviant if we fix our gaze on France, less so if we turn to Italy: Rome had no wide avenues until Mussolini tore down old buildings to make them. More importantly, the argument runs the risk of confusing preference with practicality; of assuming that the British wanted what the British got. In fact they were keen enough, especially in the later nineteenth century, to emulate the grandiose town planning of the Continent. The new stone façade clamped on to Buckingham Palace in the early years of this century, the Queen Victoria Monument and Admiralty Arch at either end of the Mall are all parts of an attempt to give London a triumphal classical-cum-baroque centrepiece worthy of an imperial capital. Given the constraints, there were limits on what could be achieved. Given the space and freedom, in India, the British strove to outdo Rome, Paris, Washington and St Petersburg, stamping upon New Delhi a scheme of classical city planning on a colossal scale.

The Victorians were fond of contrasts or dichotomies: between the south of Europe and the north, between pagan and Christian, ancient and modern, Greek and Gothic. These pairs of contrasts are not of course synonymous, but they tended to get conflated. Britain was northern, Christian, modern; therefore it was natural for it to be Gothic rather than classical. So people sometimes felt, and the feeling was supported by ingenious though not always plausible arguments. In his influential *Lectures on the Drama* A.W. von Schlegel had argued that the Gothic style was intimately connected with the northern spirit, and we shall find Ruskin trying to establish the same case with a wide range of arguments drawn from race, climate, landscape and geology.[4] But if there were a fair number of Victorians who liked to suppose themselves the natural heirs of the Gothic Middle Ages, still the question remains: were they right? For it is easy for an age or a people to get a false impression of itself. Journalists today keep writing that death has become a taboo subject in our society; from which one may deduce that it is not taboo at all. The English reprove themselves for being stiff and reserved. Like much self-reproach this is a covert form of self-congratulation; but in any case the dispassionate observer sees the English behaving with an extroversion that may strike a Spaniard (say) as painfully undignified. The French call the English perfidious, though their conduct of foreign affairs has been ever innocent of the morality into which British policy has occasionally lapsed.

The English accuse the French of indecency, the French accuse the English of hypocrisy; on reflection one may suspect that each nation projects its characteristic vices on to its ancient enemy. If nineteenth-century Englishmen put on a medieval air, we need not rush to believe them; we may first ask what emotional urge they are satisfying.

Let us set architecture on one side and see what we are left with. We can certainly find many examples of Victorians putting on medieval airs, once we start looking, but the more one examines these phenomena, the more slight they appear. In 1822 Sir Kenelm Digby published his grand exercise in romantic snobbery, *The Broad Stone of Honour*, a long and preposterous book in praise of the chivalric ideal; it had no real importance. 'Young England', a small group of aristocrats, tried to invent a new feudal radical Toryism; it foundered. (This short-lived movement acquired an odd immortality through its appearance in the *Communist Manifesto*, where we are told that the people dismissed it with irreverent laughter − one of that document's more accurate statements.) In 1839 came the Eglinton Tournament, when a number of noblemen donned armour and tried to joust and tourney in pouring rain. It was a gloriously dotty enterprise, and to most people it seemed dotty at the time. For the common view of such things, we need only look at *Punch* or Dickens. Late in the last century, and early in this, there was a rather limp cult of knightliness, chivalry and manliness, sometimes mixed up with St George and *Scouting for Boys*, with a seasoning of racial and social snobbery tossed in.

But how thin and bloodless these day-dreams seem, how irrelevant to what was really going on. Such anaemic romanticism had little or no effect on most of the men who shaped the nineteenth century (though Tennyson was lightly touched by it), and it left the mass of the people unmoved. We are dealing, after all, with a period of huge energy and invention: wherever the heart of Victorian thought, imagination and activity was, it was not here. Once we leave aside the visual arts and their interpreters, it is hard to think of a major Victorian whose imagination owed more to the Middle Ages than to the classical world (there were of course great Victorians whose imagination owed nothing to either; Dickens for one). Even Tennyson is a doubtful exception. Though he versified the Arthurian legend, his treatment owes more to Homer, Virgil and Theocritus

than to medieval poetry; the theme of *Idylls of the King* does not in itself make Tennyson a medievalist any more than Matthew Arnold's *Sohrab and Rustum* makes him an orientalist (in fact that poem is stuffed with Homeric allusion). Even among visual artists one may wonder whether many major figures, architects apart, really owed much to the Middle Ages. The Pre-Raphaelites looked back to Italy before Raphael: that is, to the early Renaissance; Burne-Jones surely belongs more with the symbolists and mystagogues than the medievalists. Ruskin himself will prove a complicated case; but he must abide our question for the time being.

The Victorians were zealous hero-worshippers, and they used both the Middle Ages and classical antiquity to serve their purpose. Within antiquity it was the Greeks, not the Romans, who were the great objects of adoration, but though Greece was venerated as devotedly as the Middle Ages, it was in a different style: the Victorians did not claim to be natural heirs to Hellenic culture. The Germans — sometimes — did. Their obsession with ancient Greece took various forms; many of them were impressed by the gulf between Germany and Greece: between the ancient and modern worlds, between a Mediterranean civilization and the Teutonic north. But there was also another strand of thought: that while the lush, florid culture of Rome passed down into the bloodstream of the Latin nations, the pure northern race of Germany had a kinship with the Aryan civilization of Greece. Even Hitler had something to say on the subject. But this idea is largely absent from Britain, where the constant cry was rather: look how unlike us the Greeks are. This does not mean that Greece was not influential. On the contrary, the remoteness of Hellas from the modern world becomes an abiding theme in Victorian art and thought: it provides a standard, a sense of distance. But Hellenism is not the only kind of nineteenth-century classicism. In considering the classical aspects of Victorian art, we must keep in mind two things: first, the prestige of Hellenism and the more or less direct influence of Greece, taken virtually pure and undiluted; but also the persistence of the broad classical tradition of Europe. In the one case we find the conscious imitation of a distant age and its art, or at least a conscious allusion to it; in the other the half instinctive continuation and adaptation of something that had become acclimatized to Britain over two centuries and more.

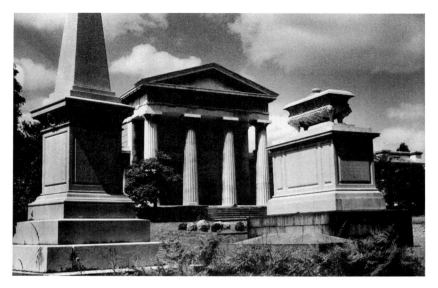

12 The classical dignity of death: Kensal Green Cemetery, London. The chapel (late 1830s) is in the form of a Greek Doric temple; in the foreground is the tomb of Princess Sophia, daughter of George III (1846).

That rather tiresome personage, the imaginary sceptic, may now make his last appearance. 'All right,' he now says, 'the classical tradition in the building trade was stronger than I realized; but that apart, I still think that the classical taste was a mandarin taste, a habit of the upper classes. I don't suppose it touched the middle class much, and certainly not the mass of the people.' It seems a fair comment. So let us lower our eyes from the heights of Parnassus to the foothills, starting with the prosperous middle class and working downwards towards popular culture.

Cemeteries make an interesting study, for the dead are sincere. In the presence of death people often forget to like what they are told to like, and indulge their real tastes, as any churchyard shows, to the cultivated distress of tasteful persons. It is revealing, therefore, to see that Victorian funerary art is quite often classical, at least in the earlier part of the Queen's reign, as for example at Nunhead and Kensal Green cemeteries in London (Plate 12), both exhibiting the Greek style in a surprisingly pure form for the mid century. The cemeteries of Scotland, such as the Glasgow Necropolis, are still more persistently classical.

And before they were laid beneath the sod, how did the bourgeoisie spend their leisure hours? Let us now look towards the latter part of the century. Perhaps they shopped at Liberty's, or went to Gilbert and Sullivan at the Savoy Theatre. Now there is more Hellenic comedy in those operettas than one might imagine. The libretti of *Iolanthe* and *The Grand Duke* cannot be printed without the use of a Greek font (which shows that the standards of musical comedy have changed), while *Patience* and (again) *The Grand Duke* contain much satire directed at the fashion for Hellenism in literature, art and life. And when the audience bought the Savoy Theatre's programme, they might find a classical-pastoral advertisement for Liberty's (Plate 13). As we shall see later, more humdrum products too were publicized in a classical style (Plates 212 and 213).[5]

The shops themselves make their bow towards the classical dignities. There is a popular tradition here, which goes on so modestly and steadily that examples are often hard to date. The shopfront in

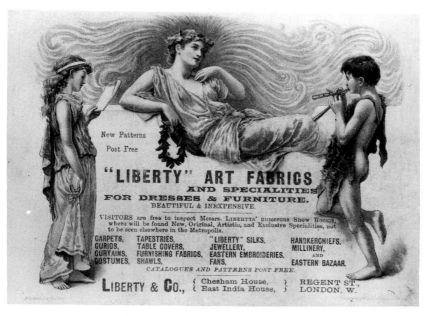

13 Arcadian pastoral indicates the refinement of Liberty's; an advertisement from the programme of a Savoy Opera, 1880s.

21

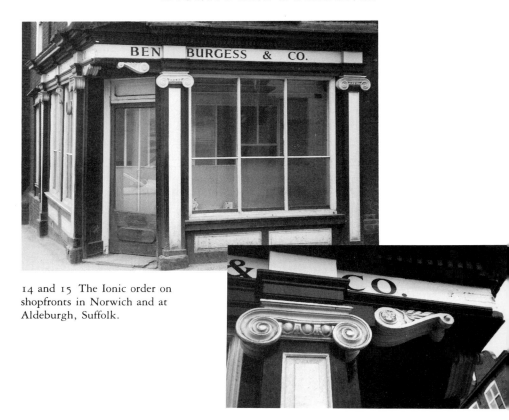

14 and 15 The Ionic order on shopfronts in Norwich and at Aldeburgh, Suffolk.

Norwich shown in Plate 14 — so pleased and proud to be classical that its Ionic capitals are rather too big — might date from the 1830s, the shopfront at Aldeburgh (Plate 15) from some fifty years later. In this instance the scheme is not really classical at all, but the designer has wanted his Ionic pilasters none the less; so he has rather charmingly tacked them on to the façade, adding an air of propriety and worthiness: those volutes and flutings assure the public, 'Reliable merchandise within'. And the broad classical tradition is the style for fun and entertainment. There were few Gothic pubs, but for a drinking-place a broad-classical style (sometimes a very-broad-classical style) was just the thing (Plate 16). Theatres and music halls were voluptuously and idiosyncratically classical. And if you went to the fairground to ride on the Scenic Dragon, what a glorious spectacle met your eyes (Plate 17). Up in the pediment sits Apollo, complete with lyre; a line of Ionic columns runs below. A glance at Vitruvius is enough to show that this is an Ionic order of original design and unorthodox proportions, but plainly Ionic it is, all the same.

These things, slight in themselves, reveal a popular deference

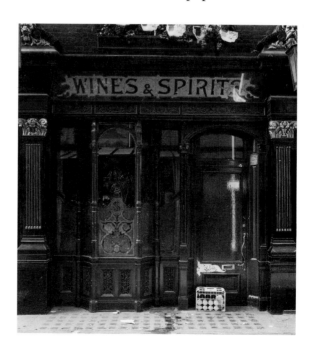

16 Public-house classicism: the Corinthian order handled with cheerful unorthodoxy at the Marquess of Salisbury, St Martin's Lane, London.

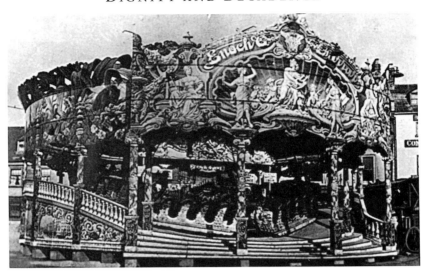

17 Folk-classicism: exotically Ionic columns, with Apollo in the pediment, on the Scenic Dragon.

towards the classical tradition, and this finds its reflection also in literature. We have looked at shopfronts; now let us cross the threshold and see what, in Dickens's imagination, is happening inside. David Copperfield recalls his visits as a boy to the pawn-broker: 'The principal gentleman who officiated behind the counter, took a good deal of notice of me; and often got me, I recollect, to decline a Latin noun or adjective, or to conjugate a Latin verb, in his ear, while he transacted my business.'[6] Such vicarious pleasure in the prestige of classical accomplishments finds its visual equi-valent in the Grecian columns on the shops' façades.

· We have been to the fairground and admired the Scenic Dragon. Half a century earlier we might have gone to Wombwell's Circus and passed through the classical portals illustrated in Plate 18. Now let us go to the fairground with Dickens, in *The Old Curiosity Shop*, and pay our money for Mrs Jarley's waxwork.[7]

'It isn't funny at all,' repeated Mrs Jarley. 'It's calm and — what's that word again — critical? no — classical, that's it — it is calm and classical. No low beatings and knockings about . . . like your precious Punches . . .'

And Mr Slum declares admiringly, 'What a devilish classical thing this is! By Gad, it's quite Minervian!' Though pretension and snobbery play their part in such popular deference to the classical, the feeling is not merely false or superficial. Whether you are going to the music hall to see Albert Chevalier, or stepping out at the *Palais de Danse*, or simply sinking half a quartern in the pub, you want to do it in surroundings that have a bit of fun and glamour and self-importance about them; and these things the broad classical tradition provides. Some Victorian classicism, as we shall see, is pale and refined; but much of the Victorian enjoyment of the classical is loud, vigorous and even vulgar.

This survey of Victorian pleasures may fittingly end in a place of education and entertainment for all classes: the Great Exhibition at the Crystal Palace. It was opened in Hyde Park in 1851, plumb in the middle of the century, a period when, it is often said, English art and letters were robustly national to an unusual degree, English through and through. In the romantic age the German sages had had a great influence, but this had now waned, and the Francomania of the later nineteenth century had yet to develop. Or to think in more classical terms, the age of neo-classicism was at an end, and the Hellenism of the aesthetic movement was still fifteen years or more away. It is the hey-day of Victorian self-confidence, the age of Dickens and Landseer, of Palmerston and Lord John Russell.

So historians say, and on the whole they are right. It is all

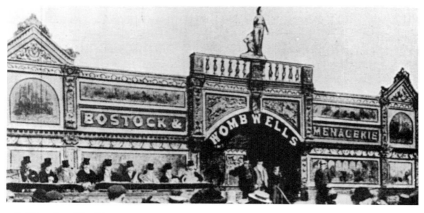

18 Wombwell's Circus: classical dignity at the zoo.

the more interesting, then, to examine the taste which the Great
Exhibition displays. When we buy the catalogue we find that the
design of the cover is not just in the broad classical tradition but
specifically Greek in allusion (Plate 19); and when we open it, we
discover quantities of decorative art in what is evidently the classical
tradition in debased form (Plate 20). In these objects we see classical
shapes disappearing beneath knobs and bumps and carbuncular
excrescences, like those amphorae encrusted with barnacles brought
up from the Mediterranean seabed. The fine arts at the Exhibition
also continued a classical tradition: two sculptures in particular
aroused comment, John Gibson's *Tinted Venus*, and the *Greek Slave*,
by the American Hiram Powers (Plates 21 and 22).

These statues may serve to raise another question about the Vic-
torians: were they as prudish as received opinion would have it?
Taken together, the two works may suggest how swift, how slippery
is the shift from innocence to prurience. The *Tinted Venus* is surely
a very harmless thing, and indeed it stirred wide interest only
because it was coloured. But what are we to make of the *Greek
Slave*? Here is more of a puzzle. The title at first seems to suggest
ancient Greece, with all its lofty associations, but actually the theme

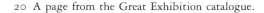

19 The cover of the catalogue of the Great
Exhibition (1851): Greek figures as the
hallmark of culture.

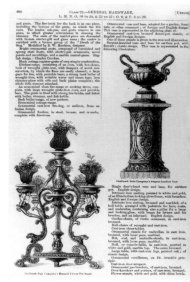

20 A page from the Great Exhibition catalogue.

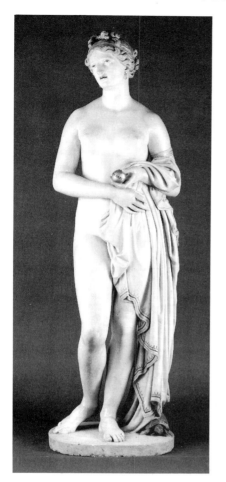

21 'Rather a grisette than a goddess', in Mrs Browning's view: Gibson's *Tinted Venus*, shown at the Great Exhibition.

22 Another sensation at the Exhibition: Powers's *Greek Slave*. The carpet and the crucifix show that the subject is not after all classical.

is more modern. Once we have noticed the patch of Turkey carpet on the left and the tiny crucifix, we realize that the girl is a slave of the Turks and presume that she is destined for the harem. This reflection, and the chains, suggest a deviant sexuality; yet as one looks at the tame, smooth marble one wonders how far this was consciously or even unconsciously meant.

No doubt remains, we may feel, when we turn to the next generation, and from sculpture to painting, as represented by such works as *The Sculptor's Model*, by Alma-Tadema (1877) or *The Cave of the Storm-Nymphs* by Poynter (1903) (Plates 78 and 23). Big prices have been paid for these pictures recently. *The Sculptor's Model* went for £110,000 in 1981. Prices in the auction-room have been moving so rapidly that this may no longer sound a large sum, but it was then far more than had ever been paid for a work by any Victorian classical painter. *The Cave of the Storm-Nymphs*, which had fetched £3,500 at auction in 1969, sold in 1981 for over £200,000 and again in 1988 for £400,000. That is even more remarkable: *The Sculptor's Model*, whatever one may think of it, is technically accomplished; but £400,000 is a lot to spend on something entirely ridiculous.

The truth cannot be evaded: if pictures of this date have a sufficiently titillating theme, £50,000 or more is added to the price. It sounds fantastic, but it is true; and the fact reveals something about the Victorians, and about ourselves. They managed, in some of their art, to be prurient and respectable at the same time. Poynter and Alma-Tadema were not rebels but members of the establishment, honoured in their time. We may notice too how each of these pictures gains propriety from association with the ancient world. In the case of *The Sculptor's Model* the classical connexion is clear enough;[8] Poynter's picture is not in truth classical at all, but its appurtenances are: the word 'nymphs' in the title and the elaborate golden frame, complete with columns, capitals and fluting.

Mankind has known since the Garden of Eden that forbidden fruit is sweeter: the advantage of repression is that it adds interest to life. There is a modern folk-myth according to which the Victorians were so prudish that they concealed the legs of tables and pianos for reasons of decency. The belief is false, but it has a symbolic value: fancy being in a state of such permanent erotic excitement that a table leg would be too much to bear. The Victorians somehow knew how to make a high drama out of the sexual as out of the moral and religious life. That is what comes through in their art, and inspires the present-day spectator with a kind of envy; and that perhaps is why the collector turns aside from what his newsagent has to offer and buys a Victorian painting, at considerably greater expense.

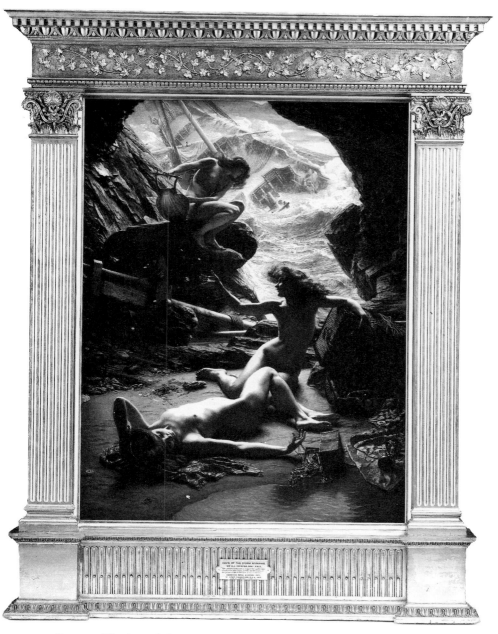

23 Poynter, *The Cave of the Storm Nymphs*. The frame is emphatically classical, the title apparently so; the painting itself is not.

There was, in fact, a fair amount of nudity in the Victorian drawing-room. The Queen herself, at Osborne, could hardly move for marble figures, clothed and unclothed. The middle classes did not have the space or money to put so much marble into their parlours, but they did the next best thing by buying Parian ware, a kind of pottery that, as its name suggests, was designed to look like marble and to evoke, however faintly, the prestige of ancient Greece.

The Victorians were in some respects freer than we are. In the 1860s there was a threat that the Prime Minister, Palmerston, then over eighty, would be cited as a co-respondent. Disraeli, a political opponent, is said to have counselled silence, for fear that he would sweep the country. It is impossible to believe that a modern party leader could survive such a scandal; more significantly, perhaps, it is hard to imagine one behaving in such a way. Ours is the age of crushing respectability in high places.

Disraeli's own conduct is interesting. It is not only that his financial affairs were so rickety for much of his life that no prime minister today would risk giving him office; it is perhaps his novel *Lothair* which most strongly challenges the conventional view of Victorian stuffiness. When it was published in 1870, Disraeli had already been prime minister once and was to be prime minister again. The pivot of the plot is an attempt by Cardinal Grandison – a thinly disguised version of Manning – to frustrate the Italian Risorgimento by faking a miracle. There is also cloak-and-dagger adventure among Fenian conspirators, and some mildly risqué joking about the seductive canvases of Mr Phoebus, the great Hellenic painter.[9] Imagination fails to conjure up the possibility of anyone high in British political life today writing a novel in which (say) Cardinal Hume fakes a miracle to influence the Palestinian question. Of course, there was no one quite like Dizzy; but the important fact is that he could get away with it. In some respects the Victorians were indeed less tolerant than ourselves; in others it would be better to say that the bounds of their tolerance were different. Even Oscar Wilde's imprisonment, so often taken as the supreme example of Victorian hypocrisy or intolerance, does not quite carry the moral usually attached to it. The crime of which he was convicted is still on the statute book and, though practice may be changing today, not long ago four years would have been a likely enough sentence. Wilde got two.

Upon the longest view the Victorian age now appears as an age of liberation. Maybe we were not brought up to think so: an older picture set the Victorians in contrast to the carefree Regency, when England was full of handsome bucks and rakes destined for reincarnation in the pages of Georgette Heyer. There followed William IV's seven years (we were never quite sure what to think of that awkward period) and then in came puritanism, respectability and all the rest. But on a closer look this picture falls apart. Consider the famous horror childhoods of the nineteenth century which have coloured the folk view of the Victorian age. The story of Elizabeth Barrett Browning's constricted youth is well known. But she was born in 1806; her upbringing was a Regency upbringing and her Victorian period was her time of liberation: elopement, marriage, a free life in Italy. Ruskin's account, in *Praeterita*, of his severely regulated boyhood is eloquent. He was born in 1819; again, it was a Regency childhood. Or take Dickens: readers of *David Copperfield* who see Mr Murdstone and his ghastly sister as archetypal Victorians are wrong. The novel is partly autobiographical, and Dickens, born in 1812, is looking back to his youth; his own servitude in a blacking factory was a good dozen years before Victoria's accession. As Victorians, writers like Dickens and Ruskin looked back on an earlier period and passed judgement upon it, but posterity has misunderstood: it is as though the Bloomsbury Group were regarded as fervently religious because Lytton Strachey wrote about Gordon and Manning. Generally those Victorian accounts of evangelicalism turned sour and childhoods blighted by adult tyranny are pictures of a world that had passed or was passing away. Perhaps the most obvious exception is Edmund Gosse's *Father and Son*, a memoir of his upbringing in the fifties and sixties, but Gosse's parents, as members of the exclusive branch of the Plymouth Brethren, were oddities in their own time. Of course it would be absurd to claim that there were no killjoys or heavy fathers in the Victorian age; but on a wider view and with the advantage of hindsight we can perhaps see that they were fighting a long rearguard action. The Regency was their time of triumph.

What then of those Regency rakes? We cannot pretend that they never existed. One view has been that the aristocracy took fright in the late Georgian period. The spectre of revolution stalked across Europe; the English nobleman saved himself from the fate of his

French counterpart by turning himself from a gay blade who ruined the milkmaids into a frock-coated paterfamilias with side-whiskers and ten children. The aristocracy, it is said, adopted the style and appearance of the middle classes.

This is rather less than a half truth. It would be hard to find individual cases of noblemen who were turned from profligacy to piety by fear of the mob's displeasure. More generally, this notion misrepresents Victorian society. Those Regency rakes did not vanish; they went on regardless. Their clothes grew a little uglier, their style a little coarser, but their behaviour changed hardly at all. Consider the world of the Prince of Wales: adulterous, extravagant and irreligious. That was as typical of the Victorian aristocracy as the pious earls whose daughters distributed tracts to the servants. Despite virtuous noblemen, despite the great importance of the respectable working class, it can also be said that Victorian society was significantly pagan at both top and bottom. That is not to deny that it was a religious age. It was indeed, and to some extent because it was also a pagan age. Christianity and heathenism, in a sense, needed each other. One cannot read much Victorian literature without discovering their sense of the high drama of the spiritual life. Sin and evil are felt as immensely powerful forces; no less powerful the assurance of salvation, of iniquity washed clean in the blood of the Lamb. There is a feeling of struggle, of thrilling danger; it is as though religion, like sex, was more exciting in those days. One of the ways in which the Victorians now seem most different from us is their sense, in many departments of life, that the stakes are very high. And if we find in Victorian art a tension between unabashed eroticism and monumental high-mindedness – sometimes between one man and another, sometimes within a single mind – we may perhaps see it as reflecting a battle within Victorian society itself.

The Regency was a time of religious fervour, and the Victorian age was more irreligious than popular belief has it; which is not to deny that there was change as well as continuity. Kingsley wrote in 1862, 'The attitude of the British upper classes has undergone a noble change. There is no aristocracy in the world . . . which has so honourably repented.'[10] Hippolyte Taine, travelling around England in 1861–2, was struck by the religiousness of English schoolboys in comparison with those of his native France.[11] But

this more cheerful picture gives us only half the story. Dickens's *Little Dorrit* (1857) and Trollope's *The Way We Live Now* (1873) inveigh against a *beau monde* that is greedy and corrupt, and though something must be discounted for a novelist's exaggeration, their case can be supported by evidence straight from Victorian life. And there is a further point. Though there were of course pious noblemen, it was more among the country gentry and the bourgeoisie that a shift towards religious devotion and a high sense of moral obligation occurred; indeed in many cases it had always been there. Aristocrats might be flashy, vulgar or irreligious; they might marry dairymaids, chorus girls or moneyed Americans; many of the lesser gentry went on living much the same country life that they had lived for generations, never marrying badly, constant at church, firm in the exercise of duty.

In any case, piety among the wealthy, where it existed, did not affect their style or expenditure as much one might expect. Few Victorian houses are more ostentatious than Tyntesfield or Cardiff Castle. The owner of Tyntesfield, William Gibbs, was a devout High Churchman, and the most lavish part of the building was a large chapel. Cardiff Castle was commissioned by the Marquess of Bute, one of the richest men in England, who had caused a sensation by his conversion to Rome and whose style of life, a strange blend of luxuriance and monkishness, continued to excite fascination. We have to take into account an aesthetic theory which licensed and even encouraged conspicuous expense, provided it was upon a worthy object. Pugin's aesthetics were religious in inspiration; at the same time he hated modern – that is classical – architecture for being mean and cheap. He saw the expenditure of time and treasure on building as part of a religious view of life which believed in man doing the best work that he could as a means of honouring God. Ruskin's attitude in *The Seven Lamps of Architecture* is similar. One of his seven principles of good architecture is the Lamp of Sacrifice. This principle holds that good buildings, at least if their purpose is virtuous, ought to look expensive and be expensive. For it is man's duty to sacrifice to God: the rich man should sacrifice his money, and the craftsman should offer his best energy and talents. Incidentally, buildings like Tyntesfield and Cardiff Castle surely disprove the idea that the upper classes were adopting a low profile to avoid the indignation of the rest. Profiles could not be much

more dramatic than these: their picturesque irregularities were inspired by aesthetic not social causes.

Of course attitudes were changing in the Victorian age; this is the period, after all, in which Britain develops from oligarchy to representative democracy, a profound transformation achieved with remarkably little fuss. In the fifties and sixties perhaps the most important force working for the liberalization of British attitudes was not fear but optimism: the Victorians could accept deep changes because at heart they believed that things were getting better. There were two exceptions to the general sunniness. Many people were despondent – how could they not be? – at the way in which towns grew uglier year by year and the countryside shrank. And the decline of religious observance caused sadness and anxiety. But on the whole it seems true that the Victorians – the mid Victorians at least – were a hopeful set of people. The Victorian sages may seem to give a different impression: Carlyle, Ruskin, Matthew Arnold and even Dickens seem steeped in deepest gloom about the condition of their age and nation. But once again we should beware of taking sages too seriously. 'The second-rate superior minds of a cultivated age and nation,' John Stuart Mill remarked, 'are usually in exaggerated opposition against its spirit',[12] and the same can be true of the first-rate too; thus in fourth-century Greece the intellectuals were all against democracy just at the time when it was most widespread. Besides, it now seems that the pessimism of some Victorian sages was a kind of luxury emotion, licensed by a fundamental optimism. It is unsuccessful countries, after all, which take refuge in a defensive nationalism, intolerant of criticism. The booming noise of Victorians beating their breasts echoes a basic security and confidence. How hostile Ruskin sounds towards modern England; and yet he could also write, 'Where are men ever to be happy, if not in England? . . . Have we not a history of which we can hardly think without becoming insolent in our just pride of it?[13] There is a parallel with student rebellion in the 1960s: subconsciously the rebel knew that he could retreat into a merchant bank. When the prospect became less certain, student rebellion disappeared. The chattering classes flay their society when deep down they know that their society is safe; and the Victorian sages too knew that, in the end, Britain was best, manifestly superior to the Continent's confusions and the New World's vulgarity. Those

respectable Victorians who were not actually hostile to the demo-
cratic habits of America probably regarded it rather as does Fabrice,
the hero of Stendhal's *Chartreuse de Parme*: after a while the liberty
of the New World would be as limiting as life in an Italian auto-
cracy, and there would be no opera in the evening.

But how far, we may ask, did social attitudes or social back-
ground affect the choice of style? How gratified the historian would
be if he could show that the aristocracy (say) tended to the Gothic
and the *nouveaux riches* to the classical. But he must face disappoint-
ment. The high aristocracy went Gothic at Eaton Hall (the Duke
of Westminster; Plate 64) and Cardiff Castle, but Gothic Tyntes-
field was built on a foundation of bird-droppings: the Gibbs family
were small gentry who had made money in guano. Royal Osborne
was Italianate, but so was Prestwold Hall, built for a Leicestershire
squire, and any number of bourgeois mansions. With churches and
chapels there is some fit between style and denomination; but with
private houses we seem to find no fit between style and social class.
And, on reflection, we should not perhaps be surprised. England
has never had an *haute bourgeoisie* in the full Continental sense. In
some of the European *anciens régimes* aristocracy and bourgeoisie were
sharply distinct, the distinction being not economic – a bourgeois
could be very rich, a nobleman impoverished – but one of caste.
By contrast, the English class system, so called, is misnamed; there
is no system about it. The younger sons of the nobility are com-
moners (whereas every child of a French marquis, for example, is
in turn a marquis or marquise); hence whether or not someone is a
gentleman or an aristocrat or not becomes to a fair extent a matter
of judgement or perception; in the *anciens régimes* of the Continent
it might be a matter of fact. Gentility has been defined as the
possession of inherited money; it is a definition that suits the British
case well, but it would not fit all societies. The Victorian self-made
industrialist might never pass as a gentleman, even though he were
made a baronet or a peer; but his sons probably and his grandsons
certainly would be safe, whether the family had picked up a title
or not. Thus the upper bourgeoisie tend to become assimilated to
the gentry: if a man has an upper-middle-class income and leads an
upper-class life, it is hard to tell whether he is the grandson of a
workman or a peer. And so bourgeois taste similarly follows the
gentry. Indeed it is notorious that the self-made families of the

nineteenth century soon bought land, settled in country houses and turned themselves into country gentlemen. The Crossleys of Halifax, carpet manufacturers, are a case in point. At first they live grandly in the middle of Halifax and adorn it with parks and public buildings. But then they migrate from Yorkshire to Suffolk; the head of the family becomes Lord Somerleyton, taking the title from his new rural home, and abandons Congregationalism for the Church of England. There are a few exceptions to this tendency. The rich Unitarian families of Birmingham – the Chamberlains and the Kenricks – who stayed in the city and continued to have an urban and industrial character, are perhaps England's nearest equivalent to a Continental *haute bourgeoisie*.

How far then should we try to relate a society to its art? Probably there can be no general rule: sometimes the two things are closely linked, sometimes not. We can see the problem by looking to either side of the Victorian age. Plainly the French Revolution and the First World War are two of the most important events of the past three hundred years. Let us take the first of these. We tend to feel that this upheaval and its aftermath are connected in some way with the art and thought of the time. The Roman simplicities of David's paintings, the austerities of neo-classical architecture, Beethoven's music, the cult of the noble savage and the natural man – the relation between these and political revolution may be hard to pin down, but we feel obscurely that these cultural changes are forces or the products of forces which also led to political transformation. And we may be right to feel this.

Sometimes the connexion between art and politics seems straightforward. The Haus der Kunst (House of Art) at Munich is a Nazi building, and it looks like a Nazi building (Plate 24). When we see the hard, brutal shapes to which the architect has reduced the Doric forms perfected in the democracy of ancient Athens, we may suppose that the structure tells us much about the society that gave it birth. At least it is gratifying to think so; gratifying also to find that the architecture of Stalin's Russia bears so strong a resemblance to German architecture of the same date. One feels that if the statesmen of the time had devoted their attention to aesthetics, they could have foreseen the Russo-German pact. These intuitions may well be right; yet even in the thirties one might be misled. Plate 25 shows another House of Art, also a brutal building. Again the

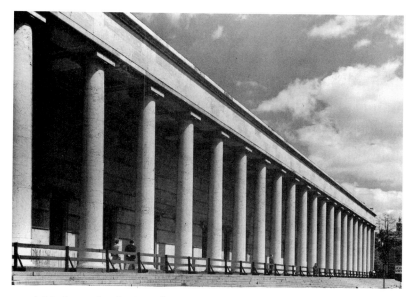

24 A Nazi temple of culture brutalizes the classical tradition: the Haus der Kunst, Munich.

25 Liberal democracy but still a brutal architecture: another cultural temple – the National Gallery, Wellington, New Zealand (1929–36).

final solution has been applied to a classical order: the bases and capitals have been liquidated, the columns drilled into rigid squareness, with only the fluting left to acknowledge their distantly classical inspiration; yet this, the National Gallery in Wellington, New Zealand, was put up by one of the most progressive democracies in the world.

And what of the great beard question? In the 1950s beards were rare, and they were socially expressive: a man who wore one was telling the world that he was a bohemian or a simple-lifer or possibly that he was George Bernard Shaw. The efflorescence of hair in the sixties was again symbolic – of permissiveness, liberation, protest. The history of the twentieth-century beard shows aesthetics and sociology satisfactorily linked. But in an earlier age the picture is different. The eighteenth and early nineteenth centuries are a completely clean-shaven time. In spite of revolution, romantic rebellion and the cult of the primitive hardly anyone chooses the obvious way to be natural, that is, to stop shaving. But then, unpredictably, in the middle of the nineteenth century hair sprouts all over the western world: the face of Europe is literally changed. Little seems to be said about this phenomenon at the time, and no one has satisfactorily explained it since. It is not merely flippant to raise the issue: if we cannot explain a visible change which affects every man, what chance have we got of explaining loftier aesthetic questions? In the matter of whiskers, we have have to accept that there is a large change – the biggest for centuries – which lacks an obvious moral or sociological explanation. Will the same be true of other Victorian phenomena?

We have touched on the French Revolution. Let us now look to the other side of the Victorian age, to the event which is often seen as putting an end to it: the First World War. A historian from Mars might well conclude that the art of the time reflects the way in which the conflict destroyed the social and political fabric of Europe. Like the German and Austrian empires (he might say), like the cities of Flanders, the grandiose romanticism of the late nineteenth century was blown apart – by modernism. But this dramatic picture would be false. 'Modern art' begins in the first decade of this century: Picasso painted *Les Demoiselles d'Avignon* in 1907; Schoenberg wrote *Erwartung* in 1909. Joyce began *Ulysses* in 1914; that seems a symbolically fitting date, but the war did not

influence its style or subject. Politically, socially, economically the First World War is of huge importance; in the history of aesthetic culture it is of no great account.

Two morals may be drawn. First, sociological explanations of aesthetic phenomena may be persuasive or partial or plain wrong; each case must be judged on its merits. Secondly, it may be a mistake to think too much in terms of events. We should think also of processes; in the last few centuries arguably the two most important of these, not just in Europe but in the world, began in Britain: the evolution of representative government and the industrial revolution. If absolutism had triumphed in the seventeenth century and the first of these processes had not occurred, the second might not have been possible, and our own lives might be more different than we can readily imagine. The Greeks and Romans, despite brilliant science and mathematics, did not produce a technological revolution. Why should they? With plenty of cheap labour from slaves and the poor free, there was no incentive. They did not even think of the windmill, the watermill or the wheelbarrow; these were inventions of the Middle Ages. Likewise, a secure aristocracy underpinned by a despotic state would have had no impetus towards technological change. The importance of the industrial revolution itself as an engine of historical development needs no comment. We shall have to see how far it affected Victorian art and culture.

However, to understand the Victorians we need to understand what they inherited. The next chapter is devoted to architecture, and much of it will be concerned with the relation of Victorian style to the Greek Revival, which was at its zenith in the early part of the century. But it will begin even further back, at the end of the Middle Ages, so that the classical element in Victorian architecture may be seen in the light of a long tradition.

The Architectural Inheritance

The Gothic Revivalists of the Victorian age looked back upon medieval English architecture with a glow of patriotic pride: and with reason. In the early fourteenth century England became the teacher of Europe, developing the curvilinear Gothic style, derivations of which were to dominate the architecture of many lands for more than a hundred years. By the fifteenth century the English themselves had abandoned it in favour of 'Perpendicular' Gothic, to which they were to stay obstinately attached. This style remained purely native, but it too produced buildings of the highest quality. If we compare (let us say) King's College Chapel Cambridge or the tower of Canterbury Cathedral with Brunelleschi's churches in Florence we do not feel that the English buildings are inferior to the Italian ones, merely that they are very different. However, we may be surprised by the fact that it is the English buildings which are of later date, and that is because we know that in the fifteenth century the Italian style was the style of the future; sooner or later it was to be imitated all over Europe. In the sixteenth century Francis I of France brings Leonardo to the Loire valley and Primaticcio to Fontainebleau; Henry VII gets Torrigiani to design his tomb at Westminster. But in the process the art of northern Europe becomes provincialized, even in France. To say that is not to make a judgement of quality, but to describe a fact. Renaissance buildings in France and England are sometimes very beautiful; but they defer to Italy. In the fifteenth century the English were putting up buildings that were purely English in style, executed with utter assurance and deferring to nobody. The prodigy houses of the Elizabethan age, on the other hand, though not exactly bashful, none the less by their use of capitals and pilasters make obeisance to the classical, Mediterranean world, and from a great distance. There is a kind of humility – sometimes touching, occasionally enchanting

– in the application of classical decoration to these unclassical structures.

England, 'bound in by the triumphant sea', came to seem in cultural terms cut off, and this produced what may be called an 'archaeological' or 'antiquarian' effect. Progress in architecture comes to seem a matter of grasping the facts about the orders, of learning the correct proportions, of finding out the true nature of classical style and structure. In the seventeenth century England edges slowly towards a purer classicism. Something of this can be seen, for example, in Oxford. The Tower of the Five Orders dates from James I's time; the use of all the orders of architecture, one above the other, is a display of classical learning, but the structure is still Gothic, and the tower is a little quaint, despite its scale and a kind of homely grandeur. The Canterbury Quadrangle of St John's College was put up in the reign of Charles I; it is still a mixture of Gothic and classical, but now assured, romantic, exquisite. Meanwhile, Inigo Jones, who had been in Italy, was producing a revolution in English architecture with the Banqueting House in London and the Queen's House at Greenwich. For the first time pure Italianate architecture had reached England.

How is national pride to cope with a cultural inferiority? For the patriot there seem to be two alternatives. The first is to try to catch up with the leaders as quickly as one can: in the seventeenth century this would mean full imitation of the Italian style, so that England might take its place among the first cultural powers of Europe. At a later date this was to be the American solution: every large city in the United States has a gallery full of European art, and Washington is designed to look unlike any other American city because it must be able to stand comparison with the European capitals. The alternative reaction is to say that each country ought to follow its own national and natural style; it is wrong for the English architect to copy foreigners. This view was to appeal to the champions of the Gothic Revival; and at the end of the nineteenth century there will be a surprise when the argument is turned on its head and a form of classicism presents itself in patriotic guise.

In the case of England there is another factor: what might be called cultural imbalance. The French speak of the seventeenth century as their *grand siècle*, but it is more truly England's great age. The English have preferred to attach their myth of national

glory to the age of Elizabeth, although most of her reign was rather barren in cultural terms, while Shakespeare was as much a Jacobean as an Elizabethan in his greatest phase. The French attach their myth to the seventeenth century; yet in that time they produced no dramatist to equal Shakespeare, no poet to match Milton, no composer as good as Purcell, no scientist to compare with Newton. All of which goes to show, once more, that what nations say about themselves is not necessarily the truth. Moreover, while France was hardening into a sclerotic autocracy, England was starting to develop the representative institutions which were to be the pattern for the future. Hence a striking imbalance: England leads the world in literature, science and polity, but is still partially provincial in architecture, and in sculpture and painting is a third-rate power. Here was a soil from which would grow an odd cross between patriotic self-confidence and the awareness of an inferiority. It is a blend which marks many Victorian attitudes.

The eighteenth century continues the process; for now Britain becomes a world power while still remaining in some respects culturally dependent. A nobleman needed to do the Grand Tour to be properly educated (a man who has not been in Italy, Dr Johnson said, is conscious of an inferiority); the libretti of the operas written for the London stage were in Italian, and the music was composed by foreigners like Handel and Bononcini. Gibbs was the most successful architect of the early-middle eighteenth century. But then Gibbs had a special advantage: he had studied in Rome.

English architecture prided itself on being Palladian, and Palladianism was an ambiguous ideal. As its name indicates, it is from one viewpoint a homage to Italy. Yet it also became a national style: the Palladians cut themselves off from the mainstream of Continental architecture, the baroque style, to produce buildings that were decent, orderly, distinctively English. As we shall see, the fact that the English went their own way at this date was to have consequences later: the Greek Revival was to spread over Europe (and America too), but the British were to come at it by their own path.

The middle of the eighteenth century saw, right across Europe, the beginnings of the biggest shift in taste since the Renaissance. This aesthetic change was but one aspect of a transformation of ideas and attitudes that was to affect most branches of life. Its causes

are mysterious, and this is not the place to enquire into them; a very brief and superficial account of a few of the symptoms will have to suffice. In the realm of politics this transformation leads to the French Revolution and if not to the American Revolution itself (a rather different kind of phenomenon), then at least to the aspirations of the new republic; in the realm of ideas it produces the cult of the natural man and the idealization of the noble savage. The Enlightenment is one of its manifestations, and Romanticism is among its daughters. Its products are not all in harmony one with another – the ideas of the Enlightenment and of Romanticism are in many respects opposed – but however complex or confused the processes may be, there is little doubt that the earth begins to shake in the mid eighteenth century and from its travails much of the modern order is born.

In the aesthetic sphere this change appears as a rejection of the baroque, a casting off of fopperies and fripperies, a search for austerity and simplicity. Now the whole war between the baroque and its enemies is (in a broad sense) within a classical context. For much of baroque architecture cannot be properly appreciated without an understanding of how it adapted Graeco-Roman forms. A couple of examples, one sacred, one secular, will clarify the point.

The front of Borromini's church of San Carlo alle Quattro Fontane in Rome (1667; Plate 26) has what seem to be classical columns; but the capitals are of a strange design invented by the architect himself. The façade is twisted and moulded as by a sculptor's hand, bending with alternate concavity and convexity in the lower storey, scooped into three concavities above. The pediment is broken, as though by the force of the oval rammed into it. The use (in both storeys) of the giant order – that is, smaller columns enclosed within larger ones – derives from the Renaissance, but this is, as it were, a Renaissance façade seen in a distorting mirror and, to appreciate its strange plasticity, we must recognize what has been distorted.

The Kaisersaal in the Bishop's Palace at Würzburg (1735–42, by J.B. Neumann) uses a classical order, but breaks as many rules as it observes (Plate 27). The door is not in the middle but to one side, and instead of the columns standing at equal intervals the distance between the two central ones is less than the distance between the others. Neumann has used the Corinthian order – after a fashion. The gilding of the capitals draws attention to their

26 The classical grammar twisted and teased: S. Carlo alle Quattro Fontane, Rome.

misbehaviour: in the middle a fragment of each capital shoots upwards to the level of the architrave, while at the sides a piece of gilding dribbles down over the neck on to the top of the shaft, as though the architect had passed his sleeve across his drawing while the ink was still wet. (Baroque architecture seems to have little in common with the so-called baroque music of the same date, but perhaps it does have a kinship of sorts with the deliquescent roman-

ticism of German music in the late nineteenth century.) The festive exuberance of the room is produced in part by the naughty flouting of the classical rules, and to enjoy the naughtiness we need to know what the rules are in the first place. What Paul Valéry said of classicism could be said as well of the baroque: the essence of this style is to 'come after'.

England too had its baroque phase, seen at its most idiosyncratic in the hands of Vanbrugh and Hawksmoor. Though their work tends to seem alien to Englishmen, it is in fact a uniquely English development, without near parallel on the Continent. And though its austerities and asperities are so unlike southern baroque, the English style too is one which teases at the classical vocabulary. At Blenheim Palace, for example, Vanbrugh plays with a combination of the Tuscan and Corinthian orders (Plate 28). If we look at one of the wings we see a line of Tuscan columns marching towards a tower and seeming to disappear into it, only to emerge at the side,

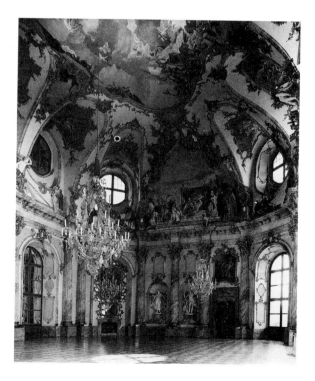

27 The Kaisersaal or Imperial Saloon, Würzburg: more sporting with the classical vocabulary.

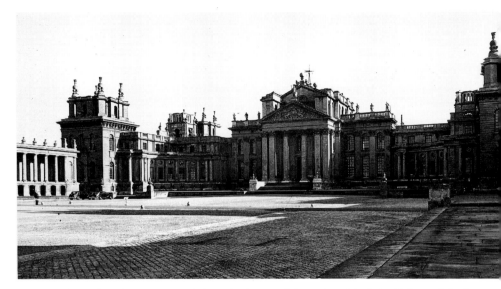

28 Vanbrugh's more stressful manipulation of the orders: Blenheim Palace, Oxford-shire (begun 1705).

at an angle of ninety degrees. The line of columns then turns back through a right angle, curves round in a quarter circle and makes one more sharp turn before vanishing at the point where the central *corps de logis* begins. The *corps de logis* itself is ornamented with giant Corinthian columns and pilasters, but the Tuscan order reappears again behind the portico, half the height of the columns which loom in front of it. The elements in this elephantine game · are classical, but no architect of antiquity would have toyed with them in this way. Occasionally English architects rivalled the wilful mannerism that had been affected by some of the Italians. At Heythrop House (Plate 29) Thomas Archer designed a window with a broken pediment, the two halves of which face away from each other, as though he had bought a prefabricated kit of classical pieces and got left and right confused. The pilasters are narrower at the bottom than the top, the odd bits of decoration above them allude to the idea of a capital without being capitals, the bases rest on no firm foundation but merge into the wall surface below. All this is not merely naughty but perverse.

The English soon turned away from these extravagances, and the full-blown baroque is scarcely to be found after 1730, though

46

baroque elements were still used by some architects, most subtly by Gibbs. Palladianism became the dominant style, its keenest advocates being perhaps Lord Burlington and Colen Campbell. Burlington's Assembly Rooms at York (1730) reintroduces the 'archaeological' tendency into English architecture, its design being based on a description in Vitruvius (Plate 36). Campbell's folio, *Vitruvius Britannicus* (1715), also sounded the archaeological theme and used moralistic language to attack Italian baroque: 'The Italians can no more now relish the Antique Simplicity'; Bernini's work was 'affected and licentious'; Borromini had 'endeavoured to debauch Mankind with his odd and chimerical Beauties'.[1]

The moral note was to be sounded again later (and louder) by Laugier in France. In his *Essay on Architecture* (1753) and again in 1765 he argued that buildings should be simple and functional and thus in accordance with the laws of nature. In the spirit of Rousseau he looked back to the earliest works of man, concluding that the primitive hut was 'the model upon which all the magnificences of

29 Borromini comes to Oxfordshire: Thomas Archer affects to put the two sides of a window back to front at Heythrop House (begun 1706).

architecture have been imagined'. The radical dogmatism of this theory can be seen as classical in two senses. First, the idea of architecture as based on the primitive hut derives from Vitruvius; secondly, the purification of architecture from modern excess would mean, in effect, the rejection of Roman and Renaissance models in favour of ancient Greece. For Laugier himself the Maison Carrée, a small, plain Roman temple at Nîmes, was the model of what architecture should be, but then he had no knowledge of Greek buildings to call upon; one feels that the Maison Carrée has this role forced upon it for want of anything else. After all, most Roman architecture was arcuated, that is, based upon the arch and the barrel vault; but the Maison Carrée, like the Greek temples from which it derives, was trabeated, that is, based upon a post-and-lintel construction first invented for building with timber, and adapted to stone buildings without fundamental change. In a way the Parthenon is indeed the primitive hut transcendentalized.

'Back to the fountainhead' was the spirit behind the slow aesthetic revolution of the eighteenth century. Literary culture began to exalt Greece at the expense of the Latin authors who had guided taste since the Renaissance. The Romans, after all, were imitators (so people began to say); the Greeks were starker, purer, more sublime. Virgil yielded the palm to Homer. The primitivist reaction against the baroque had the same thrust as this revolution in literary attitudes, and it was natural that it too should look back beyond Rome to Greece. In the mid eighteenth century there remained one large obstacle, however: people still had no exact idea of what Greek architecture looked like. By the end of the century that obstacle had gone.

There is an undercurrent of extremism in the origins of the Greek Revival: a dogmatic demand for austerity and rationality, rejecting all superfluous ornament. The Greek Revival happened all over Europe, and even in Britain this undercurrent can sometimes be detected; but the British route towards the recovery of ancient Greece was in some ways distinct. There was less radical dogmatism because there was less to react against: the full-dress baroque had long been abandoned. English experiments in gothick and chinoiserie, light and fanciful though they were, suggest that there was some vague, undirected dissatisfaction with the prevailing style; but if there was an English style that had recently lost the charms

of novelty, it was Palladianism. This was not 'primitive', but it was elegant, reposeful and touched with grace. The restless splendours of the baroque were bound in the end to induce a sense of satiety (it was as though, having eaten nothing but strawberries and cream for weeks, people had begun to long for bread and water), but Palladianism could give that peace which the baroque cannot give.

So the motive force behind the search for a new style was somewhat different in Britain from elsewhere. But where was a new style to be found? The answers came through a combination of three factors: the archaeological tendency in British culture, Britain's growing wealth and power, and the peaceful state of Europe for much of the century, which made travel relatively safe and simple. Britain prospered as southern Europe decayed, and many British noblemen used their wealth and leisure to make the Grand Tour through Italy, bringing back modern paintings and classical antiquities to decorate their country seats. A few bolder spirits penetrated the softening fabric of the Ottoman Empire and in folio volumes of fine engravings made known classical sites which had been little more than names before. Robert Wood published the ruins of Palmyra in 1753 and Baalbek in 1757; Robert Adam published Diocletian's palace at Split in 1764. Adam's aim had indeed been to promote his career as an architect, and the Adam style duly drew upon what he had found. New discoveries in Italy also had their influence: the excavations at Pompeii and Herculaneum, and the finds of Greek vases, which were at first believed to be Etruscan. Several houses by Adam and his imitators have a Pompeian or an 'Etruscan' room.

But all these sources (except the Greek vases) exhibited the sumptuous refinement of later antiquity; they did not provide an escape from the Roman-cum-Renaissance tradition. For that purpose the key lay in another part of the Ottoman Empire. A few Englishmen began to explore the Aegean. Lord Sandwich was there in 1738–9, and returned with a shipload of antiquities; Lord Charlemont followed ten years later. Both these noblemen were members of the Society of Dilettanti, a curiously mixed body of gentlemen, scholars, artists and rakes, which brought together earnestness and dissipation in a manner characteristic of the eighteenth century (it claimed among its members seven prime ministers and a murderer).[2] The Dilettanti, through money and influence, helped

to make possible the visit of James Stuart and Nicholas Revett to Athens in 1751–3.

Like Sandwich and Charlemont, Stuart and Revett travelled among the remains of ancient Greece and brought back some record of what they had found. Like Wood and Adam they published classical ruins in splendid folios. But what makes their work more important than those other expeditions into the eastern Mediterranean is that it enabled the two impulses which were leading toward the Greek Revival – the archaeological and the ideological – to meet. They provided detailed, measured drawings of masterpieces of Greek architecture which had hitherto been known inaccurately or not at all. If someone wanted to recover an accurate knowledge of the best classical forms – the archaeological impulse – here was evidence which enabled him to get back beyond Rome to the great age of Greece. If he wanted novelty, here was a classical architecture strikingly different from that imitated hitherto. If he wanted primitive strength and simplicity – the ideological or dogmatic impulse – here were the perfect models.

The career of James Stuart himself – Athenian Stuart, as he became known – illustrates the dilettante side of the early Greek Revival. He was content to use his almost unique knowledge of Greek architecture for the most part on minor pieces of design, a pulpit here, an ornamental garden building there. At Shugborough in Staffordshire he scattered over the park a variety of structures derived from Athenian originals: a Doric temple, a Tower of the Winds, 'Demosthenes' Lanthorn', an 'Arch of Hadrian'. The Greek models for these are of mixed styles and dates – one of them belongs to the Roman period, centuries after the rest – and they have little in common beyond the fact that they are all in Athens. Stuart disposes his trophies over the landscape in the spirit with which noblemen filled the insides of their houses with the mixed spoils which they brought back from the Grand Tour in Italy.

For some reason Stuart and Revett were immensely slow in publishing their discoveries, and meanwhile the Grecian taste remained a minor pleasure, enjoyed by a few connoisseurs. The first volume of *The Antiquities of Athens* dealt only with minor buildings; not until the second volume came out, in 1787, did the world learn the true appearance of the Parthenon and the Erechtheum. Here was inspi-

ration; and now at last a scholarly recreation of Greek forms was possible.

The Greeks of the fifth century BC had used two orders of architecture, Doric and Ionic, and these were to become the hallmark of the Greek Revival. Both could claim the charms of newness; as Stuart himself observed, 'Palladio's "Collection of Antiquities" has no example of a Doric building, and only one of an Ionic, the Temple of Fortuna Virilis, so decayed that. . . the form of the mouldings cannot be properly established.'[3] The Ionic order was indeed already known in the West (it is one of the four orders used on the Colosseum), and though it had not appealed to the Renaissance and the age of the baroque, its elegance commended it to Adam and his imitators. However, in its full Greek form, complete with fluting on the columns, it was substantially a novelty. The Ionic strain in the Greek Revival allowed into the new style a type of building which, though clearly neo-classical, yet suggests a continuity with the Palladian past. These buildings have a chastened severity, a self-conscious rectitude which is new in feeling; but they enabled something of Georgian grace to carry on into the nineteenth century. Stuart's Lichfield House in London, of 1764–6 (Plate 30), with Ionic columns resting upon a rusticated ground floor in the manner of Kent or Burlington, has a transitional character; here the end of the Palladian school seems to meet the beginnings of the Greek Revival.

In the case of the Greek Doric, no such tactful compromise was possible; and this order was to become almost the symbol or talisman of the Greek Revival. For one thing, it was the greatest novelty turned up by the recovery of Greek architecture: the Romans had not used it, and it was utterly unfamiliar in western Europe. In fact there are Doric temples surviving from the Greek colonies of Sicily and southern Italy, above all at Paestum, where the order is to be seen in its rudest, most powerful form; but they were largely neglected until taste began to change in the later eighteenth century. In 1787, Goethe paused at Paestum on his way south and found the ruins 'offensive and even terrifying'; on his return from Sicily, where he had been plunging himself in the 'primitive' beauties of Homer's poetry, he turned aside to Paestum once more and found his view transformed; it was, he decided, the last vision he would take with him on his journey north, and perhaps the greatest.[4] This story of a conversion seems symbolic – as surely Goethe intended it

to seem – of the earthquake that was cracking open the hard, bland surface of eighteenth-century classicism and letting the fires of romanticism burst forth.

For here, indeed, was another attraction of the Doric: it was, in a modest way, an *avant-garde* taste. These Greek forms were attacked for their clumsiness by Piranesi in Italy and in England by Sir William Chambers, who as Comptroller of the Works was in effect the head of the architectural profession in his country. The nature of the controversy can be well seen from the reply to Chambers by the young architect Willey Reveley in his preface to the third volume of *The Antiquities of Athens*, which appeared in 1794 after Stuart's death. Chambers had claimed that the Parthenon was not as large as the church of St Martin-in-the-Fields. Reveley gave the dimensions to refute this, and added,[5]

> Artists who . . . ever read Vitruvius, know, that Saint Martin's church . . . is no more than a very inferior imitation of the Greek Prostyle temple, and will not enter into the slightest degree of comparison with the chaste grandeur, the dignified simplicity, the sublime effect of the Parthenon. Sir William seems to insinuate . . . that the Parthenon would gain considerably . . . by the addition of a steeple. A judicious observer of the fine arts would scarcely be more surprised were he to propose to effect this improvement by adding to it a Chinese pagoda.

This last remark was cheeky: Chambers had designed the pagoda in Kew Gardens.

These observations bring out the classical side of the Greek Revival – classical not only in going back to ancient sources but in the further sense that it sought discipline and severity, a purging of architecture from the impurities which had encrusted it. St Martin's is criticized for imitating a Greek model without being truly Greek and for complicating what should be simple. The steeple and the portico belong to different kinds of architecture; Chambers is wrong to suppose that they can be satisfactorily combined. When Reveley talks of 'grandeur' and 'simplicity', he is borrowing his terms from Winckelmann, the seer of neo-classicism, for whom the very absence of turbulence and passion in Greek art – what might almost be called its anti-romantic character – was its glory.

30 Lichfield House, St James's Square, London: a conventionally Palladian composition, chastened by the introduction of the Ionic order in its fifth-century Athenian form.

But other parts of Reveley's preface have a romantic tone. Chambers, he says, had censured Doric buildings for 'their gouty columns, their narrow intercolumniations, their disproportionate architraves', to which he retorts,[6]

> There is a masculine boldness and dignity in the Grecian Doric, the grandeur of whose effect . . . can scarcely be understood by those who have never seen it in execution . . . the columns rise with considerable diminution in the most graceful, sweeping lines, and, from the top of the shaft, projects a capital of a style at once bold, massive, and simple. The entablature is ponderous and its decorations few in number, and of a strong character.

This style, he adds, has an 'awful dignity and grandeur', 'a solemn and majestic feeling'; true, 'The Grecian Doric is by many indis-

criminately censured for clumsiness', but it has great 'dignity and strength'.[7] Bold, massive, strong, awful and even ponderous – these are words of praise for Reveley, suggesting that the younger generation might admire in Greek architecture the very qualities that Chambers had disliked. Stuart had retained an eighteenth-century politeness: in the very volume which contains Reveley's introduction, he drew attention to the 'Portico of Philip' on Delos, which 'on account of the lightness of its proportions differs from all the other examples we have given, and is more suitable for common use'. Those words suggest that the Greek Revival would have a place for those who wanted to continue the elegance of the Palladian and Adam styles by other means; but Reveley shows that it was also a style expressive of romantic neo-classicism. It could be classical or romantic or both; and that was part of its success.

Reveley's language also suggests that the Greek style, strangely enough, could provide in architecture the thrill of agreeable awe and horror that was found in the 'Gothic' novel. Eighteenth-century Gothic was sumptuously domestic, like Strawberry Hill, or exquis-itely attenuated, like Tetbury Church (Plate 49), but Doric could convey a sense of weight and vigour even in small buildings. In 1789 Joseph Bonomi used the Doric order inside a building for the first time at Great Packington Church; it is not big, but the concep-tion is monumental. The exterior, of bare brick, is blunt and sturdy; a solid square, weighted at the corners with four squat towers. Within the church takes the form of a cross (Plate 31). Low arches, which seem almost to have been burrowed into the masonry, link its arms. The central space is roofed with a tunnel vault, devoid of ornament, and supported on four columns, which are not only Doric but Doric of the most primitive kind, short and stocky, with violent entasis and surmounted by fragments of hugely ponderous entabla-ture. The result is unlike any Greek building that ever existed, and in fact the brick exterior, the vault and the large lunette windows derive from the baths and basilicas of imperial Rome. So much the better: Greek forms could be used inventively to create a new architectural expression. Two years later, in 1791, William Cowper published his new translation of Homer. In a preface he attacked Pope's florid, ornamental translation, which he likened to rococo taste in the visual arts: it resembled a French print in which 'Agamemnon addresses Achilles exactly in

the attitude of a dancing-master turning miss in a minuet'. By contrast Cowper aimed at rough energy, even awkwardness. Some of the lines, he granted, had 'an ugly hitch in their gait, ungraceful in itself' but they had been 'made such with a willful intention'.[8] Bonomi's church might be seen as a visual equivalent of this deliberate ungracefulness.

This little building shows, right at the beginning of the Greek Revival, that it could inspire an eclectic architecture which was original and yet incorporated the new forms into the broad stream of the classical tradition descending through the Renaissance from Rome. However, such eclecticism was at first untypical: the first quarter of the nineteenth century saw the zenith of a historicist architecture which tried to apply Greek forms to modern buildings with as little compromise as possible. The difficulty for these purist revivalists was that they denied themselves the resources invented since Greece's hey-day. The Romans had used the arch; they had superimposed different orders, one above the other; and they had

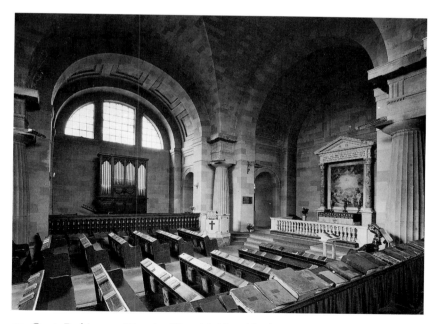

31 Great Packington Church, Warwickshire. The barrel vault is Roman, but the aggressively stocky Doric columns assert themselves as Greek and primitive.

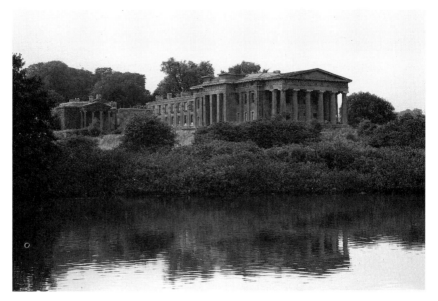

32 The Grange, Hampshire, by Wilkins: the austerity of early nineteenth-century neo-classicism planted in an eighteenth-century arcadia. (The later additions by Cockerell, seen behind and to the left, have been demolished.)

found a harmonious way of putting a line of columns in front of a row of arched apertures. All these techniques can be seen on the Colosseum. The Renaissance, through the use of the giant order, had started combining orders of different sizes, one within the other. The hard-line Greek Revivalist denied himself all these possibilities. And there were practical difficulties too: Doric porticoes and the like could easily be the enemies of modern comfort and convenience.

The problems and possibilities are well shown by The Grange (1804–9), one of the most thoroughgoing attempts to construct an entire country house on the Greek model. It is by Wilkins, another of the scholar-architects: when he began work on it, he was newly returned from four years in Greece and Asia Minor, and would later publish two volumes on their antiquities. Even a brief glance at this building shows that 'ideology' has entered architecture (Plate 32). The model for the portico is the Theseum at Athens, a cooler design than the 'awful' temples of Paestum; but Wilkins has cultivated an austere masculinity which ironically goes beyond the

Greeks. The pediment is completely bare, whereas on the Theseum it would originally have been filled with sculpture. Stuart and Revett's illustrations show the metopes of this temple filled with lively sculptural panels; Wilkins allows only plain roundels in their place. His portico is two columns deep, importing a massive solemnity into what is only a country house of moderate size; Pevsner praises its 'tremendous pathos'.[9] The flanks of the house, too, are relentlessly stern.

Yet despite the dour radicalism of this work, it also joins an English tradition in being an 'archaeological' design, one which looks to the Mediterranean world for correctness of form and proportion. The difference is that this building is not just classical but revivalist, not only drawing on ancient architecture for motifs but in some sense trying to reproduce it. Glancing at a photograph of the portico, we might for a moment suppose it to be in Greece, and not, as is in fact the case, a few miles from Basingstoke. This portico, despite its more than Greek asceticism, is a close reproduction of the Theseum, as Stuart and Revett had recorded it; and the southern flank of the building faithfully echoes the Choragic Monument of Thrasyllus (Plate 33). This was destroyed in the 1820s, and is thus little known today, but it was very important

33 The Monument of Thrasyllus, from Stuart and Revett's *Antiquities of Athens*: Wilkins's model for the southern flank of The Grange.

for the Greek Revival, as it provided a model for handling flat surfaces in a properly Hellenic fashion. Windows were a problem for the Greek Revivalists (one reason why the style seemed so suitable for museums was that only skylights were required), but The Grange shows how windows could be subordinated to a rhythm of Doric pilasters. Wilkins's fidelity to his model was exceptional; but his treatment of the whole southern flank illustrates how a basically Georgian plan and proportion could be adapted to a trabeated design on the Greek model. We shall see that the designers of some Regency and Victorian terraces learnt the lesson.[10]

As a composition, The Grange is a success. The gentle northern landscape around is a pleasing foil to its relentless Hellenism; it broods above a large and lovely lake formed in the eighteenth century, its sternness softened. Visiting it in the spring of 1823, C.R. Cockerell decided that there was nothing like it this side of Arcadia, while the trees were more luxuriant than any that ever grew on the banks of Ilissus. And on another occasion he concluded, 'Nothing can be finer more classical or like the finest Poussin, it realizes the most fanciful representations of the painter's pencil or the poet's description.' In these remarks Cockerell, himself a Grecian architect, fits one of the most tough-minded of all Grecian buildings into the Georgian tradition; but he also discussed it in the romantic-sublime terms which we met in Reveley: 'It has something of overcharge & resembles those marked & striking features which have a more than masculine coarseness when near, but the value of which is confessed at a proper distance.' But, he added, 'As to the Propriety of making a Grecian Temple a domestic habitation, that is a question admitting of much doubt.'[11]

And there was the rub. The building is impractical for domestic purposes, above all in a northern climate. The Thrasyllus centrepiece darkens the interiors; still more so the Doric portico. And a visit in January showed Cockerell another disadvantage of this feature in England, as a north-east wind sliced between the columns. In fact the Greek style was not as inflexible as is sometimes thought: we shall find that some quite modest architects found ways of adapting Greek forms to middle-class urban life. But it was a difficulty for the toughest of the Greek Revivalists, once the novelty of the style had worn off, that even if their public did not find it boring, they found it uncomfortable.

34 A blend of Gibbs
and Greece:
St Pancras Church,
London.

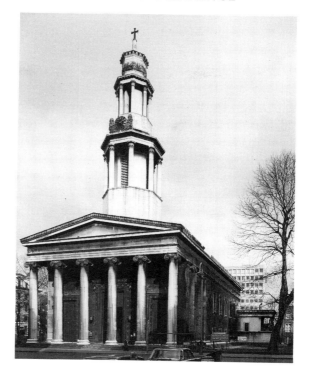

After the Napoleonic Wars ended, in 1815, there was a spate of church building. Many of these churches were put up on the cheap, in working-class areas of the expanding cities, and it proved an asset of the Grecian style that it could be done at modest cost. That, indeed, would be one of the reproaches flung at the Greek Revival by Pugin: that it was tawdry, flimsy and starved. A much more expensive model, St Pancras Church, London, by H. W. and W. Inwood (1819–22), shows both the scope and the limits of the Grecian style for church-building (Plate 34). In some respects it fits into a long established classical tradition; and what is more, a classical tradition of a distinctively English kind. In the towers of his City churches Wren had ingeniously twisted classical and baroque forms into shapes that echo the spires of the Middle Ages. Gibbs carried on the same manner; and with St Martin-in-the-Fields he took the further step of putting a spire directly behind a classical portico. (This scheme, often in a much simplified form, was to

become the pattern for countless churches in North America and the British Empire, thus making St Martin's, in terms of influence, one of the chief buildings of the world.) The Inwoods reproduce this pattern, but replace Gibbs's Roman richness with a Greek simplicity. The fine Ionic portico is derived from the Erechtheum (on which H.W. Inwood was to publish a volume: archaeological scholarship and architectural practice were still marching hand in hand). The spire is derived from a mixture of two other Athenian structures, the Tower of the Winds and the Monument of Lysicrates. In fact, the pattern is repeated, one smaller 'tower' being put on top of another, after Wren's manner at St Bride's, Fleet Street.

All of this looks very well, and shows the new Greek forms fitting comfortably into a tradition. But if we walk round to either flank of the church, we get a surprise (Plate 35). On each side there projects a small wing closely modelled on the caryatid porch of the

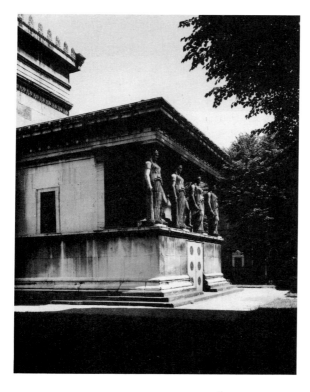

35 Paganism invades the churchyard: one of the side porches at St Pancras.

60

Erechtheum. They seem out of place, and awkwardly tacked on to a building that is otherwise a simple rectangle; though illustrating the persistence of the archaeological impulse against heavy odds, they also show the unadaptability of some Greek forms. And there was another problem. Whom do the figures represent? Are they saints, martyrs, allegorical virtues? They carry inverted torches, symbols of mourning which indicate that the doors beneath them give access to burial vaults; but this symbolism is classical, and pretends to no Christian significance whatever. Here was ammunition for Pugin: this was an infidel architecture, a godless aping of pagan forms.

The Greek Revival can easily be seen as a failure, alien and highbrow, a period when architects went up a blind alley. On this view its only real importance for the Victorian age was as an irritant: it was what the Gothic Revival reacted against. Ruskin was to insist that people only pretended to like Grecian buildings because they thought it proper to do so,[12] and it is true that no major work of the Greek Revival has yet earned the public's wholehearted affection. Everyone loves Big Ben; no one loves the British Museum. It asks for respect; it does not lift the spirits. Wit, playfulness and *joie de vivre* went into the minor architecture of the early nineteenth century, and that is what people usually have in mind when they praise the Regency style; but the larger buildings of the time often run the risk of staidness. The one Regency architect who remains famous and popular is John Nash. Not a pure Greek Revivalist, he is none the less part of the story, showing how Grecian or neo-classical forms could be swept up into an elegant worldliness in the Georgian tradition. His replanning of the West End of London was one of the two largest urban developments of its date in Europe, the other being neo-classical St Petersburg. His Regent's Park terraces survive, scorned by purists, but among the most pleasing urban environments to be found anywhere.

But what of the Greek Revival's tougher, uncompromising streak? Perhaps even this is not as far out of the mainstream of the English tradition as is often thought. The English believe that their architecture is essentially gracious, even cosy, but there is another streak that runs through the native tradition, an admiration for the bare and brutal. In our own century, at a time when the cool, clean style of Mies van der Rohe was so influential in America, British

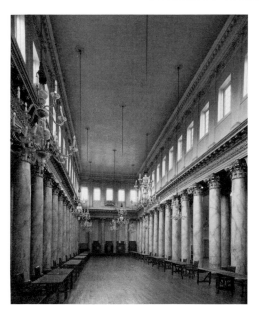

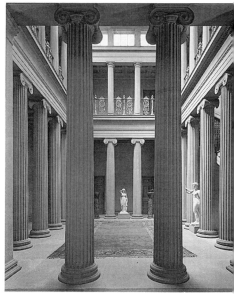

36 Solemn columns and archaeological intent:
Burlington's Assembly Rooms, York (1731)
looks forward to neo-classicism.

37 A neo-classical procession of columns:
Belsay Hall (by Sir Charles Monck, Sir William
Gell and John Dobson, 1810–17).

architects were tending to prefer something more restless and
aggressive, slamming angry slabs of raw concrete into the urban
fabric. The uncompromising severity of Inigo Jones's St Paul's,
Covent Garden, with its dumpy Tuscan columns, outsize pediment
and overhanging eaves, could be taken for a neo-classical building;
it is hard to believe that it dates from the 1630s. Continental
baroque was often blithe and festive; not so the English version of
the style. The Great Hall of Blenheim Palace is dominated by vast
spaces of blank stone wall such as no baroque architect in Italy
or Germany would have tolerated; the roof-line of the Palace is
deliberately stressful and laborious. Hawksmoor's London churches
are sombre, strange and sometimes deliberately unharmonious.

Elements of Vanbrugh and Hawksmoor appear in the work of
Cockerell, on the threshold of the Victorian age. We can see a
community of spirit too between neo-classicism and some of the
works of the Palladian period. Burlington's York Assembly Rooms
share something with the interior of Belsay in Northumberland

(Plates 36 and 37); in both is a solemn multiplication of close columns, and a severe antiquarianism. At Mereworth Church (1744–6) an unknown architect designed an interior of powerful austerity (Plate 38). It has much in common with Wyatt's neo-classical church at Dodington (c.1796; Plate 39), though the earlier work is much more forceful. In spirit, and in one or two features, Mereworth seems to belong with Great Packington. The exterior echoes Jones's St Paul's, Covent Garden, and looks forward, again, to Bonomi. The persistence of Gothic in England, even into the seventeenth century, is a familiar fact, and so it has often been felt that Gothic is the style with which Englishmen really feel at home; that was Pugin's view, and Ruskin's. But perhaps we should notice the persistence of the classical also, and not just as the taste of the cultivated few. After all, the mass-produced villas of our own century ape Georgian as well as Tudor forms. Two impulses are recurrent in British architecture, their relative strengths varying from time to time. Perhaps this is the way to interpret Victorian architecture: the continuing flow forward of two streams, side by side.

In the case of Sir John Soane we find an architect soaring out of the Greek Revival into a style of high originality. Some of his boldest ideas were realized on a miniature scale in his own London house. The ceiling of the breakfast room seems almost weightless (Plate 40); instead of lying flat, it expands like a bubble into a shallow dome, the centre of which dissolves into empty air, where light descends from a cupola above. Mirrors in the spandrels of the dome and elsewhere still further dissolve the surfaces into patches of liquid light. No columns receive the ceiling's weight; instead, it seems to hang suspended, and below the points where the dome's pendentives meet the sides of the room more mirrors are let into the wall in long strips, so that there is again a luminous dissolution where we would expect pillars to be. On two sides the ceiling does not even reach the edge of the room, but there is a gap, through which light floods down from a hidden source. It is one more levitational effect, produced by an illusionism that has more in common with baroque Germany than classical antiquity.

Some have denied that Soane belongs to the Greek Revival at all; be that as it may, what matters is to see that however idiosyncratic he may be he does not abandon the old motifs altogether. The details in the halls which he designed for the Bank of England are

not an irrelevance: it is of the essence that those should be Greek key patterns sketched upon curving surfaces, or that those are Greek caryatids lifted from the solid earth to float upon vacancy (Plate 41). We shall draw a similar model from a much later stage of the Greek Revival.[13] Like the baroque, Soane's is an art whose nature it is to come after; he too rearranges and transforms a classical vocabulary, though his own starting point is Greece rather than Rome or the Renaissance.

Another outgrowth of the Greek Revival was what may be called eclecticism. This has something in common with Soane's free style in its originality and idiosyncrasy, but differs by being more firmly rooted in historical forms. Unlike the purist Greek Revival, however, it takes in historical forms from diverse periods. The master of this classicism was C.R. Cockerell (1788–1863), whose career takes us deep into the Victorian age; indeed, his progress might be taken to exemplify the development of English Hellenism, growing out of the romantic era, when antiquarian exploration blended with

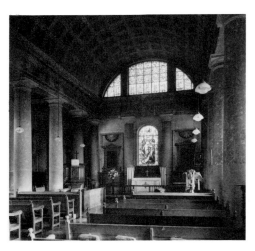

38 Mereworth Church, Kent, anticipates neo-classical austerity in the 1740s.

39 Neo-classicism at the century's end: Dodington Church, Avon (formerly Gloucestershire) (1796).

40 The breakfast room in Sir John Soane's House, Lincoln's Inn Fields, London: a liquefaction of the classical elements.

the glamour of travel in the Levant. Scholarship, adventure, a pleasantly melancholy yearning for the vanished glories of Greece – such was romantic Hellenism. Professor Cockerell, an elder statesman of the Victorian architectural profession, had once been the young man who rowed out from Piraeus to serenade Byron on shipboard, and ran naked round the tomb of Achilles.[14]

In the 1840s he designed Bank of England branches in three provincial cities; they can be seen as variations on a theme. Let us take the façade of the Liverpool building (though façade is hardly the word for something so deeply sculptural in conception). Cockerell creates a kind of counterpoint: the frontage can be read as one unit or two (Plate 42). The powerful rusticated piers at the sides, the deep eaves, cut away below the gable so that the outline of the building is emphasized, the granite plinth on which the entire structure rests – all these encourage the spectator to take it as a single, unified whole, fitted with a certain grand simplicity to the child's idea of the shape a house should be. But if we look to the columns and the emphatic entablature above them, rammed right

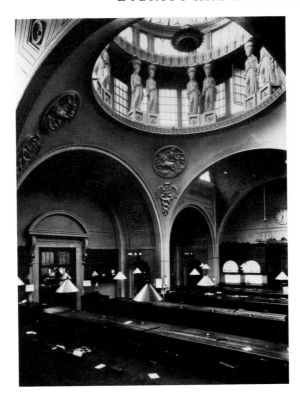

41 Soane's Dividend
Office, Bank of England
(1818; demolished):
Greek caryatids
levitating in a spatial
scheme that owes
nothing to Greece.

across the breadth of the frontage so forcefully that it breaks the line of the enclosing rustication at the sides, we see a kind of temple façade, broader than it is high. Conventionally, the pediment should rest upon the entablature; instead, a massive attic storey, deep shadowed by the big eaves, bears down ponderously. The huge concave brackets which support cornice and gable bend as though beneath the solemn weight thrust down upon them; they seem to store energy like coiled springs, strong by virtue of their very flexibility.

The treatment of the gable and the semicircle below it derives ultimately from Palladio. The combination of clasping rustications with an attic storey above an entablature can be seen at Vanbrugh's Blenheim Palace. And indeed the sombre, vehement counterpoint of Cockerell's bank does have much in common with the English baroque. Of specifically Greek features it has few: the two small Ionic columns below the semicircle, the frieze of key pattern in the

66

entablature. Later we shall examine his bank building in Bristol, where rather more of the elements are Hellenic.[15] But more important than the specific character of his forms is the idea of combination: the adapting of diverse parts of the classical vocabulary into new and powerful kinds of organization. Cockerell is a Hellenist; but he also continues, with full conviction yet in a distinctively nineteenth-century manner, the tradition which descends from the Renaissance through mannerism and the baroque.

In the 1840s he built the Ashmolean Museum in Oxford. This is not merely classical but distinctively Greek, with pilasters of Thrasyllus type and Ionic columns. Indeed, the antiquarian streak in the Greek Revival continues here: in his youth he had made archaeological discoveries in Greece, including an unusual form of

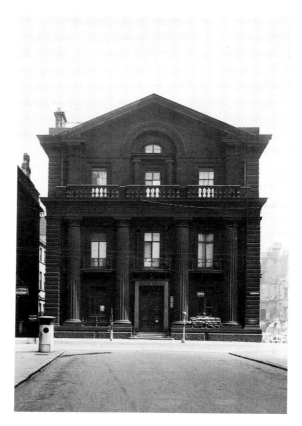

42 Hellenic baroque: Cockerell's Bank of England, Liverpool (1845–8).

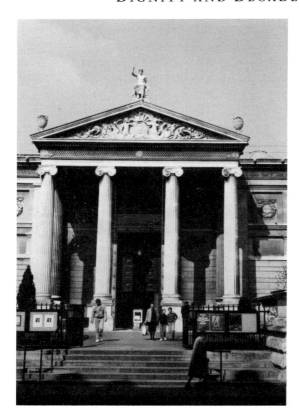

43 A mixture of Greece, Palladio and free invention: Cockerell's Ashmolean Museum, Oxford (1841–8), with sculpture and decoration by W.G. Nicholl.

Ionic capital which he had found in the temple at Bassae. He uses it here, in place of the more familiar type best known from the Erechtheum; the Bassae capital is less graceful but livelier. These Greek elements are incorporated into a structure much of which is far from Greek in derivation. The portico (Plate 43) has Greek columns, but they are lifted up on high bases (again the model seems to be Palladio), so that it is taller in relation to its width than any Greek example. The strange frieze, apparently imitating basketwork, has no exact Greek precedent; it bulges outward, so that the pediment seems to rest lightly upon a springy bed. The Bassae capitals add to the buoyancy: whereas the flattish curve and counter-curve of the Erechtheum capital form a spreading cushion which looks as though it has a substantial pressure upon it, the volutes of the Bassae capitals turn continuously downwards from

68

their central point nodding outwards away from the architrave, so that the entablature seems not to weigh upon them. The sculpture in the gable, vigorously carved by one William Nicholl, is unlike anything Greek: a swirling, bubbling froth of sparkling white, deeply cut stone, the central figures rearing themselves from the eddying sprays of foliage like mermen from the foam.

For the right-hand wing of the building (Plate 44) Cockerell has again devised a sort of counterpoint. The massive bracketed cornice under the roof frames the whole block and invites us to see it as a single simple rectangle (the motif derives from Renaissance Italy). But the two Greek orders below (Bassae columns and Doric pilasters) hold up what appears to be a second, lower cornice, emphasized by the broad basketwork frieze. This horizontal accent is not quite continuous. Between the Bassae columns it breaks – and yet does not break. The plaited frieze is interrupted and the round-headed windows shoot upwards through the entablature into the attic storey; yet a broad stone bar continues the line of the frieze so that the vertical stress of the fenestration and the horizontal stress of the entablature seem to fight each other with an awkward, muscular energy.

44 Ashmolean Museum: the Taylorian wing.

Some of the detail has an almost baroque rhythm of echo and variation. The Bassae capitals have a concave section; that is to say, they turn outwards away from their central point. The basketwork frieze has a convex section: that is, it bulges in the middle. Directly above the columns the basketwork gives place to a jolly, swirling design in which the Greek anthemion ornament appears amid shapes which seem to reflect the whorls of the Ionic volutes upside down. Both in detail and overall composition, this building emerges as one in which Greek forms – let it be stressed, distinctively Greek – are mingled with others, very different from them, into a successfully eclectic blend. In Cockerell's Hellenism, antiquarianism and the broad classical tradition descended from Italy all come together, and the result is not derivative but impressively new.

The Ashmolean Museum, finished in 1848, takes us almost to the mid point of the century. But meanwhile a battle of the styles was being fought out between Greek and Gothic; though battle is not quite the right metaphor, since almost all the polemic came from the Goths. The fiercest and funniest of these was Pugin. He was a phenomenally hard worker; in the space of seventeen years he designed houses and many, many churches; he wrote and illustrated disputatious books and pamphlets; he married three wives and fathered eight children; and he died in a state of physical and mental collapse in 1852, at the age of forty. He was a man of violent passions and enthusiasms; and like a storm, he blew himself out.

His most entertaining polemic was *Contrasts* (1836), in which drawings of an idealized medieval past were set beside caricatures of modern towns and buildings. His assault on the classical had two main thrusts, patriotic and religious. It was an intoxicating blend; our own century has shown how potent is the mixture of nationalism with moral or quasi-religious self-righteousness. There was no need to visit Greece and Egypt to learn about art, he wrote: 'England alone abounds in . . . antiquities of surpassing interest.' As for St Peter's, Rome, it was 'by no means comparable to either St Peter's of York or St Peter's of Westminster'.[16] Indeed he once startled Newman when they were together on the Janiculum in Rome, looking down on the basilica. 'Oh that the dome might fall!' he exclaimed,[17] revealing in answer to enquiry that he desired to rebuild St Peter's in the English Middle Pointed style. It is an attitude which suggests small respect for the *genius loci*; yet in

England the *genius loci* came to his aid. As he wrote in *Contrasts*, the English medieval cathedrals 'still proudly stand pre-eminent over all other structures that the puny hand of modern times has raised beside them', stirring 'astonishment and admiration'.[18] And indeed the influence of the English cathedral over the English imagination is not in doubt.

Pugin's second main principle was that Gothic was the true Christian style, while classicism was pagan. The Gothic half of this argument was vulnerable: Newman pointed out that 'the see of St Peter's never was Gothic', while the Oratorian order to which he himself belonged was begun in the Counter-Reformation, and thus could not be fittingly represented by medieval forms. (Pugin, for his part, decided that the Oratorians were 'monstrous' and 'worse than the Socialists'.)[19] But the claim that classicism was pagan had force: as Pugin put it, 'The inverted torch, the club of Hercules, the owl of Minerva, and the cinerary urn, are carved, in lieu of saints and angels, on the tombs of popes, bishops . . . and warriors, frequently accompanied by Pagan divinities, in Pagan nudity; the pious supplication for a prayer for the soul of the deceased, is changed into a long and pompous inscription detailing his virtues and exploits.'[20] Essentially he was right: these classical ornaments are not purely the result of a change of taste: they are a symptom of worldliness, of Christian faith gone watery. Ruskin was to return to the charge, which carried weight in an age as fascinated by symbolism as the nineteenth century. And indeed the caryatid porch of St Pancras Church seems as loosely connected to the idea of Christian witness as it is to the body of the building.

Pugin's patriotic and religious arguments are both in a broad sense moral arguments; the enormous assumption behind them is that an architecture which is morally pleasing will also be pleasing to the eye. But he also had a purely aesthetic argument, which in *Contrasts* was carried through more in pictures than words: that nineteenth-century classicism was a drab, dingy, starveling thing. He depicts medieval buildings as generously three-dimensional, with deep recesses of shadow lovingly hatched in, whereas modern classical buildings are made to look angular, flat, and scant of ornament (Plate 45). When he illustrates the Carlton Club, he draws in every line of the sash windows to create a hard, grid-like effect; and he indicates shadow by bleak straight lines, in contrast to

45 Pugin caricatures classical architecture as mean, hard and angular in the frontispiece to his *Contrasts* (1836).

the cross-hatching by which Gothic shade is realized. The National Gallery and the Westminster Hospital (superficially Gothic, but classical in plan underneath, and thus to Pugin detestable) are made more prickly, more dominated by dull, rigid horizontals and verticals than is really the case. The stone-built Angel Inn at Grantham appears vigorously three-dimensional compared to the mean, flat stucco façade of the Angel Inn, Oxford, with its weakly elongated pilasters clamped inorganically on to a rectangular grid (Plate 46). Pugin almost entirely ignores the Doric order and the massy solidity of some Grecian architecture. It is all very entertaining; and very unfair.

In 1835 the competition for rebuilding the Houses of Parliament was announced, and it was stated that the style should be either Gothic or Elizabethan; in other words, a national style. This decision can easily be seen as a turning point, marking the clear

victory of Goths over Grecians. Yet in one respect it was an incomplete victory. Charles Barry, an architect hitherto best known for Italianate work, won the competition, and Pugin was appointed to design the Gothic detailing. How pure was the result? Pugin was not convinced: 'All Grecian, sir,' he told a friend, as they sailed past on the Thames; 'Tudor details on a classic body.'[21] And if we look at the long river frontage (Plate 47), we can see that it is fundamentally a Palladian composition. We can even detect, beneath the Gothic cobwebbery, the pattern of the great houses of the eighteenth century: a central block, with wings extending to smaller blocks on either side. And yet Pugin was not entirely right, for Barry set against this regularity the picturesque asymmetry of

ANGEL INN GRANTHAM
CONTRASTED PVBLIC INNS

46 Mellow stone in the good old days, flat stucco today: Pugin's 'Contrasted Inns'.

ANGEL INN OXFORD

73

47 'Tudor details on a classic body': the river frontage of the Houses of Parliament is at heart a Palladian composition, counterpointed by the asymmetrical towers.

his two main accents, Big Ben and the Victoria Tower. If we consider Pugin's work, we may conclude that he enriched a Gothicism which might otherwise have seemed perfunctory. If we look simply to Barry's composition, we may reckon that he succeeds by tempering romantic medievalism with classical discipline. From either point of view the lingering on of a classical tradition, long since absorbed into the bloodstream, has contributed to a building which in its final effect is masterly.

Even in his own writings Pugin paid a sort of compliment to the classical style; not, of course, by intention. For he suggests that it is natural to the modern age. Oscar Wilde was to write, many years later, 'Whatever . . . is modern in our life we owe to the Greeks. Whatever is anachronism is due to medievalism.'[22] Pugin's outlook was very different from Wilde's; yet in an odd way he would have agreed. *Contrasts* ends by depicting a pair of scales: one pan sinks beneath the noble bulk of a Gothic cathedral; in the other a ragbag of classical buildings, St Pancras Church among them, is weighed in the balance and found wanting (Plate 48). However, the two sides are not labelled 'Gothic' and 'classical' but 'XIV century' and '19 century'. It is a contrast between past and present, and Pugin

takes the side of the past. His Gothic passion grows out of a world excited and disturbed by industrial revolution. At one extreme were those who held that (in Disraeli's provocative phrase) Manchester was a greater achievement than Athens; against them stood many who were horrified by smoke and science and democracy – all the monsters to which the pollution of industrialism was giving birth. They fled for sanctuary to Athens; or to Rouen, or Venice, or Merrie England in the happy days before Luther and Inigo Jones had got at it. Some of Pugin's illustrations show his hatred of the new with a pitiable clarity: one plate is 'dedicated without permission to The Trade'. Trade – a low occupation. A lecture is advertised on 'Antideluvian [sic] Babylonian Greek Roman and Gothic Architecture by Mr Wash Plasterer'; trade again. And it is to be given at the 'Mechanicks Institute'. It is not just that machines are objects of loathing; the sort of people who work with them are likely to be free-thinkers and democrats, and their efforts at self-improvement a threat to old hierarchies. This emerges from the plate of 'Contrasted College Gateways', where King's College London is measured against Christ Church Oxford. Outside the former a man holds a board advertising 'Cheap Knowledge Lecture Mechanics Institute

48 The endpiece to *Contrasts*: Gothic architecture represents the past, classical the present.

75

Mr Gab on the Power of the People'. Pugin anticipates Marx in finding a connexion between the new industrial order and the prospect of social revolution. It is an irony which perhaps neither of them would have enjoyed.

Similarly the Greek Revival is stigmatized as 'the new square style', and some carpenters' measuring tools are depicted to ram the point home (Plate 45). Ruskin was to argue that Gothic was in reality the practical style for the nineteenth century. But was it? Pugin's polemic suggests a different moral: that the odious rectangularity of classicism fitted the hard new world of scientific measurement. Pugin was so ferociously anti-utilitarian that this would have worried him not a jot; but it was a weakness of his case that he had no arguments to address to those concerned about cost and practicality. A different line of attack would have been possible. No one thinks that the frontage of the National Gallery on Trafalgar Square is an entire success; it shows how hard it was to adapt the Greek manner to large, spreading, complex buildings, which some modern purposes did require. Gothic can ramble more happily.

Pugin did not want to solve new problems; he wanted to bring back the Middle Ages. It was an impossible dream, but even in its own terms one may doubt whether the argument of his drawings is truly persuasive. Faced with his idealized vision of medieval England, we answer that it was not really like that; even in his own pictures, those saintly monks and beadsmen look false and stagy, whereas his degenerate modern world is at least alive. Of course the 1830s have a period charm for us that they did not have in Pugin's day, but there were men of his own time who could see vitality in what he found merely abhorrent. In his street arabs, peelers and resurrection men, we glimpse a world that we now call Dickensian. Through his classical nightmare stroll Mr Slum and Mrs Jarley; and they feel quite at home.

The dispute over style has been largely seen, both at the time and since, as a war between Greek and Gothic. That is hardly surprising: after all, we all know the difference between a Gothic pillar and a classical column; and everyone can enjoy the drama of an aesthetic Lepanto, a battle royal between pagan and Christian forms. And yet in some ways this outward battle is a screen, behind which we can detect other divisions which cut across the conventional categories. One of these is the division between strength and

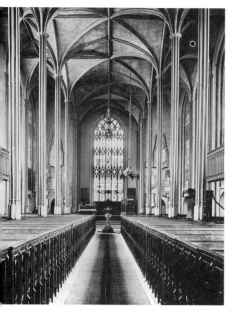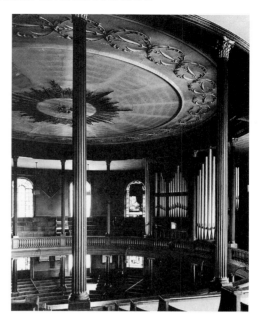

49 and 50 Two modes of eighteenth-century attenuation: Gothic at Tetbury Church, Gloucestershire (by Francis Hiorn, 1781), classical at St Chad, Shrewsbury, Shropshire (by George Steuart, 1790–2).

slenderness. If we go back to the eighteenth century and compare Tetbury church and St Chad, Shrewsbury, we see at once that one is Gothic, the other classical, but that neither treats its models with much solemnity (Plates 49 and 50). In either case the historical forms are the starting point for an exercise in elegant attenuation; both are the antithesis of Doric masculinity. The difference between classical and medieval forms here is of secondary importance only.

Now Pugin hated a skimpy Gothic as much as any kind of building, and in *Contrasts* he tried to show the strength of Gothic in comparison with classical styles. But the Grecian architect could play the same game. In Edinburgh W.H. Playfair designed two public buildings in a Greek style vigorous enough for the sternest taste (Plate 51). The Royal Scottish Academy (1822–35), with its stocky Doric order, is especially robust; the National Gallery of Scotland (1850–7) is more graceful, and it is, incidentally, adapted admirably to its function: the galleries are arranged as a series of octagonal rooms, lit from above, which by combining a sense of

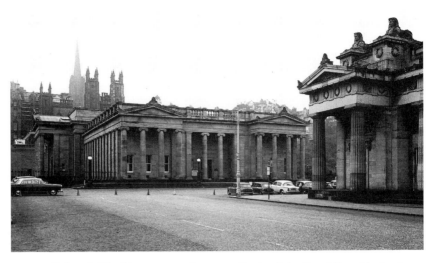

51 In Edinburgh Playfair contrasts the severe Doric of the Royal Scottish Academy and the serious Ionic of the National Gallery with the spindly Gothic towers of New College.

spaciousness with a sense of enclosure make one of the best settings for showing pictures yet devised. Outside, the absence of flutings from the columns, the empty pediments, bare of sculpture, and the compact, deep-shadowed organization of the forms temper the refinement of the Ionic order with a northern austerity. The two buildings are contrasted, but they blend well.

High above them, on the rim of the rocky spine upon which the old town of Edinburgh stands, Playfair put a third building, New College (1846). Its Gothic spindliness recalls the playful mock-medievalism of the eighteenth century, and he may have had in mind the rather similar pair of towers that Hawksmoor designed for All Souls College Oxford in 1716. It roused the wrath of Ruskin, who used it, in Pugin's manner, for a contrast of his own. He sets it beside the campanile of St Mark in Venice, and very meagre it looks in comparison (Plate 52). But in a sense he had missed the point. It is true that Playfair's towers will not bear too severe a scrutiny, but perhaps he did not mean that they should. He too is making a contrast, but for him Greek is the strong and Gothic the slender style. He uses New College as scenery, as a backdrop;

78

and indeed it is a pleasing addition to the great wall of towers and tenements, mixed with the temples, domes and palaces of commerce, that rises cliff-like across the valley from Princes Street.

So Pugin's argument could be turned upside down. And besides, was he not drawn himself to the charms of slenderness? There was something feminine in his sensibility. His spires aim for height at the cost of solidity; they are picturesque, certainly, but scarcely robust. Some of the plates in *Contrasts* reveal a liking for the very late Gothic buildings of France and Flanders, so curiously smudged and carious in their ornament, deliquescent like rotting fruit. On the title page the soft, spiky entwinements of a luxuriant, faintly sinister foliage ramp around the Gothic lettering, with oddly decadent effect. In his work on the Houses of Parliament, how he loves

52 Ruskin contrasts the weakness of New College, Edinburgh with the virility of St Mark's Campanile, Venice: a plate from *The Stones of Venice*.

the gilding and colouring, the endless cusps and crockets and finials. Superb in its way, all this fuss and filigree seems far removed from the almost aggressive masculinity of mid-Victorian Gothic. Street, with his stocky columns, and Butterfield, with his angry zigzags of polychromatic brick abrading the sensibility like the teeth of a saw, have perhaps as much in common with the sturdier classicists as with some of their brother Goths.

Revivalism was a comparatively new phenomenon. Though the Renaissance was in part a rediscovery of ancient Rome, and its architecture manipulated a classical vocabulary, it used classical forms as a resource to be turned towards new kinds of expression; it was left to a later age to take the style of an era long gone and try to reproduce it as nearly as might be. The Greek Revivalists looked to fifth-century Athens, Pugin to England in the fourteenth century, Ruskin to Italy in the thirteenth. All this implied a denial of the idea that architecture grows, as it were organically, from the society which creates it; that buildings are bound, in the end, to say something about the people who design them or pay for them.

We, though, can pursue the line of enquiry that the revivalists implicitly shut off. Does revivalism itself, we may ask, tell us anything about the nineteenth century's character? As I have suggested, social explanations of aesthetic fashion may be merely facile; changes of taste may come from whim or chance or the game of follow-my-leader; but the nineteenth century is so deep-dyed in revivalism that it is reasonable to search for its causes. Its seeds seem to lie in the eighteenth century, too early for the industrial revolution to have germinated them; we can plausibly see its origins in that archaism which so often arises in elaborate, over-sophisticated societies. Pater was to become aware of this tendency: he examines the archaism of the second century AD in his philosophical novel *Marius the Epicurean* and likens it to the eclectic revivalism of his own, late-Victorian day. In the eighteenth century a tough form of the archaizing fashion is the primitivism which takes refuge in neo-classical austerity, while a playful form of it devises pretty, *faux-naif* villas and pavilions in the gothick style. But though factories and steam-engines may not have begotten revivalism, they may well be responsible for its persistence: amid the swirl of fast and bewildering change, it was natural to cling to the past as to an anchor. In the writings of the Victorian revivalists we find the

glories of past architectures evoked as a contrast to the ugliness of the new age (which was reasonable enough), but we also find, beyond their hatred for the visual squalor of industry, a loathing for the materialism which they see behind it: the greed and getting and spending. We have met it in Pugin; in Ruskin we shall meet it again. There is, in fact, an awkwardness in the revivalists' argument. On the one hand they see the beauties of the Middle Ages as the natural expression of medieval virtues, the ugliness of modern England as an all too true reflection of English society; on the other, they believe that these bygone forms can be successfully reproduced in Victorian Britain. Ruskin's answer to this would have been that his moral and aesthetic demands were inseparable: 'be good' and 'build in a thirteenth-century Italian style' were two parts of a single prescription. The argument is uncomfortable, none the less.

On the Continent the nineteenth century was an age of new nationalisms: out of small principalities Italy and Germany were formed. Revivalism could express patriotism. The Germans often favoured the 'round-arch style', imitating the Romanesque architecture to which medieval Germany had remained attached for many years after France and England had gone Gothic. Or the message could be more complex, mixing the celebration of past glories with present aspirations: Mussolini's Fascist architecture blends allusion to the gigantism of ancient Rome with a coarse, chunky modernism that seems to insist 'we are not just a land of ice-creamers and museum-keepers'. This too assertive modernity echoes the feelings of the Italian Futurists, whose hatred for the beauties of their country was summed up in their plan to asphalt the Grand Canal.

We have seen a nationalist streak in Pugin; but one may doubt whether patriotism was the chief reason why the Gothic Revival lasted in England. Perhaps we may see it as related to Victorian attitudes in a subtler way. It is hard to look long at Victorian Britain without being struck by its extraordinary mixture of self-confidence and self-doubt. Was she not the most powerful nation upon earth? Had she not the greatest empire ever known? On the other hand, Darwin and the geologists were gnawing at old certitudes, and social changes were eroding ancient hierarchies. As for the arts, were the English perhaps inferior to other races? Composers always seemed to be foreigners. Many nations which had

not produced great composers in the past were producing them now – Russia, Bohemia, even Belgium and Norway; England alone seemed to be left out. There was a touch of grossness in the English race, Matthew Arnold said; how different from the lightness of ancient Greece.[23]

Now the nature of revivalism is to be both diffident and assured. The assurance lies in taking the very best period of the past and supposing that one can match it. And yet to advocate this was to confess that the nineteenth century had no style of its own and no prospect of making one; it was to defer to another age, and perhaps to another nation too. If Victorian Britain blends arrogance and diffidence, their buildings are a curiously apt expression of that amalgam; and the more we explain them in these terms, the more does it seem that revivalism itself, and not any particular style, is the crucially new thing. In this light Hellenism appears not so much an autonomous movement as an area within which various issues could be sifted and problems worked through.

There are at least two divisions which cut across the conventional ranks of Goths and Grecians. One is between the pure revivalists and those who wanted to direct historical forms to substantially new ends; seen in this light, Cockerell and (say) Butterfield are in the same camp, ranged against Wilkins, Smirke and Pugin. But there is also a division between the revivalists in general, including those of eclectic stamp, and the architects who were moving towards the abandonment of historical styles altogether. If we pretended that the church in Plate 53 was put up in the Baltic around 1910, we might not be disbelieved. In fact it is early Victorian: Christ Church, Streatham, by J. Wild, 1840–2. The general outline may be inspired by the Lombardic churches of Italy, but essentially this building has thrown off historicism. Soane's work evolves out of the Greek Revival, but in some of it, like the Colonial Office in the Bank of England, the revivalist element has faded almost to vanishing point (Plate 54). 'An unaffected stylelessness of difficult simplicity' – that would not seem a bad description of it; but as we shall discover it was written (by Beresford Pite) to describe the architecture of seventy years later.[24]

From one point of view the Greek Revivalists were in retreat by the mid 1830s, to be swept aside by the invading Goths; but from another viewpoint all the Victorian revivals can look like an

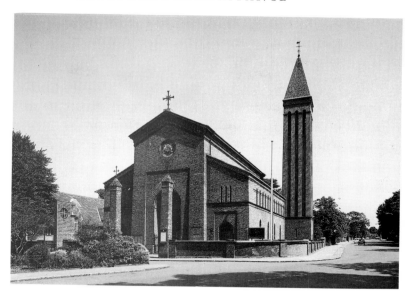

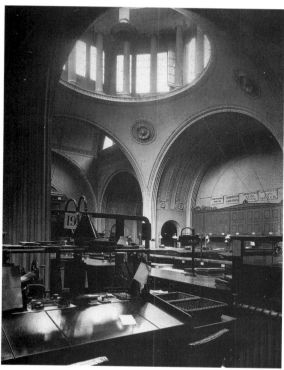

53 and 54 Historical allusion reduced almost to vanishing point in two London buildings: Christ Church, Streatham (by J. Wild, 1840–2) and Soane's Colonial Office, Bank of England (1818; demolished).

interruption of the natural progress of architectural history, a side road which however picturesque or engaging would lead nowhere and eventually run into the sand. The Gothic spires that still punctuate the skyline of Britain's industrial cities seem witnesses to a last great age of faith. We think of the evangelical missionaries and the Anglo-Catholic slum priests, of Father Lowder and General Booth, of Josephine Butler befriending fallen women and Cardinal Manning settling the London dock strike. But suppose that the Gothic Revival be seen in two ways: partly as the essentially Victorian style, partly as being in the nature of a dyke built to hold back the current of modernism but sure to crumble in the end. In this double light does it perhaps reflect an ambiguity of the age?

55 and 56 The fancy-dress game and the Prince Consort's knees: Emil Wolff, *Prince Albert* and William Theed, *Victoria and Albert as Anglo-Saxons*.

Was the religious energy of the time one of the central facts of the nineteenth century, or was it a valiant but temporary resistance to the tide of secularization that floods right through the Victorian age into the twentieth century and which may not yet have fully spent its force?

In the earlier nineteenth century there were signs at moments that architecture might break with historicism and develop something like a 'modern' style (even amiable, courtly Nash could be 'modernistic' in certain moods). Perhaps it was never a strong possibility; but there is an unobtrusive tradition of building in a simple classical manner, sometimes verging on 'stylelessness', that runs through the Victorian age, and we should not be surprised to find

progressive architects, towards the close of the century, looking back to the most original classicists of fifty years earlier for inspiration. In the early part of the century there was a trend towards a scholarly historicism and a trend towards the simplification, even dissolution of historical forms; the Grecian school provided a place where the two tendencies could meet. The end of the century was a period of uneasy rebellion, with a culture unsure whether to continue the traditions of the past or to react against them, and here too we shall see the classical styles providing a kind of neutral ground. It is a paradox of the Greek Revival at the beginning of Victoria's reign that it seems at once dated and prophetic.

By way of tail-piece to this chapter and transition to the next, Albert's knees may suggest to us that in the revivalist game the distance between classicism and medievalism could sometimes be a hairbreadth wide. In 1844 the Prince Consort shows a leg as a Greek warrior, in 1868 as a Saxon (Plates 55 and 56). Sometimes one wonders whether the sillier side of the Victorians is intrinsically more comic than that of other ages, or whether it is just that every generation likes to laugh at its great-grandparents. These pictures surely settle the question.

The Idea of Sculpture

THE AWKWARD ART

Any account of how sculpture has influenced the European imagination in the last two centuries must start with Winckelmann (1717–68), the inventor of art history as we know it; indeed, the man who invented ancient Greece as an object of idolization. Born in north Germany, the son of a cobbler, and starting life as a village schoolmaster, he became possessed of a passion to get to Rome and see the great sculptures of antiquity for himself. The cost proved to be a diplomatic conversion to Catholicism, a small price in his eyes; for a sight of Greece, he said, he would gladly have been castrated.

He can have seen scarcely one original statue of the fifth century BC, which he decided was the best period of Greek art. What he found in Rome were Graeco-Roman copies, together with a few late Greek works. But by a leap of faith and imagination he discovered a Greece that was the antithesis of his own crabbed, cantankerous nature: the characteristics of Greek art, he concluded, were 'a noble simplicity and a calm grandeur'. With a perversity so odd that there is a touch of genius about it he took as example of these qualities a very late Greek work, the Laocoön, a complex, contorted composition representing a man and his two sons writhing in agony, wrapped in a serpent's coils. His contention was that although Laocoön and his children are dying in pain, their faces express no violent anguish: only a faint sigh issues from the father's lips. Actually, this was a misdescription; but by some sorcery he had described some – not all – of the fifth-century sculpture that he never knew better than the works which he had seen.

And for another wonder he persuaded educated Europe that he was right. But he also provoked a controversy. For he claimed that noble simplicity and calm grandeur characterized all Greek art, literature included, and this stung Lessing to write his essay, *Laocoön*, in reply. He accepted what Winckelmann said about

sculpture (before the coming of photographic reproduction it was easier for this to carry conviction), but argued that literature was sharply different, taking as example Sophocles' *Philoctetes*, in which the hero, like Laocoön, is gripped by physical agony. But does he bear it calmly? No: he shrieks and howls.

Perhaps not many Englishmen read Winckelmann and Lessing. But German ideas were popularized in Britain by A.W. von Schlegel's *Lectures on the Drama* (1807), which were in turn pillaged by Coleridge for his own lectures. Sculpture is the art of the ancient world *par excellence*, said Schlegel, as music of the modern world. Greek drama itself is sculptural in nature, whereas modern art, in all its forms, is romantic, turbulent, coloured. Citing with approval the view that 'the ancient painters were perhaps too much of sculptors and the modern sculptors too much of painters', he declared, 'The spirit of ancient art and poetry is *plastic*, but that of the moderns *picturesque*.'[1] Thus there were two views about literature in the air. The first was that all Greek art, poetry included, aspires to the condition of sculpture. The other was that Greek literature is emotional in a way that Greek sculpture is not. In either case sculpture is perceived as peculiarly the ancient art, the Greek art.

These views persist right through the nineteenth century, but they were not the only views about. For Winckelmann's idea of Greek sculpture had been jolted by the arrival of the Elgin Marbles in London, in the early years of the new century. The English approach to Greece was already somewhat different from the German, as we have seen, partly because they were not reacting so immediately against the baroque, partly because of the 'archaeological' tendency of their culture. It may be, too, that the British are by temper more empirical, less theoretical than the Germans. At all events, Hellenism in Britain already had some local flavour, and the coming of the Elgin Marbles was to strengthen it. Their influence on British culture was to be greater than it had ever been in Greece. Indeed, the very notion that these works are sacred icons of the Greek nation was a British invention. When romantic young Englishmen went to visit the relics of ancient Greece what they found in the inhabitants was the battered remains of a late Byzantine culture. The banditti who fought the Turks did not always understand the foreigners' Hellenic enthusiasms: 'Who is this Achilles?' one asked. 'Has the musket of Achilles killed many?'[2] It was

Englishmen who taught the Greeks to feel aggrieved about Lord Elgin. Melina Mercouri claims to be a victim of British cultural imperialism; she speaks more truly than she knows.

Far from seeming calm and classical, the Elgin Marbles struck the public as thrillingly romantic. Mrs Siddons saw them and wept.[3] Fuseli ran through the streets to get to them, cursing and swearing as he tangled himself among a flock of sheep in the Strand. 'By gode,' he declared in his Swiss-German accent, when he finally found himself before them, 'De Greeks were godes! de Greeks were godes!' The painter Haydon persuaded himself that the influence of these works would inaugurate a new era of British art. He took his young friend Keats to see them; an occasion which was to inspire the poet for the rest of his short life.[4] His sonnet, *On the Elgin Marbles*, stresses the wild, disturbing emotions that they roused in him: these wonders bring round the heart 'a most dizzy pain, That mingles Grecian grandeur with the rude Wasting of old Time'. Not much stillness and serenity there. Flaxman was reputed to have said that compared to the Theseus the Belvedere Apollo was a mere dancing-master.[5] The Apollo had long been — as it is now hard to remember — the most admired sculpture in the world. Hazlitt's reaction is interesting: he is so excited by the Elgin Marbles that at heart he wants to dismiss the works hitherto most praised, but he is not quite bold enough to do so.[6]

After seeing the Apollo, the Hercules, and other celebrated works of antiquity, we seem to have exhausted our stock of admiration . . . But at the first sight of the Elgin Marbles, we feel that we have been in a mistake, and the ancient objects of our idolatry fall into an inferior class or style of art. They are comparatively, and without disparagement of their vast and almost superhuman merit, *stuck-up* gods and goddesses. But a new principle is at work in the others . . . a principle of fusion, of motion, so that the marble flows like a wave . . . in the fragment of the Theseus, the whole is melted into one impression like wax; there is all the flexibility, the malleableness of flesh; . . . the statue bends and plays under the framer's mighty hand and eye, as if, instead of being a block of marble, it was provided with an internal machinery of nerves and muscles, and felt every slightest pressure . . .

Truth to nature was a rallying-cry for the romantics, and this, Hazlitt felt, the Elgin Marbles provided: they united 'the ease, truth, force, and delicacy of Nature': 'The flesh has the softness and texture of flesh, not the smoothness and stiffness of stone. There is an undulation and a liquid flow on the surface, as the breath of genius moved the mighty mass.' By contrast, 'The Apollo and other antiques are not equally simple and severe. The limbs have too much an appearance of being cased in marble . . .'[7] That is a shrewd observation, and one reason for Hazlitt's impression is now obvious enough to us: the Elgin Marbles are originals, whereas most of the antique sculptures which had been known before are copies.

Despite the popularity of the Elgin Marbles, veneration for the most famous Graeco-Roman pieces was to linger on for many years. None the less, once the Greek fifth century had been revealed in all its splendour, the popularity of the old favourites was doomed to wane in the end. Henceforward there would be something a little artificial in modelling a sculptural style upon the Apollo and the Medici Venus, as though the Parthenon Marbles had remained unknown. So we might expect these newly revealed masterpieces to have powerfully influenced the sculpture of the romantic age. But here comes the surprise: in practice they seem to have affected everyone except the sculptors themselves. Canova, born in 1757, spoke of them with warm admiration, but he was too old and too smooth to change now. Much the same might be said of Flaxman (born in 1755), who continued to practise a neo-classical calm. Hazlitt noticed that Flaxman had praised the Elgin frieze in his lectures and regretted that he had not 'extended his eulogium' to the free standing figures.[8] This was perceptive: much of Flaxman's work in the round is of gods and mythological figures in the line of descent from the Belvedere Apollo; it is in his reliefs that he shows a specifically Greek influence – not of the Elgin frieze, but of the softer, sweeter style found on Athenian tombstones. This manner is seen at its most enchanting (and Flaxman is not often enchanting) in his monument to the botanist Sibthorp in Bath Abbey (1799–1802): bare-legged, and in the costume of a Greek traveller, the professor steps from the ferryman's boat on to the shores of Elysium (Plate 57). Flaxman has known how to temper his pure neo-classicism with just the right degree of modernity: the sharp cutting of the flowers and the individuality of the portrait

57 From Oxford to Elysium: Flaxman's monument to John Sibthorp, professor of botany, in Bath Abbey.

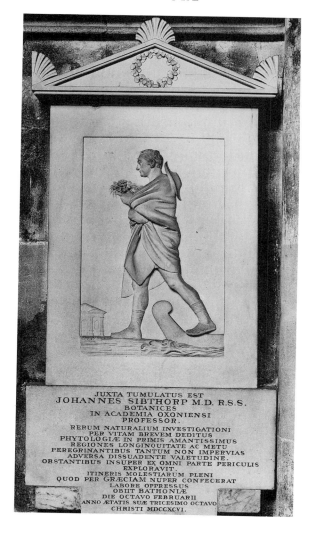

JUXTA TUMULATUS EST
JOHANNES SIBTHORP M.D. R.S.S.
BOTANICES
IN ACADEMIA OXONIENSI
PROFESSOR.

RERUM NATURALIUM INVESTIGATIONI
PER VITAM BREVEM DEDITUS
PHYTOLOGIÆ IN PRIMIS AMANTISSIMUS
REGIONES LONGINQUITATE AC METU
PEREGRINANTIBUS TANTUM NON IMPERVIAS
ADVERSA DISSUADENTE VALETUDINE.
OBSTANTIBUS INSUPER EX OMNI PARTE PERICULIS
EXPLORAVIT.
ITINERIS MOLESTIARUM PLENI
QUOD PER GRÆCIAM NUPER CONFECERAT
LABORE OPPRESSUS
OBIIT BATHONIÆ
DIE OCTAVO FEBRUARII
ANNO ÆTATIS SUÆ TRICESIMO OCTAVO
CHRISTI MDCCXCVI.

head, unlike the ideal, uncharacterized heads on Athenian grave-stones, contrast with the flat, simple modelling of the rest. It is Grecian, but with an almost humorous delicacy typical of the eighteenth century; a classical equivalent of chinoiserie or the gothick taste. It is playful, and moving because playful. And it looks backward, away from the new century, in another respect also: of Christian iconography there is not a trace. Here paganism

invades a Christian fane in the way that was to enrage Pugin and Ruskin.

Hazlitt remarked that Flaxman's compositions, though classical, were 'poetical abstractions converted into marble, yet still retaining the essential character of words'.[9] At first sight this may seem a surprising judgement: in painting certainly, the love of telling a story is already evident in the first years of the century, and was to grow still stronger in the Victorian age; it is part of that nineteenth-century taste for the cosy, the domestic, the sentimental which in Germany and Austria is called biedermeier. But it is less obvious that sculpture can retain the 'character of words'. And yet Flaxman's works do on occasion seem to be trying to 'say' something, if not exactly in Hazlitt's sense. His monument to the school-master Joseph Warton (1804) displays a pure classicism, similar to that in Sibthorp's tablet, but lightly tinged with modern sentiment (Plate 58). The allusion to antiquity is reinforced by the busts of Homer and Aristotle, complete with Greek lettering, rigidly frontal

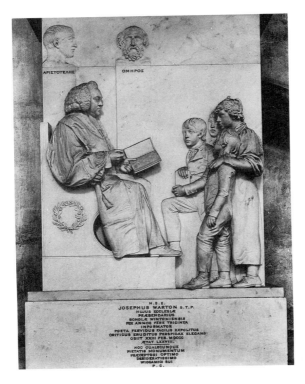

58 Athenian simplicity with a tincture of domestic sentiment: Flaxman's monument to Joseph Warton, Winchester Cathedral.

59 The Grecian manner with domesticity and emotion more openly expressed: Chantrey's monument to Anna Maria Graves, Waterperry, Oxfordshire.

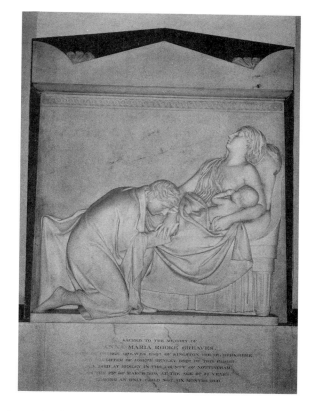

or in rigid profile; but the boys on the right add a touch of the modern genre scene – scarcely more than a touch, for the treatment is fresh and pretty without being sentimental. It is this manner, in essence, that was carried on by Flaxman's rather younger contemporary, Sir Francis Chantrey (1781–1841). His monument at Waterperry to Anna Maria Graves (c.1819) is still restrained in handling, but the mood has become more domestic, the emotion more overtly pathetic; Victorianism seems close at hand (Plate 59). And indeed what is recognizably a neo-classical tradition of sculpture persists right into the middle of the century and even beyond, gradually growing a little fussier in detail, softer in sentiment – but only gradually, as the biedermeier spirit slowly suffuses the current of sculpture, like dye spreading through water. As for romanticism, it might never have existed as far as most sculptors were concerned.

93

Native English sculpture was more distinguished in the first half of the nineteenth century than it had been since the Middle Ages. (The eighteenth century was a finer time for sculpture in England, but most of the leading artists then had come from abroad, Rysbrack and Roubiliac for example.) Flaxman was the first English sculptor to win an international reputation, and indeed the only one before Henry Moore, though it may be significant that his European fame was more for his line drawings than his statues; significant too that few Englishmen are aware that their country was so successful at this time in this field. In the popular view of the nineteenth century sculpture is simply left out of account, and to a large extent this is because, in a curious way, the romantics and Victorians left it out of account themselves: to the nineteenth-century imagination, sculpture is the art that 'doesn't fit'. The German sages pronounced that sculpture was the art of the ancient world *par excellence*, out of place in modern times; and the sculptors seemed to confirm them by continuing to chisel classically while a romantic turbulence seethed around them. The two tendencies may have fed upon each other, with sculptors staying neo-classical in part because that was what the literary men expected, and the literary men seeing sculpture as essentially classical because of what the sculptors put before them.

As a matter of fact, there are signs that Flaxman was indeed stirred by the romantic reinterpretation of antiquity, but that romanticism comes through in his work strangely transmuted. When Fuseli draws Achilles at the pyre of Patroclus he seeks to bring out the primitive side of Homer (Plate 60); significantly, he has chosen the moment at which Achilles kills some prisoners as an offering to the dead man, a barbarity without parallel elsewhere in the *Iliad*. When Flaxman draws Achilles mourning for Patroclus, the result is very different, and to our taste a little insipid (Plate 61). But the poets whom Flaxman chose to illustrate, Homer, Aeschylus and Dante, were all authors who were regarded as grand and simple and as coming 'early' in the history of the civilizations to which they belonged. Flaxman's method of drawing, in outline alone without any shading, is likewise simple, and inspired by another 'early' species of art, the paintings on Greek vases. The barbarity celebrated by Fuseli represents one aspect of the primitive, the plainness of Flaxman another.

60 and 61 Primitive
savagery, primitive simplicity:
Fuseli's *Achilles at the pyre of
Patroclus* (*c*. 1800–5) and
Flaxman's engraving of
Achilles mourning for Patroclus
(1793).

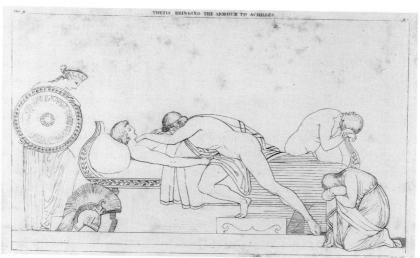

John Addington Symonds wrote, half a century after the sculptor's death, of 'the purity of Flaxman's inspiration, the deep and inborn sympathy that made him in this nineteenth century a Greek'.[10] One may feel momentarily surprised that after so many years Symonds had not acquired a robuster notion of what it was that made a man 'Greek', but 'purity' had remained a key word for describing the Hellenic spirit, and if a sculptor were pure, he had gone as far towards being a Greek as a sculptor, at least, was expected to go. The flux and energy that impressed the public in the Elgin Marbles did not greatly change their idea of how modern sculpture should be; it did not even much affect their idea of what would make modern sculpture 'Greek'. The deliberately flat linearity of Flaxman's illustrations is another surprise: whereas Henry Moore seems always to be striving towards the third dimension even when he is drawing sheep in a field or sleepers in the Underground, Flaxman seems to be drawing in outline even when he is carving in marble. 'His compositions as a sculptor are classical,' Hazlitt said, '. . . but, generally speaking, they are elegant outlines.'[11] Others might not have echoed the note of disapproval in this judgement; the sculptors and critics tended to conspire together, once again, to play down the element of depth and bulk in plastic art.

Ruskin, though a very prolific writer, did not devote a book to sculpture until he was past fifty; in this he allowed that an element of good sculpture was 'the disposition of beautiful masses', but then qualified the statement in such a way as to deprive it of almost all meaning: 'That is to say, beautiful surfaces limited by beautiful lines. Beautiful *surfaces*, observe.'[12] Indeed sculpture, he said, 'is essentially the production of a pleasant bossiness or roundness of surface'.[13] Pater made outline a key to the Greek spirit in his essay on Winckelmann, writing of the 'antique world' with 'its intense outlines', 'the clear ring, the eternal outline of the genuine antique', 'the antique, with its eternal outline' — again and again that word, like a *leitmotiv*.[14] With his usual allusiveness, Pater hints at the old idea that sculpture is the quintessential art of the ancient world; and subtly he lets that allusiveness bear with it other suggestions: that the Greek idea is something of which we catch sight, romantically, from afar; that Greek culture aims at clarity and definition above all things, but passes by the shadowy complexities explored by the art of more recent times. Later he observes, 'We are accus-

tomed to think of the Greek religion as a religion of art and beauty
. . . Yet such a view is only a partial one, in it the eye is fixed on
the sharp, bright edge of high Hellenic culture, but loses sight of
the sombre world across which it strikes.' Much of the sugges-
tiveness of this lies in the phrase 'sharp, bright edge', which links
the idea of outline with the idea of light, another key concept in
the Victorian interpretation of Greece, most memorably captured
in the phrase which Matthew Arnold plundered from Swift, 'sweet-
ness and light'. When we look at, say, the group of figures known
as the Fates (Plate 204), we may well think that, noble as their
outline is, it has less importance than the depth of cutting in the
draperies and the rhythmic interrelationship of planes. But to these
qualities the critic remains indifferent as he constructs his idea of
the Greek spirit in art; sculpture is to be seen as white, bright,
linear and pure.

The sages implied that modern sculpture was an anomaly, and
the critics had little to say about it; from which one might deduce
that the Victorian sculptor had few outlets for his talent. Not so;
once again, we must be sceptical about the way in which an
age describes itself. The market for funerary sculpture declined
somewhat, but commemorative statuary sprouted in the public
spaces of Victorian cities like toadstools after rain; churches and
public buildings were more lavishly ornamented with sculpture
than they had been for centuries, and the rich started to clutter
their houses with carved stone. In the eighteenth century a few
grandees had built themselves galleries to house the antique
marbles acquired on their Italian tours; now the fashion spread,
and in spreading moved from ancient to contemporary works.
What is more, the Victorian *horror vacui* ensured that the quantity
of objects per square foot in the drawing-room increased: Pope's
phrase, 'statues thick as trees', applies as well to the mid
nineteenth century as to anything he saw himself, as the Queen's
own Osborne House has shown us.

The gap between theory and practice, the way that sculpture was
believed alien to the modern world at the very time when it was
becoming ubiquitous, made this art fascinating to the literary
imagination. The critics might neglect it, but the novelists did
not. We have already met Dickens's Mrs Jarley maintaining that
her waxwork show was classy because it was classical:[15]

Classical, that's it – it is calm and classical. No low beatings and knockings about . . . like your precious Punches, but always the same, with a constantly unchanging air of coldness and gentility; and so like life, that if waxwork only spoke and walked about, you'd hardly know the difference. I won't go so far as to say, that, as it is, I've seen waxwork quite like life, but I've certainly seen some life that was exactly like waxwork.

'Coldness and gentility' – classical sculpture is evidently what Dickens has in mind, and indeed the association between the coldness of marble and the coldness of polite society was not new. Byron had made play with the idea:[16]

> But all was gentle and aristocratic
> In this our party; polish'd, smooth and cold,
> As Phidian forms cut out of marble Attic.

But Dickens develops the satire by connecting classical sculpture with a humble kind of cultural snobbery. Two ideas come together here, one concerned with life, the other with art. First, superior society is cold and artificial, governed by stiff conventions distant from the vivacity of the people's everyday life. Second, sculpture itself is the art that does not belong: it too is artificial, conventional, remote from a lively naturalism. The link between these two ideas was provided by the notion that people did not really enjoy classical art, but pretended to like it because they thought that admiration was expected of them. Thus in classical sculpture cultural pretentiousness and social pretentiousness could be symbolized together. It was a bonus that marble is a cold material; its very colour and texture could be used against it. The corpse-like classicism to which Mrs Jarley aspires is in contrast with the Gothic fantasies amid which Little Nell lives and dies. There is the Old Curiosity Shop itself, a romantic chaos of suits of armour like ghosts and fantastic carvings from monkish cloisters, tapestries, rusty weapons and 'strange furniture that might have been designed in dreams'.[17] Add to this the ruinous medieval mansion in which Nell passes away and the little church, grey and venerable, with tumbledown cottages around it, where her body reposes.

Mrs Jarley's pretensions are matched in the literary sphere by Mr

Slum, the poet ('What a devilish classical thing this is!'). He tries to sell her his verses for five shillings: 'Cheaper than any prose.' She doubts the value of poetry ('It comes so very expensive, Sir, and I really don't think it does much good'), but agrees at last to buy his acrostic for three and six.[18] Later, when she has trouble getting custom, Dickens tells us, 'In this depressed state of the classical market, Mrs Jarley made extraordinary efforts to stimulate the popular taste' – namely, a nun whose head shakes up and down, illustrating the degrading effects of Romanism.[19] The joke lies in her entire lack of humour: the vulgarity of her show does have the vitality of popular entertainment, but she refuses to recognize it. Like Mr Slum she aspires in her own line of business to high art, to things that 'don't do much good' and nobody really cares for ('cheaper than any prose'). Ordinary life is full of animation and variety (by contrast, one of the things that she admires about a cold classical gentility is that it does not change); she turns her back on all this, the world of prose – the world of the novel, in fact. Still, one may doubt whether Dickens's satire achieves exactly the effect that he intends. The curiosity shop seems too easily romantic, the ruined mansion a sentimental fantasy. But in Mrs Jarley, caricature though she be, there is a truth to life. The 'Gothic' parts of the book are unreal, but the aspiration to a genteel classicism, however snobbish or self-deceiving, was an authentic element in Victorian life.

Dickens's illustrator Phiz provided a frontispiece for *Little Dorrit* showing the heroine and her sister arriving at the tycoon Merdle's house (Plate 62). A classical statue stands to one side, its supercilious expression matching the smirks on the faces of the condescending flunkeys, its stony nudity representing the Merdles' social pretensions. A few years later, a scene in George Eliot's *Felix Holt the Radical* attracted another illustrator (Plate 63). Though the composition is quite unlike Phiz's picture, there are similarities: here again is the contrast between classical statuary and the vivacity of humble life; here again, in the bust on the right, is a stone head slightly inclined with a superior expression, matched by the look on the flunkey's face; even the legs of the Apollo at the top of the picture are in the same niminy-piminy pose as in Phiz's design. It is not that one artist is copying the other; but, like the writers whom they illustrate, they share a common attitude to sculpture.

62 and 63 Classical sculpture contrasted with everyday life: the frontispiece to Dickens's *Little Dorrit* and a plate illustrating George Eliot's *Felix Holt the Radical*. The statues' legs are expressive.

The scene depicted from *Felix Holt* describes the hero's silly, garrulous mother going to visit Esther Lyon, who has been brought up as the daughter of an independent preacher but is now residing at Transome Court, where she is being introduced to the cultivated habits of the gentry:[20]

When Esther had . . . descended again into the large entrance-hall, she found its stony spaciousness made lively by human figures extremely unlike the statues. Since Harry insisted on playing with Job again, Mrs Holt and her orphan . . . had just been brought to this delightful scene for a game at hide-and-seek, and for exhibiting the climbing powers of the two pet squirrels. Mrs Holt sat on a stool, in singular relief against the pedestal of the Apollo . . . Harry, in his bright red and purple, flitted about like a great tropic bird

after the sparrow-tailed Job, who hid himself . . . behind the scagliola pillars and the pedestals; while one of the squirrels perched itself on the head of the tallest statue . . .

. . . [Esther] saw that Mrs Holt's attention, having been directed to the squirrel which had scampered on to the head of the Silenus carrying the infant Bacchus, had been drawn downward to the tiny babe looked at with so much affection by the rather ugly and hairy gentleman, of whom she nevertheless spoke with reserve as of one who possibly belonged to the Transome family.

'It's most pretty to see its little limbs, and the gentleman holding it . . . but it was odd he should have his likeness took without any clothes. Was he Transome by name?' (Mrs Holt suspected that there might be a mild madness in the family.)

George Eliot's attempts at Dickensian comedy do not often come off, and this is heavy-handed. Besides, she condescends: we are not far from *Punch* and the servant joke, poking fun at the ignorance of the lower orders. But the clumsiness makes all the clearer the rather conventional ideas that she is using: there are contrasts between the well-bred sculpture and the vulgar Mrs Holt, between animated movement and classical stillness, between bright colour and cold stone (the children innocently act out a theme from Schlegel); and the old lady's incomprehension of the Silenus shows the remoteness of classical conventions from ordinary, natural life. One of the two boys is a gentleman's son, the other a child of the people, but they can play together unaffectedly, while their elders are divided one from another by the artificial rules of society. Esther is torn between her modest upbringing and the vision of gentility held out by the Transomes. The sight before her of stony artifice and humble liveliness contrasted makes visible her dilemma.

It was Dickens himself who best caught the place of sculpture in the middle-class imagination. When Flora Finching hears that Little Dorrit has gone abroad, she lets the stream of consciousness flow free, lurching as ever towards a memory of her late husband, 'Mr F':[21]

In Italy is she really? with the grapes and figs growing everywhere and lava necklaces and bracelets too that land of poetry

with burning mountains picturesque beyond belief though if the organ-boys come away from the neighbourhood not to be scorched nobody can wonder being so young and bringing their white mice with them most humane, and is she really in that favoured land with nothing but blue about her and dying gladiators and Belvederas though Mr. F himself did not believe for his objection when in spirits was that the images could not be true there being no medium between expensive quantities of linen badly got up and all in creases and none whatever, which certainly does not seem probable though perhaps in consequence of the extremes of rich and poor which may account for it.

This is one of the most entrancing descriptions of Italy ever written. An odd poetry spills from the cascade of utterance, in which the great Victorian subconscious seems to find a voice. In the nineteenth-century picture of Italy blue sky and mountains and lively popular life were all mixed in with high culture; and this last included antique sculpture − 'dying gladiators and Belvederas' − which you duly admired, of course, though sometimes you might let slip a disrespectful thought: those statues, either nude or seemingly over-draped − was there not something artificial about them, something which 'could not be true'?

It is not in books alone that we find the idea of sculpture as the art which fails to fit; there are photographs of mansions which suggest, in all innocence, the same notion. The Duke of Westminster's Eaton Hall (1870–2) was equipped with suits of armour marching up the Gothic staircase; incongruously, a marble nude joins the end of the line (Plate 64). The visitor to Humewood Castle, as he walked along the landing, found himself suddenly confronted, between Gothic arches, by the bottom of the Medici Venus (Plate 65). Such domestic nudity was the more readily accepted because sculpture was peculiarly associated with purity and innocence; other forms of art were more questionable. The heroine of George Eliot's *Middlemarch* is troubled by her uncle's collection of 'severe classical nudities and smirking Renaissance-Correggiosities': there is a distinction here between the sternness of the casts and the suggestiveness of the pictures.[22] The critic S.C. Hall observed, shrewdly enough, that French nudes looked as if

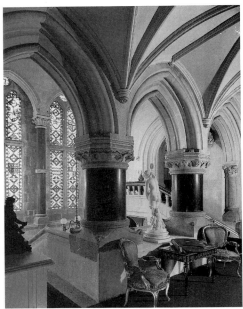

64 and 65 White classical nudity among the Gothic arches: Eaton Hall, Cheshire and Humewood Castle, Co. Wicklow, Ireland.

they had taken their clothes off, Greek ones as if they had never thought of clothes; again he was comparing not only France with Greece but painting with sculpture. Henry Alford, a future Dean of Canterbury, praised sculpture as 'fitted for exciting pleasure . . . by the unclothed symmetry of the wonderful frame with which the Creator has endowed us'.[23] ('Some of us,' one is tempted to murmur.) It is hard to think that a clergyman would have spoken in quite that way about painting (though one must envy the Victorians' skill at adorning with moral language the occupation, not naturally unwelcome, of looking at beautiful bodies; compare the title of P.H. Rathbone's lecture in defence of Alma-Tadema. 'The Mission of the Undraped Figure in Art').

None of this needs much explanation: it is the fact that painted nudes tend to have more erotic force than marble ones. The Victorians having recognized this, it was an easy step for them to suppose that because sculpture lacked some of the erotic charge of painting, it was pure, even virtuous. And the feeling was helped on by the immense prestige of Greece in this art. Greece had the

reputation for virtue in any case: if something was Hellenic, it was almost bound to be pure. Besides, even by the standards of sculpture, Greek work was notably chaste; Renaissance sculptors treat the body less austerely. What is more, Greek sculpture was white – a further badge of virtue. Time and again Victorian writers let their thoughts play around the whiteness of statuary, often using it as an emblem of purity; the awkward but already well known fact that Greek marbles were commonly painted was blandly passed by. The association of sculpture with purity is simply illustrated by the title of J.H. Foley's harmless little nude, modelled for manufacture in Copeland ware (1847): *Innocence*.

The Pre-Raphaelites' passion for the Middle Ages needs no comment. How revealing, therefore, that Thomas Woolner, the only sculptor among the seven founders of the Pre-Raphaelite Brotherhood, should show no trace of medieval influence. Instead, he plainly descends from the neo-classical school, and he is sometimes not just classical but mildly Hellenic. When he made a bust of Gladstone, in 1866, the one aspect of the great man's multifarious activities to which he alluded was his study of Homer: the plinth is decorated with scenes from the *Iliad* (Plate 66). The statesman's other labours and distinctions go uncommemorated; so much more suitable is a Greek theme for marble. Woolner also wrote a quantity of Hellenic verse, 'distinguished,' said the *Athenaeum*, 'by a lofty dignity and strength that makes it resemble . . . his own sculpture': *Tiresias* in six books, *Silenus* in ten, *Pygmalion* in twelve. The last of these, published in 1881, has a sculptor for a hero. His is an art, Woolner suggests, fettered by exceptionally tight rules, established by Pygmalion's race, the Greeks: these lines return several times in the poem, like a refrain:

> And this in pure immortal marble he
> Laboured to show; bound by those rules of Art
> The Wise had found inexorably fixed.

Purity and inexorable rules – such is the prestige of Greece that Woolner locks the chains upon his own wrists.

Ruskin was cross about the heathenism of sculpture, complaining that for centuries the nation had produced no sculpture representing Christ or any New Testament scene with even superficial merit

enough to attract the public.[24] There was some shrewdness in this: England's parish churches are stuffed with sculpture of the eighteenth and nineteenth centuries, the best of it very fine, but somehow it continues to feel pagan and alien, a foreign intrusion into an atmosphere of indigenous Gothic sanctity. These marbles are for the most part funerary monuments, commemorating men rather than God, and often the iconography is only loosely Christian, if at all; the formidable cherubim of the Bible and the Middle

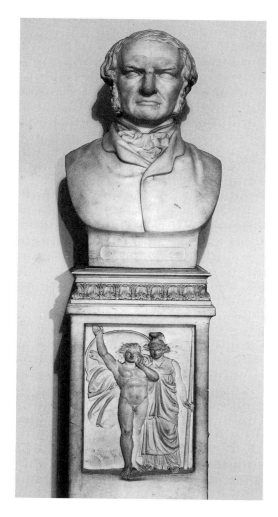

66 Woolner's portrait of Gladstone; the pedestal is decorated with three reliefs of scenes from Homer (seen here, Achilles and Athena).

Ages turn into pretty putti, merely Cupids lightly disguised. But Ruskin suggests no way to a better state of affairs. He too lays stress upon restrictions and limitations: 'The conditions necessary for the production of a perfect school of sculpture have only twice been met in the history of the world, and then for a short time; nor for short time only, but also in narrow districts' – namely in Ionian Greece and in Florence.[25] *Only, short, narrow* – the words all speak of constriction. And he sees the moral demands of sculpture as a further constraint. He had always believed, to be sure, in the connexion between moral goodness and good art, but he held it to be especially close in this case: *'There is no instance of fine sculpture being produced by a nation either torpid, weak, or in decadence.* Their drama may gain in grace and wit; but their sculpture, in days of decline, is *always* base.'[26]

What then should the poor carver do to be saved? According to Ruskin, 'It is the function of the best sculptor – the true Daedalus – to make stillness look like breathing, and marble look like flesh.'[27] This demand for super-realism seems a curiously weak ideal, coming from Ruskin, and revealingly it is one alien to medieval art. On the other hand, some of Canova's work – his portrait of Pauline Borghese on a sofa, for example – would fit the bill quite well. But in any case, not everyone agreed with Ruskin; for to one kind of Victorian taste a distance between statuary and life seemed fitting. Thus in Woolner's poem Clytie looks at Pygmalion's work with unease:

> To her
> The statue seemed more like Ianthe than
> A statue. Is it pardonable fault
> For statue not to look one?

Realism was in fashion for painting, but marble ought to look – well, marmoreal. Mrs Jarley might have agreed.

The decline in the reputation of Graeco-Roman statuary is perhaps the furthest fall from grace in the history of European taste. In the eighteenth century the Apollo Belvedere was probably the most admired statue in the world; in our own time Lord Clark has taken it, at the start of his *Civilization*, as an example of a work which quite fails to move us, comparing it unfavourably with an

African mask. The experience of seeing the Elgin Marbles and other authentic Greek statuary – the Venus de Milo, the Winged Victory of Samothrace, the sculptures of Delphi and Olympia were all nineteenth-century discoveries – gradually taught the world that the antique statues which it had most revered were reproductions, and sometimes not very good reproductions. Moreover, most people's knowledge of art before the nineteenth century had been mostly a knowledge not of originals but of casts, copies and engravings. The camera and the railway train changed all this, taking large numbers of people at speed and modest cost to see the masterpieces of the Continent and bringing more accurate reproductions into their drawing-rooms. Meanwhile, the vast growth of the National Gallery was enabling Englishmen to see the work of most great painters at first hand without crossing the Channel. All this went to create a cult of the original (which has now reached such heights that there may be a difference of millions of pounds between the master's own hand and the finest copy from his workshop). Now it is in the flesh (if the metaphor is not too ironic in this marmoreal context) that the dethroned masterpieces of Graeco-Roman sculpture fail: the Apollo Belvedere is noble in conception, but in execution lifeless. Many such works, too, were further spoiled by Renaissance restoration. With the wisdom of hindsight we should not be surprised that new circumstances should eventually topple the 'stuck-up gods and goddesses' from Olympus. But their glamour lingered a long time. Byron, romantic though he might be, was rapturous in praise of the Belvedere Apollo. As for the Venus de' Medici, there was no need of any pedant critic to establish its virtues: the spectator's pulse and blood did that.[28] As late as the 1850s Ruskin allowed that his contemporaries – ordinary people, not properly educated in Ruskinian principles – genuinely enjoyed the most famous works of Graeco-Roman sculpture:[29]

> The beauty of the Apollo Belvedere, or Venus de' Medici, is perfectly palpable to any shallow fine lady or fine gentleman . . . the shallow spectator, delighted that he can really, and without hypocrisy, admire what required much thought to produce, supposes himself endowed with the highest critical faculties, and easily lets himself be carried into rhapsodies about the 'ideal', which, when all is said . . . will be found

to mean nothing more than that the figure has got handsome calves to its legs, and a straight nose.

Almost twenty years after this Henry James could still celebrate the charm of the Apollo and its companions. In his first novel, *Roderick Hudson*, the cultivated Rowland Mallet enters the Vatican Galleries and feels that 'the comparative chill of the image-bordered vistas was as tonic as the breath of antiquity'.[30] The alien, chilly quality of Graeco-Roman statuary is part of its charm, appealing to the escapist side of the Victorian temper: it is as a cool breath wafted from a distant clime. James was evidently pleased with this idea, for he returned to it in *The Portrait of a Lady*. We are in Rome again, with Isabel Archer 'among the shining antique marbles', but this time in the Capitoline Gallery:[31]

> She sat down in the circle of these presences . . . resting her eyes on their beautiful blank faces; listening, as it were, to their eternal silence. It is impossible, in Rome at least, to look long at a great company of Greek sculptures without feeling the effect of their noble quietude; which, as with a high door closed for the ceremony, slowly drops on the spirit the large white mantle of peace.

The hero of *Roderick Hudson* is a young American sculptor resident in Rome. The book investigates his creative dilemmas, and once more purity, limits, the dominance of the Greek example and the sculptor's difficulty in fitting his art to the circumstances in which he finds himself are the themes which come through most strongly. It is not perhaps a very convincing picture of a sculptor's mind, and maybe James's ideas, for all the sophistication of his manner, are rather commonplace; but this makes the book the more representative of how sculpture worked on the Victorian literary imagination. James had, it seems, studied George Eliot's handling of the theme, for in *Roderick Hudson*, as in *Felix Holt*, the intelligent hero's unsophisticated mother is displayed, with ironic significance, amid alien marble: we see her at the Villa Borghese, 'sitting patiently on a stool, with folded hands, looking shyly here and there at the undraped paganism around her'.[32] Like Mrs Holt too, though in different style, she has trouble in coming to terms with stone

nudity: as Rowland Mallet's cousin puts it, she has a 'holy horror' of the sculptor's profession, 'which consists exclusively, as she supposes, in making figures of people divested of all clothing'.[33]

Hudson's potential patron, the wealthy, stuffy Leavenworth, is meant to be commonplace. 'What do you say,' he asks, hoping to commission the young sculptor, 'to a representation, in pure white marble, of the idea of Intellectual Refinement?' And later: 'Intoxication . . . is not a proper subject for sculpture . . . Spotless marble seems to me false to itself when it represents anything less than Conscious Temperance.'[34] But the truth is (and here James becomes elegantly ironic) that Hudson himself has similar feelings, though in less moralistic style. He does not talk of spotless white marble being false to itself, but he does feel the limits of his art, and in terms of its colourlessness: 'A sculptor's such a confoundedly special genius; there are so few subjects he can treat . . . If I had only been a painter . . .' – and he complains that the light and colour and picturesqueness of Italy cannot be put into sculptural form.[35] His need to get beyond mere whiteness has to come out in another guise: 'His plastic sense took in conversation altogether the tone of colour.'[36] He too feels that there are 'proper subjects' for his art, that his scope, even within the bounds of what can be done in marble, should be self-consciously restricted; and here the ideas of purity and perfectionism interact with the distinction between Hellenism and Hebraism made famous by Matthew Arnold:[37]

> I may make a David [Roderick says], but I shall not try any more of the Old Testament people. I don't like the Jews . . . David . . . is rather an exception; you can . . . treat him as a young Greek . . . he looks like a beautiful runner at the Olympic games.

And he refuses to make a Judas. 'Never! I mean never to make anything ugly. The Greeks never made anything ugly, and I'm a Hellenist; I'm not a Hebraist.' This outburst leads James to another theme, a form of the familiar notion that the sculptor is an alien in the modern world. He seeks to be a Hellene; yet how can he be? As a friend tells him, 'There's no use trying to be a Greek. If Phidias were to come back he would recommend you to give it up.'

Leavenworth's request for a statue of Intellectual Refinement is

merely comic; but Hudson too, in his own way, wants to give bodily form to high abstractions, and though he has not Leavenworth's pietist tone, he too desires to excite a kind of religious impulse. (And this notion, it seems, had some appeal to James himself, for what he says about the effect of a company of sculptures in *The Portrait of a Lady* is lightly touched with the colour of sanctity.) Hudson debates his intentions with another expatriate, Miss Blanchard:[38] 'When Phidias and Praxiteles had their statues of goddesses unveiled . . .' he says, 'don't you suppose there was something more than a cold-blooded, critical flutter? The thing that there was is the thing I want to bring back. I want to thrill you, with my cold marble . . . I want to produce a sacred terror: a Hera that will make you turn blue, an Aphrodite that will make you turn – well, faint.' She replies that religious feeling can only grow out of a real religion, honestly believed: 'Phidias and Praxiteles had the advantage of believing in their goddesses. I insist in believing, for myself, that the pagan mythology isn't to be explained away by ruthless analysis, and that Venus and Juno and Apollo and Mercury used to come down in a cloud into this city of Rome.' Hudson disagrees, thinking that he will be able to make statues that rationalize Greek religion: 'They shall be simply divine forms. They shall be Beauty; they shall be Wisdom; they shall be Power . . . That's all the Greek divinities were.' But to this bloodless notion she has the just and crushing retort, 'That's rather depressingly abstract, you know.' Religion and statuary seem unable to combine: we are back with Ruskin's complaint about the lack of good Christian sculpture. The building of new churches and the restoration of old ones brought a huge demand in the nineteenth century for statuary to fill Gothic niches or adorn Gothic portals: some of it is highly competent, but it never engaged the interest of the very best sculptors of the day and it somehow seemed outside the mainstream. The sculptural tradition and the Christian religion were both embedded in the history of Europe; yet in modern circumstances – or so people felt – the two did not naturally come together.

The failure of sculpture to fit into the modern world comes out again in the controversy over costume: should modern worthies be portrayed in their own dress or in classical garb? It is not a very interesting controversy, since there is little to be said on either side

which is not obvious; it is more illuminating to see how the problem was faced in practice. The feeling that there was something prosaic or inartistic about modern clothes was not restricted to sculpture. 'The costume of the nineteenth century is detestable,' says Lord Henry Wotton in Wilde's *Picture of Dorian Gray*. 'It is so sombre, so depressing.'[39] Nor was it aesthetes alone who felt the severance of frock coats from romance. The enormous changes wrought by the industrial revolution unlocked powerful forces of energy and pride; yet the scale of these changes also created an anxiety which often shaped itself into a distrust of modernity, a feeling that everything new to the nineteenth century was flat, dull and ugly. This should not be regarded as a symptom of a 'decline of the industrial spirit', insurgent during the later part of the century. It is the obverse of industrialism itself, present from the time of Blake's 'dark satanic mills' onwards, one of the inescapable birthpangs of the modern world. The feeling that modern clothes were prosaic was one example of this self-mistrust.

Yet that is not the whole story. A chafing against the unromantic quality of modern life is indeed a distinctively nineteenth-century phenomenon, stimulated not only by the new industrial order but by Romanticism itself, which encouraged a scorn for the civilities of the drawing-room that would have puzzled an earlier age. 'Dressing up', as we shall see later, is markedly a feature of some Victorian art, another expression of the escapist urge.[40] But the loading of portraits with heroic accoutrements was a tradition descending from the eighteenth century, part of the apparatus of baroque convention. On the whole the Victorians thought it ridiculous; Dickens is typical in laughing at the 'full-length engraving of the sublime Snigsworth . . . snorting at a Corinthian column, with an enormous roll of paper at his feet, and a heavy curtain going to tumble down on his head . . .'.[41] No one was still painting like that in the mid nineteenth century. Once again, there is something especially awkward about sculpture: modern dress was fine on canvas, but marble trousers were embarrassing.

William Huskisson might be said to have died the first modern death, knocked down by a locomotive in 1830; so it is something of an irony that John Gibson should display him in Pimlico wrapped in a toga. More remarkably he gave Sir Robert Peel the same treatment, even among the Gothic arches of Westminster Abbey

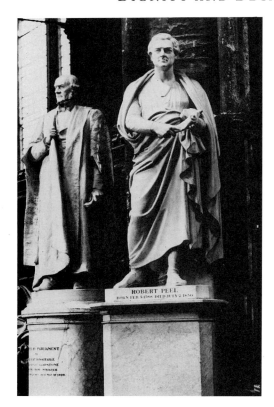

67 Prime Minister as Roman statesman: Gibson's monument to Peel, Westminster Abbey.

ROBERT PEEL.
BORN FEB 5 1788 DIED JULY 2 1850

and as late as 1852 (Plate 67). By this time debagging statesmen was rather an old-fashioned sport, but an unease about modern dress lingered on, and efforts were made to modify or disguise it. Long cloaks or academic dress were used to conceal the lower limbs, while in Matthew Noble's statue of Prince Albert at Salford (1864) we meet an embarrassed compromise: one leg is revealed in breeches, the other hidden in a gown (Plate 68).

In the last third of the century the movement sometimes called the New Sculpture finally broke free from vassalage to Graeco-Roman example. Sir Alfred Gilbert's *Icarus* (1884) takes its subject from Greek mythology, but its inspiration from the quattrocento: Donatello's *David* provides the model (Plate 69). The blend of classical theme with unclassical treatment is one example of a self-conscious eclecticism which we shall find taking many forms in

later Victorian art, Gilbert's most famous work, the statue of Eros in Piccadilly Circus (1886–93), illustrates the aesthetic movement's fondness for toying with a vague Hellenism (for what, after all, could be more unsuitable as a monument to the evangelical Lord Shaftesbury than a pagan god of sexual desire?), but the style owed nothing to Greece. Harry Bates's *Pandora* (1891) seems to symbolize the moment at which the neo-classical tradition meets the *fin de*

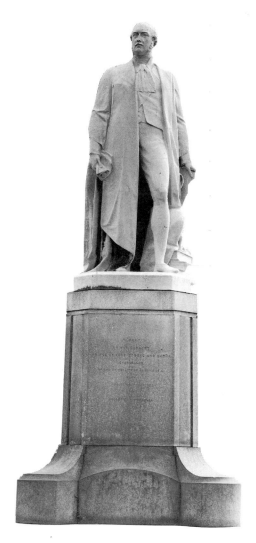

68 The problem of costume: Noble compromises (*Prince Albert*, Salford).

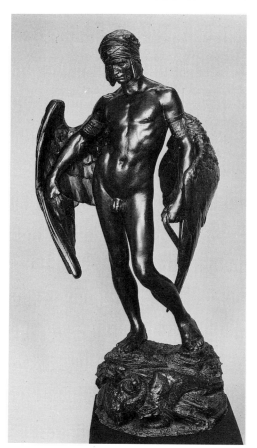

69 Gilbert, *Icarus*: title from Greece, inspiration from Donatello.

70 Neo-classicism contemplates aestheticism: Bates, *Pandora*.

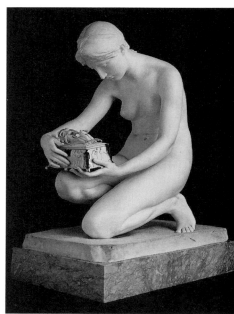

siècle (Plate 70). Pandora is the Eve of Greek mythology, the woman whose curiosity led her to open the chest or jar in which all evils were contained, thus letting sorrow and misfortune into the world. In Bates's piece a bland nude descended from neo-classicism contemplates a writhingly 'aesthetic' casket; the woman is made of marble, the box of bronze and ivory. Shall she open it and release the slithery complexities of the decadence? Shall the soul with all its maladies pass into her pale chalky body and tinge its vacancy with the colour of the modern world?

THE IDEA OF SCULPTURE

PYGMALION

The story of Pygmalion haunted the nineteenth-century imagination: a man once made a statue so beautiful that he fell in love with his own creation; he besought Venus for his desire to be fulfilled, his prayers were answered and the statue came to life. So familiar was this myth to the Victorians that Ernest Dowson could turn it upside down, confident that his readers would catch the allusion:[42]

> Because I am idolatrous and have besought,
> With grievous supplication and consuming prayer,
> The admirable image that my dreams have wrought
> Out of her swan's neck and her dark, abundant hair:
> The jealous gods, who brook no worship save their own,
> Turned my live idol marble and her heart to stone.

The myth's popularity was no doubt one more instance of the Victorians' mesmerized adoration of Greece. Yet the curious fact is that in its familiar form it is probably not a Greek myth at all. The original story is one of grotesque perversion: Pygmalion is a king who gratifies himself by lying with a statue. The present version of the tale cannot be traced earlier than the *Metamorphoses* of the Latin poet Ovid, and it was probably he himself who invented the story as we know it, a delicate parable of the nature of creativity.

It is intriguing, also, to observe that the myth has been further developed since antiquity. The nineteenth-century writers and artists who drew upon it knew that the statue's name was Galatea; what perhaps none of them knew is that this detail had been added by Rousseau only a century before.[43] They believed themselves to be drawing on a primitive myth, while in reality the story originated in one sophisticated society and was elaborated in another; it was, in fact, tailor-made for a self-conscious culture. But wherein did its peculiar charm lie? I shall approach the question obliquely, beginning with some cruder exploitations of Greek mythology.

It may be that some men at all times enjoy the thought of binding or chaining women (Tiepolo harps on it in his exquisite frescoes at the Villa Valmarana ai Nani), but the hard fact remains

that the theme becomes more common in nineteenth-century art. It is no surprise to find it first in statuary. Sculptors could venture where painters might at first fear to tread: once again, 'purity' was their licence. We have already seen that Powers's *Greek Slave* tactfully blended ancient and modern (Plate 22): the word 'Greek' evokes the nobility of classical Hellenism, while details reveal that she is a Christian victim of the Turk.[44] One distinguished lady, at least, was delighted: Mrs Browning penned an enthusiastic sonnet praising its 'passionless perfection'.[45] Explaining that the artist's purpose was to 'confront man's crimes . . . with man's ideal sense', she hoped that it would strike and shame the strong with 'thunders of white silence'. Whiteness and moral protest are the work's virtues; in this judgement aesthetic and ethical values almost merge into one. It is curious that, though admiring the *Greek Slave*, Mrs Browning could not accept Gibson's *Tinted Venus*, which she thought 'rather a grisette than a goddess'; indeed thanks to the flesh-like colouring she had 'seldom . . . seen so indecent a statue'.[46] The *Greek Slave*'s pallor protected it.

Powers's theme was too good to be left to America; in 1868 John Bell produced a variant in *The Octoroon* (Plate 71). The style represents the fag-end of neo-classicism, but again the title showed that the subject was more or less modern: the slave trade, indeed the almost-white slave trade. By the same token, the title advertises high moral purpose, and the work found its way into a Lancashire town hall. Earlier Bell had found a more Hellenic excuse for tying a woman up in the myth of Perseus and Andromeda. His *Andromeda* (c. 1851) could not lay claim to moral earnestness, but it too earned female approval, and from the most exalted source: it was bought by the Queen. The painters were in due course to pick up the myth, and Andromeda on her rock was depicted by Leighton, by Poynter twice, and in two forms by Burne-Jones as part of a cycle representing the whole Perseus story (Plates 72, 73, 178 and 179). Words like 'passionless', 'ideal' and 'moral' seem a world away from these sinuous or writhing figures; the traditions of painting differed from those of sculpture, and in any case public taste was growing more permissive as the century wore on.

How little these paintings have to do with antiquity; the myth is a convenient peg on which to hang a modern preoccupation. By chance, there survives a wall-painting of Perseus and Andromeda

capacious spirits, and Millais could not sell the work. In the words of his son,[47] he decided that 'the beautiful creature would look more modest if her head were turned away' – a remark which retains the painting's salaciousness. What is remarkable is not that the work should have aroused protest, but that Millais made it in the first place and that the revised version found a buyer.

The rescuers are clad from head to foot in armour; the women are in a state of undress, partial or complete. They seem victims; but the titles of these two pictures allude to a tradition of medieval romance in which the man is his lady's servant. That is a paradox which may have a connexion with the charms of the Pygmalion myth. But let us now put Andromeda and her medieval cousins on one side and approach Pygmalion from another angle. The subject of Edwin Long's *The Babylonian Marriage-Market* (1875), one of the most popular pictures of its day, is taken from the historian

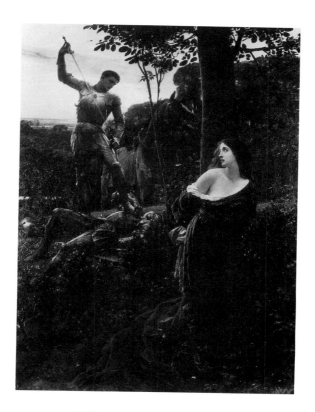

74 The Andromeda theme in medieval costume: Dicksee, *Chivalry* (*c*.1885).

Herodotus (Plate 76).[48] Every year in each village, he says, the Babylonians took the girls of marriageable age and sold the pretty ones off as wives to the highest bidder, starting with the fairest of all and working downwards. The money raised was then used to get husbands for the rest. This time they would start with the ugliest girl and work back upwards again, giving each one to the man who would take her with the smallest dowry, until all had found a mate.

Herodotus praises the custom for its humanity: the rich men buy beauty, the poor get cash; the plain women get husbands and the fair ones marry money. Long's treatment is less amiable. He extracts comedy from the row of maidens in the foreground: the gradual decline in beauty as we move from left to right – the cast in order of appearance – is amusingly managed, and the varieties of mood and character shown in their faces provide the kind of anecdotal interest that art-lovers enjoyed. The picture is undeniably entertaining, even if some of the fun is unkind, especially if we look at the

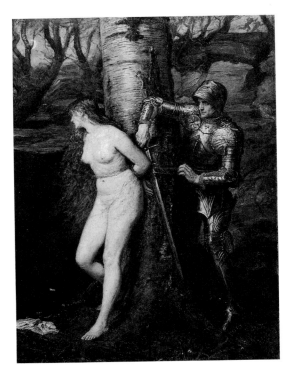

75 Another of Andromeda's sisters: Millais, *The Knight-Errant*.

120

two girls furthest to the right and the humorous amazement of the men above them. Other features are more unpleasing. For this is another picture of woman as victim. The maidens are exhibited half-naked; the men examine the girl with a rapt attention, their eyes fixed, it appears, not on her face but on the breasts that the artist teasingly conceals from us. None of this is in Herodotus, nor is the elaborate apparatus of the auction-room, replacing the village setting of his account. We are not far from those paintings of harems and slave markets which proliferated towards the end of the century; it is interesting that the Babylonian slave-market in D.W. Griffith's epic film, *Intolerance*, should pay Long homage (Plate 77).

'We are sold,' Ethel protests in Thackeray's *The Newcomes* (1853–5), '. . . we are as much sold as Turkish women; the only difference being that our masters may have but one Circassian at a time.' Later in the book Pendennis says much the same about the 'Turkish system' in modern England.[49] Thackeray strikes the pose of social protest, though one may suspect that he enjoys mixing prurience with moral indignation, a phenomenon not unknown in our own time. In W.H. Mallock's satire, *The New Republic* (1877), one of the characters says of young women, 'Men can't see through you at a glance as they did; and that alone . . . will have increased your value tenfold in our Babylonian marriage-market.'[50]

Henry James has Rowland Mallet come to watch Roderick Hudson working on a bust of the beautiful Christina Light.[51] He finds her in a white dress, adjusting her hair before a mirror under the sculptor's direction. Suddenly she looses her tresses and lets them fall over her bare shoulders: an act of coquetry, Mallet suspects, but coquetry of the highest finish.

> 'Hudson has the luck to be a sculptor, in his way,' Rowland remarked with gaiety; 'but it comes over me that if I were only a painter –!'
> 'Thank goodness you're not!' said Christina. 'I'm having quite enough of this minute inspection of my charms.'
> 'My dear young man, hands off!' cried Mrs Light as she came forward and seized her daughter's hair. 'Christina love, I'm more surprised than I can say.'
> 'Is it indelicate?' Christina asked. 'I beg Mr Mallet's pardon.' Mrs Light gathered up the dusky locks and let them fall

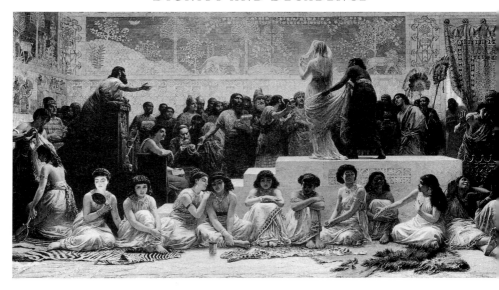

76 Herodotus, the Orient and the modern auction room: Long, *The Babylonian Marriage-Market*.

through her fingers, glancing at her visitor with a significant smile. Rowland had never been in the East, but if he had attempted to make a sketch of an old slave-merchant calling attention to the 'points' of a Circassian beauty he would have depicted such a smile as Mrs Light's. 'Mamma's not really shocked,' added Christina in a moment, as if she had guessed her mother's by-play. 'She's only afraid that Mr Hudson may have injured my hair and that, *per conseguenza*, I shall fetch a lower price.'

Rowland's reflections, Mrs Light's 'significant smile' and her daughter's expressions – 'this minute inspection of my charms', 'I shall fetch a lower price' – are all means by which James represents the three of them as tacitly conspiring to act out a fantasy of the oriental slave-market. And Rowland recognizes that a painter has an advantage in playing this game. Talk about the Turkish system or the Babylonian marriage-market suggests an ancient or Eastern analogy to a modern institution; Long's painting goes through the converse process, outwardly representing the ancient world, but with modern thoughts and desires concealed within. W.M. Rossetti

combination of charm before which every note save undivided admiration was silent.'[55] That was not exactly true, but it cannot be very far from the truth. Contrast the fury excited by Manet's *Déjeuner sur l'herbe* some fifteen years earlier in France, a country popularly believed to be more liberal in these matters. Manet shows two painters picnicking in the countryside with their naked model; unlike Alma-Tadema's sculptor, they are not ogling her, but the combination of their modern dress and her nudity was deeply shocking, presumably because it suggested the licence of the contemporary *vie de Bohème*. Manet's inspiration was the *Concert Champêtre* in the Louvre, probably by Titian, which depicts two richly dressed men in a landscape with two nude women of mysterious import. His work is the obverse of Alma-Tadema's: he takes what might loosely be called a 'classical' theme, drawing on the central tradition of European art, and transfers it to a modern setting; Alma-Tadema's setting is classical, but take away the sculptor's costume and the picture is revealed as a modern *pose plastique*. With Manet the externals are modern, the inspiration classic, with the Dutchman the reverse. It was Manet who could justly have claimed, in Standing's phrase, a 'purity of conception'; it was Alma-Tadema who got away with it. So much difference did the costume make.

Alma-Tadema's model is based on the Esquiline Venus, probably a copy of a lost fifth-century statue; he imagines a Greek sculptor at work on the 'original' piece. This Venus is an interesting choice on his part, as she differs from most of the nudes of antiquity (Plate 80). Here, for once, is no perfect beauty: the breasts are small, high and wide apart, the pelvis too elevated, the legs too short, waist and ankles too thick; Maillol said that he could find 300 such girls in a single French town.[56] But how well is she therefore suited to Alma-Tadema's purpose. His girl is a model for the goddess; she is thus both a Venus and not a Venus. As Venus she carries with her all the so respectable associations of high art; as an ordinary girl, photographically painted, she becomes an object of desire. Helen Zimmern was only half right in calling the nudity 'rather unpleasant, because a little lacking in ideality'. In truth the lack of ideality is all too pleasant, rendering the girl the more appealingly real. While keeping the proportions of the Esquiline Venus, Alma-Tadema turns the minor awkwardness of the original into an

alluring immaturity; 'the slender girlishness of the figure', as Standing put it, helps draw the ogling male.

A cunning piece of work, therefore; but is it really? How far did the artist know what he was doing? It is a question that arises often in the Victorians' art, and it is seldom precisely answerable. They seem to have achieved just that balance of knowledge and ignorance which would give them freedom to indulge their fantasies and yet stay respectable. The picture would fail of its effect were there not enough in it to disquiet Helen Zimmern and upset the bishop, but it would fail equally if the sources of the effect were too crudely obvious. Small wonder that collectors in our own day should pay so handsomely to recover the joys of repression.

Watts's *The Wife of Pygmalion* (1868) was another painting inspired by antique sculpture, in this case a bust known as the Oxford Sappho. Swinburne waxed lyrical in its praise (nothing remarkable, it must be admitted, in one for whom rage and rhapsody were the most commonplace emotions):[57]

> The soft severity of perfect beauty might serve alike for woman or statue, flesh or marble, but the eyes have opened already upon love . . . ; her curving ripples of hair seem just warm from the touch and the breath of the goddess . . . So it seems a Greek painter must have painted women . . . Her shapeliness and state, her sweet majesty and amorous chastity, recall the supreme Venus of Melos. In this 'translation' of a Greek statue into an English picture, we see how in the hands of a great artist painting and sculpture may become as sister arts indeed . . . ; how, without any forced alliance of form and colour, a picture may share the gracious grandeur of a statue, a statue may catch something of the subtle bloom of beauty proper to a picture.

It seems to be the blend of apparent opposites, or the transition from one state to another, that fascinates Swinburne: softness and severity, flesh and marble, sweetness and majesty, amorousness and chastity, painting and sculpture, Greece and England. The enticement of the Pygmalion myth was the box of paradoxes that it opened. Byron had fastened upon the moment of transformation from stone to flesh:[58]

The mortal and the marble still at strife,
And timidly expanding into life.

The 'mortal and marble' theme returns again and again in Victorian books; even where there is no direct allusion to Pygmalion, one may suspect that he hovers in the author's mind. When Alton Locke, hero of Charles Kingsley's novel of that name (1850), first catches sight of the fair Lillian, he observes her 'masque and features delicate and regular, as if fresh from the chisel of Praxiteles' and her 'skin of alabaster . . . stained with the faintest flush'.[59] In part Kingsley is here using the social connotations of sculpture, as we have seen Dickens and George Eliot do: the humble Locke has fallen for a woman of higher class than his own, and his likening her to a statue brings out that fact. But the 'faintest flush' upon her skin introduces another idea, that of the woman who is almost a statue,

80 Model for the *Model*; the Esquiline Venus.

the statue which is almost a woman – almost but not quite. She is like Pygmalion's creation at the miraculous moment, as colour begins to infuse the stony surface.

In Pater's *Marius the Epicurean* we again find a young man in admiring contemplation of a woman; and once more the theme of sculpture steals into the text. Marius, the sympathetic pagan, has come to know the Christian Cecilia: 'Her temperate beauty brought reminiscences of the serious and virile character of the best female statuary of Greece. Quite foreign however to any Greek statuary was the expression of pathetic care, with which she carried a little child, at rest in her arms.'[60] Cecilia is both statuesque and emotional, stone and love; and Pater has added to this another idea: the contrast between Greek and Christian, ancient and modern, or a paradoxical fusion of these opposites.

George Eliot had played a similar game in *Middlemarch*.[61] Dorothea is visiting the Vatican Galleries, and has been spotted by Ladislaw, who will eventually marry her, and his friend Naumann, beside a sleeping Ariadne. 'There lies antique beauty,' Naumann says, 'not corpse-like even in death, but arrested in the complete contentment of its sensuous perfection; and here stands beauty in its breathing life, with the consciousness of the Christian centuries in its bosom.' And he goes on to describe Dorothea as 'antique form animated by Christian sentiment – a sort of Christian Antigone – sensuous force controlled by spiritual passion'. Naumann begins with a simple polarity; indeed the fact that the statue is of a woman asleep heightens the contrast, made in the manner of Schlegel and Winckelmann, between the calm repose of pagan antiquity, exemplified in its sculpture, and the breath, force and passion of the modern, Christian world. Yet this Ariadne's slumber carries a rather different message too; for if a woman is asleep, she will in time waken, as Ariadne awoke to ecstatic union with the god Dionysus, as Dorothea will in the end awaken to Ladislaw's love. Indeed, Naumann makes his contrast only to override it, for his second thoughts present her as both Greek and Christian, with the emotions of a modern woman enclosed within the shape of a classical marble. She is, in short, like Pygmalion's image, 'antique form' into which spirit is infused. As yet she is not fully alive to the love that will eventually be hers; as with Pygmalion's story, it is the process of transition that draws the artist's eye.

And James, too, can be caught playing this game in *Roderick Hudson*. Christina Light's very name implies her double character, for 'Christina' is a simple anagram of 'Christian', while light was especially associated with Greece: Matthew Arnold had summed up Hellenism as 'sweetness and light', while in Pater's more laborious language, 'Hellenism . . . is the principle pre-eminently of intellectual light (our modern culture may have more colour, the medieval spirit greater heat and profundity, but Hellenism is pre-eminent for light).'[62] What is more, Christina's adorer, Hudson himself, is a sculptor, though unlike Pygmalion he will never possess the woman whose image he has made. Nor is it pure chance that Pater, James and George Eliot are all led to their theme by Rome, in the Victorian imagination at once the most monumental of cities and the most animated, the omphalos of Christendom, yet a shrine of the classical idea.

In passages such as these Eros is usually hovering somewhere in the background; the sexual theme is further to the fore in Woolner's poem *Pygmalion* (1881). Himself a sculptor, he treats the old story as a metaphor for the artist's creative struggle: Pygmalion's technique is superb, but his works do not 'come to life' (in the common metaphorical sense) until he has sculpted Ianthe, a girl with whom he is unconsciously in love. At first the statue is marvellous but lifeless, and Pygmalion prays to Aphrodite, asking her to breathe life into it; he recognizes his love for Ianthe, and now he can make a 'living' sculpture. All this is high-minded parable; but Woolner has linked it to a more delicate topic. The magic between Pygmalion and Ianthe begins when a gust of wind blows her robes up and he catches sight of the nakedness beneath.

The artist and his naked model – Alma-Tadema's picture raises the issue in a crude form; Burne-Jones handles it more elusively (or should one say evasively?) in his series of four Pygmalion paintings: *The Heart Desires*, *The Hand Refrains*, *The Godhead Fires*, *The Soul Attains* (Plates 81 and 82). Burne-Jones painted this cycle twice, first in 1868–70, at a time when he was passionately involved with his model, Mary Zambaco. That must surely be significant; yet at first blush the pictures seem to offer more allegory or symbolism, with vaguely religious overtones. It is the soul that attains in the last painting, not the body, and indeed the consummation of Pygmalion's desires is not sexual, or at least not conventionally so: he

81 and 82 Reverence and desire: Burne-Jones, *The Hand Refrains* and *The Soul Attains*, from his second Pygmalion series.

is on his knees before the woman in a posture of adoration, recognizing (we infer) the godhead that has kindled her.

Pygmalion has made the statue himself, and he owns the thing that he has made; yet he kneels before her. The idea of the creator or possessor as worshipper is one that we shall find in Victorian literature, often in connexion with the Pygmalion myth, but there is an analogy of another kind within Burne-Jones's own work. *King Cophetua and the Beggar-Maid* (1884) illustrates the story, made famous by Tennyson, of the king who fell in love with a waif and married her (Plate 83).[63]

> So sweet a face, such angel grace,
> In all that land had never been:
> Cophetua sware a royal oath:
> 'This beggar maid shall be my queen!'

The girl is as humble as could be, and in making her his queen Cophetua is in a sense creating or inventing her (Tennyson does not suggest that she had any say in the matter), but in Burne-Jones's treatment the king is below the beggar maid, in a pose half way to genuflection. She is as still and blank as a statue, while he gazes up at her from an angle similar to that of Burne-Jones's Pygmalion, contemplating her with an expression which suggests not so much lust as adoration. 'Adoration' is not too strong a word, for the composition derives from a Madonna by Mantegna in which the donor, clad in armour like Cophetua, kneels before the Virgin and Child enthroned.[64] Burne-Jones displays a man who is both lord and suppliant, a woman who is beggar and queen; and again there are overtones of a dim, impalpable religiosity.

Burne-Jones was an artist of some subtlety; not so John Collier, whose *In the Venusberg* plunges the worship of female beauty into deepest absurdity (Plate 84). Here the alcove behind Venus as well as the kneeling knight are borrowed from Italian paintings of the Madonna, and the borrowing is richly vulgar. In this case, since Venus is straightforwardly a goddess and in no way the knight's creation, there should be no ambiguity, we might suppose, between worship and dominance; yet this is not exactly so. For here is an armoured man engaged with a naked woman, as in Millais's *Knight-Errant* or Burne-Jones's Perseus paintings. In a sense the

woman is still at a disadvantage: like Alma-Tadema's *Sculptor's Model* she is open to the man's inspection. As it happens, Alma-Tadema was Collier's teacher, and painted the picture as a gift to his pupil.

Despite its air of quiet mystery, almost spirituality, Burne-Jones's *Cophetua* points also to a more down-to-earth matter: the gentleman who marries a servant-girl. The theme crops up in nineteenth-century literature, and the thing happened from time to time in nineteenth-century life. And here we come back to Pygmalion. In 1823 Hazlitt published the story of his desperate infatuation with a girl of humble station, and called it *Liber Amoris, or The New Pygmalion*. The immobile perfection of sculpture is one of her charms: 'I have had her face constantly before me, looking so like some faultless marble statue, as cold, as fixed and graceful as ever statue did . . .' Her very lack of wit and education helps to make her statue-like: 'Her words are few and simple; but you can have no idea of the . . . graces with which she accompanies them, unless you can suppose a Greek statue to smile, move and speak.' She sounds becomingly deferential, an object who can be shaped by her Pygmalion according to his pleasure, and yet Hazlitt wants to worship her as well: 'I will make a Goddess of her, . . . and worship her on indestructible altars, and raise statues to her.' The new Pygmalion, like the old, adores his own creation.

Hazlitt's theme was to be most elaborately developed in Vernon Lee's novel *Miss Brown* (1884), the story of Walter Hamlin, a selfish artist who educates a beautiful servant-girl with the aim of marrying her and thus nourishing his vanity by possessing a wife whose beauty he can show off to others and whose grateful adoration will feed his self-satisfaction. The girl herself is repeatedly likened to a statue, while Hamlin's plan is that his 'life should be crowned by gradually endowing with vitality, and then wooing, awakening the love of this beautiful Galatea whose soul he had moulded, even as Pygmalion had moulded the limbs of the image which he had made to live and love'.[65] He may be based in part on Burne-Jones; not only is he an artist, but his affair with the fiery Russian Madame Elaguine recalls Burne-Jones's entanglement with the fiery Greek Mary Zambaco. Hamlin's purpose in taking up a servant is plainly to dominate her, to shape her to a pattern of his suiting, but he too enjoys the pretence of worship: he is happy to 'play that comedy

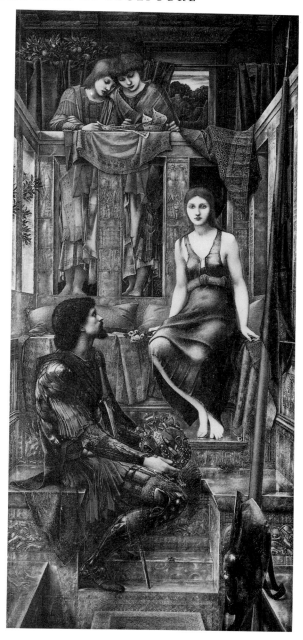

83 The master as worshipper: Burne-Jones, *King Cophetua and the Beggar Maid*.

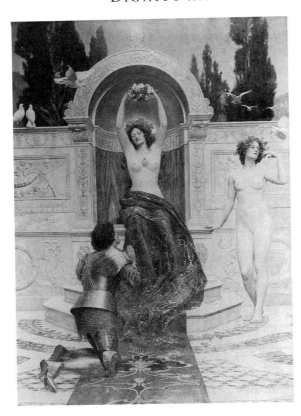

84 Medieval
chivalry and
classical goddess:
Collier, *In the Venusberg*
(1901).

of respectful distant adoration, of freedom of choice in her, of
absence of all rights in himself'.[66]

The Pygmalion theme is given a harsher edge in John Davidson's
Earl Lavender (1895). The hero of this strange parody-fantasy
encounters a mysterious Veiled Lady; he whips her and she whips
him in turn (the latter scene was illustrated by Beardsley in a
frontispiece [Plate 85], sinister in its extreme delicacy and
elegance). She is both active and passive, mistress and victim;
and sure enough, Pygmalion's story slips into the narrative once
again: 'Her stillness was like that of a statue – of Galatea
wakening into life.'[67]

Pygmalion lived on into the early twentieth century. In Comp-
ton Mackenzie's melodramatic novel *Carnival* (1912) Maurice
Avery, a young man of good education and callow aesthetic

ambitions, falls in love with a chorus-girl, and promptly turns from writing poetry to making sculpture:[68]

'Now I must mould you, Jenny . . . By gad! I'm thrilled by the thought of it. To possess you in virgin wax, to mould your delicious shape with my own hands, to see you taking form at my compelling touch. By gad! I'm thrilled by it. What's a lyric after that? . . . if I make a glorious statue of you, I give you – you for ever and ever for men to gaze at and love and desire. By gad! I'm thrilled by the thought of it. There's objective art . . . By Jove, the Nereids in the British Museum. You remember those Nereids, darling?'

Jenny looked blank.

85 Davidson's curious variant on the Pygmalion story illustrated by Aubrey Beardsley: frontispiece to *Earl Lavender*.

And by gad, one can see why Avery will never make the grade as a writer.

Jenny's blankness is a witty touch. It makes her the more like a statue, but it stems from her lack of education: she knows nothing of museums and Nereids, and Avery is too self-absorbed to notice that he is not communicating with her. What he supposes to be an outpouring of love is really an outpouring of egoism, a masculine fantasy of enforcing submission: words like 'virgin', 'possess' and 'compelling' bring that out. And once more, too, there is something not far from voyeurism in the lover's ambition: Jenny is to become a work of art which men — a significant plural — shall gaze at and desire. Avery calls sculpture an objective art; that is true in a sense which he does not consciously intend, for an object is what he is trying to make of her.

Shaw's *Pygmalion* (1913) tells of a professor who teaches a Cockney flower-girl to talk so well that she can pass for a duchess. The gentleman and the maiden of low degree — we can see by now that Shaw's title alludes less to a classical myth than to a Victorian one. Professor Higgins, however, will not succeed in keeping the fine lady whom he has 'made', for as Shaw concludes, 'Galatea never does quite like Pygmalion: his relation to her is too godlike to be altogether agreeable.'[69]

We have seen how common is the Pygmalion theme in Victorian art and literature; we have seen that it appears sometimes spiritual and refined, sometimes with a twist of perversion; we have seen its links with other themes: the toff and the servant-girl, the artist and his model, the man in armour and the naked woman, woman as idol, woman in chains. What hopes or desires lie behind all this? Let us go back for a moment to Burne-Jones. This was a cautious handling of the theme — just how cautious can be seen from comparison with a French treatment of about the same date: Gérôme's *Pygmalion and Galatea* (Plate 86). This is crude, indeed comic, in a way that Burne-Jones could never be; but it is not inhibited.

Burne-Jones's cycle is related, it seems, to a crisis in his own emotional life; but ambiguously. In one way comparison with Gérôme brings out something that is half hidden in the Englishman's paintings: that they are an erotic daydream, a fantasy of possession. But in another way the difference between the two artists is as important as what they have in common: Burne-Jones's

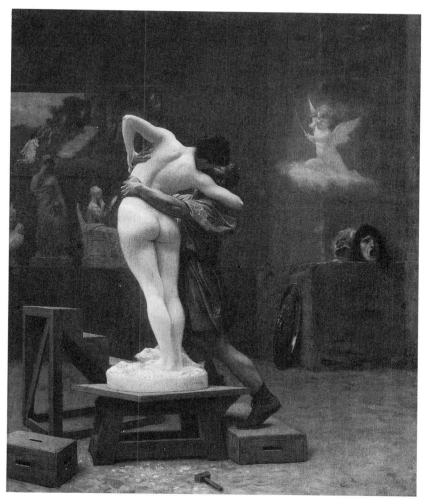

86 Excited marble: Gérôme, *Pygmalion and Galatea* (1890).

timidity in handling his theme seems to be not wholly due to
reticence or decorum or fear of giving offence; in part it is a vehicle
for expressing sexual emotion but in part it is also, one suspects, a
means of damping it down. In real life it appears that Mary Zam-
baco's passionate temperament was rather too much for her admirer,
and in the end he may have been glad enough to sink back into
married respectability. On canvas, though, and through the myth of

Pygmalion, he could make a Mary whom he could both worship and control; and at the same time he could paint over indiscretion with the gloss of high culture and soulful aspiration. Is he giving rein to his desires in these pictures or is he taming them? Is this an indulgence in sexual fantasy or a flight from sexuality? It is hard to tell; but indeed the charm of the Pygmalion myth was that it enabled one to dodge the choice, and to do both things at once.

Let us think back to Powers and *The Greek Slave*. Mrs Browning called it passionless; in a way that seems naive, but in a way was she not right? Considered as an exercise in immorality this is a dim performance, and surely not simply because of timidity or poor technique on the sculptor's part. This cold, correct and characterless nude is perhaps a visual equivalent to those impossibly pure heroines of the Victorian novel, such as Dickens's Agnes Wickfield or Thackeray's Laura Bell, whose perfect virtue and compliance drain them of personality, so that they seem to suppress the sexual instinct even as they satisfy it. Such creatures seem not far from Galatea, at once objects of adoration and yet malleable to their masters' will.

There are two widespread beliefs about the Victorian male's attitude to woman: first, that he idolized her, put her on a pedestal, looked up to her as far above himself in moral qualities and protected her from anything that might bring a blush to her cheek; second, that he kept her in subjection. These beliefs may give an incomplete or inaccurate account of a complex reality; but let them stand as a hypothesis. What was new about the subjection of women? it might be asked: had this not been their lot from time immemorial? Yes, indeed; the new factor was that the rights of women were gradually becoming an issue. Slowly the nineteenth century shakes up the social order, and such a shaking could not for ever leave unmoved the relation between men and women. Once more, we should think of the Victorian age as a time of liberation. Women were beginning to act: Florence Nightingale and Josephine Butler, earlier Elizabeth Fry, represent a type of female achievement scarcely imaginable before their century. The Victorian age sees the start of suffragism; and though John Stuart Mill's tract of 1869, *The Subjection of Women*, seemed at the time eccentric in demanding equality between the sexes, it was a straw in the wind. Trollope's *The Way We Live Now* (1875) indicts the age for the corruption of its manners and morals;

among the symptoms of decline, recurrent in the book, is the increasing freedom enjoyed by the female sex.

From our perspective the liberation of women looks, in the language of cliché, like one of the great slow tides of history; a tide that is still on the flood. Few Victorians, if any, were conscious of this, but conscious motives are not the only motives. One can imagine that a growing desire for independence among women, even in a small degree, might make the male sex feel insecure. Against this threat there were two natural defences: what might be called the sentimental defence and the repressive defence. The second of these is obvious enough: to hold women down, to restrict their chances, to bind them with metaphorical chains. The sentimental defence is more subtle: it is to put woman on a pedestal, to idolize her purity. This is a fantasy of consolation; for if woman is truly the 'angel in the house', in Coventry Patmore's notorious though perhaps misunderstood phrase, there can be no danger, unless she be false to the nature of her sex, that she will desire anything other than a virtuous compliance with her husband's will. At the same time it is practically effective. The repressive and sentimental defences may seem opposite strategies, but they can come together: for the determination to keep women safe from the contaminations of the world, to preserve the young person from anything that might bring a blush to her cheek was both a form of reverence, sincerely felt no doubt, and a means of domination.

Dominance and veneration; we seem to be back once more with Pygmalion and Galatea. And perhaps it is reasonable to think that this myth had an especial appeal to the Victorian situation. The worship of woman represents the ideality and extravagance of the romantic age gone bourgeois: Goethe's Eternal Feminine has taken up household management. Men wanted their wives to be angels, but angels are pure spirit, and men wanted the solid pleasures of the flesh as well. Angel and mistress, passionate and passionless, a personality wholly conformable to another's will — what woman could incarnate all these things? In reality, none; but in the imagination, a woman who was also a statue. Thackeray makes one of his young heroes, Clive Newcome, declare,[70]

Give me a calm woman, a slow woman — a lazy, majestic woman . . . About great beauty there should always reign a

silence . . . When I saw the great Venus of the Louvre, I thought, Wert thou alive, O goddess, thou shouldst never open those lovely lips but to speak lowly, slowly; thou shouldst never descend from that pedestal but to walk stately to some near couch, and assume another attitude of beautiful calm.

It is a depressing attitude to both art and love (for though the portrait of Clive is in part humorous, it seems not to be wholly so). The Pygmalion theme could even be given a homoerotic twist. Oscar Wilde has Lord Henry Wotton reflect upon Dorian Gray, who has already been repeatedly compared to a classical statue:[71]

> There was something terribly enthralling in the *exercise of influence . . . To project one's soul into some gracious form . . .* ; to hear *one's own intellectual views* echoed back to one with all the added music of *passion* and youth; to *convey one's temperament into another* as though it were a subtle fluid . . . ; there was real joy in that . . . He was a marvellous type, too, this lad, whom by so curious a chance he had met in Basil's *studio*; or *could be fashioned* into a marvellous type, at any rate. Grace was his, and the *white purity* of boyhood, and *beauty such as old Greek marbles kept for us.* There was nothing that one could not do with him. *He could be made a Titan or a toy.*

There is no explicit mention of Pygmalion, but indeed there is no need. Nor is it any great surprise that Wilde should produce his own version of the theme: there is a slithery side to Ovid's imagination, naturally attractive to the decadent sensibility. As for the decadent sensibility – but that must await a later chapter.

CHAPTER FOUR

Ruskin's Dilemma

Ruskin, to be sure, went mad. For the last ten years of his long life he spoke barely a word, but dwelt in silence beside Coniston Water, glooming into his long white beard, guarded and tended by the devoted Joan Severn. Years earlier his mind had already shown evidences of disorder; the lectures he gave as Slade Professor at Oxford grew ever more eccentric, and on one occasion he showed his audience a picture of a pig, explaining it as the type of the Protestant Church.[1] After that, his friends persuaded him to retire.

The causes of his brain fever are unknown, its nature obscure, but its origins seem to lie a long way back in his life: when he was no more than forty, signs of an unbalanced mind were already appearing in his writings, and it is tempting, rightly or wrongly, to see his later craziness as the natural outcome of a temperament that always tended to excess, violent in its hatreds, passionate in its loves. His was a spirit in conflict: his religious opinions went through various mutations, and his political views were Socialist, near Fascist and Tory at different times, or all at once. Yet for all his faults and follies he remains a man of genius, and his exaggerations and blindnesses were the defects of a vision that saw some things with a rare blend of accuracy and imagination. He looked at flowers and trees and mountains, at landscapes, pictures and buildings, with an intensity and purity few have matched; what is more, he had the gift of describing what he saw — the curve of a leaf growing on a tree or carved in a spandrel, the shape of an Alpine peak, the twist and texture of water flowing from the edge of a lake — with a combination of clarity and poetic insight which puts him, at his best, among the masters of English prose.

I have stressed his oddity, perhaps too much, because I do not want it to be thought that he was typical of his time. Yet because he tried to think through the consequences of his beliefs, at the

risk of embarrassment or inconsistency, he can help us to define the influence of the ancient world in Victorian culture. The very dividedness of his mind is a symbol or symptom of the conflict within the age between classical and romantic, worldliness and piety, the spell of the Middle Ages and the spell of the ancient world. Did Ruskin admire the Greeks or did he not? How far was Hellenism woven into Victorian culture? Each question may shed some light on the other.

English education was of course both literary and classical; Ruskin gained from it a deep admiration for Greek poetry, Homer above all (about whom he was to write brilliantly in *Modern Painters*, of all places). But he also felt that the English way of studying the classics was too narrow: fixed upon literature, it failed to grasp the ancient world as a whole. For one thing, the Greeks should be seen, by the mind's eye, in a landscape:[2]

> I have not loved the arts of Greece as others have; yet I love them, and her, so much that it is to me simply a standing marvel how scholars can endure . . . to have only the names of her hills and rivers upon their lips, and never one line of conception of them in their minds' sight. Which of us knows what the valley of Sparta is like . . . ? which of us, except in mere airy syllabling of names, knows aught of 'sandy Ladon's lilied banks, or old Lycaeus, or Cyllene hoar'?

And of course a proper study of Greek culture should include Greek art: in one of his Slade Lectures he expressed his indignation that undergraduates, so well schooled in Greek literature, should take no interest in the Greeks' manual work.[3] The criticism was just; yet Ruskin himself was more the victim of this weakness than perhaps he knew. Despite his lifelong admiration of Greek literature, Greek art failed to arouse in him the same enthusiasm. Greek sculpture he respected, but it did not stir his blood, and, as we have seen, he produced no full-scale study of it until 1870, when his powers were already in decline; however, this work, *Aratra Pentelici*, has moments of humour, and of brilliance. Ruskin was happy, like so many others, to use Greece as a sublime contrast to the vulgarity of the present day, and here he allowed play to a cheerfully broad humour, comparing the Apollo of Syracuse and the

modern self-made man (Plate 87).[4] The brilliance comes through when he sets a Greek and an Indian representation of a bull beside each other (Plate 88).[5] The Greek bull is tiny, merely the reverse of a coin, the Indian one huge, yet it is the little bull which conveys strength and energy, while the big one is lifeless and inert: merely decorative values are supreme in it, the sculptor having no feeling for the force and truth of animal nature. It would be hard to imagine a more vivid demonstration of how little in art mere size has to do with the representation of power.

Only two perfect schools of sculpture had ever existed, Ruskin declared: the Greek and the Florentine.[6] All this may seem flattering to the Greeks, and yet the fact that so much of *Aratra Pentelici* is devoted to coins tells, to some extent, another story. Where in these lectures were the greatest works of Greek sculpture? They had no very great appeal to a man for whom this art was essentially a matter of 'pleasant roundness and bossiness of surface'.[7] Such a feeling could not do justice to the pedimental figures from the Parthenon, and the frieze too left him cold.[8] Why then did he trouble to pay such handsome tribute to things which did not much move him? He witnesses to the spell of Greece by the way that he

87 Greek past and vulgar present: 'The Apollo of Syracuse and the Self-Made Man', from Ruskin's *Aratra Pentelici*.

145

88 Ruskin's contrast of 'Greek and Indian bulls' shows that energy can be expressed on a tiny scale.

felt impelled to come to terms with a school of art for which he lacked instinctive sympathy.

He admired Greek sculpture, at least, even if he did not love it; his feelings about Greek architecture were more equivocal. On the one hand, he adored the Greeks and wanted to assert the unity of their achievement; on the other, his theory of architecture exalted the Byzantine and Gothic styles, and compelled him (so it seemed) to attack the classical manner. About Roman architecture and its Renaissance offspring he had no doubts – he pronounced them base and disgusting without a qualm – but when he dealt with the Greeks, he could not feel so confident. Architecture and ancient Greece were two central preoccupations of his life; ancient Greek architecture brought them together, and they clashed. This conflict makes his writings about Greek architecture fascinating and at times oddly moving. Sometimes he was too cocksure; in this case, the difficulties with which he wrestled make him at once passionate and thoughtful.

He set out his theory in *The Seven Lamps of Architecture* (1849), and though this is essentially a tract on behalf of the Gothic style, he slips in some discussions of Greek art which suggest that, whether right or wrong, he had thought earnestly about the matter. For instance he stresses the importance of the distinction between

146

'mass' and 'interval' in architecture, since 'there are two marked styles dependent upon it: one in which the forms are drawn with light upon darkness, as in Greek sculpture and pillars; the other in which they are drawn with darkness upon light, as in early Gothic foliation'.[9] This might seem to suggest that Greek and Gothic were two equally worthy styles, but soon a note of discontent is heard: 'The Greek workman cared for shadow only as a dark field wherefrom his light figure or design might be intelligibly detached: his attention was concentrated on the one aim at readableness and clearness of accent; and all composition, all harmony, nay, the very vitality and energy of separate groups were, when necessary, sacrificed to plain speaking.'[10] He next considers Byzantine capitals; unlike the Greek examples, these were cut down from a solid block. He allows that the Byzantines had less technical skill and that the Greek capital is more elegant in line, but he prefers the Byzantine capital because its light and shade are more 'grand and masculine' and closer to the quality of natural objects. The direction of his sympathies becomes more and more clear, and eventually Ruskin the moralist lets fly:

[The Byzantines] had truer sympathy with what God made majestic, than the self-contemplating and self-contented Greek. I know that they are barbaric in comparison; but there is a power in their barbarism, a sterner tone, . . . which could not rest in the expression or seizure of finite form. It could not bury itself in acanthus leaves.

Yet even this outburst testifies to the spell of Hellas, for he had shocked himself into making a correction, added to later editions: 'The bit about self-contented Greeks must be omitted. A noble Greek was as little content without God, as George Herbert, or St Francis.'[11]

To denigrate the Greeks was indeed close to blasphemy: many Victorians approached them in a quasi-religious spirit, and Ruskin was himself often among them. We catch the reverential tone as he discusses fourteenth-century Venice: 'To my mind there never existed an architecture with so stern a claim to our reverence. I do not except even the Greek Doric.'[12] That is a high tribute to Doric; yet even here Doric is second-best. Both styles are virtuously

147

restrained, but the Venetian is nobler: 'The Doric manner of orna-
ment admitted no temptation; it was the fasting of an anchorite –
the Venetian ornament embraced, while it governed, all animal and
vegetable forms; it was the temperance of a man, the command of
Adam over creation.'[13] Ironically, he prefers the Venetians on what
are, so to speak, Protestant grounds, putting the virtuous and
temperate sexuality of Adam above the unnatural asceticism of the
popish hermit – or the Greek.

The Byzantine builders were closer to nature, and hence to God;
and the absence of nature from Greek architecture was to be the
basis of his attack on it in later books. In *The Seven Lamps*, too, the
idea nags at him from time to time. Thus he criticizes the 'Greek
fret' ornament for taking a form that does not occur in nature. But
then there crops up a problem that would agitate hardly anyone
but himself: 'It so happens that in crystals of bismuth . . . there
occurs a natural resemblance of it almost perfect.' Shall we then
have to change our minds? No, all is well: the form of bismuth
crystals is 'unique among minerals; and . . . only obtainable by an
artificial process, the metal itself never being found pure.'[14] The
Greek egg-and-dart moulding, however, is true to nature, and
Ruskin accepts that 'its perfection, in its place and way, has never
been surpassed. And why is this?' he continues. 'Simply because
the form of which it is chiefly composed is one not only familiar to
us in the soft housing of the bird's nest' – in other words, the egg
is egg-shaped –'but happens to be that of nearly every pebble that
rolls and murmurs under the surf of the sea, on all its endless
shore.'[15] Here his rhetoric has gone soft; but the next sentences are
lit by a flash of brilliance:

> And that with a peculiar accuracy; for the mass which bears
> the light in this moulding is *not* in good Greek work . . .
> merely of the shape of an egg. It is *flattened* on the upper
> surface, with a delicacy and keen sense of variety in the curve
> which it is impossible too highly to praise, attaining exactly
> that flattened, imperfect oval, which, in nine cases out of ten,
> will be the form of the pebble lifted at random from the roll
> of the beach. Leave out this flatness, and the moulding is
> vulgar instantly. It is singular also that the insertion of this
> rounded form in the hollowed recess has a *painted* type in the

plumage of the Argus pheasant, the eyes of whose feathers are so shaded as exactly to represent an oval form placed in a hollow.

Ruskin here combines a scientific exactness in the study of tiny detail with a poetic capacity for bringing out the likenesses in unlike things. Who but he could have written those sentences? The best things in *The Seven Lamps* are the loving observations of ornamental detail; but ornament was the feature of Greek building most sure to disappoint him. He chafes at its dry formality: 'In the Doric temple the triglyph and cornice are unimitative: or imitative only of artificial cuttings of wood. No one would call these members beautiful. Their influence over us is in their severity and simplicity. The fluting of the column . . . feebly resembled many canaliculated organic structures. Beauty is instantly felt in it, but of a low order.'[16]

By the time that he wrote *The Stones of Venice*, he was out of temper even with the egg-and-dart (or 'egg-and-arrow') cornice. It was 'a nonsense cornice, very noble in its lines but utterly absurd in meaning. Arrows have had nothing to do with eggs (at least since Leda's time), neither are the so-called arrows like arrows, nor the eggs like eggs, nor the honeysuckles like honeysuckles; they are all conventionalized into a monotonous successiveness of nothing, – pleasant to the eye, useless to the thought.'[17] And he compared this Greek pattern to Christian cornices (Plate 89).[18] His first two examples were derived ultimately from Greece, and, as he allows, are less sophisticated in workmanship than their model. But they better express (he says) the supporting power of the cornice: their design is rooted in the lower part of the moulding and springs upwards; its curves are shaped like the bough of a tree, elastic, expressive, with a sense of growth. By contrast his third example, though Christian, is copied from a classical mosaic, and is mere pattern-making. The last two examples are supreme, retaining 'classical formalism' (his own words),[19] but combining it with naturalism. The Greeks are honoured as originators; classicism is honoured as a good though insufficient principle; but the medievals win the true glory.

Similarly, Byzantine and Gothic carvers put lively variety into their capitals, as the Greeks did not. In *The Seven Lamps* Ruskin

does his best to find imitations of nature in the Greek capitals, but it is uphill work:[20]

> The Doric capital was unimitative; but all the beauty it had was dependent on the position of its ovolo, a natural curve of the most frequent occurrence. The Ionic capital (to my mind . . . exceedingly base) nevertheless depended for all the beauty that it had on its adoption of a spiral line, perhaps the commonest of all that characterizes the inferior orders of animal organism and habitation. Farther progress could not be made without a direct imitation of the acanthus leaf.

This last sentence refers to the Corinthian order, which Ruskin unfashionably admired, again for truth to nature: 'The Corinthian capital is beautiful, because it expands under the abacus just as Nature would have expanded it; and because it looks as if the leaves had one root, though that root is unseen.'[21] The architects of the Greek Revival had passed the Corinthian order by, partly because they associated it with Rome and the Renaissance, partly because it was almost unknown until after the fifth century, the 'best' period of Greek building. Ruskin's preference for Corinthian over Ionic showed careful and independent thought; far different is the careless contempt with which he dismisses Renaissance and baroque architecture entire. Indeed, it was remarkable that he should praise an order which had such strong associations with the hated Renaissance school. In later years he must have thought still further about the orders, for in *The Stones of Venice* he found a subtler reason for admiring the Corinthian and depreciating the Ionic.

At some times his approval of Greek architecture is grudging; at others he seems to praise with faint damns:[22]

> The most familiar position of Greek mouldings is in these days on shop fronts. There is not a tradesman's sign nor shelf nor counter in all the streets in all our cities, which has not upon it ornaments which were invented to adorn temples and beautify kings' palaces. There is not the smallest advantage in them where they are . . . they only satiate the eye and vulgarize their own forms . . . how is it that the tradesmen cannot understand . . . that people come to them for their honesty

. . . and not because they have Greek cornices over their windows . . . ?

Here his respect for the Greeks seems to come through: he wants to protect their architecture from vulgarization. Very similar is the disgust he felt when his beloved Gothic was debased by being used for railway stations.

And yet there remains a difference in his treatment of the Greek and Gothic styles. He is respectful towards ancient Greek buildings, but condemns the Greek Revival for vulgarizing them; he is

89 Ruskin, in *The Stones of Venice* illustrates 'Christian Cornices' to illustrate his argument that they surpass Greek cornices both in expression of their architectural function and in love of nature.

reverential towards Pisa and Venice, yet believes they may be freely imitated. In the last chapter of *The Seven Lamps* he considers the best style for the nineteenth century: 'The choice of Classical or Gothic . . . may be questionable when it regards some single and considerable public building; but I cannot conceive it questionable . . . when it regards modern uses in general: I cannot conceive any architect insane enough to project the vulgarization of Greek architecture.'[23] No, there are four possible styles for the nineteenth century, and four only: Pisan Romanesque, Early West Italian Gothic, Venetian Gothic and English Earliest Decorated.[24] There is precision in this prescription; one is tempted to say, a crazy precision. But it is revealing: his passion, his love of Gothic and the cruel disintegration of his mind in later life seemed to mark him as a romantic, but like so many Victorians, he had a strong 'classical' streak. Two of his favourite words were 'right' and 'central'. His purpose in *The Seven Lamps* was to seek out the right style for modern use: he wanted to lay down normative principles, to establish rules. The second of his Lamps was Truth, and the last Obedience. In his final chapter he makes his classicism startlingly clear:[25]

We must first determine what buildings are to be considered Augustan in their authority; their modes of construction and laws of proportion are to be studied with the most penetrating care: then the different forms and uses of their decorations are to be classed and catalogued, as a German grammarian classes the powers of prepositions; and under this absolute, irrefragable authority, we are to begin to work; admitting not so much as an alteration in the depth of a cavetto, or the breadth of a fillet.

Indeed, he speaks of this grammar as a 'dead language' which we have to bring to life. Ironically, Greek architecture is rejected on 'classical' principles: it lacks 'the facility of adaptation to general purposes' and is therefore too inflexible to be taken as a ground of authority.[26]

Yet along with his advocacy of rule and correctitude went a cry for passion, a romantic appeal for direct human expression which would not be easy to reconcile with the demands of law and gram-

mar. He wanted buildings to be as personal as painting; architecture, he believed, 'should express a kind of human sympathy, by a measure of darkness as great as there is in human life . . . there must be, in this magnificently human art of architecture, some equivalent expression for the trouble and wrath of life, for its sorrow and its mystery . . . so that Rembrandtism is a noble manner in architecture, though a false one in painting.'[27] This too went rather against the Greeks; he could have found Rembrandtism, had he sought it, in the temples of Paestum and in a few buildings of the Greek Revival, but on the whole this was an area in which the Greek style could not match the dark, irregular grandeur of Gothic forms. He also had a keen feeling for texture: 'I think a building cannot be considered as in its prime until four or five centuries have passed over it.'[28] It is significant that he never went to Greece, and for all his lamentation over the airy syllabling of lilied Ladon, never seems to have felt a strong desire to do so. He adored the limestone of Italy: 'I hardly know that association of shaft or tracery,' he confessed, 'for which I would exchange the warm sleep of sunshine on some smooth, broad, human-like front of marble.'[29] Now the Greek temples are mostly built of marble, and time has matured them well; surely he would have delighted in their colour and texture, had he seen them for himself. Sometimes it is hard to tell whether he is speaking of ancient Greece or the Greek Revival; subconsciously he judges the one by his experience of the other. Had he gone to Athens, his opinions might have changed.

The Seven Lamps is a rather foolish work as a whole, and Ruskin himself was later to condemn it as 'a wretched rant of a book';[30] but *The Stones of Venice* is a masterpiece. The second and third volumes are still, despite his hatred of the Renaissance and baroque, the most inspiring guide to the city that exists (and incidentally, his criticisms of Venetian baroque, and even of Palladio, are more telling than most people now admit), while the first volume comprises his most sustained attempt to establish the general principles on which architecture should be based. The whole of the first volume, all 350 pages, is a single argument; his method is to look at the different elements of a building one by one — wall, cornice, shaft, capital, and so on — and to deduce from first principles in what form they should best be made. It is a brilliant performance.

He is for ever turning round to address the reader. How would you build this part? he keeps asking. Wouldn't you do such-and-such? How simple it all is really – and the reader is carried along by what seems a tone of relentless common sense. The concentration upon detail is intense and unremitting – what rhythm of concavity and convexity will best suit the mouldings of that base? what profile shall we give that cornice? – yet these minutiae are directed at giving strength and significance to the art of building as a whole. His blind spots – the unconcern for spatial values, the lack of sympathy for illusionistic or paradoxical architecture – are as large as ever; yet few books have been written which can so enhance the reader's visual sense. After reading *The Stones of Venice* we *see* buildings with a new clarity.

'The principles it inculcates are universal,' Ruskin says of his book.[31] Still his concern is with rules and laws. This is again the classical element in his make-up; indeed he loathed the baroque largely for distorting and perverting classical forms. For him Greek architecture is alike symbol and fountainhead.[32] 'All European architecture . . . is derived from Greece through Rome . . . The history of architecture is nothing but the tracing of the various modes and directions of this derivation . . . the Doric and the Corinthian orders are the roots, the one of all Romanesque, massy-capitalled buildings, Norman, Lombard, Byzantine . . . ; and the Corinthian of all Gothic, Early English, French, German and Tuscan.' He now has a more persuasive reason for belittling the Ionic order: 'I have said that the two orders, Doric and Corinthian, are the roots of all European architecture. You have, perhaps, heard of five orders: but there are only two real orders, and there never can be any more until Doomsday.'[33] The point is that all capitals (except for the horrid Ionic) are basically either convex or concave. The former class are all essentially Doric, the latter Corinthian; the Greeks have formed the pattern for all time. Although it is unclear whether this is a historical argument or merely a useful means of categorization, the tribute to Greece is considerable. Yet even this compliment is back-handed, for it means that in the sense in which there are five classical orders, based on certain canons of shape and proportion, there are thousands upon thousands of Gothic and Romanesque orders. In these latter styles every column, every capital creates, on his principles, its own order, and in a series of

plates he demonstrated this superabundance of creativity (Plate 90). So Gothic and Romanesque are infinitely more inventive than the classical or Renaissance styles.

In *The Stones of Venice* he returns to the attack on Greek ornament. The builder, he says, 'has all the lovely forms of the universe set before him . . . there is material enough in a single flower for the ornament of a score of cathedrals';[34] but the Greeks missed their opportunity. He chooses to believe that one of their decorations is a symbolic representation of the sea, and condemns them for reducing to 'measure and rule' the ocean's majestic irregularity:[35]

90 Ruskin, 'Concave Capitals'; all are derived from the Corinthian order, he argues, and yet each is original.

155

This is the thing into which the great Greek architect improves the sea —

Thalatta, thalatta: Was it this, then, that they wept to see from the sacred mountain — those wearied ones?

Still worse was the classical building of more recent times: he contrasts the lively, inexact wall decoration of the Middle Ages with the hard precision of Palladian rustication (Plate 91).[36] In this argument aesthetic and moral considerations come together. Classical architecture was 'servile': it made the workman a slave, commanded to cut his stone into unvarying, predetermined patterns, whereas each medieval craftsman had his own small part in making a building's character, which accordingly shared the variety and irregularity of the organic world.

In the third volume Ruskin whips himself up across 200 pages into a froth of fury at Renaissance and baroque architecture, and finally the Greeks are found guilty, along with their degraded Italian imitators, as accessories before the fact:[37]

> The whole mass of the architecture, founded on Greek and Roman models, which we have been in the habit of building for the last three centuries, is utterly devoid of all life, virtue, honourableness, or power of doing good. It is base, unnatural, unfruitful, unenjoyable, and impious. Pagan in its origin, proud and unholy in its revival, paralysed in its old age . . . Whatever has any connection with the five orders . . . — whatever is Doric, or Ionic, or Tuscan, or Corinthian, or Composite, or in any wise Grecized or Romanized . . . — that we are to endure no more.

But this attitude is not in fact typical of *The Stones of Venice* as a whole. His 'Conclusion' might bring to mind the last chapter of Newman's *Apologia*:[38]

From the time that I became a Catholic, of course I have no further history of my religious opinions to narrate . . . I have had no changes to record, and have had no anxiety of heart whatever. I have been in perfect peace and contentment. I have never had one doubt.

'Of course' – shall so much anxious thought, so many painful, honest questionings end in these flat, impassable simplicities? As one may suspect with Newman, so one may be sure with Ruskin that the appearance of simple confidence masks a more complicated state of mind. The rhetoric does not clothe assurance; it disguises uncertainty.

For in the other two volumes he is more carefully equivocal.[39] There are three great architectures in the world, he says: 'A, Greek: Architecture of the Lintel. B, Romanesque: Architecture of the Round Arch. C, Gothic: Architecture of the Gable.' Lintel Architecture, however, is the worst of the three. Once more, he blends praise and belittlement in his handling of the Greeks; and throughout the first volume credit and blame are doled out to them in roughly equal quantities. The Doric cornice is censured for 'useless

91 Ruskin, 'Wall Surfaces': the dead regularity of Palladian rustication (compare Plate 30) set against the lively texture of a medieval façade.

appendages'; the fluting of Doric columns is wrong in principle but harmless, while the Corinthian is 'always rigid and meagre'; the caryatid is 'one of the chief errors of the Greek schools'.[40] But the type of moulding used for the bases of their columns 'has never been materially improved as far as its peculiar purpose is concerned'.[41] None the less, challenging the Greeks on the ground where their superiority was supposedly greatest, namely perfection of detail, he concludes, 'There can be no question of the ineffable superiority of these Gothic bases, in grace of profile, to any ever invented by the Ancients.'[42] His eye for detail is fresh and sharp. Take, for instance, the bracket, supporting a projecting lintel or cornice. The power of the construction, he argues, 'depends upon the stones being well *let into* the wall; and the first function of the decoration should be to give the idea of this insertion.'[43] Types *a*, *b* and *c* in Plate 92 are thus proper, vigorous forms; *d* is a barbarism (and accordingly much favoured in the Renaissance). A shape common in classical architecture is that in Plate 93; not a bad form in itself, Ruskin agrees, but absurd in its place, because it looks feebly pinned on and in danger of sliding down. It may be wrong to hold that architectural members should always express their function; but if that theory be accepted, his argument seems unanswerable.

On the other hand, his concentration upon detail leaves little room for appreciating stylistic unity in a building as a whole. How shall we design our door? 'It is clear that the best heading must be an arch, because the strongest, and that a square-headed door must be wrong . . . Thus, while I admit the Greek general forms of

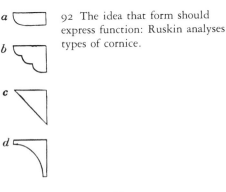

92 The idea that form should express function: Ruskin analyses types of cornice.

93 Classical bracket, illustrated in *The Stones of Venice*.

temple to be admirable of their kind, I think the Greek door always offensive . . .'[44] What are we to conclude? Many years before, Reveley had satirically accused Chambers of wishing to ameliorate the Parthenon by adding a steeple;[45] shall we now, without the trace of a smile, seek to improve Greek temples by giving them round-arched doors? By contrast, Ruskin admires the Doric column for having no base: there is 'a strange dignity in its excessive simplicity'.[46] But perhaps he likes this feature because it is shared with one of his Gothic loves, for he continues, 'Two of the most perfect buildings in the world, the Parthenon and Ducal Palace of Venice, have no bases to their pillars.' Then follows one of those analogies from the living world, poetic yet rooted to the argument, which make him like no other writer on architecture: 'The pier base is the root or paw of the pier', and the Doric base is like the foot of an elephant. Here again, though, he seems to value the Doric order less for itself than for its likeness to another sort of architecture,[47] for he speaks of 'the Doric base of animality', and 'animal activity', he believes, is a distinguishing mark of northern building.[48]

The dichotomy of north and south is at the heart of his thesis, and he uses it in several ways. Perhaps the shakiest of his arguments is that from natural scenery. He bases this on 'the tree which is to the German mind what the olive or palm is to the Southern, the spruce fir'.[49] As he explains,

The eye which has once been habituated to the continual serration of the pine forest . . . is not easily offended by the repetition of similar forms, nor easily satisfied by the simplicity of flat or massive outlines. Add to the influence of the pine, that of the poplar, more especially in the valleys of France; but think of the spruce chiefly, and meditate on the difference of feeling with which the Northmen would be inspired by the

frost work wreathed upon its glittering point, and the Italian
by the dark green depths of sunshine on the broad table of the
stone pine.

The argument will hardly stand up. Repetition, as Ruskin is pleased
to point out elsewhere, is more characteristic of Greek than northern
ornament; the Lombardy poplar (named, of course, from Italy) was
not a feature of the French landscape when the Gothic style was
invented; nor does the spruce fir characterize most northern land-
scapes. The trees of England and northern France and Germany are
typically massive and rounded, while fir and pine are most conspicu-
ous in the Alps, which lie between north and south and extend into
Italy.

Allied to this argument in Ruskin's account is another which
could be scenic, climatic or racial, but which he does not clearly
distinguish from the first: 'There is . . . in the North an animal
activity . . . an animal life, naturally expressed in erect work, as the
languor of the South in reclining or level work.'[50] This argument is
backed up by an appendix on 'the Northern energy', in which he
argues that even when energy is found in Italian architecture, as in
the Lombardic style, it is for one reason or another essentially
'Northern'. The theory is perhaps connected in his mind with the
argument from race: 'Now observe: those old Greeks gave the shaft;
Rome gave the arch; the Arabs pointed and foliated the arch. The
shaft and arch, the framework and strength of architecture, from
the race of Japheth; the spirituality and sanctity of it from Ishmael,
Abraham, and Shem.'[51] This claim is apparently based on the
doubtful theory that the Gothic style, as developed in France, had
an Arab source; but perhaps it is just a grand symbolic statement.
Pugin had protested that Greek architecture was pagan, and Gothic
the one true Christian style; Ruskin rings his own odd change on
this idea by maintaining that Gothic is at root Semitic and 'Old
Testament'. There is some kinship with Matthew Arnold's division
of man's spiritual impulses into Hellenism and Hebraism.

Many of Ruskin's propositions are more persuasive, among them
the argument from climate. He shows how the shape of the gable
in Germany and Switzerland is determined by the need to tolerate
heavy snowfalls, how a rainy climate may affect even the shape of
a moulding:[52] 'The dripstone is naturally the attribute of Northern

buildings, and therefore especially of Gothic architecture; the true cornice is the attribute of Southern buildings, and therefore of Greek and Italian architecture: and it is one of their . . . eminent features of superiority.' Then there is the argument from geology.[53] He invites us to take a geological map of Europe and look for the spots where travertine or marble is found; next we are to 'mark the districts where broken and rugged basalt or whinstone, or slaty sandstone, supply material on easier terms indeed, but fragmentary and unmanageable'. The geology forms the style: 'You will, in the first case, lay your finger on Paestum, Agrigentum, and Athens; in the second, on Durham and Lindisfarne.'

In an eloquent passage he lifts his reader high above ground and invites him to look down upon Europe.[54] To the south lies the Mediterranean, 'a great peacefulness of light, Syria and Greece, Italy and Spain, laid like pieces of a golden pavement into the sea-blue'. Turning northwards, the eye falls first upon 'a vast belt of rainy green', then upon 'mighty masses of leaden rock and heathy moor'. The very beasts imitate the changes of clime and landscape: the brilliantly patterned tiger and leopard dwell in the south, while in the north roam wolf and bear, shaggy and grey. In this analysis climate and physical geography come together to form the character of nations and their art.

Part of his case for the British being temperamentally unsuited to build in Greek style takes the form of a simple appeal to experience, his advocacy at times amounting to the assertion, 'This is so. Can you deny it?' Nor is this a contemptible form of argument. Sardonically he asks,[55]

Do you suppose that any modern architect likes what he builds, or enjoys it? Not in the least. He builds it because he has been told that such-and-such things are correct and that he *should* like them . . . do you seriously imagine, reader, that any living soul in London likes triglyphs? — or gets any hearty enjoyment out of pediments? You are much mistaken. Greeks did: English people never did, — never will . . .

Like Pugin, he suggests, in effect, that the Grecian style is both alien and highbrow. Medieval buildings, on the other hand, appealed to all. 'What are your daughters drawing,' he asked an

audience in Edinburgh, '. . . as soon as they can use a pencil? Not Parthenon fronts, I think, but the ruins of Melrose Abbey, or Linlithgow Palace . . . , their own pure Scotch hearts leading them straight to the right things, in spite of all they are told to the contrary.'[56] And he slipped in another mischievous question: 'Suppose Sir Walter Scott, instead of writing, "Each purple peak, each flinty spire," had written, "each purple peak, each flinty pediment."'

In a magnificent chapter of *The Stones of Venice* he listed the six 'characteristic or moral' elements of the Gothic style: Savageness, Changefulness, Naturalism, Grotesqueness, Rigidity, Redundance. Expressed as characteristics of the builder they are Savageness or Rudeness, Love of Change, Love of Nature, Disturbed Imagination, Obstinacy, Generosity.[57] These qualities may strike us as well describing the Victorians and their art: the spirit of the age, we may feel, was all for exuberant fancy, profuse ornament and richness of detail. Ruskin found Grecian buildings dull; he wanted an architecture about which he could care passionately, and he wanted others to care passionately too. He imagined his Edinburgh audience arguing with him: 'Well, but, you will answer, you cannot feel interested in architecture: you do not care about it, and *cannot* care about it.' But this was because Scots architects built in a style that could not stir enthusiasm. He allowed that the eighteenth-century New Town had 'a certain dignity in its utter refusal of ornament. But,' he added, 'I cannot say that it is entertaining.' And even when ornamented, classical building remained boring: 'Your decorations are as monotonous as your simplicities. How many Corinthian and Doric columns do you think there are in your banks, and post offices, institutions, and I know not what else, one exactly like another? – and yet you expect me to be interested!'[58] And once more he contrasts these dead regularities with the inexhaustible variety of nature.

His aim was noble: that architecture should be a source of delight for all people. The confidence that Gothic could give life and give it more abundantly shone through his Edinburgh lectures: '"Well, but" you still think, . . . "it is not *right* that architecture should be interesting. It is a very grand thing, this architecture, but essentially unentertaining. It is its duty to be dull . . . ; it cannot be correct and yet amusing." Believe me, it is not so . . . architec-

ture is an art for all men to learn, because all are concerned with it.'[59] With one part of himself he too advocated correctness; another part of him held that there was no truly noble architecture which was not imperfect. Law and liberty were both needful, and each alike pointed to Gothic as the style for the nineteenth century. He made an eloquent case. How far was he justified?

A WALK IN THE WEST COUNTRY

Ruskin's arguments in favour of Gothic are fundamentally two: first, it is the more practical style; and second, it is what people really like, if they are honest. The first argument does not in the end convince. It was sharp of him to observe that the pointed arch is stronger than the lintel, but the fact is that for ordinary purposes flat-topped doors and windows were cheaper and easier to construct. And perhaps a more serious objection is that he was forced to ignore or despise new materials and functions. Suppose that you were using cast iron: the greatest strength would be achieved by shapes and proportions different from those which are best for a brick or stone building. Faced with this new material, Ruskin deserted the argument from function and fled: iron was a base, vulgar substance, and that was that. Suppose that you were building a factory or a railway station; he had no advice for you. Steam and machinery were part of the hideousness of the modern, materialist world, and a terminus could be nothing but a place of horror.[60]

Now it is reasonable enough to maintain that some materials do not please the eye (who loves shuttered concrete?); reasonable too to claim that the purposes of some buildings are such that it is hard to make them attractive. But Ruskin's wholesale refusal to face the aesthetic challenge of the industrial revolution suggests that in his medievalism, as in Pugin's, there was something of weakness and timidity. Though pressing Venetian Gothic on the modern architect, he really fled to Venice as a refuge from modern life; and indeed, when architects took him at his word, he disliked the result. In any case, posterity has found much to admire in the utilitarian structures on which he turned his back: bridges, train-sheds, warehouses. Was there ever an entrepreneur as daemonic as Brunel? Yet

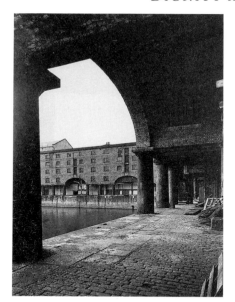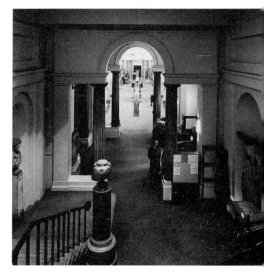

94 and 95 North and south, utility and culture: Doric austerity is combined with the 'Venetian window' pattern of arch and lintel in both the Albert Dock, Liverpool and the Ashmolean Museum, Oxford.

when we look at his Clifton Suspension Bridge we see that − by accident, it may be − he was an artist too.[61]

The Victorians produced one or two *tours de force* in Gothic cast iron − the Oxford Museum, for instance, or the train-sheds of St Pancras and Liverpool Street Stations − but classical forms and proportions could more easily be adapted to metal construction. As early as the 1820s Telford was using cast-iron Doric columns for the St Katharine's Dock, London. In 1841−5 Hartley and Hardwick employed them again for the Albert Dock, Liverpool, now much admired for its austerity and dark Piranesian grandeur (Plate 94). Here we can find a link between utilitarian building and fine art: the Albert Dock is based on the combination of arch with post-and-lintel construction; at the same date Cockerell was putting lintel-arch-lintel over Doric columns inside the Ashmolean Museum (Plate 95). And we may also feel that the Albert Dock has a spiritual ancestry in the English baroque: in Hawksmoor's St Alphege, Greenwich, we find not only a similarity of forms but a comparable severity of spirit (Plate 96).

For office buildings the Victorians developed as early as the 1840s a grid system using broadly classical forms; later in the century such buildings were often constructed on an iron frame. Many iron-frame buildings were modest, like the one in Norwich, dating from about 1868, illustrated in Plate 97. From one point of view this is a purely functional building, following the logic of glass and iron construction, the capitals and columns the faintest of tributes to a classical past. Yet the shape and proportions are virtually Georgian; and a building like this reveals a kinship between industrial construction and the post-and-lintel method from which the classical forms originally derive. There is a vernacular, descending from the classical tradition, which can be found, expressed in wood or metal, over much of the world in the nineteenth century, whether in antebellum Mississippi or on the verandas of India and Australia, or in an East Anglian warehouse. It is a modest tradition; but it is

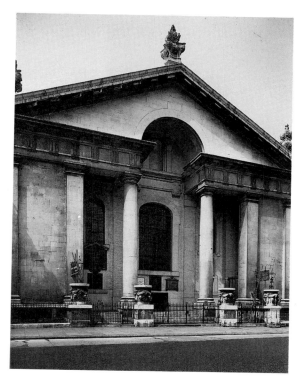

96 An ancestry for the Albert Dock and the Ashmolean in the English baroque: the east end of St Alphege, Greenwich (by Hawksmoor, 1711–14).

part of the nineteenth-century story, and it grew naturally out of the nineteenth-century soil, without any sage or guru commanding it.

What of Ruskin's other claim? – that people enjoyed Gothic architecture as they did not enjoy classical. He argued it with eloquence, humour and some charm, and there is at least some truth in it. Gothic cathedrals, castles and ruined abbeys do seem to appeal to the childlike in us as no other architecture does. And in Britain at least Gothic is usually the first and last love of those who enjoy architecture at all, partly because of England's great medieval cathedrals, partly because the ancient parish church is part of that quaint old village in which most Englishmen have made their spiritual home. Yet in the end one may doubt whether Ruskin's claim is more than a half-truth. He objects to Hellenism at the fishmonger; but to this objection two replies can be made. The first is that this distaste can be felt for any form of decoration whatever, as he was himself to learn. In later life he was dismayed that architects, under his guidance, as they supposed, had 'dignified

97 Industrial building, Castle Hill, Norwich. The iron-frame construction attenuates the columns but the overall design maintains a tradition (notice the clasping rustications; compare Plates 42 and 117).

our banks and drapers' shops with Venetian tracery' and appalled by his influence on the style of cheap villas and public-houses selling 'gin and bitters under pseudo-Venetian capitals copied from the church of the Madonna of Health or of Miracles'; these were, he confessed, 'Frankenstein monsters of, indirectly, my own making'.[62]

And we may question his claim for another reason also. There seem to be two kinds of classicism to which he objects; let us call them plain classicism and showy classicism. We may today prefer to think of the first kind as pleasantly unobtrusive, inheriting from the eighteenth century a tradition of decent, well-mannered crafts-manship; and as we watch mid-Victorian design decline into over-blown floridity, we may wonder whether Ruskin's generation could afford to despise any kind of decoration for being dull. At the same date Owen Jones was arguing for a very different approach to decoration; in the words of his disciple, Lewis Day, writing in 1880:[63]

> Owen Jones laid down the law that 'Flowers and other natural objects should not be used as ornaments, but conventional representations founded upon them . . .' A quarter of a century ago the so-called 'natural' treatment of foliage and flowers was rampant . . . I think it was mainly owing to the preaching of Owen Jones that the full tide of our tastelessness was turned . . . Even his timidity (he was almost morbidly afraid of a touch of nature) was perhaps useful in effecting a clean sweep of all naturalistic ornament whatever.

'There is scarcely a more useful expedient in decoration,' Day added, 'than repetition'; and he supplied a plate to illustrate the point (Plate 98). These principles were directly opposed to Ruskin's. Jones and Day are not famous as Ruskin is, but it was they who won — in two senses. First, public taste did swing away from naturalism towards formalism and repetition (Morris patterns are a good example): second, posterity has judged the change a great improvement.

Showy classicism brings us back to the question which Mrs Jarley posed us: if it is the outcome of people wanting to cut a figure, does that mean that it is false? Should we not rather take it as an

98 Lewis Day's illustration 'Repetition' challenges the Ruskinian praise of variety.

authentic expression of popular culture? The wish to look posh, to cut a dash, is grounded in human nature: public-house classicism and music-hall baroque are embodiments of that wish which it seems absurd to call bogus. On the contrary, this is people's art, and its cheery vulgarity warms the cockles. There is a spectrum from the one type of popular classicism to the other; somewhere in the middle of it are the shopfronts of which we have seen examples (Plates 14 and 15).[64] With their neat flutings and jolly Ionic volutes they are the work of ordinary, unpretending craftsmen, who would seem, from the look of things, to have taken an unaffected pleasure in what they were doing. This is the virtue which Ruskin so eloquently praised in the craftsmen of the Middle Ages, but he could not see it in the humbler work of his own time.

It is true that Grecians themselves began to feel in the 1830s that their revival had run out of steam. James Elmes admitted as much: 'We had converted Greek architecture into the most humdrum sort of design . . . the only alternative left was to escape from it by plunging *headlong* into the Gothic and Italian styles.'[65] And looking back in 1880, Day observed shrewdly:[66]

It would be curious to inquire to what extent the Gothic
revival owed its attractiveness to the obvious possibility of
achieving something like success . . . Gothic work . . . does
depend far less upon perfection of execution . . . In the very
perfection of Greek . . . art there is, on the contrary, some-
thing deterrent . . . Dare we enter into rivalry where anything
less than perfection is utter failure?

The argument is quite similar to Ruskin's, though Day is more
sympathetic to the Greeks; and there is much in it. The
capaciousness of the Gothic style leaves room for imperfection,
whereas Grecian buildings, if the proportions displease or the orna-
ment is indifferently executed, can be dull and clumsy at the same
time. The Gothic Revival had a scope for variety that enabled it to
go through several mutations without ceasing to be Gothic in a
way that was not equally possible for the Greek Revival.

Yet if the Greek Revival slipped from favour, the broad classical
tradition went on (Elmes names Italianate as one of the styles into
which his contemporaries had plunged deep). And even the Greek
Revival lasted longer and more successfully than has often been
allowed. As late as 1853, Owen Jones was saying, 'When Stuart
and Revett . . . published their work on Greece, it generated a
mania for Greek architecture, from which we are barely yet
recovered.'[67] That remark may seem less surprising if we look away
from the metropolis to the English provinces, where so much of
the nineteenth century was made. Consider Newcastle upon Tyne,
for instance. It is almost unique among English cities in having
been both a major regional centre since the Middle Ages and a
powerhouse of the industrial revolution, and it provides a fine
example of the high provincial culture of the last century, bour-
geois, rooted in a long past, but inquiring and progressive. These
qualities are embodied in the Literary and Philosophical Society;
here Robert Stephenson lectured and the competition to design a
miner's safety lamp was organized; here Sir Joseph Swan demon-
strated his electric light bulb and the wombat was first exhibited
to a European audience. Its premises (by John Green, 1825) are a
handsome specimen of near-Victorian neo-classicism. The plain
Greek frontage, honourably reticent, would not attract attention,
but the interior of the library is another matter (Plate 99). The

Grecian detailing is delightfully crisp, both rich and restrained, and it has adapted itself to go with modern materials, glass and iron, seemingly without strain. A bridge across an alley connects the Lit and Phil to the Victorian Gothic Mining Institute, a symbolic and actual link between the two cultures which the twentieth century cannot easily match.

Newcastle, then, was no mean city; nor was it backward, but a prosperous and dynamic society. Between the 1820s and the 1840s the citizens built themselves a neo-classical town centre of great distinction, the centre-piece being Grey Street, constructed between 1835 and 1840 by local architects, John Dobson and John and

99 The Literary and Philosophical Society, Newcastle upon Tyne: Grecian decoration mingles with modern construction in glass and iron.

Benjamin Green. Gladstone called it the finest street of modern times. Laid out along an old stream-bed, it had to be built on a curve and on a fairly steep slope; these accidents gave the architects their chance. The vista unfolds gradually as we walk up from the bottom. The eye rests naturally on the outer side of the curve and the groups of classical columns which punctuate its solemn progress (Plate 100). The right-hand side, in splendid counterpoise, has just one dramatic account, the boldly projecting portico of Benjamin Green's Theatre Royal, which forms the pivot on which the whole curve of the street seems to turn (Plate 101). The columns stand free, breaking up the wall of austere stone buildings, and letting air into the composition as a whole. Just beyond the Theatre Royal, Dobson replies across the street with another accent, a domed corner building, its rotundity interrupting the monotony of flat frontages, its convexity breaking out, in pleasant counterpoint, from the concave side of the curve. A monumental column closes the vista; the left-hand curve leads the eye towards it; the pillar of the Theatre Royal on the right echoes its verticality. Fittingly it commemorates Lord Grey, hero of the Great Reform Act of 1832 and the Factory Act of the following year, the two events which more than any other seem to mark the start of the early Victorian age.

Not every building in the street is strictly Grecian; but it is throughout remarkably and consistently severe. This is neo-classicism, and in its sterner guise; the spirit is everywhere that of the Greek Revival, and mostly the letter is Greek too. In one respect this noble street may suggest the limits of the style. The awkwardness of the site was a stroke of luck, which allowed severity to be tempered by touches of the picturesque; if Dobson and the others had been building along a flat, straight road, could they have escaped staidness? But there are other, more cheering morals to be drawn. Newcastle shows how strong, how restrained early Victorian design could be, chastened by a continuing classical discipline; and it also illustrates the vitality of the provinces. Neo-classical Newcastle is wholly the work of local men; and nineteenth-century London has nothing in the same kind that quite comes up to Grey Street.

Newcastle is the capital of the North-East; the capital of the West Country, and the largest provincial city in southern England, is Bristol. The best way to decide the nature and extent of the

classical tradition in the nineteenth century is to walk round a large town, looking for what it has to show, and Bristol will serve the purpose. It is not a typical English city, for the simple reason that no English city is typical. Regional variety in materials largely disappeared during the last century, as the railways transported cheap bricks and Welsh slates all over the country; Scotland alone kept its individuality, and to some degree keeps it still. And just as materials travelled more easily, so did fashions: the old provincial cultures lost their individuality, and the little quiddities of locality were slowly smoothed away. But these processes were gradual; the complete uniformity that makes a housing estate in Southampton just like a housing estate in Sunderland had to wait until our own century. The semi-detached villas of late Victorian Bristol are not beautiful, but the practised eye can scan a photograph of almost any of them and identify the city from which they come.

Bristol came to prominence as a thirteenth-century boom town. In the early fourteenth century it had the most brilliantly experimental architecture in Europe. In 1497 it was an expedition from

100 Neo-classical consistency: the western side of Grey Street, Newcastle.

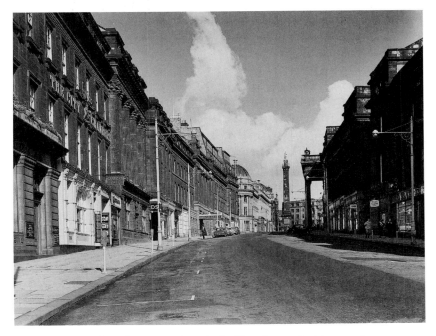

101 A counterpoint of curves and verticals: Grey Street, looking north.

Bristol, under John Cabot, that discovered the continent of America, before Columbus. For some hundreds of years Bristol was probably the second largest town in England; in the nineteenth century it lost that pre-eminence: there was not much coal nearby, and its port was narrow and awkward, unable to handle the big new ships as London and Liverpool could. It had some likeness to Newcastle in being an historic city, a regional capital and the home of a high provincial culture; it was unlike in not having a large industrial development. But though expanding less than most English cities, it continued to be the home of a mercantile culture, soberly progressive. The nobility lived at a distance: to the north the Dukes of Beaufort, princes of Gloucestershire, in their palace at Badminton and, more modestly, the Earls Waldegrave in the Mendip Hills to the south. Businessmen ran the place, their sense of their own significance crystallized in the Society of Merchant Venturers, a provincial version of a City livery company. In 1831 the mob rioted in support of the Great Reform Bill and burned

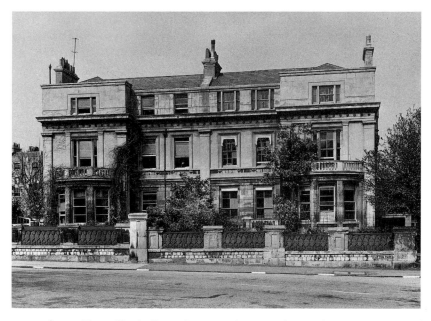

102 and 103 Two villas built to the same plan in Clifton Park, Bristol: the Greek forms match the structure; the Gothic details are only skin-deep.

down the Bishop's Palace; it fits the Bristol character that they first rescued the contents of the bishop's cellar and auctioned it off on College Green. In some respects Bristol may have been a little sleepy in the nineteenth century; in others, it was in the van. Brunel touched it with his daemon. His Great Western Railway, from London to Bristol, was a triumph of engineering; the driving of the Box Tunnel through the west Wiltshire hills, at the cost of many Irish navvies' lives, is the first of the heroic horror stories of railway history. High across the Avon Gorge he flung the Clifton Suspension Bridge, funded by a Bristol merchant's bequest; though far surpassed in size by later structures, it still seems to some the most beautiful and thrilling suspension bridge yet built. Despite the relative lack of industrialization, Bristol seems to have rubbed along well enough: its Victorian buildings suggest a settled prosperity (and the need for bigger warehouses led to an idiosyncratic local style, since nicknamed Bristol Byzantine).

It was perhaps longer attached to the classical tradition than many places. 'Provincial retardation', some say, but maybe the

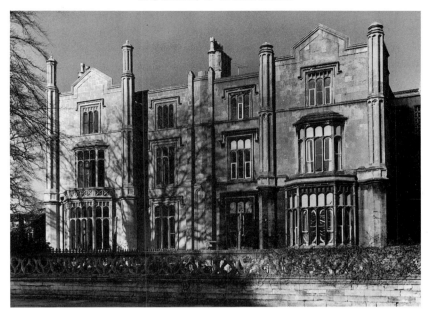

metropolitan smugness of the phrase underestimates the shrewdness of a trading city that had found a good line and stuck to it. The suburb of Clifton was begun around 1770. Perched dramatically above the Avon Gorge, it is like an untidier version of Bath, combining Georgian elegance with a hint of raffishness, as though English propriety had married the American Old South. A full description of Clifton is beyond our scope: our concern is with the end of its development, as the Regency shades into the Victorian age, and for this purpose the significance of its beginnings lies in their continuity with what was to come later. Clifton was eighty or so years in the building, and though the style changes somewhat in that time, as Georgian gives way to the Greek Revival, the terraces of the 1850s are recognizably in the same tradition as those of the century before. What we may think of as Regency style penetrates deep into the Victorian age: the builders and speculators of Bristol had tried the classical manner and found it good; they saw no reason to change. And why should they? For this is one of the most pleasing settings for urban life in Europe.

The men who designed nineteenth-century Bristol are usually obscure and sometimes anonymous, and that is their importance for us. We are not dealing with striking genius; whatever we find has grown out of the ordinary English soil. As it happens, one of these men has through personal disaster found immortality in another land: Francis Greenway, architect of the Clifton Club, was transported to New South Wales, where the governor spotted his talent and set him to designing the young colony's handsomest buildings. His portrait now appears on the Australian ten-dollar note; he must surely be the only forger to have received this species of honour. Modern Australia is justly proud of him, and yet he was no better than half a dozen other Bristol architects of his time; this is a period of good manners and good design.

A comparison between two houses, built probably in the 1830s and standing side by side in Clifton Park, suggests the advantages

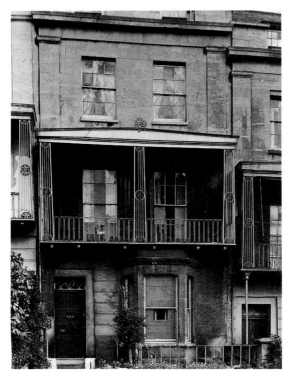

104 The skeleton of a Greek temple: Clifton Vale, Bristol.

of the classical style (Plates 102 and 103). Though of identical plan, one has been given a Gothic skin, the other a Grecian. The Doric pilasters of the latter building effectively articulate its rectangular form; they express the structure in a way that Ruskin should in theory have approved. In the other case the Gothic forms are merely surface decoration, awkwardly accommodated to a plan which does not naturally fit them – 'Tudor details on a classic body', as Pugin said of his own work at Westminster. Even ironwork proved receptive to the use of Greek decorative forms. For the very best examples we must travel to Cheltenham, forty miles to the north; but in Clifton Vale an unknown designer managed to create a whole temple façade in slender metal, complete with pediment, acroterion at the top and diminution of the columns (Plate 104). The result is almost modern in its simplicity, but graceful and witty as well.

The problem in designing a large terrace was how to shape it into a coherent composition. Georgian builders had tended to rely on fine detail and proportion and let the composition as a whole take care of itself: as grand an urban space as Merrion Square in Dublin completely lacks an overall design. There had been more ambitious schemes, to be sure: in Edinburgh for example, and above all in Bath, where the John Woods, father and son, had pretended that their spa town was a great city and given to speculative building the flavour of imperial splendour. The journeyman architects of Grecian Clifton often had quite high ambitions, and Greek forms helped them to be realized. Vyvyan Terrace, dating probably from the 1830s, combines the colonnade with composition *in antis*, that is, the enclosure of columns within pilasters. The Ionic order of the columns breaks the monotonous line of windows and provides variety from the Doric pilasters which articulate the rest of the façade, while the little balconies peeping from behind the columns emphasize both the depth of the recession and the scale of the giant order (Plate 105). And these fifteen bays are only the centre-piece of a terrace that is in total very much longer. At each of the ends there are two Ionic columns again, echoing the centre and thus giving some unity to the façade's rather sprawling length (Plate 106). There is a rhythm of advance and recession, the central section coming forward a little from the sides, but then the first and second floors retreating again behind the giant order. It is an attractive piece of work; but the architect's name was not recorded.

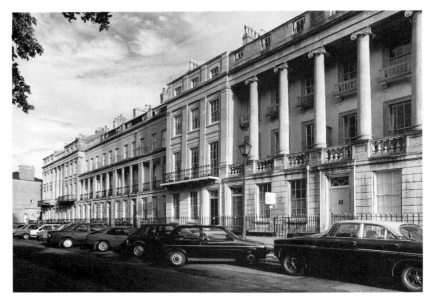

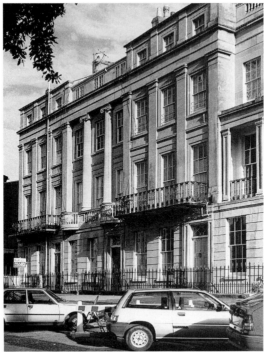

105 and 106 Vyvyan Terrace, Clifton (?by R.S. Pope; begun 1845): Ionic columns articulate the middle and the ends of a very long facade.

Still more impressive is Worcester Terrace. This is full-blooded Greek Revival, and if one were asked to guess its date, one might well plump for 1830; in fact it was put up in the 1850s. This was provincial conservatism, in a way; but perhaps one should rather say provincial quality, for is there any domestic building of the time in London as good as this? Yet the designer was just an obscure local man, Charles Underwood, one of a family of architects whose separate identities are not easily disentangled. He was lucky to inherit a strong tradition: he built at a time when decorative art was mostly hideous but an architect brought up in the old school could still design with strength and assurance.

This is a severely rectangular design, the surface articulated almost entirely by plain Doric pilasters of the Thrasyllus type, but it escapes monotony (Plate 107). The very long façade is not flat, but divided into five sections of alternating projection and recession. A firm geometry controls this rhythm, the central section being just twice the width of the other four. Ornament is very sparing, but two horizontal decorated bands run the full length of the façade, counteracting the vertical stress of the pilasters; one is the cast-iron

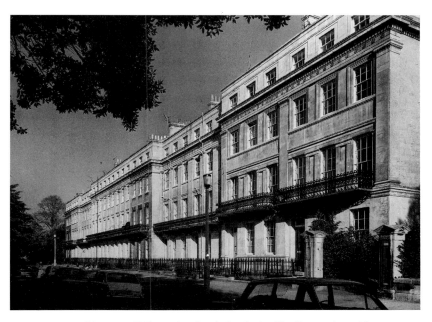

107 Worcester Terrace, Clifton: the Greek Revival still alive at the mid-century.

balcony that runs below the first-floor windows, the other the cornice above the second floor. Here the repetitive multiplicity of detail (which Ruskin would have hated) contrasts tellingly with the overall austerity; yet it is in itself plain, the rosettes, for example, being a simple version of a Greek decorative pattern. Each of the four storeys is treated differently. The cornice marks off the fourth floor as an attic storey, while the heavy balcony takes our eye away from the ground floor. Turning to the end sections we find our eyes focused upon the rectangular area defined by the cornice above, the balcony below and the pilasters at either side. This space too is elegantly and unobtrusively articulated. The first and second storeys look very similar, but between each window on the first there are coupled pilasters, while there are none on the second, so that the first floor is marked out as a *piano nobile*. The six bays are divided into two by a pilaster which runs through both storeys, so that the area between balcony and cornice can be read either as one rectangle or as two. Even the pilasters at either side are not quite identical, for one goes right down to ground level, marking the limit of the entire façade, while the other goes no lower than the balcony. In these ways the simple Greek forms act as a module for the entire composition, giving both unity and variety.

But we have yet to examine the design's most unusual feature. At either end of the terrace the architect has added a villa, attached to it and yet half detached. Between terrace and villa is a deep recession, in the dark shadow of which lurks the one concession to a Roman form, the semicircular lunette window above the porch (Plate 108). The villas themselves continue the decorative forms of the terrace in new proportions and combinations (Plate 109). We have seen how classical forms could be used to organize terrace façades which would otherwise be merely undifferentiated extensions. The arrangement here goes further, turning the terrace into a free-standing composition with two sides as well as a frontage. The stern geometry of the flanks is almost modernistic, yet derives from Greek Revival forms: again, cornice and pilasters control the composition. The severity is such that even the balustrade above the central bay is just an accent placed inside a plain oblong box. The bow window is not, of course, a Greek feature, but it fits well into its setting, its semicircularity making a pleasing foil to the straight lines all around it while remaining neatly geometrical.

108 Worcester Terrace:
the junction between the
terrace and one of
the attached villas.

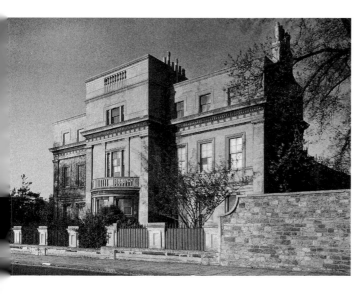

109 Villa attached to
Worcester Terrace: the
forms of the Greek
Revival handled with a
severe simplicity.

Worcester Terrace does perhaps mark the end of the Greek
Revival in Bristol. Yet its shadow lingered a while longer. As late
as the 1870s Doric pilasters can still be seen on villas which bear
the same relation to the Greek Revival as a bolted lettuce to a
lettuce fit for the table. Other houses sprang up at this period in a

110 Decoration of classical inspiration cohabiting with Ruskinian Gothic: Victoria Square, Clifton.

kind of grim Gothic-Italianate (but really the style is indescribable); at the same time smooth Bath stone was abandoned in favour of a rebarbative rubble-stone called Pennant. These villas are ugly, but distinctively Bristolian: there is nothing quite like them anywhere else. And on their Bath-stone dressings patches of Greek decoration – anthemion ornaments and the like – linger on, with a kind of nostalgia (Plate 110). It is as though late-Victorian Clifton, gone stylistically to seed, still clung to a memory of younger, better days.

But let us now stroll down from the heights of Clifton into the city centre. On the way we can glance at a couple of churches. St George's Brandon Hill, by Sir Robert Smirke (1823), shows the Greek Revival in its hey-day (Plate 111). The portico is pure Doric, and even the bell tower has been made as Greek as it can be, with Doric pilasters clasping an almost plain drum. The result is neat, dignified and might be a trifle dull but for the splendid hilly site. St Mary-on-the-Quay (by R.S. Pope, 1839), built for the Irvingite Church, shows the Greek Revival fading away (Plate 112). A kind of classical austerity remains, but the Corinthian portico is more

Roman than Greek, and fractionally less self-denying than the Doric of St George's. Soon these styles will hardly be acceptable for churches at all: the Irvingites, like the Anglicans, will go Gothic, while the Roman Catholics, if they do not build Gothic, will go for a riper Italianate. The moral is enforced the more clearly by a secular building of the same date, the Victoria Rooms (1839–41), where neo-classicism settles down into a plush comfortable Victorianism (Plate 113). The sculpture in the pediment does its best to be Hellenic (in the centre Athena stands in her chariot, a Greek helmet upon her head), but the architect gives no encouragement. This is the broad classical tradition, but not Greek at all, and not all that much Roman either. The interior dome, however, shows the long lingering on of Regency Grecian design: a memory of Georgian elegance meets a foretaste of modern simplicity (Plate 114).

Finally let us look at one short street in the heart of the town, allowing ourselves a couple of glances into adjoining streets. The

111 St George, Brandon Hill: the Greek Revival at its plainest.

183

Commercial Rooms in Corn Street, by C.A. Busby (1810–11; Plate 115), simple and sober, belong clearly enough to the Greek Revival (notice the Ionic order). But the Greek Revival, like the Gothic, was often unscholarly in its early stages, and this little building, though its plainness is Grecian in spirit, does not trouble to be exactly Hellenic in detail; for example, the columns are unfluted. It makes an interesting comparison with Smirke's Old Council House (1822–7), almost next door, a refined essay in the adaptation of the purist Greek Revival to modern purposes (Plate 116). Though the use for the doorway of half-size Doric pilasters within a giant Ionic order lacks a Greek precedent (as does the essentially Georgian box shape of the building as a whole), 'pure' does seem the right word. The effect lies in the astringent accuracy of the Grecian forms and in the fine bands of crisp, terse ornamentation. The placing of the Ionic columns *in antis*, within Doric pilasters, and the A B A B A rhythm of Doric and Ionic as (looking from left to right) we move from pilaster to column to smaller pilaster and back again give the façade a considerable depth and variety of articulation within a small scale. The difference between this building and the Commercial Rooms is partly a difference between the metropolitan architect and the country cousin; but it

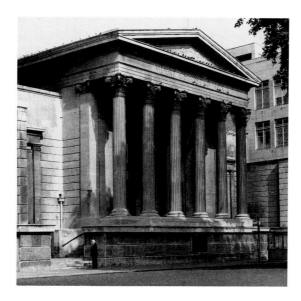

112 St Mary-on-the-Quay: more ceremonious, Roman forms as the Greek Revival begins to fade.

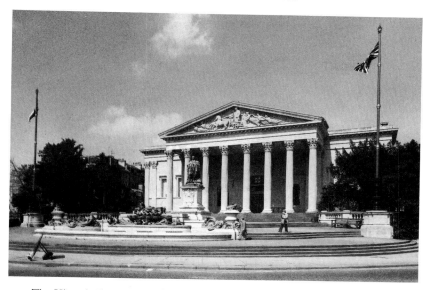

113 The Victoria Rooms: Greek figures in the pediment but a Roman architecture.

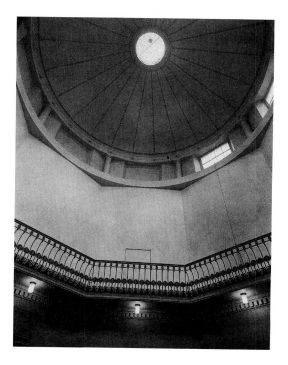

114 Victoria Rooms,
an interior.

185

also suggests the ripening scholarship of the Greek Revival as it reaches its high noon.

Here too can be seen the Greek Revival in its later, eclectic phase, for a peep round the corner into Broad Street reveals one of Cockerell's Bank of England buildings (1844–7) in his unmistakable brand of Hellenic baroque (Plate 117). The Doric columns are firmly Greek, as above them is the entablature, which drives an emphatic horizontal line across the building's full width. But what has happened to the pediment which should rest on the entablature? An attic storey has forced its way in between. The line of the columns is continued above by pilasters; these and the pattern of fenestration create a strong vertical accent which fights the horizontal emphasis. It is as though the windows had pushed up through the line of the entablature, like the blunt tip of a hyacinth breaking the soil's surface, and lifted the gable with them, their rounded tops heading the onward thrust. Elevated by this upward drive, the pediment floats twenty feet or so above the entablature on which we might have expected it to lie; the effect of levitation is enhanced by the way in which the band of stone around the gable is cut away below. Baroque or mannerist in spirit is the way that the frontage is flanked with massive, strenuous rustication; mannerist too is the fashion in which the doorways (oh, very Greek in form) are stuffed into the extreme edges of the façade.

Cockerell's Bank represents a last stage of the Greek Revival, but from another point of view it is the first in a sequence of Victorian bank buildings, the rest of which are to be found in Corn Street. Two buildings of the same date show how variously the classical tradition might be used in the mid century. For Stuckey's Bank (Bagehot's family firm) R.S. Pope designed in 1855 a building so modest and well mannered that it easily escapes notice. 'Quietly Late Classical and Victorian only in certain details,' says Pevsner; not classical, of course, in the sense of imitating antiquity, but still comfortably in a line of descent from the eighteenth century. No one, though, could call the West of England Bank undemonstrative (Plate 118). This is another kind of revivalism, for the model is the sixteenth-century Library of St Mark in Venice by Sansovino, though Victorian exuberance makes the Italian baroque seem almost restrained by comparison. Directly opposite the Liverpool, London and Globe Assurance Building rears itself up, scarcely less ebullient,

115 The Commercial
Rooms (1810–11):
Greek in spirit, but
not archaeologically
exact.

116 The Old Council House: the Greek
Revival at its apogee in the 1820s, scholarly
and refined.

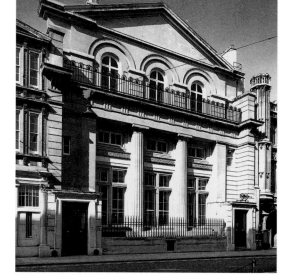

117 Bank of England, Bristol:
Cockerell's mannerist
manipulation of Greek and
Renaissance forms.

187

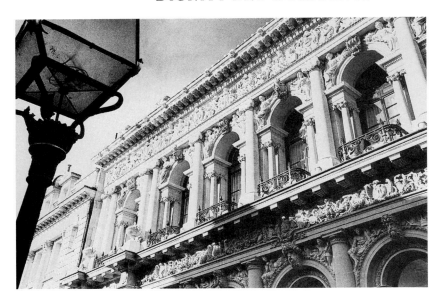

118 Venice on Avon: the West of England (now Lloyd's) Bank (by W.B. Gingell, 1854–6) imitates Sansovino's sixteenth-century Library of St Mark in defiance of Ruskin.

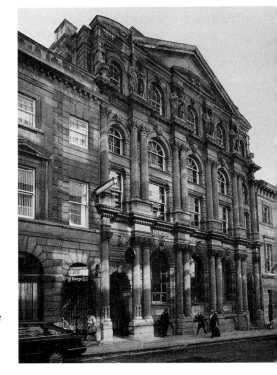

119 The Liverpool, London and Globe Assurance (now the National Westminster Bank), Corn Street (by Gingell, 1864): cheerful pomposity.

but perhaps more Frenchified than Italian, cheerfully pompous with pediments straight and curved, broken and unbroken, urns, caryatids, coupled columns, the whole box of tricks (Plate 119). It is interesting that these banks are so diverse in style and yet all, in one sense or another, classical; for that is what banks ought to be. For other buildings, other styles might be appropriate: a decade before Stuckey's Bank, Pope had designed the Guildhall in late medieval and the Buckingham Chapel in a strict Early English style. Or the choice of style might be a matter of taste or caprice. The West of England Bank building was begun a year after Ruskin had launched his all-out assault on Venetian baroque in the third volume of *The Stones of Venice*; it is as though he had never written. On the other hand Foster and Ponton made deep obeisance to his influence when they designed the Museum (1867–71): a smaller, redder Doge's Palace rises at the gates of Clifton. The sages might be absolute in their demands; the public was more eclectic.

A step round the corner into St Nicholas Street brings us another lesson in change and continuity with the tiny Stock Exchange by Henry Williams (1903; Plate 120). It has a one-storey tetrastyle portico like the Commercial Rooms and it uses a Corinthian order like St Mary-on-the-Quay. But the spirit is different, Roman or Renaissance rather than Greek, and austerity gives way to Edwardian playfulness. Round-headed windows appear behind the columns (a combination invented by the Romans) and the pediment, with a gable too steep to be Hellenic, is filled with cheerfully gilded heraldry.

Looking back into Corn Street, we encounter a twentieth-century variation on the classical theme with an example of what Osbert Lancaster christened Banker's Georgian (Plate 121). Here is the Corinthian order once more, but now the blend of brick and Portland stone and the rusticated ground floor below the columns evoke the eighteenth-century Palladianism of Kent and Chambers. This is a classicism that derives from the ancient world at one or more removes; the primary historical allusion suggests a nostalgia for an English past. John Wood the Elder's magnificent Exchange of 1740–3, on the other side of Corn Street, also uses rustication and the Corinthian order, but it is built of local Bath stone in contrast with the alien materials used on its younger, duller cousin. Another twentieth-century bank reveals a variant of the English-classical

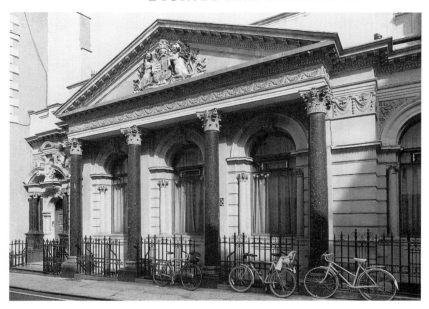

120 Stock Exchange, Bristol: Edwardian playfulness.

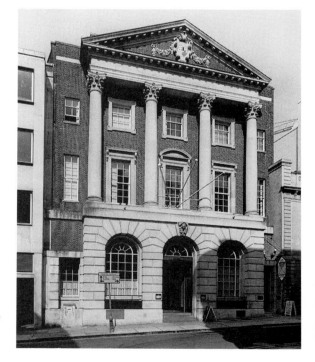

121 'Banker's Georgian': the Palladianism of the mid-eighteenth century (cf. Plate 30) evoked in the twentieth. Corn Street, Bristol.

122 Change and continuity in Corn Street: the twentieth-century cupola echoes eighteenth-century All Saints, but the Portland stone brings a touch of London to the west.

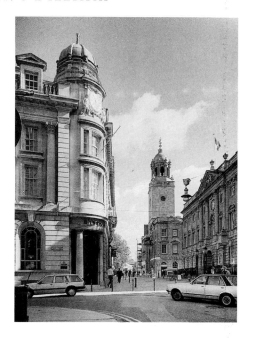

revival; this time the style is that Edwardian or post-Edwardian baroque which claimed Wren for its spiritual father (Plate 122). Significantly the material is Portland stone, foreign to Bristol but used for London's grander edifices since the seventeenth century. This bank is trying to look metropolitan: the age of uniformity is upon us. Its dome echoes, let us hope deliberately, the cupola of All Saints (1711–16) which commands the end of the street. Between them, the two domes mark the limits of a varied, more or less continuous tradition some two centuries long. In its course we meet Palladianism original and Palladianism revived; we see the Greek Revival wax strong, turn eclectic and disappear; and in buildings put up since the mid point of the last century we find classicism grave and gay, sober, undisciplined, riotous and stuffy. Corn Street is attractive, but not startlingly unusual; and that is its significance. For it suggests that the classical tradition in architecture was not something that ceased or went underground in the Victorian age, but was a constant presence, decorous sometimes, sometimes unabashed, part of the setting in which Victorian lives were led.

Hellene High Water

Most sculpture was still broadly in the classical tradition at the mid point of the nineteenth century; not so painting. Any connoisseur in the 1850s would have been surprised to learn that English painters in the last third of the century would win popular success from classical styles and themes. This and the next two chapters will examine the nature and the causes of this remarkable resurgence; but we must first go back to the beginning of the century to see how and why the classical tradition dwindled away.

Haydon, who was sure that the Elgin Marbles would inspire a new era in British art,[1] failed to inspire all his friends as he had inspired Keats. His fellow painter, David Wilkie, deflated his enthusiasm by discussing his own notion of a suitable subject for a picture: two small boys squirting each other with water.[2] As with many anecdotes, it is less important whether the story is true than that it should be told. For here, in miniature, is the quarrel between high art and what, for want of another term, we may call low art; and this quarrel was to run right through the century, affecting literature as much as painting and sculpture. The advocates of high art held that art should be grander, nobler and perhaps more passionate than ordinary life. Greatness should be its theme, not the commonplace; literature should deal with heroes and heroines, not with Mr So-and-So; sculpture should portray perfect men and women, not the sagging and ill-proportioned bodies possessed by the mass of humanity. Opponents of this view held that high art was pompous, empty and false; the writer or artist ought rather to seek truth to nature and have the imagination to find what was elevating in everyday joys and sorrows. The novelists, not surprisingly, tended to the latter view, and some of them were conscious of the analogy with painting. George Eliot devoted a whole chapter of *Adam Bede* to explaining that her novel, as a study of ordinary

unromantic life, was the prose equivalent of a Dutch picture;[3] Hardy gave to *Under the Greenwood Tree* the sub-title, 'A Rural Painting of the Dutch School'.

In *The Newcomes* a painting of a duchess prompts Thackeray to the sarcastic observation, 'One would fancy fate was of an aristocratic turn, and took especial delight in combats with princely houses — the Atridae, the Borbonidae, the Ivrys; the Browns and Joneses being of no account';[4] and he makes fun of the classical painter Gandish, with his cockney accent and grandiose aspirations. In a chapter called 'A School of Art',[5] Clive Newcome visits Gandish in company with his father, the Colonel, and Alfred Smee, RA Gandish's passions are for English history and the ancient world: 'You reckonise Boadishea, Colonel, with the Roman 'elmet, cuirass, and javeling of the period — all studied from the hantique, sir, the glorious hantique.' But it turns out that the picture, done many years before, has proved unsaleable:

> 'There's good pints about that picture . . . But I could never get my price for it . . . 'Igh art won't do in this country, Colonel — it's a melancholy fact.'
> 'High art! I should think it *is* high art!' whispers Old Smee. 'Fourteen feet high at least.'

Gandish has in fact been faithful to the style of an earlier age: 'Mr Fuseli . . . said to me, "Young man, stick to the antique; there's nothing like it." Those were 'is very words. If you do me the favour to walk into the Hatrium' — and so on. As a matter of fact, Fuseli did not by any means stick to the antique (though we have seen him drawing Achilles),[6] but no one has ever thought his style domestic.

The Newcomes was written in 1853–5; in the middle of the century Thackeray assumes that a classical painter of Gandish's type is unsuccessful and outdated. Fuseli had died in 1825, more than quarter of a century earlier. Smee, who laughs at high art, is a Royal Academician, a success; Gandish's Boadicea was painted before Smee ever became an associate of the Academy. Gandish paints, besides historical scenes, large allegorical canvases like *Beauty, Valour, Commerce, and Liberty condoling with Britannia on the death of Admiral Viscount Nelson*. Such things seemed hopelessly *démodé* in the 1850s.

Very different is Wilkie; and he too was a success, receiving a knighthood in 1836. Dutch painting of the seventeenth century was indeed his model; *Duncan Gray* (1814) will serve as an example (Plate 123). This is genre painting. It is also an anecdote: we look at the picture and supply a story. As it happens, the picture illustrates Burns's poem of the same name, but the anecdotal detail is all Wilkie's invention. Evidently the young man has just proposed and the girl has turned him down. We are invited to speculate about what we see, to gossip. Mother wants her to change her mind, you can tell. What is father thinking? And who is that peering in through the door on the left? Even when he takes a grand historical theme, Wilkie prefers to handle it anecdotally. *Chelsea Pensioners Reading the Gazette of the Battle of Waterloo*, a sensation at the Royal Academy in 1822, commemorates a great event in British history, but obliquely (Plate 124). The pretty girl with her eye upon the dashing horseman, the quaint veterans, comic or touching – these are Wilkie's matter.

At this date, then, classical painting is in the opposite camp

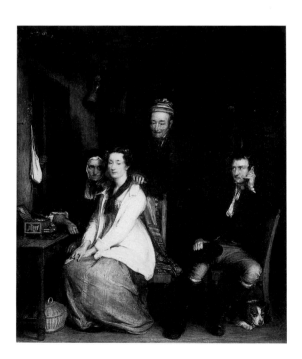

123 Vain courtship: in the early nineteenth century, genre paintings like Wilkie's *Duncan Gray* are seen as the antithesis of the classical or historical school.

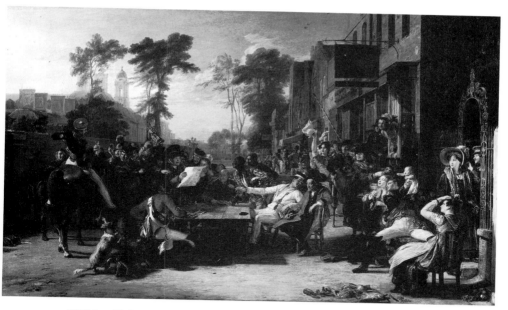

124 Wilkie, *Chelsea Pensioners Reading the Gazette of the Battle of Waterloo*: a grand historical event handled as anecdote.

from genre painting, from the 'Dutch school'. That observation will prove important when we come on to the later century. Wilkie and his like represent the antithesis of those painters of Greek and Roman inspiration; fact and anecdote alike contrast them with Haydon or the fictional Gandish. Haydon's ideal of historical painting is indeed different from Wilkie's: for instance, *Marcus Curtius Leaping into the Gulf*, a tale from Livy (Plate 125). Alas, it is absurd. One thinks of the remark made by some wit about Beerbohm Tree's Hamlet: 'Extremely funny without being in the least vulgar.' And such painting looked at the time old-fashioned: it represents the last gasp of a tradition which goes back to eighteenth-century neo-classicism, to Gavin Hamilton and Jacques-Louis David. But 'Igh Art would no longer do – not in an age suffused by the biedermeier spirit of cosiness and domesticity. Haydon made a last effort to elevate public taste by displaying two of his choicest canvases, depicting Aristides' banishment from Athens and Nero fiddling amid the flames of Rome, at the Egyptian Hall in London. Unfortunately the famous American dwarf, General Tom Thumb, was on

125 A classical tradition plunges to its doom: Haydon, *Marcus Curtius Leaping into the Gulf.*

display in another part of the building, and the crowds flocked to him instead. The contrast between the general's success and his own failure preyed upon poor Haydon's distracted mind; despairing, he took his life. Low art had vanquished high art in a cruelly literal sense; it all seems sadly and suitably symbolic. As late as the 1860s Hippolyte Taine, visiting England, could look down pityingly on the art of that benighted land:[7]

> Heroic painting is rare and poor, as likewise figure painting, whether nude or draped in the antique style or *à l'italienne* . . . Great and noble classical painting, the feeling for a beautiful body, understood and loved, that tasteful and learned paganism to which David and M. Ingres made themselves the heirs in France has never taken root here. Their school is a branch of the Flemish . . .

By which last remark Taine means what others called the 'Dutch School'. That theme again!

In this twilight of classicism, what was going on instead? The most famous new school of the mid century is Pre-Raphaelitism, but the Pre-Raphaelite Brotherhood did not bulk quite so large in the public imagination at the time as it has with posterity. Winterhalter was the man who painted royalty; and the most popular artist of the day was Landseer, famous for his animal paintings, ranging from scenes of carnivorous savagery to sentimental pictures of bloodhounds and Scotch terriers. (He too painted the Queen, who is said to have complained that he had made her too pink; Sydney Smith, advised to sit to him, quoted Naaman the Syrian: 'Is thy servant a dog that he should do this thing?') But certainly the Pre-Raphaelites made quite a splash. And they were anti-classical. They refused to study from the antique, then the conventional method of training in art schools, and Ruskin praised them for it: look how popular Landseer was: 'Do you suppose that he studied dogs and eagles out of the Elgin marbles?'[8] The Pre-Raphaelites' pet hate was what they called 'slosh' − vigorous and conspicuous brushwork − and the symbol of all that they most disliked was Sir Joshua Reynolds, whom they nicknamed Sir Sloshua. Now a painting like Reynolds's *Mrs Siddons as the Tragic Muse* (1784; Plate 126) is classical in a very vague sense, in that it latches on to a central, Renaissance tradition in art: the pose is modelled on one of Michelangelo's Sibyls in the Sistine Chapel. And the sloshiest painter of the Pre-Raphaelites' own day, William Etty (1787−1849), seemed also to be, in a very loose sense, the inheritor of a classical tradition. In a painting such as *Venus and her Satellites* (1835; Plate 127) the ancient world is fuzzily present: in the trophy on the left, in the temple on the right, in the subject (notionally a Graeco-Roman goddess), and in the nudity, which was felt especially at this time to be in a classical tradition because it was out of fashion in painting but still common in sculpture, which continued to employ a Graeco-Roman neo-classical style. There is no natural link between slosh and classicism, but in the cultivated public's imagination the two things seemed to be connected, and the ancient world was found guilty as an accessory before the fact. Ruskin declared,[9]

You have had multitudes of other painters ruined, from the beginning, by that grand school. There was Etty, naturally as good a painter as ever lived, but no one told him what to paint, and he studied the antique and the grand schools, and painted dances of nymphs in red and yellow shawls to the end of his days. Much good may they do you! There was Flaxman, another naturally great man, with as true an eye for nature as Raphael – he stumbles over the blocks of the antique statues – wanders in the dark valley of their ruins to the end of his days. He has left you a few outlines of muscular men straddling and frowning behind round shields. Much good may they do you! Another lost mind.

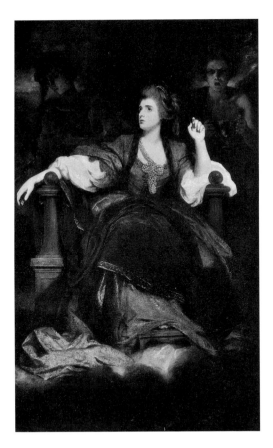

126 Reynolds, *Mrs Siddons as the Tragic Muse*: a composition derived from the High Renaissance, handled with what the Pre-Raphaelites called slosh.

127 Etty, *Venus and her Satellites*: classical slosh.

Flaxman and Etty have almost nothing in common; but Ruskin can lump them together as the enemy and associate them with a passion for the antique. Moreover, at the time he was writing, in 1854, they were both dead, and the kinds of art that they represented (Ruskin is thinking of Flaxman's drawings, not his sculpture) must have seemed dead also.

What the Pre-Raphaelites liked was precision of outline. They admired the German painters of the Nazarene school, men like Friedrich Overbeck, whose work displays not slosh but extreme smoothness, high finish and hard edge (Plate 128). Their model was Italian painting of the fifteenth century, particularly the Umbrian school; in short, Italian art pre-Raphael. This technique was to be imitated by the Pre-Raphaelite Brotherhood, especially in their earlier works; Millais's *Isabella* (1848–9) is a good example (Plate 129).

But if classical painting was pompous and dated, if (as Ruskin told the world) Pre-Raphaelitism was the great new school of the nineteenth century, how did the classical painters make their comeback? Now the Pre-Raphaelites were very young when they formed

128 Hard edge and imitation of the Italian fifteenth century: Overbeck, *Italia and Germania*.

their brotherhood – undergraduate age;[10] and their group had undergraduate characteristics, enthusiasm, exaggeration, a self-conscious shockingness, and some silliness as well. Their ideas were not clearly worked out. Among their small number was the sculptor Woolner, whose work we have seen to be, like most statuary of the time, fundamentally in the classical style.[11] As we watch the return of the classical tradition in painting to centre stage, it is as well to keep in mind the continuance of the classical tradition in sculpture; to be aware, also, that across the Channel, in France, a florid classicism is still part of the salon painter's stock in trade. To some degree it is possible to view the return to classical models as a restoration of the normal state of affairs; in this light it is the Pre-Raphaelites who appear the aberration. To say this is not to imply a judgement of quality; it is not to say that the Pre-Raphaelites were worse (or for that matter better) than what followed them; it is merely to look dispassionately at the shape of cultural history.

Besides, the Brotherhood themselves changed; the dogmatic fervour of their youth faded with the passing of the years. Rossetti grew sloshier as he got older, and though he never became in the least classical in style, he did occasionally take a classical subject; his *Proserpine* (1874) exemplifies both the classicism and the slosh (Plate 130). Burne-Jones, not one of the original Brotherhood but

soon to be associated with them, developed a personal style in which classical and medieval were combined. Here, then, was one way in which change took place: painters who had found their inspiration in the Middle Ages began to drift, in one fashion or another, towards the ancient world. The converse of this process was that the Hellenists could steal some of the Pre-Raphaelites' clothes. We have found hard edge entering English painting as part of an anti-classical movement; but why should classicizers not take over the technique? After all, from the time of Winckelmann sculpture had been declared to be the art of the ancient world *par excellence*, and sculpture is necessarily sharp in outline. Outline, said Pater, eternal outline, is the abiding characteristic of the antique.[12] The mature work of Leighton, of all Victorian painters the most thoroughgoing in his Hellenism, manifests a sculptural crispness, and that effect is created by smoothness of surface and sharpness of edge. One of Leighton's teachers was Edward von Steinle, a member of that Nazarene circle which influenced the Pre-Raphaelites; in a curious way the Brotherhood were paving the way for Hellenism to reappear in new guise.

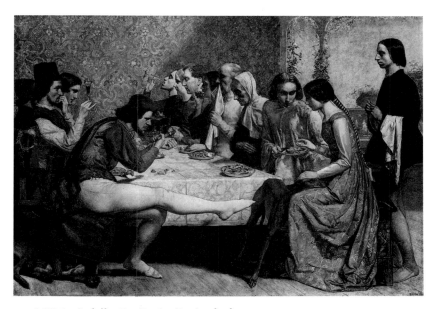

129 Millais, *Isabella*: Pre-Raphaelite hard edge.

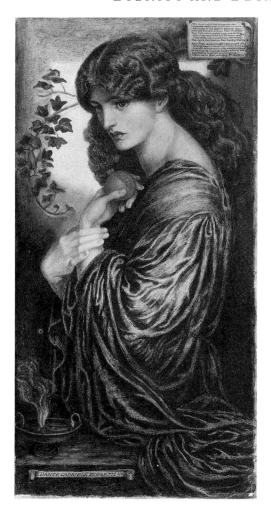

130 Hard edge abandoned: Rossetti's *Proserpine* — looser treatment and a notionally classical subject.

Frederic Leighton is so much the grandest of the Victorian classical painters and such a remarkable phenomenon that it is tempting to give him a disproportionate place in the story. The temptation will not be resisted here; and indeed he is worth study, not because he was like other painters but because his abnormal success may tell us something about the tastes and aspirations of his age. In some ways he seemed to typify his period, in others to have been born outside his natural time and place. This is not just a modern

judgement; as we shall discover, it was already made by some of his contemporaries.

Whether we look at a comparatively early work, like the *Syracusan Bride* (1865–6) or a mature piece like *Winding the Skein* (c. 1878), it is clear that high art is back with a vengeance (Plates 131 and 132). The *Syracusan Bride* is a dull piece, murkily painted, but already it shows some of Leighton's distinctive techniques. The effect is that of a sculpted frieze. A horizontal line is rammed across the bottom of the picture from one end to the other by the edge of the platform upon which the principal figures are walking; another strong horizontal is formed by their heads, all placed at virtually the same level. The columns at the left, the trees in the middle and to the right are as remorselessly vertical. The procession is lifted on to a stage, with a few humbler figures placed beneath it: low art is set against high art. The landscape has no depth but the flatness of a backdrop; given the deliberate staginess of the foreground, the effect may have been designed. The costumes and architecture are plainly Greek not Roman; the subject is in fact inspired by a line or two from Theocritus. The composition is deliberately static, the movements of the principal figures slow. Even the wild beasts are no longer wild. We are supposed to think that they have been tamed by the bride's beauty and chastity; it is unfortunate that they seem merely to be stuffed.

In *Winding the Skein* one may wonder if there is not a touch of biedermeier cosiness invading even this most elevated of painters. This is after all a domestic scene, two women, perhaps a mother and daughter, engaged in a simple household task. A contemporary critic, Ernest Rhys, described it as[13]

two Greek maidens as naturally employed as we often see English girls in other surroundings. This idealization of a familiar occupation – so that it is lifted out of the local and casual sphere, into the permanent sphere of classic art, is characteristic of the whole of Leighton's work. He . . . contrived also to preserve a certain modern contemporary feeling in the classic presentment of his themes. He was never archaic; so that the classic scenarium of his subjects, appears as little antiquarian as a medieval environment, shall we say, in the hands of Browning.

But if there is a touch of biedermeier, it is no more than a touch, for Leighton has lifted the scene on to a generalized and almost abstract plane. Domesticity has become monumental; here is one of the respects in which Leighton is curiously both like and unlike his age. Again we observe the frieze composition, the horizontals driven across the canvas (the edge of the parapet, the shoreline below the mountains), the firm verticals in the girl's pose and the mother's torso, the Greek costumes, the flatness of the background. But now Leighton's technique is improved; the draperies, especially the mother's, are exceedingly crisp and clear; both from the form of her dress and the way it is handled in paint Leighton's model is evident as Greek sculpture of the fifth century. Even the leg of the stool, in fact, is taken from the Parthenon frieze.

But where we are, and in what period of the past? Surely the answers are 'nowhere' and 'in none' – as bumbling Rhys rightly saw. Leighton is not trying to imagine or reconstruct any time or place in the ancient world; that will become plainer as we look at other works of his, and plainer still when we compare him with his contemporaries. He takes us into a timeless world, what Rhys calls 'the permanent sphere of classic art'; in other words, he generalizes. Reynolds had argued in his *Discourses* that great art generalizes; and

131 Leighton, *The Syracusan Bride Leading Wild Beasts in Procession to the Temple of Diana*: frieze-composition and a subject from Greek poetry.

204

Blake had crossly scribbled in the margin of his copy, 'To Generalize is to be an Idiot. To Particularize is the Alone Distinction of Merit.' Now the diversion between generalizers and particularizers is part of the quarrel between high art and low art, and it can serve to show that this quarrel could apply to the depiction of nature as well as to the depiction of human beings. The generalizing view has never been better put than by Sir Philip Sidney, back in the sixteenth century:[14]

> Nature never set forth the earth in so rich tapestry as divers Poets have done, neither with pleasant rivers, fruitful trees, sweet smelling flowers, nor whatsoever else may make the too much loved earth more lovely. Her world is brazen, the Poets only deliver a golden.

In other words, art can depict a world more beautiful by far than that which we see with our own eyes, and if it merely shows nature exactly as it is, with all its imperfections, it gives up its peculiar advantage. The opposing view is that the poet or painter should seek truth to nature in studying landscape, as he should in studying people, submitting himself to the reality of the physical world with

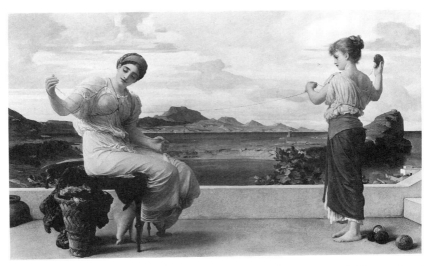

132 Leighton, *Winding the Skein*: a domestic scene made monumental. The stool and the drapery are from the Elgin Marbles.

all its quiddities and irregularities; and this attitude was dominant in the nineteenth century. Blake, the particularizer, advised the would-be artist to stare at the knot in a tree-trunk for an hour. That microscopic fascination with the detail of nature for its own sake looks forward to the Victorians: to Ruskin examining the form of a mountain or the exact curvature of a leaf, to Hopkins investigating the precise shape, texture and motion of a wave. The Pre-Raphaelites at first painted trees and flowers and grass with a minute, almost obsessive particularity; Millais's *Ophelia* and Holman Hunt's *Hireling Shepherd* are examples. As a generalizer, Leighton ran counter to one strong trend in Victorian taste; that makes his success demand explanation all the more.

His *Nausicaa* (*c.*1878) shows one of the ways in which he 'generalized' his themes (Plate 133). It is based not merely on Greek legend but on a specific passage in Homer's *Odyssey*. The shipwrecked Odysseus has been found by the princess Nausicaa, who has taken him home to her father the king. She has already been thinking that it is time for her to find a husband and is evidently impressed by the stranger; it is as though we are witnessing the start of a romance. But nothing happens; she drifts out of the picture and we have almost forgotten her when she comes to say

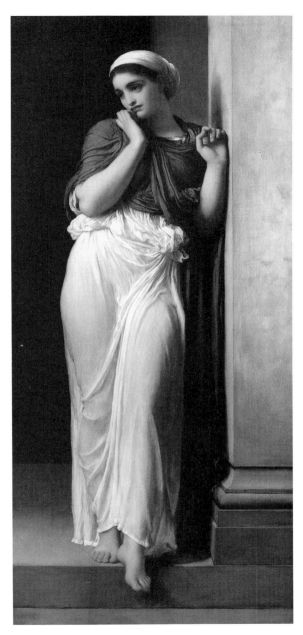

133 Leighton, *Nausicaa*: Homeric simplicity with small touches of riper sentiment.

goodbye to Odysseus, who is now feasting in the king's hall. The scene is very brief; here it is, in a translation contemporary with Leighton's painting:[15]

And Nausicaa . . . stood by the pillar of the well-builded roof, and marvelled at Odysseus, . . . and spake to him winged words:
'Farewell, stranger, and even in thine own country bethink thee of me upon a time, for that to me first thou owest the ransom of life.'
And Odysseus of many counsels answered her saying:
'Nausicaa, . . . may Zeus . . . grant me to reach my home and see the day of my returning; so would I, even there, do thee worship as a god, . . . for thou, lady, hast given me my life.'

This is the last we hear of her. What has always impressed readers about Homer's treatment of Nausicaa is its extreme restraint. Here is a tale that seems bound to be treated with tears and lush emotion; but he resists the slightest temptation in that direction. Nausicaa is happy and that happiness is not to be shattered. There will be no weeping, no passionate sorrow; she stays at a distance from Odysseus in this last scene, and there is nothing more than the lightest poignancy at the moment of parting.

Compared to this, Leighton's handling may seem a little sentimental. His Nausicaa leans against her pillar, a small but significant divergence from Homer, who merely has her stand beside it; there is a touch of archness in that pose, in the curve of the head and the downward glance, in the lift of her right hand close to her mouth, in the bare foot dangling, with a hint of pathos, over the threshold. Our instinct is probably to think that Leighton has made the girl a thought too Victorian, but that this has nothing to do with his conscious intention: when Florentine painters of the Renaissance depicted classical men and women they turned out like contemporary Florentines, and similarly when Leighton painted a Greek maiden she would be found to end up, at least in posterity's eyes, with something of a Victorian air. That may not be the whole truth. Mrs Russell Barrington, a formidable lion-hunter who managed to bag some of the most celebrated artists of her day and displayed her trophies to the world in a series of stout, admiring volumes of

biography, observed of Leighton's *Atalanta*, 'For noble beauty of the Pheidian type . . . , it would be difficult to find its peer in Modern Art, and yet it was only the worthy record of the beauty of an English girl.' And Leighton himself remarked, in his Academy Address of 1883, 'In the art of the Periclean Age . . . we find a new ideal of balanced form, wholly Aryan and of which the only parallel I know is sometimes found in the women of another Aryan race – your own.'[16]

So the Victorian coquettishness of his Nausicaa was perhaps part of his plan; it may be that he designed her to be in some degree both Greek and English, and aimed in other pictures too for an art that was both of its day and in a grand classical tradition. And perhaps the composition of *Nausicaa* displays a similar doubleness in its careful blend of the sentimental and the austere. There is the hint of a simper in the girl's pose and expression, but it is balanced by the statuesque quality of her crisp drapery, by her broad rounded features, and by her columnar verticality matching the pillar at her side. Maybe the picture is sentimental; but it is only a little sentimental. And maybe Leighton means it that way.

It is the pillar itself that most clearly reveals his generalizing idea. For, as he well knew, the mouldings at the base are of a kind that did not come into existence until hundreds of years after the Homeric age. Whereas other classical painters strove to get their archaeology meticulously correct, he deliberately avoids anything that resembles historical accuracy. For him classicism is not the recovery of a romantically distant past but an idea of form and spirit, permanent and timeless.

Captive Andromache (*c.*1888), an enormous canvas, 77 by 160 inches, is one of his most ambitious works and the most thorough-going expression of his ideal, timeless and yet devoutly Hellenic (Plate 134). This picture too illustrates a particular passage of Homer. In the sixth book of the *Iliad* Hector parts from his wife Andromache, foreseeing his death in battle and her leading into captivity:[17]

> So shalt thou abide in Argos and ply the loom at another woman's bidding, and bear water from fount Messeis or Hypereia, . . . and sore constraint shall be laid upon thee. And then shall one say that beholdeth thee weep: 'This is the

wife of Hector, that was foremost in battle of the horse-taming Trojans when men fought about Ilios.' Thus shall one say hereafter, and fresh grief shall be thine for lack of such an husband as thou hadst to ward off the day of thraldom.

Leighton's painting shows this prophecy realized, but in some respects he departs from the Homeric spirit, and surely with intent. The scene between Hector and Andromache is famous for its simple intimacy: when she speaks, we feel that this could be any wife and any husband, and their baby son takes fright at the nodding plume on his father's helm. Leighton, by contrast, assumes the grandest of grand manners. Once again he chooses a frieze composition, though this time with an elegant modification. The lowest horizontal – that is, the edge of the stone platform on which the principal figures are standing – runs across the entire picture, but the higher horizontal lines are arrested at a distance from the right side of the picture, while the steps by the well raise the right-hand group of figures, so that if we imagine the horizontals drawn across the painting from the left, they seem to curve gently upward as they reach the end of their path. Enhancing this feeling of a light lifting is a sense of slow movement from left to right. Indeed, there is even a perceptible increase in momentum as we move up the line of the procession. The colouring picks out three figures especially: the blue-clad woman on the left, balancing a pot on her head, Andromache herself in the centre of the picture, dressed in black, and the orange-clad figure at the foot of the steps. The first of these has the static solidity of a caryatid, but she is turned, very slightly, towards the right; Andromache is in full profile and has evidently been moving towards the spring, though she has paused for a moment; the woman ahead of her is moving up on to the step even as we look.

None the less, the picture is statuesque in a full sense; we think of a panel of sculptural relief. The frieze composition, naturally, contributes to this effect; so, oddly enough, does the colouring. In the clothing of his principal figures Leighton uses isolated areas of high colour with a hard, almost metallic sheen: the cold bright blue of the tall woman on the left, the staring orange of the woman at the foot of the steps, the group by the spring in brown, beige-brown and pinky-beige, the mother sitting toward the right of the terrace, in yellow skirts, their tonal value a sort of steely primrose.

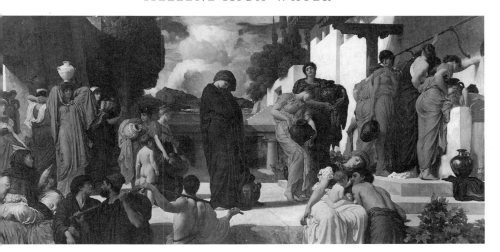

134 Leighton, *Captive Andromache*: high tragedy above, everyday life below.

The colouring, then, tends to isolate the chief figures or groups of figures; so does the composition. Andromache stands entirely alone, disconnected from everything around her; the figures on either side of her fall into two groups each, in a carefully contrived combination of symmetry and variety: the trio of women in blue on the left, then the group of three around the naked child; in front of Andromache a smaller group by the steps, two only, balanced by the four women at the well. Similarly, the figures below the terrace are very obviously separated not only from the figures above but from one another: there are three clearly defined units, with the single man in the centre echoing the solitary Andromache above.

There are other isolating effects – 'statuesque' effects, these also. The draperies are painted with an extraordinary crispness, so that they seem to stand out from the canvas with a three-dimensional hardness that reminds one of those stereoscopic photographs which the Victorians so enjoyed. And those draperies are so heavy. Take the woman in orange by the steps. As we have seen, she is moving upwards, but her pose and the droop of her head and the weight of her pot and the heaviness of her clothing – the heaviness even of its hot orange coloration – all seem to exert a downward drag. The draperies feel heavy in part because they have the projection and hard edge of draperies carved on a relief; with sculpture, too, we are especially conscious when figures are represented in motion that

it is motion arrested — caught and frozen into immobility; so the oddly static quality of the moving figure becomes another statuesque element of the piece.

This was not, as we know, the first time that Leighton had lifted his principal actors on to a sort of stage, but in this case the stage relates to the content of the picture in a way that differs from the *Syracusan Bride*. The figures on the lower level form an audience for the grand processional spectacle enacted above them; only the upper part of them is visible, like the people in the front of the stalls who come between us and the actors. This is a scene of high tragedy — literally, indeed, since Andromache is lifted above the onlookers — and the sense of high art is enhanced by what might perhaps be called the stage properties. Though the subject is drawn from Homer and the triangular-headed arch on the left implies the Mycenaean architecture of the second millennium BC, the vases distributed across the canvas are of a much later date, being mostly black-figure (sixth or early fifth century BC) or red-figure (middle to later fifth century). Leighton thus avoids recreating a period of past history; instead he draws upon the 'best' poet and the 'best' epoch of ancient art to represent a universal Hellenism independent of specific time and place.

Maybe the landscape in the background, too, contributes to the same end. The trees are Mediterranean enough (though more typical perhaps of Italy than Greece), but the sky is thickly clouded, its blue areas dark and lacking luminosity, and the tones of the purple mountains suggest Wales or Cumberland more than Greece. Leighton had been in Greece and tossed off some dashing oil sketches of the landscape; so he knew what the scenery was like. The evocation of the lights and colours of the south, so important to other classical painters of the period, seems not to interest him at all. Critics have tended to use words like 'dream' and 'escapism' in talking about the classicizers of the later nineteenth century, but for Leighton these terms are quite wrong. Here is none of the lightness of the magic carpet, none of the haziness of a dream; his figures have a bulk and sobriety, his colours even a heaviness, resistant to fantasies of nostalgia and escape. The inspirations are literature and the sculptor's art, not the actual life of the ancient world; his people belong to every age, or to none.

What Leighton has done here, as in the *Syracusan Bride*, is to set

high art and low art against each other: the humble figures on the lower level contrast with the heroine of tragedy and epic poetry above. The ingenuity in this case is that the contrast is related to the passage of Homer: these ordinary folk are the people who will say, when Andromache is captive, ' This is the wife of Hector, who was foremost in battle . . .' Moreover, Andromache the work of art tells us something about Andromache the woman: her peculiar misfortune is to belong to the world of high grandeur. It is because she is the captive widow of a prince and hero that she has to be set upon a stage, to stand isolated from other people, to be the object of the indifference or casual sympathy that we see portrayed in the ordinary folk below her, to know herself cut off from the simple delights of family life represented by the man, woman and child on whom she is gazing so wistfully.

Captive Andromache shows the academic idea in art at its most thoroughgoing, carried out with utter self-confidence and on an enormous scale ('High art! I should think it *is* high art . . .'). It may not be to everyone's taste, but on its own terms it impresses. And yet one may still wonder whether Leighton really intended to do all that he has done. Did he mean the sky to come out so sombre? Did he mean the woman at the foot of the steps to seem so heavy, so static? Did he mean the draperies to seem to start from the canvas brighter and more three-dimensional than anything else in the picture? There is a school of thought that would sweep aside such questions, claiming that the final result is all that counts. However, this is a picture which seeks to communicate in what is almost a literary way; it is indeed intriguing to see how far even so lofty a work of art as this invites us, in the manner of the genre painters, to pick up the clues and develop the story. Andromache's pitcher stands on the ground. She must have paused in her task – why? Ah, her eye is fixed on the baby in the right foreground. She must be thinking of her own little boy, slaughtered by the victorious Greeks.

It is here that doubts most easily creep in. The group goes too far towards a cosy biedermeier sentiment. The lean of the mother's head is at once too contrived (so that the three heads, like the group as a whole, shall form a triangle) and too easily emotional. The pathos of Andromache, the mother thinking of her dead baby, is too cloying, too reminiscent of a weaker Victorian novel for the

carefully classic setting. Homer, for his part, does not allow Hector to foretell his son's death; pathos there is balanced by restraint. There is a dutiful seriousness about Leighton's Hellenism which we do not find in the other classical painters of the time, but even he cannot help letting a love of the narrative element in painting and a certain Victorian softness of sentiment steal into the scene. Swinburne, no great admirer of his, was none the less willing to praise him 'for the selection and intention of his subjects – always noble or beautiful as these are, always worthy of a great and grave art; a thing how inexpressibly laudable and admirable in a time so largely given over to the school of slashed breeches and the school of blowsy babyhood'.[18] It is an interesting judgement. Swinburne sees how far Leighton is from the costume drama or biedermeier sentimentality of so much Victorian painting; yet it is in the 'selection and intention of his *subjects*' that his beauty and nobility lie. Literary reference, emotive allusion remain essential to the effect.

Leighton's usual method, which has precedent in the European tradition, was to design his figures first in the nude and paint their clothing over them afterwards. As it happens, we have a photograph of the underpainted version of *Captive Andromache*, so that we can see how the process worked. And this raises another of those questions which make Leighton, for all his apparent straightforwardness, such an elusive figure. We have seen that the extraordinary crispness of his draperies, which seem to be more solid and three-dimensional than the figures they enclose, is an important part of the statuesque, frieze effect of his works; or is it an accident, an undesired side-effect of his method? For certainly the method disquiets. One of the assets of Hellenism was that it carried with it the cachet of academic high art, and his handling of drapery seems to be academic in the most unfavourable sense of that word. He once told a friend, 'I can paint a figure in three days, but it may take me thirty to drape it.'[19] And Mrs Barrington observed enthusiastically that his figures were draped rather than dressed.[20] That was meant for praise, but we can hardly take it as such. The handling of drapery has become one of the separate categories in which a great master, and above all a great Hellenic master, is expected to excel; it seems to bear little relation to the rest of the picture. This is most evident in his weaker paintings, above all *Greek Girls Playing at Ball* (1859), where the draperies seem to have taken on a life entirely of their own – though

life is hardly the right word for something that looks so little like cloth and so much like crepe paper (Plate 135).

The curse of academicism seems to lie heaviest on him in a picture such as *Clytemnestra from the Battlements of Argos watches for the Beacon Fires which are to Announce the Return of Agamemnon* (c.1874; Plate 136). The best one can say for it is that it accurately conveys the impression that Agamemnon is in for a bad time when he gets back. But it is devoutly Hellenic in two respects: the subject is taken from the grandest of Greek dramas, Aeschylus' *Oresteia*, and the figure is patterned on the caryatids from the porch of the Erechtheum. But Leighton has surely been more Hellenic than sensible: the breadth of the caryatid figures, which is in any case less than that of his Clytemnestra, has an aesthetic function, being related to the fact that they have a load to bear on their heads. Leighton has removed the cornice from Clytemnestra's head, but left her so posed that we feel its absence. No doubt she has a weight on her mind; it does not seem justification enough.

The later nineteenth century is a time of idiosyncrasies: the eclectic blends that the variously classically inspired painters achieved are often peculiar to themselves, but these diverse artists do at least have this in common, that their works tend to be 'Greek-and-something-else'. This is less true of the purist Leighton than of his

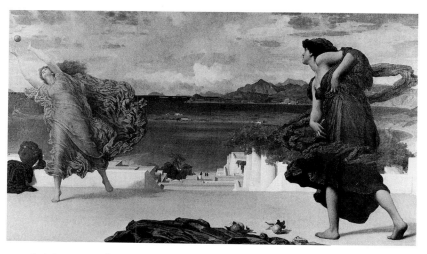

135 Leighton, *Greek Girls Playing at Ball*: a master of drapery?

contemporaries, but even with his work the hint of eclecticism slips in. We have already found him, even at his most Hellenic, being 'Greek and modern' or 'Greek and English' in a way that seems conscious or half conscious; and some of his most successful paintings are eclectic in a stronger sense, for instance *Flaming June* (*c.* 1895; Plate 137). The trappings – awnings, seat and so on – are as Greek as ever, the horizontals of the frieze composition as firm. But counterpointing this horizontality is the baroquely contorted pose of the sleeper, with its double pattern of curves: the two ovals formed the one by the head and arms, the other by the head, back, thigh and left leg; and the great S-shaped sweep of head, thigh and right leg. The figure is hardly Hellenic at all, and certainly not in pose: if anything, she is Michelangelesque. Matching these troubling contortions is an oppressiveness: the figure is enormous, too close to us,

136 Leighton's *Clytemnestra. . .* shows him at his most laboured.

137 Hellenic baroque: Leighton's *Flaming June*.

crushed into the canvas; a violent orange burns out of most of the
picture space; the sky is sultry grey with excess of heat. It is not a
charming picture; it is artificial and perhaps even repellent; but in
its fashion it is effective. And the wrestle between the Hellenic and
the un-Hellenic is perhaps the key to its effect.

So too with *The Garden of the Hesperides* (*c.*1892; Plate 138). The
subject is Greek, as are some of the stage properties; a trace of frieze
composition remains in the straight line of the horizon. But we
notice again the hot, oppressive coloration, the sultry sky, the
weary yet restlessly unrelaxed poses of the three women, the sinister
curling of the snake, round the tree, and round again, and round
the central figure. Half of Leighton's inspiration is Hellenic, half
of it Michelangelo's metallic *tour de force*, the *Doni Tondo*. And once

217

138 Leighton, *The Garden of the Hesperides*: restless and sultry.

more it is the eclecticism of Leighton's sources that makes the work memorable.

One may well feel, then, that Leighton is happiest when he tempers his Hellenism with something else. Why, then, did he often aim for a purist Hellenism, if the natural bent of his talent was in a somewhat different direction? For it was a remarkable talent, as can be seen from his drawing of a lemon tree on Capri (1859; Plate 139), which was admired even by Ruskin, who was usually cool about Leighton's work. It is complex and yet clear both in detail and in overall control; one wishes that he had done more in this vein. Why did he not? The key is perhaps to be found in the way that he painted himself (1880; Plate 140). In one way this

is as unrevealing a self-portrait as we could well imagine; in another
it is all too informative. For this is unmistakably a portrait of the
artist as hero. It is also a picture of an ancient Greek who has
somehow been reincarnated in Victorian England. Observe the Par-
thenon frieze in the background, its presence justified by the fact
that he had a cast of it adorning his studio. Observe the Apolline
curls that cluster on his brow, and the passionless Olympian ser-
enity, which suggests, even to the fifth-century cut of the beard,
Pericles or even Zeus. Presumably the swirl of robes beneath rep-
resents some honorary degree, but it adds sufficiently if vaguely to
the generally classical effect. Other artists did not portray him so:
in Brock's hands (1892; Plate 141) he is the society artist, the man
of the world (notice the slight turn and lift of the head, in contrast to
the self-portrait's blank monumentality, the flowing tie, so superbly
artistic, yet without taint of bohemianism); while Watts's Leighton
(1890) is mild and melancholy (Plate 142). But these three portraits
have one thing in common: they all seem too good to be true.

139 Leighton off duty:
a drawing of a lemon
tree on Capri.

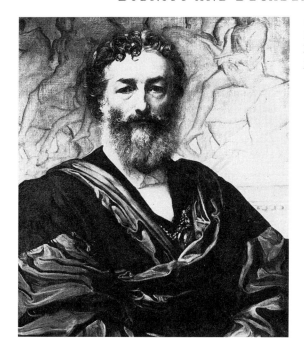

140 The Pericles of Holland Park: Leighton's self-portrait.

And now comes the surprise. We turn to a photograph and find that the reality matched what the artists portrayed (Plate 143). Leighton was simply perfect. In pose and clothing, in beard and hair, the artist and the society lion are flawlessly combined. The Apolline curls do cluster on the brow; and the beard is the beard of Pericles. One starts to find fault with the self-portrait for under-estimating the reality. He was even more handsome than he paints himself, and he has done no justice to the charm and kindliness of his expression. And the camera did not lie. His parties were magnificent, his generosity unremitting. Mrs Minto Elliot recalled how he had seemed as a young student in Rome:[21] 'a youth, with the form and features of a Greek god, nor wanting either the tower of ambrosial curls of the Apollo, neither vain of person nor of work, yet with a certain exclusiveness about him even *then*, which held him aloof from all contact with his fellows, as he passed them by hurriedly, as if afraid to linger – on some high errand'. A bachelor, he seemed to be unaware of the soul with all its maladies. Modern scholars have searched for a skeleton in his cupboard, it it has proved

nearly as bare of bones as Mother Hubbard's; an avuncular interest in one or two male pupils and later in a female model is the most that anyone has found.

Leighton was indeed so remarkable a phenomenon that he attracted the attention of novelists. He appears in Disraeli's *Lothair* as Gaston Phoebus, the Hellenic painter, and Henry James made him the subject of a short story, *The Private Life*, under the guise of Lord Mellifont. His perfections may have seemed almost uncanny; at least, James treats him not naturalistically but in a ghost story. Mellifont is superbly charming and assured in company; but it turns out that so much of him is put into his external graces that when he is not with other people he literally ceases to exist. He is contrasted with the novelist Clare Vawdrey, said to be based on Browning, who is unimpressive in company; but whereas Mellifont is less than a whole person, he is two people: there is another Vawdrey upstairs writing novels while the duller Vawdrey is among his

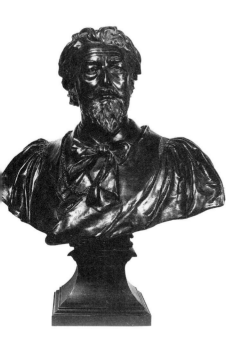 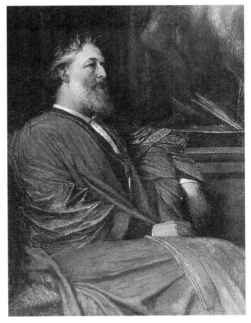

141 and 142 Leighton portrayed by Brock as society lion, by Watts as mildly reflective.

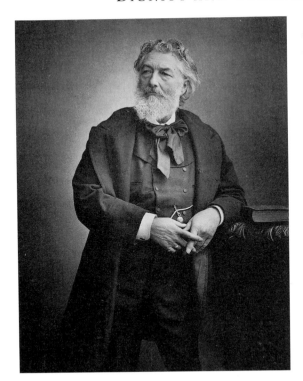

143 Leonine
affability:
photograph of
Leighton by Walery.

fellow men. And the narrator has one especially fascinating thing
to say about Mellifont:

> When he was talked about I always had an odd impression
> that we were speaking of the dead – it was with that peculiar
> accumulation of relish. His reputation was a kind of gilded
> obelisk, as if he had been buried beneath it; the body of
> legend and reminiscence of which he was to be the subject had
> crystallized in advance.

I said that Leighton was a Greek deposited in Victorian London;
James says, more or less, that he is a dead old master who is
somehow also alive and among us. That perhaps is why he is so
heavily Hellenic: he was an old master, and therefore he had to paint
masterpieces: he had therefore to belong to the classical tradition
and to the most prestigious part of the tradition; and that

meant fifth-century Greece. It is interesting that his first big suc-
cess, before he had gone thoroughly Greek, was *Cimabue's Celebrated
Madonna is carried in Procession through the Streets of Florence* (1853–
5; Plate 144). In the centre of the picture is Cimabue himself,
holding by the hand the boy Giotto; thus we see two great geniuses
of painting, one of them still a child, walking through the streets
of Florence among their contemporaries just as though they were
common mortals. That was what Leighton offered to Victorian
London: the presence of a great master, who would one day be the
subject of – in James's words – legend and reminiscence, walking
among us as though he were just an ordinary man. This theme of
the artist as hero was given a Greek turn by Alma-Tadema in *Phidias
and the Parthenon* (1868; Plate 145). Phidias stands in the middle,
his great work, the Parthenon frieze, behind him. Pericles and
Aspasia, on the right, are inspecting the sculpture; the figures on
the left are said to be Alcibiades and Socrates. As we look upon the
painting, we venerate the awe-inspiring geniuses of a distant era,
and yet in a way the scene is curiously familiar. The critic Helen
Zimmern revealingly described it at the time as 'a sort of Greek
"show Sunday"'.[22] How different is it, in the last analysis, from a
picture like H.J. Brooks's *The Private View of the Old Masters, Royal
Academy, 1888* (Plate 146), which shows Leighton, the English
Phidias, surrounded, if not by Pericles and Aspasia, then by the
next best thing, three peers, two peeresses and Sir Richard Wallace?
One of these paintings is a costume drama, the other a scene from
contemporary life, but both are pictures of artists of genius while
they are still alive and not yet canonized by death.

It is a cliché to say that the Victorians were hero-worshippers;
and indeed it is true. Painters are such heroes that their studios
become shrines, to be venerated in their lifetimes through photo-
graphs in books and magazines. What is striking about these rooms
is that they are indeed heroic backdrops; there seem to be only the
simplest tokens to show that any painting goes on in them, and
the mess of oily rags and tubes of colour is nowhere to be seen.
Alma-Tadema was photographed against a Pompeian background,
Leighton with the Parthenon frieze behind. W.B. Richmond's
studio seems closer to a ducal drawing-room than to bohemia, as
does Watts's. There is a suspicion of fancy dress about some of this.
Any visitor to Leighton's house today is likely to be struck by the

contrast between the studio, with the Parthenon frieze, and the rest of the house, in which any element of Hellenism is hard to detect. The most spectacular room is the Arab Hall, which offers a different and more enjoyable fantasy: here you can play at being a pasha. There is something airless about Leighton's Hellenism: it is too good for everyday, it is not to invade the commonplaces of ordinary social intercourse. He was the victim of his own grandeur: he could not just paint; he had to produce masterpieces.

Not many of his pictures are obviously enticing; what then was the secret of his success? Escapism is clearly not the answer. It has been suggested that he was an imperial painter for an imperial age, but that cannot be true in any straightforward sense. The parallel between the Roman empire and the British was manifest to the Victorians, indeed inescapable, but Leighton said, 'The Roman is antipathetic to me – I had almost said disgusting.'[23] Instead his Hellenism for the most part advertises its remoteness from the conditions of modern life. Why then was he so popular? The answer is perhaps that he was not. One may doubt whether the public took

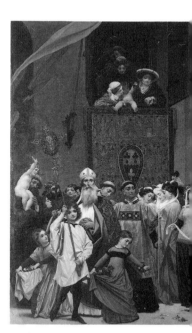

144 The artist as hero in the middle ages: Leighton, *Cimabue's Celebrated Madonna*. . . . The boy holding Cimabue's hand is Giotto.

to him enthusiastically as they took to Alma-Tadema, but what they knew was that Leighton was good for them: this was high art. The resolution of the paradox of Leighton is, I suggest, this. One strong strand in Victorian thought is a worship of the classic, objective art of the past, which was contrasted with the subjective, turbid, tangled art of their own post-romantic era. The Greeks especially were the objects of this kind of worship; they formed a yardstick against which the modern world and its art could be measured and found wanting. As a kind of Greek, as a painter strangely untypical of his time, Leighton too could become a recipient of this kind of admiration, and therefore, because he was a Greek, he was suited to become a perfect example of the English success story. The Victorians looked at themselves with both self-confidence and self-doubt; the self-confidence rejoiced in the fact that the greatest nation in the world had in its midst, as was appropriate, a great painter; the self-doubt admired this painter for being a visitant from the far land of Hellas. Let us put the matter in the Victorians' own words. Here is Sir Wyke Bayliss:[24]

Lord Leighton . . . was born on a rough English coast, he
lived his life in Hellas, and died in London. That is to say,
he was English of the English, Greek of the Greek, and
wrought his work amongst men for mankind.

And here is Mrs Barrington:[25]

Probably no Englishman ever approached the Greek of the
Periclean period so nearly as did Leighton, for the reason that
he possessed that combination of intellectual and emotional
power in a like rare degree . . . But, being essentially English
as well as Greek-like, Leighton pushed this combination of
powers to a moral issue.

Far different in tone was Vernon Lee's waspish judgement, but she
too found in him a blend of Greece and England, of ancient and
modern: 'Sir Frederick is a mixture of the Olympian Jove and a
head waiter, a superb decorator and a superb piece of decoration,
paints poor pictures, of the correctest idealism, of orange tawny
naked women against indigo skies.'[26]

145 The artist as hero in Athens: Pericles gets a private view in Alma-Tadema's
Phidias and the Parthenon.

why choose that particular piece for a pattern? – and we may reflect that this is now the third painting under our examination which is not just a nude but a picture of a woman undressing. The paradoxical quality which some contemporaries found in Leighton seems to extend into this work. The effect is curiously hard to pin down: in a way it is an alluring piece, in a way modest and decorous. What leaves no room for doubt is the attitude of some spectators. Here is James Harlaw in 1913, with a luscious mixture of striptease and high culture:[29]

Psyche's contour is perfect and her form is deliciously rounded. The exquisite pearly fairness of the skin must ever make this rendering of the amorous deity the standard of colour as well as of modelling. The dreamy eyes and the languor of the body are typical of the eclectic beauty of Leighton's art. This achievement ranks among the finest of the very greatest masters of the nude. Dorothy Dene, Leighton's favourite model, here displays her charms for the admiration of mankind.

Harlaw is a nonentity, and this may be dismissed as very vulgar stuff. Yet he is not exactly wrong. It was Leighton who chose to make the girl represent Psyche, in allusion to the story of Cupid and Psyche in Apuleius' *Golden Ass*; and it was Leighton who decided that Psyche should take a bath, an incident that Apuleius failed to include. What Apuleius can make very clear to us, however, is the subject of her reverie as she takes off her clothes: she is thinking about her mysterious, invisible lover, she is thinking about a man. Modesty and passion are satisfactorily combined.

When we turn to Sir Lawrence Alma-Tadema, the change is obvious at once. Here is no generalization, no high art; instead we have the 'daily-life-in-the-ancient-world' school. *Vain Courtship* (1900) is unmistakably a genre picture: we look at it and start to ask what story it tells (Plate 154). Why can he not interest her? why is she looking out of the window? is there another man, or is he just a bore? Now we saw that earlier in the century the classical painters and the genre painters stood at opposite poles; what has happened now is that the classical world has annexed the genre painting. Despite the Roman setting, this is another painting of the Dutch school; literally so, as it happens, since Alma-Tadema

was Dutch by birth, though he settled in London early in his career. Unlike Leighton, he does not seek a static classicism of composition; instead he likes to compose unusually and ingeniously, as in *A Coign of Vantage* (1895; Plate 155). The technique by which he shows that we are at a great height above the sea is a piece of bravura; his seeking for the *tour de force*, manifest also in the skill with which he painted marble, again marks him out from Leighton, who does not condescend to such flashy allurements. These contrasts may serve to demonstrate that the classical school of the later nineteenth century is not a school at all, if by school is meant a community of style and intention. It is better to think of the ancient

154 Alma-Tadema, *Vain Courtship*: the genre scene transferred to ancient Rome. Compare Plate 123.

234

155 Alma-Tadema, unlike Leighton, enjoyed irregularity of composition, as in *A Coign of Vantage*.

world as providing a common stock of forms, stories or allusions upon which artists can draw for widely varied purposes.

Alma-Tadema is a much simpler phenomenon than Leighton, and the key is surely fancy dress. A picture like *A Difference of Opinion* (1896) is a sentimental scene from Victorian life, but with a dollop of escapist fantasy added (Plate 156): look at all that grand marble, and the lovely Mediterranean climate, with the blossoms and the deep blue sea. What fun to dress up like that! Alma-Tadema painted both Greek and Roman scenes; mostly he favoured Rome, partly because Pompeii and Herculaneum provided him with more information about ordinary Roman life, but despite his careful archaeological correctness, the truth is that once you start on the dressing-up game, it does not greatly matter what place or period you choose. If you are invited to a fancy-dress ball, it makes little

156 Courtship in Roman
dress: Alma-Tadema,
A Difference of Opinion.

odds whether you go as a Zulu warrior or a pirate king; it is the
transformation itself which is of the essence. The Prince Consort's
knees have already taught us this lesson.[30]

Deep down, how much do these costume scenes by Alma-Tadema
differ from the pretty eighteenth-century pieces by Marcus Stone,
such as *Two's Company, Three's None* (1892; Plate 157)? Not much,
surely. But the ancient world held an advantage over other periods
when it came to this sort of painting: it was more dignified, more
learned, thanks to its associations with education at school and uni-
versity; and of course Hellas had a special prestige. It is interesting
that even today, when Tadema and his imitator Poynter are fetching
large prices in the salerooms, Stone and his kind have not done so
well; and yet his technical accomplishment and chocolate-box charm

236

are hardly less. The prestige of the classical world lingers on.

Antiquity had another attraction too. Pictures like *A Difference of Opinion* nudge us with the sentiment 'to think that those old Greeks and Romans were really just like us'. Alma-Tadema sometimes combined this with an appeal to 'the grandeur that was Rome'. It is the dressing-up game again: to the notion 'they were just like us' is added a delicious qualification: 'like us, but in such a magnificent setting'. *Unconscious Rivals* (1893; Plate 158) is another quaint little anecdote: both girls are in love with the same man; one is the outgoing type, the other more reflective; but observe the immensity of the bath-house in which they are situated. The pose of the woman on the right is a neat little ingenuity; she is evidently looking down some distance, and thus we realize that they are high up in a building of enormous scale. *The Colosseum* (1896) is in the same spirit, a mixture of public spectacle and private interest. A reviewer in the *Athenaeum* got the point; drawing attention to the 'sweet and fresh faces of the girls' and especially to the 'stately mother' on the right of the picture, he added, 'It is easy to imagine that in her noble spirit some thought of the victims of the amphitheatre arose.'[31] The delights of gossip and the delights of grandiose display are combined.

157 Courtship in eighteenth-century dress; Stone, *Two's Company* . . .

The Roses of Heliogabalus (1888; Plate 159) is again revealing. The emperor Heliogabalus was not entirely a nice man, and one of his bad habits was to have rose petals strewn upon his dinner-guests in such quantity that they were smothered to death. Now think upon Alma-Tadema's picture: this is surely one of the most respectable orgies in the decline and fall of Rome. Look at the young lady in the bottom right-hand corner; what a decorous figure! For this is a picture not of a real orgy, but of you and me dressing up and playing at having an orgy; and remaining careful not to go too far.

It might be thought that to talk about fancy dress is to impose a twentieth-century knowingness upon nineteenth-century material; but not so. Alma-Tadema was in fact fond of dressing up; Whistler was startled to encounter him at a costume party, barefoot and swathed in a toga, wearing a wreath and a pair of iron-rimmed spectacles.[32] Consider his painting of *A Picture Gallery* (1874; Plate 160), a subject that he handled a number of times; despite the

158 Alma-Tadema, *Unconscious Rivals*: the stuff of gossip, with the grandeur that was Rome as a backdrop.

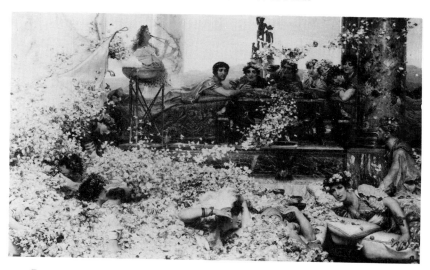

159 Proper orgy: Alma-Tadema, *The Roses of Heliogabalus.*

Roman setting it seems curiously similar to C.W. Cope's painting of *The Council of the Royal Academy selecting Pictures for the Exhibition* (1876; Plate 161). On Cope's canvas a number of well-known artists of the day are represented; in the centre foreground, for example, is Millais, looking balder and duller than at the time when he had relieved Ruskin of the encumbrance of a wife. The portrayal of Victorian worthies, natural in a scene of modern life, is something which one would hardly expect to find in Alma-Tadema's picture; but one would be wrong, for one of the figures in his Roman gallery is the dealer Ernest Gambart, garbed in the costume of the ancient world.

Or take *A Reading from Homer* (1885), a Greek scene this time (Plate 162). But how Greek is it? This picture gives the game away; for look at the central figure's bare flesh, pressed against the chilly marble: he ought to be appallingly uncomfortable. But indeed we are not in ancient Greece but in a Victorian drawing-room. The eager listener is sprawled not on marble but on a hearthrug; that stone bench behind is really a sofa. Albert Moore expresses a humorous indifference to such costume drama in his *Quartet* (1868; Plate 163); here the musical instruments are modern, the costumes antique. He thus exposes what Alma-Tadema's pictures really are: Victorian people in classical clothing. At the same time he is expressing his own purist view that a painting should not tell a

160 and 161
Victorian
cognoscenti garbed as
Romans, and as
themselves:
Alma-Tadema, *A Picture
Gallery* and Cope,
*The Council of the
R.A. . . .*

162 Alma-Tadema, *A Reading from Homer*: despite the marble, a modern flavour.

story or reconstruct a bygone era: pictorial values alone should count.

Another reason for Alma-Tadema's success was, to be sure, the admission of some discreet titillation. Here was a further respect in which the ancient world had an advantage over other periods of the past. After all, the Greeks had invented nudity, and the Romans were, to a degree, disciples of the Greeks. Alma-Tadema was especially fond of scenes in Roman bath-houses. Justified by the very proper business of archaeological reconstruction (*Blackwood's Magazine* reported of one of his works, 'As usual, the archaeology is boldly defiant of critical doubts'),[33] and affording a good opportunity for his dashing treatment of marble, these bath-houses offered an opportunity for something else as well. One of his paintings is entitled *An Apodyterium* (1886). That means simply 'an undressing-room'; but the classical word lends respectability to what is essentially a picture of a pretty girl taking her clothes off. In *The Frigidarium* (1890; Plate 164) observe the figure lifting aside the curtain. Alma-Tadema lures the spectator – the male spectator, that is – into imagining that he is actually present: 'Look quickly,' he says, 'and you can see the women undressed.' So too with his watercolour, *A Balneatrix* (1876): a little gap between the curtain and the wall allows us, accidentally as it were, to glimpse a naked body (Plate 165). Now it is not that Alma-Tadema could not have

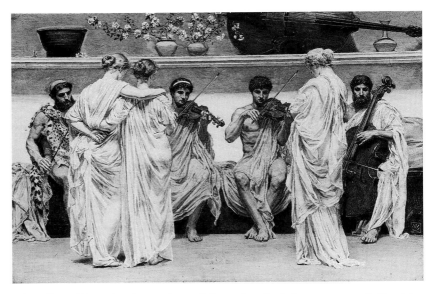

163 Albert Moore laughs at the zeal for archaeological correctness: *A Quartet: a Painter's Tribute to the Art of Music,* A.D. *1868.*

shown us more without getting into trouble, nor can this plausibly be described as an erotic picture. It is, once again, the game of make-believe that it most important, the feeling that we have managed to see, seemingly by luck, something that we were not supposed to see.

In the Tepidarium (1881) is, appropriately enough, the steamiest of his bath-houses scenes, and as such, somewhat untypical (Plate 166). But it can serve to illustrate what was and what was not acceptable in the last century if we take another reclining nude, comparing Alma-Tadema, once more, with Manet. In *Olympia* Manet portrays a scene of contemporary life, and without tenderness for his subject (Plate 167). The tart's face is not pretty, and it is hard with experience. Her legs are too short, her flesh sallow; the belly muscles are starting to sag. And the bed-linen does not look any too clean. Yet this is in a broad sense a classical composition, for it is modelled upon Titian's *Venus of Urbino.* He has taken a low, even sordid scene from modern life and invested it, movingly, with a kind of classic dignity. Alma-Tadema's painting is the reverse. He chooses ancient Rome for his setting but puts into it

242

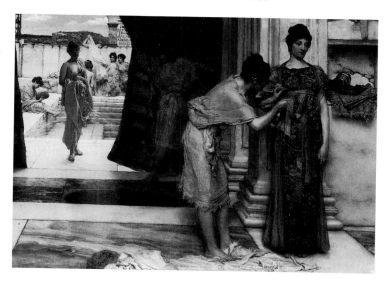

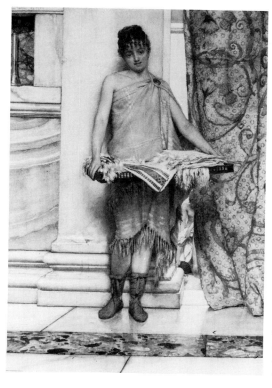

164 and 165 The quick or
accidental glimpse:
Alma-Tadema, *The
Frigidarium* and
A Balneatrix.

243

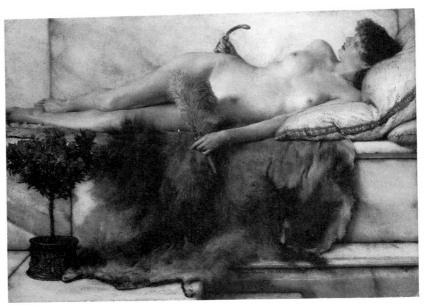

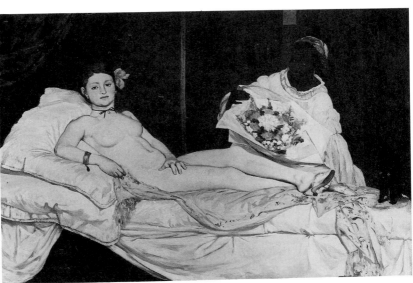

166 and 167 Alma-Tadema, *In the Tepidarium*, gives ancient Rome a modern flavour, while Manet, *Olympia*, invests modern low life with classic distinction.

what is really a modern cocotte. And the classical setting makes all the difference. Manet's picture caused an outcry in France; Alma-Tadema's career led on to public honour.

Leighton stood alone; the nearest he had to a disciple was perhaps Charles Perugini, who painted softly statuesque young women in a style half way between Leighton and life. By contrast, Alma-Tadema's scenes of daily life can be paralleled in the works of salon painters all over Europe, though few could match his technical facility. In England a run-of-the-mill imitator who achieved great popular success was Sir Edward Poynter (1836–1919), though he sometimes painted in what can be anachronistically dubbed the Hollywood-epic style, while *A Visit to Aesculapius* (1880) shows him in yet another vein, trying for the high dignity of Leighton (Plate 168). He chooses Leighton's favourite frieze composition, with dead horizontals drawn across the picture by the wall in the background and reinforced by the way that the seven figures are drawn out into a line. The painting is like Leighton, too, in that it generalizes: Aesculapius comes out of Greek myth, but the architecture is, or is meant to be, fifth-century. Yet the biedermeier spirit creeps in: we see it in the winsome poses of the four nude figures (it is hard to resist the feeling that Aesculapius is very thorough for a chiropodist), in the way that the Doric columns are reduced to the domestic proportions of a summer-house, in the faithful spaniel lying at the physician's feet. More often, Alma-Tadema was Poynter's model. One or two of his pictures have the word 'corner' in their title; for example *A Corner of the Villa* and *A Corner of the Market Place* (1887; Plate 169). It is indeed a revealing word: we know that the grandeur of the ancient world is all about us, but we zoom in upon one heart-warming detail. We enjoy the mixture of splendour – plenty of marble, though painted without Alma-Tadema's panache – and familiar domesticity. To think, we conclude, that those Greeks and Romans liked babies, just like us. Bulwer-Lytton had made the point with more orotundity in the introduction to his *Last Days of Pompeii* (1834): 'We love to feel within us the bond which unites the most distant eras – men, nations, customs perish; THE AFFECTIONS ARE IMMORTAL!' So too with *Psyche in the Temple of Love* (1882; Plate 170): a mythical tale, and a make-believe world of marble and splashing fountains, but at heart a young girl thinking about her boy-friend, and showing just a little more flesh than a Victorian girl would in such circumstances.

These painters became secure in public esteem. Leighton and Poynter were both Presidents of the Royal Academy; Poynter and Alma-Tadema were both knighted; Alma-Tadema was appointed to the Order of Merit. Leighton was given a baronetcy and shortly before his death was raised to the peerage; he remains the only painter to have received this honour. Yet even this establishment trio should not be casually lumped together. The habit has grown up of grouping them under the label 'Olympians',[34] but it should already be clear that this is misguided: there is nothing Olympian about Alma-Tadema, and very little about Poynter. Yet the three do at least have this in common, that they are middlebrow grandees; there was much Hellenism in the later nineteenth century, as we shall discover, of an altogether different kind. Disraeli was remarkably prescient when he made fun of middlebrow Hellenism in *Lothair*: Mr Phoebus, who is plainly modelled upon Leighton, at least in part, is described as 'the most successful, not to say the most eminent, painter of the age'.[35] It was too early to say that of Leighton in 1870, when he was still not quite forty, but Disraeli seems to have sensed which way the wind was blowing; unless, which may be the case, what he says of Phoebus is merely a flourish

168 Poynter, *A Visit to Aesculapius*: frieze-composition, but with domestic touches.

169 Poynter, *A Corner of the Market Place*: daily life amid the marble.

typical of a novel in which everyone is immensely rich, ravishingly beautiful or brilliantly intelligent.

But at all events his satire, fantastical though it may be, is suggestive. Let us then follow Lothair to the sculpture gallery of an aristocratic mansion near London. Beside him is the mysterious Theodora, an Italian revolutionary for whom he feels a remote and rapturous adoration, and they are inspecting a new statue representing the Genius of Freedom:[36]

> Though veiled with drapery which might have become the Goddess of Modesty, admirable art permitted the contour of the perfect form to be traced. The feet were without sandals, and the undulating breadth of one shoulder . . . remained uncovered. One expected with such a shape some divine visage. That was not wanting; but humanity was asserted in the transcendent brow, which beamed with sublime thought and profound enthusiasm.
>
> Some would have sighed that such beings could only be pictured in a poet's or an artist's dream, but Lothair felt that what he beheld with rapture was no ideal creation, and that he was in the presence of the inspiring original.
>
> 'It is too like!' he murmured.

247

The clinging drapery reveals the body, yet it might have done for a statue of modesty – on a simple level Disraeli is laughing at modern hypocrisy. But Lothair's situation is more complicated; for here is the Pygmalion syndrome once more. He is in the presence of both Theodora as statue and Theodora in the flesh; and (a further complication) the statue itself has a double character. From one point of view, as he looks on the marble, he is looking on the woman whom he loves in a state of near nakedness; from another, he is looking at a statue, and one of abstract rather than personal significance, since it is supposed to symbolize freedom, not represent an individual. Is he seeing an abstraction or a person, a statue or a woman? And there is another paradox or uncertainty. She is both goddess and mortal: the divine visage is not wanting, but humanity is also asserted. Phoebus will pick up the theme: she is 'the Phidian type', he says; 'I believe Theodora has inspired as many painters and sculptors as any Aryan goddess. I look upon her as such, for I know nothing more divine.' The worshipfulness, the mixture of remoteness and accessibility – these are the ideas that we found surrounding the Pygmalion myth.

At this point Lothair's reverie is broken by a stranger, 'of countenance aquiline but delicate', with profuse chestnut curls; it is Phoebus himself:

> A thick but small moustache did not conceal his curved lip or the scornful pride of his distended nostril, and his beard, close but not long, did not veil the singular beauty of his mouth. It was an arrogant face, daring and vivacious, yet weighted with an expression of deep and haughty thought.
>
> The costume of this gentleman was rich and picturesque. Such extravagance of form and colour is . . . rarely experienced in what might still be looked upon as a morning visit in the metropolis.

Despite some obvious differences, this description owes much to Leighton. Its significance is that the great painter must look the part: he must not only be physically magnificent, but dressed differently from those around him, and this not in bohemian fashion, but with a superb worldliness. Phoebus can carry off the role, as Thackeray's Gandish could not; or to turn from literature to life, Leighton triumphed where Haydon failed.

Lothair asks what are the true principles of art, and Phoebus replies:

> ARYAN principles . . . ; the art of design in a country . . . where the laws, the manners, the customs, are calculated to maintain the health and beauty of a firstrate race . . . these conditions obtained from the age of Pericles to the age of Hadrian . . . , but Semitism began then to prevail . . . Semitism has destroyed art; it taught man to despise his own body, and the essence of art is to honour the human frame.

Phoebus explains that Italian painters did great things because 'the Renaissance gave them Aryan art, and it gave that art to a purely Aryan race. But Semitism rallied in the shape of the Reformation, and swept all away. When Leo the Tenth was Pope, popery was pagan; popery is now Christian and art is extinct.'

170 Poynter, *Psyche in the Temple of Love*: an opulent setting for everyday sentiment.

This is again prophetic: Leighton was to lecture on Aryan principles a dozen years later. But when he wrote, Disraeli was probably thinking in large part of Matthew Arnold's discussion of Hellenism and Hebraism in *Culture and Anarchy* (1867–9). Yet Phoebus's views are not exactly Arnold's, as we learn in the sequel. Lothair confesses his ignorance, and Phoebus replies,

> Do not regret it. What you call ignorance is your strength
> . . . The essence of education is the education of the body.
> Beauty and health are the chief sources of happiness. Men
> should live in the air . . . To render his body strong and
> supple is the first duty of man . . . What I admire in the order
> to which you belong [i.e. the aristocracy] is that they do live
> in the air, that they excel in athletic sports; that they can only
> speak one language; and that they never read. This is not a
> complete education, but it is the highest education since the
> Greek.

Now this is a description not of Hellenism, as Arnold described it, but of those whom Arnold called the barbarians: the upper classes, robustly contemptuous of intellect. Partly Disraeli is satirizing (rather acutely) Arnold himself, who neglected the Greeks' admiration for sheer physical skill and beauty; partly he seems to suggest that Leighton, for all his high art and aloofness from popular sentiment, is at heart a middlebrow painter for a middlebrow public. It is a shrewd judgement, which returns us to what Leighton, Poynter, Alma-Tadema and their imitators have in common. But the later nineteenth century also saw the flowering of a very different kind of Hellenism, in which visual art became entwined with the most sophisticated literature and the most modish ideas. To that we shall now turn: we have been dignified long enough, and it is time to decay.

CHAPTER SIX

The Aesthetic Mood

Walter Pater had a broad bald head like a cannon-ball, heavy features, a walrus moustache, and according to Max Beerbohm dogskin gloves of too *bright* a colour.[1] He did not look like an aesthete, or a man of subtle sensibility; yet he it was who entranced a generation by advocating a life of glamorous aesthetic hedonism. In the notorious 'Conclusion' to his *Renaissance* he wrote that a man's one chance lies in expanding the interval that remains to him before death, 'in getting as many pulsations as possible into the given time'.

> Great passions may give us this quickened sense of life, ecstasy and sorrow of love, the various forms of enthusiastic activity . . . which come naturally to many of us. Only be sure it is passion — that it does yield you this fruit of a quickened, multiplied consciousness.

And again:

> Not the fruit of experience, but experience itself, is the end. A counted number of pulses only is given to us of a variegated, dramatic life . . . How shall we pass most swiftly from point to point, and be present always at the focus where the greatest number of vital forces unite in their purest energy?
> To burn always with this hard, gemlike flame, to maintain this ecstasy, is success in life. In a sense it might even be said that our failure is to form habits . . .

Pater himself, a reticent man, lived quietly in Oxford, teaching problems in Plato and Aristotle to the undergraduates of Brasenose College and brooding wistfully over the athletic grace of the handsomer young men. It does not seem a dramatically variegated

251

existence, nor will it strike most people as a life pulsing with ecstasy. Yet his influence was enormous; in some way his writings must have answered to the needs and aspirations of his time. They have been adored and loathed, devoured and despised; éven among his admirers, there is division between those who believe him to have had a consistent philosophical position, carefully worked out, and those who consider that though we may go to him for style and mood and the appreciation of beauty, he is not to be taken seriously as a thinker. But however we judge him, it cannot be denied that he was a subtle and equivocal performer, whose themes are easily distorted when they are simplified. Still, we shall have to take the risk: though he deserves a slow analysis, our concern must be principally with his relation to the visual culture of his time.

His first book, *Studies in the History of the Renaissance*, or *The Renaissance* for short, published in 1873, was a collection of essays written over the previous seven years; despite its title and apparent theme, it is almost as much about ancient Greece as the Renaissance, or at least about how men have approached the Greek spirit in the past and might approach it again. The last essay in the book, but the first to be written, abandons the Renaissance altogether to discuss Winckelmann, included, so Pater said, because 'by his Hellenism, his life-long struggle to attain to the Greek spirit, he is in sympathy with the humanists of an earlier century'.[2] The earliest phases of the Renaissance, Pater remarks, 'have the freshness which belongs to all periods of growth in art, the charm of *ascêsis*, of the austere and serious girding of the loins in youth.' Not only is *ascêsis* a Greek word, but the association of Greece with young athleticism and the notion that Greek civilization had been the youth or childhood of the world were recurrent themes in Victorian thought. Botticelli's *Birth of Venus*, Pater says, will give one 'a more direct inlet into the Greek temper than the works of the Greeks themselves even of the finest period'.[3] In his chapter on Leonardo da Vinci Greece reappears in a paragraph on the Mona Lisa which became a sacred text of the decadence:

The presence that thus rose so strangely beside the waters, is expressive of what in the ways of a thousand years men had come to desire. Hers is the head upon which all 'the end of the world are come,' and the eyelids are a little weary. It is

beauty wrought out from within upon the flesh, the deposit, little cell by cell, of strange thoughts and fantastic reveries and exquisite passions. Set it for a moment beside one of those white Greek goddesses or beautiful women of antiquity, and how would they be troubled by this beauty, into which the soul with all its maladies has passed! All the thoughts and experience of the world have etched and moulded there, in that which they have of power to refine and make expressive the outward form, the animalism of Greece, the lust of Rome, the reverie of the middle age with its spiritual ambition and imaginative loves, the return of the Pagan world, the sins of the Borgias. She is older than the rocks among which she sits; like the vampire, she has been dead many times, and learned the secrets of the grave; and has been a diver in deep seas, and keeps their fallen day about her; and trafficked for strange webs with Eastern merchants: and as Leda, was the mother of Helen of Troy, and, as Saint Anne, the mother of Mary; and all this has been to her but as the sound of lyres and flutes, and lives only in the delicacy with which it has moulded the changing lineaments, and tinged the eyelids and the hands. The fancy of a perpetual life, sweeping together ten thousand experiences, is an old one; and modern thought has conceived the idea of humanity as wrought upon by, and summing up in itself, all modes of thought and life. Certainly Lady Lisa might stand as the embodiment of the old fancy, the symbol of the modern idea.

We have reached a pivotal moment: Pater is at once old-fashioned and prophetic. A repeated theme of his is that ancient Greece was simple, pure, youthful and innocent: he touches upon it even while describing the Mona Lisa, as he pictures the sculpted women of antiquity, into whom the soul with all its maladies has not yet entered. This idea of a Hellas radiant, white and calm, against which the coloured turbulence of a later age is contrasted, takes us back to the German romantics of the late eighteenth and early nineteenth century, to Winckelmann and Schlegel; by 1870 it should have seemed dated. But the book also looks forward: it marks the beginning of the end of Victorianism. When Yeats produced *The Oxford Book of Modern Verse*, he printed part of Pater's description

of the Mona Lisa in irregular lines, as though it were *vers libre*, and put it first in the collection, for it was here, he claimed, that modern poetry began. The culture of the later Victorian age takes on a strongly Hellenic colouring, much stronger than the mid century. We shall find things in the art of the time that seem to hark back to romantic Hellenism; always, however, with some change of tone or nuance. Pater, returning to Winckelmann's Hellenism and yet infusing it with strange new hues, is both a symbol and a harbinger of this.

At the centre of this aesthetic scripture, then, is Hellenism, but as one term only in a contrast between innocence and troubled knowledge, the ancient world and the modern, colour and whiteness, sculpture and painting. What Pater offered his contemporaries was the idea of picking the choicest fruits of all periods and mixing them into a richly delicious salad. It could be done refinedly; or it could be done with a self-conscious decadence, as by the hero of Oscar Wilde's *Picture of Dorian Gray*, who seeks to savour the words and life and lusts of every age. But there is something of the snake about Pater: each time we think that we have grasped his purport, we find that we are clutching an empty skin, sloughed off, while a glittering new meaning slithers away into the undergrowth. Here he is not only making a contrast, rather in the manner of Schlegel, between the ancient world and the modern world (which in this case would include the Renaissance) and then stirring them into an eclectic blend of his own; for he has introduced an elaborate eclecticism into the Mona Lisa herself. He has contrasted her with Hellenism, and yet he has also subsumed Hellenism into her; and not Hellenism alone, but Christianity and the Middle Ages too: she has been Leda and she has been St Anne. And there is still more: the snake casts yet another skin. This eclecticism seems not merely aesthetic, not just 'art for art's sake', to use the phrase that Pater made famous: it suggests both religiosity and eroticism, indeed a perverse eroticism. The animalism of Greece, the lust of Rome, the sins of the Borgias, the vampire, and the grave; Leda and St Anne, the saint and the sex object; Mary and Helen, the virgin and the adulteress – what is Pater really saying?

Is there not something hidden here, something unspoken? Now part of his meaning is that the painting itself eludes precise understanding: we feel some malady, some morbidity in it, but we cannot

put our finger upon the spot. We may doubt, though, whether his interest was exclusively in analysing the art of the fifteenth century; W.H. Mallock, at least, sniffed out a fishy smell, as he made plain in *The New Republic*, the fiercest and funniest of Victorian satires, in which Pater is caricatured as Mr Rose, a name chosen because of a place in one of his early essays where he asked who would change 'the colour or curve of a rose-leaf' for 'that colourless, formless, intangible being . . . Plato put so high'.[4] 'He talks always in an undertone,' another character says of Mr Rose, 'and his two topics are self-indulgence and art.' He is interested in Greek art, but not quite innocently: 'What a very odd man Mr Rose is!' says the naive Lady Ambrose. 'He always seems to talk of everybody as if they had no clothes on.'[5] In due course he expounds his philosophy:[6]

'Would not all life's choices and subtler pleasures be lost to us, if Athens did not still live to redeem us from the bondage of the middle age, and if the Italian Renaissance – that strange child of Aphrodite and Tannhäuser – did not still live to stimulate us out of the torpor of the present age? What, but for history, should we know . . . of the *Charis* of Greece, of the lust of Rome, of the strange secrets of the Borgias? . . . Think of the immortal dramas which history sets before us; . . . of the exquisite groups and figures it reveals to us of nobler mould than ours – Harmodius and Aristogeiton, Achilles and Patroclus, David and Jonathan, our English Edward and the fair Piers Gaveston *hama t'ōkumoros kai oïzuros peri pantōn*, or, above all, those two by the agnus castus and the plane-tree where Ilyssus flowed,' – Mr Rose's voice gradually subsided, – 'and where the Attic grasshoppers chirped in shrill summer choir.'

The list of male lovers reveals what Pater, in the paragraph on the Mona Lisa at least, does not reveal: the speaker's homoeroticism.

Mallock was right, of course. What matters, however, is not the fact of Pater's sexuality – in itself a subject of merely prurient interest – but the way in which it affected his entire sensibility; and not his alone, for the whole character of aestheticism and the decadence is suffused with homoerotic feeling. This is not to say that the principal spokesmen of the aesthetic movement were all

homosexual; a fair number were – Pater, Wilde, Symonds – but others were not. Nor was the decadence necessarily decadent in a moral sense. The term is difficult to define; suffice it here to say that part of its charm was its actual elusiveness as a concept: if you embraced the decadence, your tastes might seem very pure or very contaminated or both at once, and it was sometimes not easy to say whether the purity or the contamination was aesthetic or moral. We have seen that it was Pater's style to blur things, and one of the allurements of his hedonism was a blurring of aesthetic and moral categories.

He wrote of the Renaissance 'putting forth in France an aftermath, a wonderful later growth, the products of which have to the full that subtle and delicate sweetness which belongs to a refined and comely decadence'.[7] Once again we must remember the caveat that his apparent meaning is not necessarily his whole meaning; but his primary import here is that once a culture reaches a certain stage of development, it can no longer be heroic, grand and simple, but must seek instead for subtle, complex and self-conscious forms of beauty. Epic poetry, for example, gives way to lyric poetry, mighty scale to delicacy and concentration. Much of Pater's novel, *Marius the Epicurean*, set in the Rome of the second century AD, explores the possibilities and difficulties of creating literature in a very sophisticated society, with centuries of civilization already behind it; and of course, though he is writing about the ancient world, he has one eye on his own comparably 'decadent' age.

So decadence can be a term used more or less dispassionately to describe what is taken, rightly or wrongly, to be a stage in a pattern of development to which civilizations naturally conform. Yet the word seldom remains quite colourless. At all events, the decadence of the *fin de siècle* is tinged with the hues of homoeroticism; it has the spice of outlawry about it. That spice might provide a purely aesthetic *frisson*, to be enjoyed by those whose lives were blamelessly conventional; but we should be conscious that the flavour is present, none the less.

For those who were indeed homosexual, an attraction of ancient Greece was that it offered a way in which a dangerous subject could be broached, or forbidden fantasies indulged. This is a large theme; our concern must again be simply with where it impinges on the visual arts. In Pater's *Renaissance* it comes out mainly in the essay

on Winckelmann, partly in the picture of the German's 'romantic, fervent friendships with young men' and partly through the reverie into which Pater is led by contemplating the Elgin frieze, 'that line of youths on horseback, with their level glances, their proud, patient lips, their chastened reins, their whole bodies in exquisite service'.

This homoeroticism comes closest to the surface in a later essay on the male nude in Greek sculpture, 'The Age of Athletic Prizemen'.[8] Thus of Myron's Discus-Thrower he writes, 'The face of the young man, as you see him in the British Museum for instance, with fittingly inexpressive expression, (look into, look at the curves of, the blossomlike cavity of the opened mouth) is beautiful, but not altogether virile.' The panting syntax, with its parenthesis, its repetitions, its gasping commas between preposition and noun, pulsates with sexual excitement. And this sentence introduces us to another characteristic of such homoerotic Hellenism: the element of sheer fantasy. Pater seems to be so precise, indicating exactly which of the various copies of Myron's lost original he has in mind; but the reader who rushes to the British Museum in the hope of a thrill is likely to be disappointed. Indeed, since we know none of the works of Myron and Polyclitus except through stiff copies of much later date, there is implausibility in Pater's claim to know so accurately their effect.

Yet fantasy seems to be at the heart of his enterprise, not just a flourish added to a core of sober scholarship. Whenever he speaks of Greek sculpture, he makes much of its colourless purity, its childlike innocence. On one level this was to use the confusion between aesthetic and moral values to justify what the world condemned – a male's admiration for the male body; but it was more than that. He wrote that the Venus de Milo was 'in no sense a symbol, a suggestion of anything beyond its own victorious fairness';[9] in other words, she is complete and autonomous in herself, at the opposite pole from the Mona Lisa, who suggests to him a multitude of literary meanings. He lingers over the whiteness of Greek sculpture, the absence of expression in the faces. The whiteness, the blankness are like a sheet of paper on which nothing has yet been written; and therein lies the charm. We are back with a version of the Pygmalion idea: the spectator can project into the statue what soul, what sensations he will; the 'patient lips' of those

youths, their 'bodies in exquisite service', wait patiently to serve the erotic imagination.

However, there is a change of nuance in Pater's later writings. His *Renaissance* blurred the boundaries between things which the German romantics had seen as distinct; but it seems comparatively sharp-edged when set beside what he was to write afterwards. The beauty of the Greek statues was a sexless beauty, says the earlier Pater; such a claim would hardly seem possible in 'The Age of Athletic Prizemen'. The earlier Pater uses the metaphors of light and childhood – hackneyed in themselves – to characterize Greek civilization. Later they are delicately qualified: the sunlight is momentarily dimmed, childhood passes into the anxieties of adolescence. 'A certain melancholy,' he says of those sculpted youths, '. . . is blent with the final impression we retain of them. They are at play indeed, in the sun; but a little cloud passes over it now and then . . .' In the essay on Leonardo he puts the marble women of antiquity into contrast with the Mona Lisa in being unaware of the soul with all its maladies; what will he say of the athletic prizemen? Elegantly he equivocates, saying one thing and then apparently saying the other: 'Assuredly they have no maladies of the soul any more than of the body . . . But if they are not yet thinking, there is the capacity of thought, of painful thought, in them, as they seem to be aware wistfully.'

The absolutisms of earlier generations had grown wearisome: the purism of the Greek Revival, Pugin's fanaticism, Ruskin's prophetic rage. How agreeable, for a change, to pick and choose among many styles of art; and further, what sophisticated delight in defining the character of a style or civilization and then making faint (oh so faint) qualifications. This is the technique that Pater uses again and again in his later writings, turning it sometimes upon visual art, sometimes upon the realm of ideas. In the words with which he began 'The Age of Athletic Prizemen', 'It is pleasant when, looking at medieval sculpture, we are reminded of that of Greece; pleasant likewise, conversely, in the study of Greek work to be put on thoughts of the Middle Age. To the refined intelligence, it would seem, there is something attractive in complex expression as such.' The refined intelligence – that is what we are now to cultivate. Moralism has had its day.

Marius the Epicurean describes an old, complex, accumulated

civilization; yet freshness and newness are also in it, for we are present at the infancy of the Christian church, the birth of the Middle Ages. A short story, *Apollo in Picardy*, describes how the Greek god is reborn in medieval France and infuses the Gothic building of the time with an antique dignity. In his book on Plato Pater sees in the philosopher's aesthetics the character of Dorian architecture; yet they also put him in mind of the great churches of Bourges and Rouen.[10] How piquant to discover Hellas in *la douce France* or amid the verdure of Somerset; Pater does so in 'The Age of Athletic Prizemen', indulging the fancy that the carvers of Wells and Auxerre had received influence from Italy, and thence ultimately from Greece itself. Conversely, when we examine the technical imperfections of early Greek work, 'How precisely Gothic is the effect!' He even takes an archaic marble, the Hermes Kriophoros, and in his imagination lifts it into an empty niche of a Gothic cathedral, trying out its appearance. The marbles of Aegina remind him of the Middle Ages, and not of the Middle Ages alone but of the point where they in turn pass into the early Renaissance; one penumbra is imposed upon another. This is a way of talking and thinking which makes it possible to link the physical with the abstract, art with philosophical and theological ideas. 'The Age of Athletic Prizemen' ends by taking a single statue, the Discobolus at Rest, and drifting away from it into a glowing blur of semi-religious sentiment, part Hellenic, part Old Testament, part Christian:

Take him, to lead you forth quite out of the narrow limits of the Greek world. You have pure humanity there, with a glowing, yet restrained joy and delight in itself, but without vanity; and it *is* pure. There is nothing certainly supersensual in that fair, round head, any more than in the long, agile limbs; but also no impediment, natural or acquired. To have achieved just that, was the Greek's truest claim for furtherance in the main line of human development. He had been faithful, we cannot help saying, as we pass from that youthful company . . . he merited Revelation, something which should solace his heart in the inevitable fading of that. We are reminded of those strange prophetic words of the Wisdom, the *Logos*, by whom God made the world, in one of the *sapiential*, half-Platonic books of the Hebrew scriptures: — 'I was by him, as

one brought up with him; rejoicing in the habitable parts of the earth. My delights were with the sons of men.'

The way that Pater treats the art of past ages may encourage us to look for connexions between the art of his own time and his ideas about how men should live and think. It would be wrong to deny him originality, but like some other original people, part of his skill lay in an ability to grasp the possibilities of the time, to perceive a current, to give shape and colour to what people were thinking – or would like to think, if only they were shown how. It should be no great surprise, therefore, to find others playing Pater's eclectic game of mingling diverse cultures, or seeing one culture through the eyes of another; and this game, which he so elaborated, can be quite simple, humorous and unpretentious. In 1862 Burne-Jones designed some tiles depicting sombre Greek myths: Paris and Helen's adultery, Theseus' slaughter of the man-eating Minotaur (Plates 171 and 172). But the result is not sombre at all: in his hands the stories pretend to be medieval and become prettily *faux-naïf*. Theseus is dressed as a young squire; the Minotaur pops his head round from behind a wall like a naughty child playing hide-and-seek; a few bones are scattered among the flowers

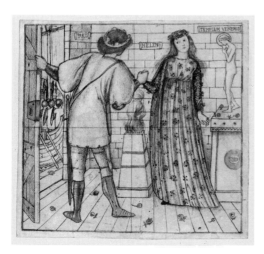 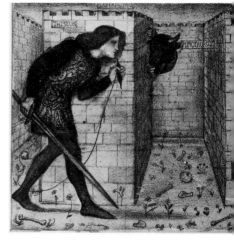

171 and 172 Burne-Jones treats Greek mythology with mock-medieval quaintness: *Paris and Helen* and *Theseus and the Minotaur*.

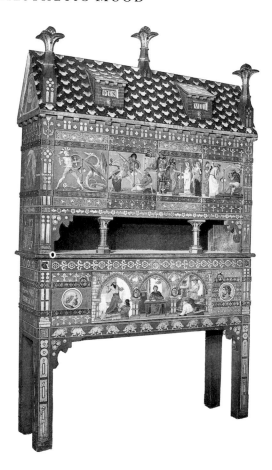

173 Burges, the Yatman cabinet: Hellenism mixed with the middle ages.

like the remains of a picnic. Helen, for her part, turns into a charming damsel, a sweet young thing in a gay flowery dress.

The architect and designer William Burges was a man of very different stamp from Burne-Jones, but he too became fascinated by the idea of mixing Greek and Gothic. The 'Great Bookcase', made for his own home, illustrated 'pagan and Christian art' (fourteen artists shared the task of painting it): among those depicted are Pygmalion, Sappho, Apelles, St John the Divine, Dante and Edward I; at the sides Plato is paired with St Augustine and Orpheus with St Cecilia. An escritoire which he designed in 1858 mixes Greek mythology (Cadmus, Europa and Hermione, for instance),

Greek history (Pericles and Anaxagoras) and the Middle Ages (Dante and Caxton). Here the Hellenic element extends to the style as well as the subjects: the Greek scenes, painted by Poynter, mimic the designs on Greek vases (Plate 173).

A quarter of a century later Wilde was to play upon the Troy story with words much the same game that Burne-Jones had played upon it with images. In his dialogue, *The Critic as Artist*, one of the characters evokes the effect which Homer still has upon the modern reader in this description of scenes from the *Iliad*:

> Yet every day the swan-like daughter of Leda comes out on the battlements . . . In his chamber of stained ivory lies her leman. He is polishing his dainty armour, and combing the scarlet plume. With squire and page, her husband passes from tent to tent . . . Behind the embroidered curtains of his pavilion sits Achilles, in perfumed raiment, while in harness of gilt and silver the friend of his soul arrays himself to go forth to the fight. From a curiously carven chest . . . the Lord of the Myrmidons takes out that mystic chalice that the lip of man had never touched . . .

The subject is a Greek poet, the colouring thickly medieval (leman, squire and page, carven, chalice), the issue the continuing spell of the poem upon the nineteenth century; three periods are blent in a spirit of sophisticated paradox. In another place he remarked that 'the very keynote of aesthetic eclecticism' was 'true harmony of all really beautiful things irrespective of age or place, of school or manner'. 'All beautiful things,' he added, 'belong to the same age.'[11] That was not exactly right: the essence of the eclectic game was to remain aware that one age differed from another, but to tease oneself with the pretence that unlike styles and manners could none the less be fused into one. His playful perversion of the *Iliad* would have had no point if Greek poetry and Gothic art truly 'belonged to the same age'.

A variant of Burne-Jones's game was to be played in turn upon his own work by another artist, Walter Crane. In 1863 he painted *The Merciful Knight*, illustrating a medieval legend about a miraculous crucifix (Plate 174); seven years later Crane produced *The Altar of Love* (Plate 175). The composition is obviously close to Burne-Jones's, but Crane has paganized the theme: in place of wooden

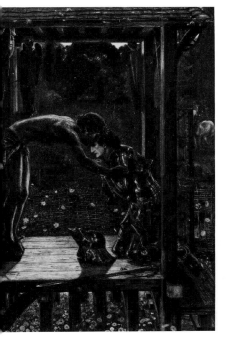

174 and 175 The medievalism of Burne-Jones's *The Merciful Knight* is turned pagan and classical by Crane in *The Altar of Love*.

posts there are classical columns, in place of the crucifix an ideal of fleshly love. And there are also hints of the Orient in the vases, to give the eclectic blend yet more tang. Yet Crane has not lost the medieval flavour altogether: the kneeler's pose, the shape and character of the altar, the pilgrim staff all draw upon Christian iconography. For indeed the elegance of the game lies partly in allowing the nuance of one thing to shadow the presentation of another; to let the taste of an old idea linger after the substance has been dissolved. The relation of Crane's picture to Burne-Jones's illustrates in a small way the shift away from medievalism at this date; but it also reminds us that the new classicism was quite often a matter of surface and decorative detail rather than a full immersion in the aesthetic ideals of the ancient world.

One of the first writers to take up the game of mixing classical and medieval was Swinburne, a poet whom Burne-Jones much admired. As we have already seen, the game can be played in

more than one style; *The Masque of Queen Bersabe* goes mostly for a pretended naivety. King David and Bathsheba (that is, Bersabe) converse in quaint pseudo-medieval English:

> I rede you have no fear of this,
> For as ye wot, the first good kiss
> I had must be the last of his;
> Now are ye queen of mine, I wis . . .

And so on. Then the royal pair watch a masque in which the 'queens' of antiquity appear before them, queens Greek and Roman, Semitic, oriental and barbarian. Theirs is a lush language much unlike that of David and Bersabe:

> I am the queen of Samothrace.
> God, making roses, made my face
> As a rose filled up with red . . .
> My hair was as sweet scent that drips;
> Love's breath begun about my lips
> Kindled the lips of people dead.

And Swinburne being what he is, some of these queens represent perverse or extravagant forms of sexuality: Sappho the lesbian, the nymphomaniac Messalina, Pasiphae who loved a bull. In two senses the poem is a blend. It mixes classical antiquity, the Old Testament, the Middle Ages and the strange luxuries of modern romanticism; and it also mixes childlikeness with an excess of experience, innocence with malady of the soul.

Another of his poems was *Laus Veneris*, a version of the tale of Tannhaüser, the medieval German legend in which a Christian knight is waylaid by the snares of Venus. It was a story with especial charms for the decadents, since even in its original version it sets paganism against Christianity, classical antiquity against the Middle Ages. Swinburne thickens the mixture with his own brand of algolagnic sexuality; here is not the quaint, archaizing type of eclecticism but the aesthetic-sinister. This poem was the inspiration for Burne-Jones's *Laus Veneris* (1873–5; Plate 176), which adds yet another ingredient to the blend: the tapestry behind Venus suggests the Italian Renaissance. The richness of colour, so different from

176 Burne-Jones, *Laus Veneris*: Swinburne in paint.

the greenery-yallery tones that he often used, suggests medieval illumination — and yet does not, for it combines with the crowd-edness of the composition to create an overladen, claustrophobic effect. Within Venus's chamber the hues are very sumptuous: green and hot orange and deep blue and a purplish colour like winestains, or like clotted blood. In stark contrast are the knights outside in the chilly glitter of metal and icy blue. Colour is peculiarly the painter's art; yet these colours seem to reflect what is already in Swinburne's poem. The room, for instance:

> Her little chambers drip with flower-like red,
> Her girdles and the chaplets of her head,
> Her armlets and her anklets; with her feet
> She tramples all that winepress of the dead.

The glimpse that Burne-Jones gives us of the exterior world also seems to draw upon the poem. Tannhäuser thinks upon his fellow knights; the scene has a wintry pallor:

Knights gather, riding sharp for cold; I know
The ways and woods are strangled with the snow . . .

And the light is hard, sharp, sinister:

Sounds and long lights are shed between the rows

Of beautiful mailed men; the edged light slips,
Most like a snake that takes short breath and dips
Sharp from the beautifully bending head . . .

And Burne-Jones also shares with Swinburne a sense of unhealthiness, of moral malady. Venus' setting is gorgeously coloured, but her pose and expression are exhausted, her face bloodless, almost grey, as with a sickness. On closer inspection the two works differ considerably in character: Swinburne's masochism is always hugely exuberant – almost one might say jolly – whereas enervation, etiolation are Burne-Jones's mood. Yet enervation is in the poet's words too:

Her gateways smoke with fume of flowers and fires,
With loves burnt out and unassuaged desires;
Between her lips the steam of them is sweet,
The languor in her ears of many lyres.

Here the lyres are already sounding a few years before Pater's essay on Leonardo; and languor will be a recurrent theme of the decadence. Indeed the fact that the tempers of Swinburne and Burne-Jones were so different added to the differences that must always exist between words and painting, make the resemblances between them the more expressive; each, in his own way, was moving along one of the currents of the time.

Like Leighton's *Nausicaa* and *Captive Andromache*, Burne-Jones's *Laus Veneris* is closely related to a poem; and yet how great is the difference. Leighton draws directly on Homer; and though Greek literature was of absorbing interest to many Victorian writers, he seems to have little connexion with the literary movements of his time, except as an object for ironic observation by the likes of Disraeli and Henry James. When we join the aesthetes, the case is

otherwise: all of them seem to belong to the same milieu, whether they be writers or artists or drones who just beautifully exist. We would not need to know that a painting like *Laus Veneris* had a literary source to see that it belonged in more or less the same sphere as Pater, Swinburne and the rest. On the other hand Burne-Jones's 'classicism' in this picture amounts to no more than the use of a name and a couple of Latin words.

The Lament shows Burne-Jones turning to a classical subject as early as 1866; a modest sign of the way the wind of fashion was blowing at this time. But most of his works, even when they had classical titles, continued to be a mixture of Pre-Raphaelitism, symbolism and the decadence. The face that Leighton and Burne-Jones each painted *The Garden of the Hesperides* means not that there was a community of purpose between the two men, but at most that the Greek myths provided a shared literary stock on the basis of which different images could be made, different ideas embodied. Often the classical element in Burne-Jones hardly goes beyond a name on the picture frame: Peleus or Psyche or Pan. That cannot quite be said of his series of Perseus paintings, however. In *Perseus and the Graiae* (Plate 177) the weird sisters seem to be a trio of Norns escaped from Wagner's *Götterdämmerung*; perhaps he takes some pleasure in handling a classical theme in so unclassical a

177 Twilit myth: Burne-Jones, *Perseus the Graeae*.

manner. But in *The Rock of Doom* (Plate 178) the classical element goes beyond the literary idea and enters the composition itself, for the figure of Andromeda is surely taken from the Venus of Cyrene. One of the beautiful white women of antiquity has descended into the subfusc world of late-romantic melancholy, and the contrast, both of form and colour, between the heroine and the setting in which she finds herself makes the image all the more telling. The idea is carried on in *The Doom Fulfilled*, one of the most powerful of all Burne-Jones's images (Plate 179); the work of a man in whom power seems often lacking. Here at least a combination of classical and unclassical gives him the force he needs.

Burne-Jones belongs in a way with aestheticism, decadence, symbolism and all that; but he grows out of Pre-Raphaelitism, and he has something in common with the middlebrow grandees (he collected a baronetcy): there is so much of statement in his paintings, so much fantasy and escape – into Greek myth, the legend of Arthur, dreams of fair women or whatever. Now it might indeed be said that the aesthetic movement itself encouraged this sort of thing; that the aesthetes were sometimes closer than they knew to the middle-class middle-Victorian culture against which they supposed themselves to be reacting. Pater turns the Mona Lisa into a Victorian painting, laden with literary and historical allusion. But there was a quite different way for a painter to respond to the aesthetic movement, as we see from the career of Albert Moore (1841–93). One side of aestheticism leads away from the anecdotalism of much nineteenth-century art towards purism; another side of it makes the anecdote richer than ever by adding the flavour of decadence or morbidity; Moore is on the purist side. As Swinburne said of his *Azaleas*, 'His painting is to artists what the verse of Théophile Gautier is to poets, the faultless and secure expression of an exclusive worship of things formally beautiful.'[12] Gautier's name was talismanic; he it was who noised abroad the slogan 'l'art pour l'art', taken up by Pater in its English form, 'art for art's sake'. Yet it was an ambivalent name to call upon, for this apostle of pure aesthetics was also the author of *Mademoiselle de Maupin*, a novel in which the worship of the beautiful is mixed up with transvestism and sexual ambiguity. His is a case which shows how near within the aesthetes' world might be purity of one kind to impurity of another. However, it would be wrong indeed to attribute to Moore's

178 and 179 One of the
'white Greek goddesses
or beautiful women of
antiquity' brought into
a darker world:
Burne-Jones, *The Rock of
Doom* and *The Doom
Fulfilled*.

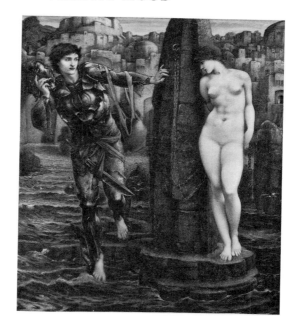

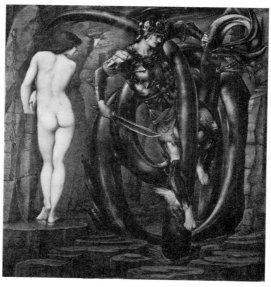

269

paintings the perverse resonances that were seldom far from Swinburne's thoughts; more than most Victorian artists, he is a painter's painter.

Moore looked directly to Greek art for guidance in a way that Burne-Jones hardly ever did. Thus the pose and proportions of the figure in *A Venus* are taken from the Venus de Milo, a fact which is even plainer if the sculpture is seen in mirror image (Plates 180 and 181). The figure in *Battledore*, though clothed, is also patterned upon the same statue; the draperies too are Greek (Plate 182). It

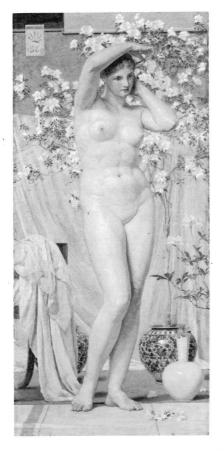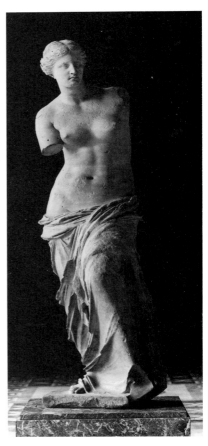

180 and 181 Moore's *A Venus*, though self-consciously two-dimensional, looks back to the Venus de Milo.

182 The Venus de Milo clothed and half-modernized: Moore, *Battledore*.

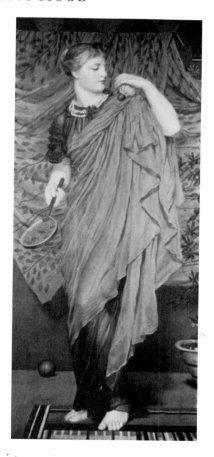

would be going much too far to claim Moore as essentially an abstract artist; but there is an attempt in pictures like these to make the values of pure form and colour paramount. He avoids giving individual features or character to his women, and though he draws on Greek statuary, the handling is almost anti-sculptural: the figures are flat against their background, and we are far indeed from that illusion of three-dimensional solidity towards which Leighton's figures seem to strive. In colour, too, Moore's figures are not in strong contrast with their surroundings, as Leighton's tend to be; instead, he goes for a carefully limited range of harmonizing tones in the manner which Whistler made famous in his 'symphonies'.

But part of Moore's charm and sophistication lies in the way

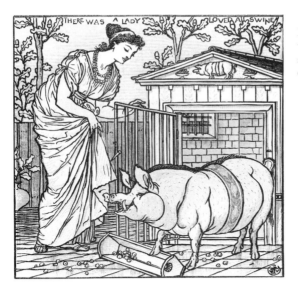

183 Hellenism for the hog: Crane, 'There was a lady loved a swine', from *The Baby's Opera*.

that he blends purism and eclecticism together. The eclecticism is perhaps of two kinds. One of these we have already seen: it lies in the mixture of sculptural influence with characteristics alien to the sculptor's art: flatness of surface and delicacy of colour. The other kind consists of the variety of sources on which he draws. Sometimes his Grecian ladies are given modern appurtenances, like the racquet and shuttlecock in *Battledore*; we have already seen this game carried further in his *Quartet* (Plate 163). That seems to be an ironic comment on the archaeological correctitudes of Alma-Tadema and his kind, but Moore could himself be teased in his turn: in his enchanting book of nursery rhymes, *The Baby's Opera*, Walter Crane picks up the game in what seems half a tribute to Moore, half a parody of him (Plate 183). 'There was a lady loved a swine' – a gracefully drooping Grecian female bends over a majestically gross hog (observe the Hellenic sty *in antis*, with its pig pediment). Moore's languid refinement seems a little bloodless when confronted with a robust animality.

Moore brings together not just different periods but different parts of the world: his Hellenism is mingled with suggestions of the East, and especially of Japan; in his *Venus*, for instance, we catch it in the pottery and the blossom. Now japonaiserie was indeed modish in the later nineteenth century; the fashion was burlesqued in Gilbert and Sullivan's *Mikado*. The influence is plain,

for example, in Whistler's portrait of Mrs Frederick Leyland, *Symphony in Flesh Colour and Pink* (1873), most obviously in the blossom on the left and the few wisps of greenery behind her (Plate 184). It is a painting which has a fair amount in common with Moore, one of the few English painters of whom Whistler had any good to say: for the pink coloration we can compare Moore's *Jasmine* (1881), for the composition his *Azaleas* (1868; Plate 185); the golden-white tones of the latter are unlike Whistler's picture, but Moore clearly shares Whistler's concern with a 'symphonic' range of related hues. Whistler's *Symphony in White No. 3* (1867) has a clear kinship with a painting of which Moore painted three versions, calling it either

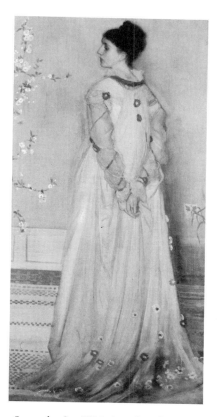
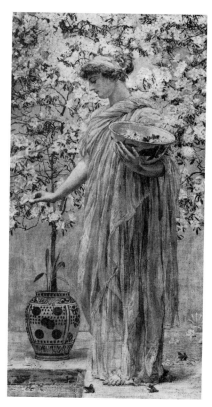

184 and 185 Whistler, *Symphony in Flesh Colour and Pink*, and Moore, *Azaleas*. Two 'symphonies' of similar composition, but Whistler does without Moore's direct allusions to Greece and the East.

Beads or *Apples* (Plates 186 and 187). Though Moore's last version is later than Whistler's picture, it was Whistler who drew upon Moore in this case;[13] as indeed we might expect, since Moore's source for the horizontality of the design is Leighton's technique of frieze composition. There is some irony in Whistler being affected, at one remove, by a painter in whom he can have found little to admire.

Yet the differences between Moore and Whistler are as expressive as the similarities. The Japanese references are more specific, more carefully spelled out by the Englishman; for Whistler the japonaiserie is really a matter of mood and style, for Moore a matter of particular stage properties, like the fan and vases in *Beads*. And the American does not see the need for Hellenism at all; the Old World more naturally takes up the weight of historical reference. It is interesting to compare the experience of the Australian painter Tom Roberts. Born in England and taken to Australia in youth, Roberts returned to his native land to learn his craft. At this time he painted *The Sculptor's Studio* (1885), which shows a modern statuary working from the life to produce a relief in the purest Greek style (Plate 188). The sculptor in the picture is said to be George Frampton, but the

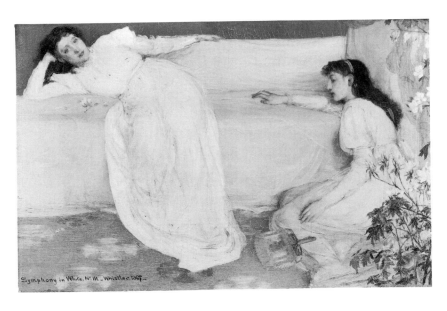

relief is far more Hellenic than is Frampton's actual work; the Hellenism, in other words, is Roberts's own doing, not just a record of what he found other artists making. But once back in Australia, Roberts was not drawn towards Hellenic allusion again.

The contrast between the Englishman and the American may serve to sharpen our awareness that part of Moore's charm lies in the conscious putting together of decorative elements drawn from very different times and places: we sophisticated connoisseurs of art are meant to take a knowing pleasure in seeing that it is an ancient Greek who is playing badminton, a Hellene who has let drop that oriental fan. To recognize the Japanese element in Whistler's art is interesting for the historian of art or culture, but it cannot be said to be necessary in order to get the full value out of his work; but the Greek and Japanese elements in Moore are part of the significance of the paintings themselves. To this extent, therefore, Moore is not exclusively concerned with purely formal beauty: he has put into his pictures allusions which the spectator must identify if he is to enjoy the finer points of the game.

And there is another respect in which Moore is less 'abstract' than he appears at first. He prided himself on not giving titles to

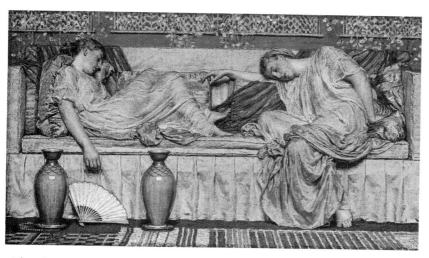

186 and 187 Whistler, *Symphony in White No. 3*, modernizes the composition of Moore, *Beads*, and lessens the languor.

his paintings until they were finished, thus showing that he had no story to tell: he was not illustrating Homer like Leighton or glimpsing life in the Roman Empire like Poynter and Tadema. And indeed it should be plain enough how unlike those painters he is. Yet for all the unlikeness there is a kinship too: though in most ways Moore is closer to Whistler than to those other classicists, there are things which the English painters have in common and which separate them from the American. One of these is the use of classical reference itself; but there is more than that. Moore may have left the naming of his pictures until they were complete, but it is significant that so many of the titles, once given, beckon us to the warm south with the names of fruits and flowers: *Jasmine*, *Oranges*, *Apricots*, *Pomegranates*. We may be reminded of Goethe's evocation of Italy in Mignon's song, verses which crystallize the northerner's yearning for the south, for all that the poet puts them into the mouth of an Italian girl: 'Do you know the land where the lemon-trees bloom, Where the golden oranges glow in the dark leafage . . . ?' In *A Summer's Night* Moore takes Leighton's frieze composition and

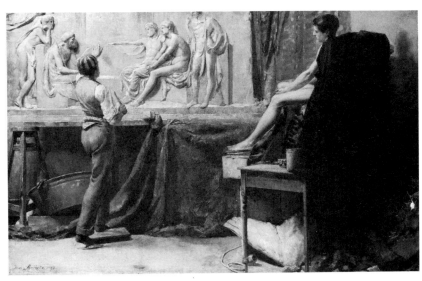

188 Roberts, *The Sculptor's Studio*: while in England, an Australian painter briefly becomes Hellenic.

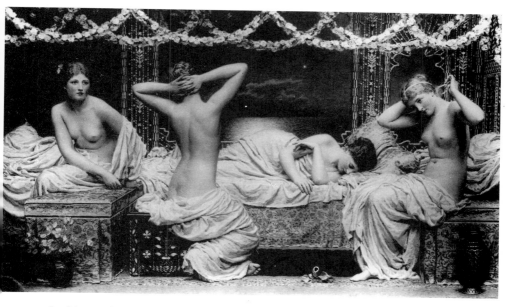

189 Moore, *A Summer's Night* (1890): intimations of elsewhere.

softens its severity, making it a pleasing decorative pattern rather than
a framework of academic rigour (Plate 189). But where are we? Neither
the frieze composition nor the classical draperies in themselves give a
determinate answer; and yet surely, despite vague intimations of the
Orient, there can be little doubt. We are not in England, at least, where
even in midsummer it would be unwise to expose quite so much flesh
at quite so late an hour. Like Alma-Tadema, though with vastly more
sophistication, Moore invites us into a glamorous idyll and bids us escape
with him to Mediterranean joys.

For all his refinement, then, he cannot altogether resist making
half sentimental pulls upon the spectator's emotions. It is revealing
that at the very end of his career he should paint, in *An Idyll*, a
boy and girl courting (Plate 190): here he has come a fair way
towards the genre scenes of Stone and Alma-Tadema. Like Tadema
again, he is fond of conducting us into the inner sanctum of feminin-
ity: we see women together reading, resting, conversing,
undressing. Though he has a reverence for the feminine which keeps
him far from Tadema's keyhole vulgarity, such pictures are still
some distance from the 'exclusive worship of things formally beauti-

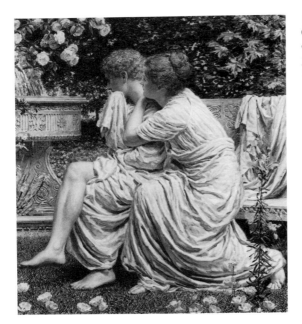

190 In *An Idyll*
(1893) Moore comes
close to the genre
picture; compare Plates
154, 156 and 157.

ful' that Swinburne attributed to him. Above all, he loved painting women slumberous or asleep; of so many of his figures it could be said, far more securely than of the Mona Lisa, that the eyelids are a little weary. Partly, to be sure, this weariness assists Moore's evocation of the south: in pictures like *Midsummer* and *A Summer's Night* we learn from the drowsiness of the figures how hot and sultry the day has been. But languor is a word recurrent in Pater's prose; and we may suspect that slumber is a peculiarly late Victorian rather than a classical theme when we find it taken up by painters of diverse stamp, even by one as robustly respectable as Leighton. He gives it a Hellenic guise in *Cymon and Iphigenia* (Plate 191); we meet it again, otherwise costumed, in Burne-Jones's Briar Rose series of paintings, especially in *The Sleeping Beauty* (Plate 192). An unconscious woman stretched out across a horizontal canvas – in some respects the two paintings are widely different, but they have something in common as well.

Whence this weariness? To answer that it is one aspect of hedonist aestheticism is merely to push the question a stage further back: why does a self-conscious decadence become fashionable at this

278

time? Perhaps we should turn the question on its head and ask why the fashion did not arrive sooner, for the decadent mood had enjoyed a vogue in France and elsewhere on the Continent for many years before its force was felt in England, and some of its roots lie in romanticism. From one point of view it is a witness to the vigour and manliness of mid-Victorian culture that it kept aestheticism at bay for so long. Yet once the aesthetic movement got under way in Britain, its vogue was so great and its effects so lasting that we

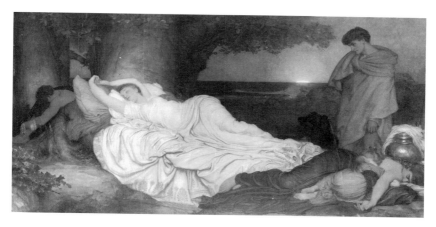

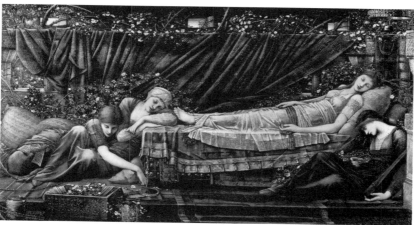

191 and 192 Sleep and languor handled classically by Leighton, *Cymon and Iphigenia*, and with medieval allusion by Burne-Jones, *The Sleeping Beauty*.

are bound to wonder what desires or emotional needs it fulfilled.

Part of the answer may lie in what one can term aesthetic exhaustion. The search for a style, that problem which had long troubled architects, was beginning to affect other arts as well: we can see in the overblown character of French salon painting or late romantic music the symptoms of a style that is coming to the end of its natural life and turning to overemphasis as a substitute for vitality. And at this time people were inclined to think that their civilization had run its course in another way also. Science and technology seemed to be almost complete; soon man would have solved the remaining problems of physics and acquired very nearly as much power over his environment as he would ever be likely to acquire. In this respect our own situation is very different from the Victorians'. We too are the inheritors of a great movement that has blown itself out — in their case romanticism, in ours modernism — but we are aware that the physical universe is vastly more complex and mysterious than our great-grandfathers imagined, while the quickening advance of technology shows us that we are not near the end of a process but standing upon a threshold. Aesthetically we may be in worse case than the Victorians (Is there any great painter or sculptor alive today? Does the best that we can show in music or literature compare with the masters of even the recent past?), but we respond differently: the approaching end of the millennium does not feel like a *fin de siècle*. Moreover, dogmatic religion has not met the rapid end which many Victorian agnostics expected it to meet. In some of them, like Arnold, the prospect of its disappearance induced a melancholy that found aesthetic expression in a pose of weariness; others, like Pater, tried to turn aesthetics into a substitute for religion, worshipping the beautiful in place of God; for others still the disappearance of traditional constraints licensed the kind of decadence that enjoyed advertising its enervation and morbidity.

Aestheticism is a dandy culture, and dandyism, it has been observed, flourishes when a society is in flux:[14] it rebels against an established order, while sustaining a view of life that is essentially aristocratic. In part the aesthetic movement is a reaction against the moral earnestness of the high Victorian period (or to put the matter in Continental terms, against the bourgeois values of the *Biedermeierzeit*), but it needed the existence of those bourgeois values

if it were to flourish, for there is no point in being a dandy if there is no audience to be scandalized (the crude excess of recent punk fashion is a dandyism gone sour, driven to desperation by the difficulty of shocking anyone). At the same time it invited its adepts to join an elite, to feel themselves superior not just to a stuffy establishment but to the common herd. Consciously and unconsciously, the possessing classes felt themselves coming under threat: abroad the rise of Germany and America was challenging Britain's pre-eminence in the world; at home the growth of trades unionism and the stirrings of socialism were preparing, slowly, to change the structures of power. To some, dispirited by the prospect of the future, an aesthetic quietism offered a way to make despondency glamorous; to a younger generation, kicking against the restraints of convention but shying away from fundamental change, the aesthetic movement presented the luxury of conservative values clad in the glittering robes of the *avant-garde*. But aestheticism is a complex phenomenon: at one end of the spectrum it dissolves into moral anarchism; at the other, it becomes yet another bourgeois fashion, to be satirized by Du Maurier in *Punch* or by Gilbert and Sullivan at the Savoy Theatre: in their 'New and Original Aesthetic Opera', *Patience*, 'South Kensington' becomes a cry of rapture.

To catch the cultural tone of the time it is instructive to watch a talented painter without strong individuality trying to form his style in the seventies and eighties; a suitable candidate is available in J.W. Waterhouse (1849–1917). Across twenty years and more he tried a variety of approaches to the ancient world; this is the more significant in that when he finally found the manner that best suited him, it was hardly classical at all. *In the Peristyle* (1874), which shows a small girl feeding pigeons among Doric colonnades, seems closest to Poynter, though the direct influence may have been Alma-Tadema (Plate 193). There is a touch of Leighton too in the grid of verticals which dominates the composition; also in the choice of a Greek setting – and the severest of Greek orders too – in place of the lusher world of Roman grandeur and polished marble commonly preferred by Poynter and Alma-Tadema as a backdrop for their domestic scenes. The title of *Dolce far Niente* (1880; Plate 194), again a Greek setting, was to be used by Alma-Tadema for one of his own pictures two years later. In itself the fact that Waterhouse's painting is the earlier would not be an argument

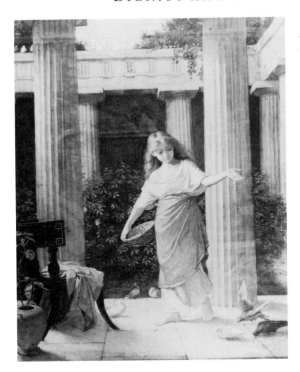

193 Waterhouse, *In the Peristyle*: the school of Alma-Tadema and Poynter.

against Alma-Tadema's influence on him; if anything the reverse, for it suggests that the rules for the fancy-dress game of displaying the life of the modern world in the costume of the ancient were so well understood that painters naturally hit upon the same themes or titles, without detailed imitation of one another. But Waterhouse's guiding light here was surely Moore: we see his influence in the shape of the design, the picture being very wide in relation to its height, in the frieze-like composition, in the choice of a recumbent woman for subject-matter, in the 'symphonic' coloration (the painting is essentially a study in yellow and pink), in the absence of story or anecdote, and in the scattering of just a few decorative stage-properties, fan, flowers, earthenware and sprigs of foliage. Waterhouse does not venture to carry imitation so far as to give these details an oriental tinge, but sticks to the conventional costume-drama: the columns are pure Greek, the sprigs of oleander straightforwardly Mediterranean. But the abstract shapes in the background seem to pay tribute to Moore's concern with pure form and design, while the

jug at the far right perhaps acknowledges Moore's eclecticism: it hardly seems classical.

Daily-life-in-the-ancient-world was of course another theme. Titles like *A Pompeian Shop* or *A Grecian Flower-Market* tell their own story. Sometimes the method of composition is borrowed from Alma-Tadema. In *A Flower Market, Old Rome* (1886), the foreground scene is squeezed into the right side of the picture; an arch on the left side allows a deep recession of perspective and a glimpse of another scene in the distance. The techniques of composing the foreground all on one side, of deep perspective and of a background scene framed by some foreground feature were favourites of Alma-Tadema: *A Coign of Vantage* and *The Frigidarium* may serve as examples. There were grander possibilities also. Waterhouse tried the religious-erotic in *St Eulalia* (1885), depicting the virgin martyr who according to tradition met her end at the age of twelve; in Waterhouse's version she perished a few years later, and wearing very few clothes. He turned to the historical-melodramatic in his *Mariamne* (1887), which shows Herod the Great sentencing his own queen to death; it offered another opportunity to depict a woman in chains.

Ulysses and the Sirens (1891) is a more unusual case, for here it is clear that Waterhouse has patterned himself with some care upon a Greek vase from the British Museum (Plates 195 and 196). The

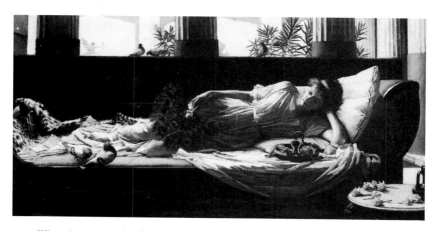

194 Waterhouse, *Dolce far Niente*: composition and stage-properties in Moore's manner.

283

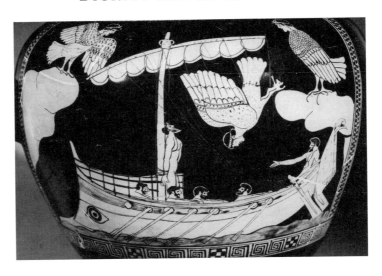

prestige of Hellas comes through in this effort to make Greece a source for the iconography as well as the story. Though the picture is not much like Leighton in style, perhaps his example lies behind this unusually scholarly approach. The painting makes an interesting contrast with H.J. Draper's cheerfully sensational version of the same tale (Plate 197). In order to be faithful to Homer's story – the point of which is that the Sirens were beautiful in voice alone, and otherwise unenticing – Waterhouse has turned down the chance for a feast of girlish nudity; he was not always so restrained.

The Siren, interpreted loosely and not with fidelity to Greece, was a popular subject. Even Leighton painted *The Fisherman and the Syren*, in which a mermaid wraps herself in close embrace around her victim, dragging him to his doom (after a ballad of Goethe – the very best of literary sources, to be sure). Waterhouse himself returned to the theme: *The Siren* (*c*.1900; Plate 198) shows a very young girl, fully human down to the lower legs, where the scales begin to grow, and entirely naked, unless a Greek lyre can be regarded as a form of concealment, looking down with almost blank expression into the sea, where a man is drowning, his eyes fixed in agonized gaze upon her teenage body. This picture brings us back again to the shy temptress, a figure whom Waterhouse had derived from Burne-Jones. In Burne-Jones's own work she is a soft version

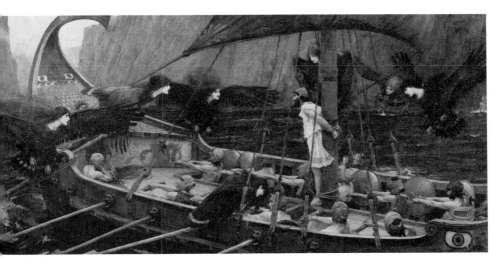

195, 196 and 197 Waterhouse's *Ulysses and the Sirens* is modelled upon a Greek vase painting (*c*.470 BC), while Draper's picture of the same title goes for a fantasy of girlish lust.

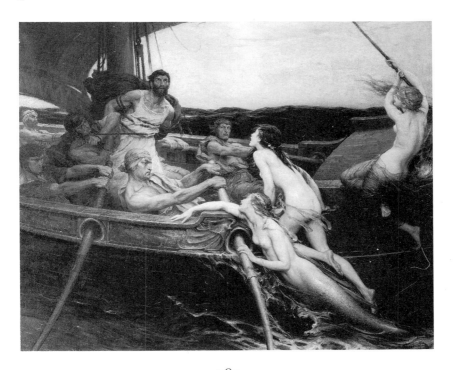

of the *femme fatale*, a creature who haunted the imagination of many writers and artists of the nineteenth century, often represented, in more formidable guise, in the figure of the Medusa, the beautiful destroyer. As with the goddess-victim, the persistence of the shy temptress in the Victorian imagination reveals itself through her reappearance in various dress and shape. She could be classical or medieval: as well as *The Siren*, Waterhouse painted *La Belle Dame Sans Merci* (1893), in which a waif-like melancholy maiden allures an armoured knight in a dim dark wood; this is Keats's ballad interpreted in the spirit of Burne-Jones's Briar Rose pictures. He also painted *Psyche Opening the Door into Cupid's Garden* (1903), which has a Burne-Jonesy ambiguity between modesty and passion; the modesty being in the visual image, the passion in the literary

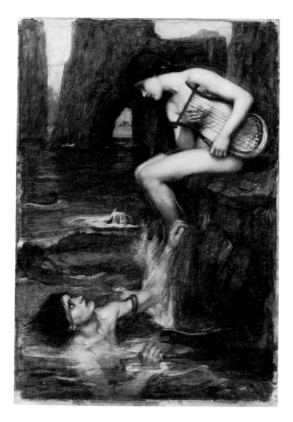

198 Waterhouse, *The Siren*: the shy temptress.

199 Modesty and passion: Waterhouse, *Psyche Opening the Door into Cupid's Garden*.

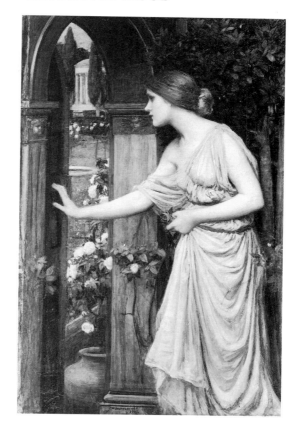

allusion (Plate 199). The picture shows a girl of respectable appearance (she even has her hair in a bun) gently pressing at a garden door with a proper bashfulness; but Psyche is the Greek for soul, Cupido the Latin for desire, and Apuleius' tale of Cupid and Psyche hints at an allegory representing the invasion of the soul by the sexual impulse. The tension between ebullience and repression which we find often in Victorian art manifests itself in varied ways. Sometimes a harmless theme (or so one might have thought it) gets a surprisingly erotic treatment. Sometimes the pattern is the reverse: the image seems mild enough, but the artist invites the literary imagination to find a more exciting message.

The vacant face above a girlish body was an image to which Waterhouse returned again and again. The culmination of this

Post-Pre-Raphaelitism is *Hylas and the Nymphs* (1896); here the shy temptresses have multiplied to seven, their forms and faces scarcely distinguishable one from another, so drained are they of character and individuality (Plate 200). Like Pygmalion's statue they are blank spaces within which male fantasy can expand, but like the Siren they are also destroyers, drawing their young victim down to a watery doom. And this picture suggests a further question: how Greek is the scene? How English those water-nymphs seem, how English Hylas: he has the face and haircut of an Edwardian undergraduate. The landscape seems thickly English: the brownish waters of the pool, the muddy banks, the sunless summer day (a flag is flowering in the upper right-hand side of the picture, fixing the time of year in late June or July). The setting is barely different from that he used for his northern heroines: his *Lady of Shalott* and *Ophelia* inhabit the same soft, sedgy, sludgy world. This further kind of eclecticism, a blending of Greece and England, echoes through the literature of the *fin de siècle* and the Edwardian age. There was a vogue for a whimsical Hellenic Englishry: writers took pleasure in tinging the ordinary, pleasant English landscape with a numinous otherness. The Greek gods, especially earthy, goatish Pan, keep invading the English countryside: we find this in Flecker, in Saki, in E.M. Forster; we find it parodied by Beerbohm and taken straight by Kenneth Grahame: in *The Wind in the Willows* the Rat and the Mole behold Pan in a setting which is lushly English in its freshness and brilliant greeness, its riotous willowherb, its rose and crab-apples, wild cherry and sloe.[15] Grahame does with words much what Waterhouse had done with paint.

The work of the middlebrow grandees, Leighton, Alma-Tadema and Poynter, seems to have almost no connexion with the literary culture of their time; Disraeli and Henry James might be fascinated by Leighton as a phenomenon, but it would be hard to find writers of any note who shared the aims or outlook of these classical painters. The closer we get to the aesthetes, the more we shall find the concerns of literature and visual art intertwined. Waterhouse – and Burne-Jones too, for that matter – seem to occupy ground somewhere between middlebrow academic art and the aesthetic movement; it is natural, therefore, that as we contemplate their work, the literary parallels should start to appear. The artist who carried aesthetic decadence furthest, Aubrey Beardsley, was in his very

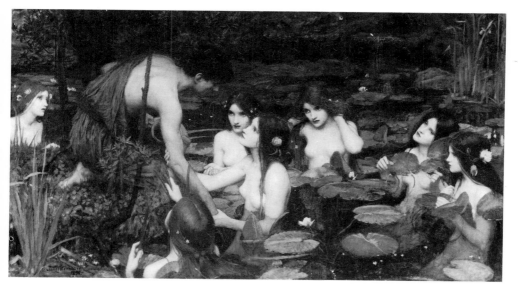

200 Waterhouse, *Hylas and the Nymphs*: Greek temptation in a northern mere.

short career a poet and novelist as well. His best known designs have an affinity with Greek vase painting, which he is said to have admired, and his elegant linearity gives him a sort of kinship even with Flaxman, another admirer of Greek vases, though Flaxman's chasteness of theme is far indeed from Beardsley's intimations of evil.

Nor would Beardsley have sought to be a pure Hellenist: indeed, he too was drawn to the eclecticism of the Tannhäuser story, which we have already seen exploited by Swinburne and Burne-Jones, and seized by Mallock as a means of parodying Pater.[16] Twenty years on, in Wilde's dialogue, *The Critic as Artist*, Gilbert looks forward to hearing the overture to Wagner's *Tannhäuser*: 'Tonight it may fill one with that *erōs tōn adunaton*, that *Amour de l'Impossible*'. The first phrase is Greek, the second French, and both mean 'love of the impossible'; the game is to mix France and Germany and Greece, antiquity and the Middle Ages and romantic art. The Tannhäuser legend was also the basis of Beardsley's erotic romance, *Under the Hill*. In his drawing of Venus between terminal gods, intended for the book's frontispiece, the two deities are obviously classical figures

201 Beardsley, *Venus between terminal gods*: some types of ambiguity.

transmogrified, while in Venus herself one may detect an eclecticism of another kind: the closer one looks at her, the harder it is to decide to which sex she belongs (Plate 201). It is an indication of the appeal of Tannhäuser's story that it escapes from the aesthetes into a quite different sphere: John Collier, Tadema's pupil, handles it with an extremity of silliness in a picture called *In the Venusberg* (1901; Plate 84). The painter has striven to make his Latin-cum-medieval theme more stylish by putting in an inscription written in Greek, but though Collier's father was raised to the peerage, one must conclude that in his hands the cultivated depravities of Wilde and Beardsley have become distressingly middle-class.

The Tone of the Time

Hellenism is in the bloodstream of later Victorian art, seeping into many odd places, suffusing, brightly or faintly, works of very diverse character. We have already seen it as a buttress of middleb-row academic art and as a guiding star of decadence and aesthet-icism. These are worlds which seem far apart one from another, though, as usual, the boundaries are not so clear in practice: Burne-Jones is one example of a man who seems to have a foot in both camps. As we trace the Hellenic idea diffusing itself into the flow of culture we shall meet more of this blurring of boundaries, but we shall also be led on to new terrain: we shall find Hellenism being associated with advanced ideas of a political or social kind; we shall see it used as a peg or support in the search for a style. In architecture and the decorative arts we shall discover the more adventurous employing it as a means towards its own abolition, while to the more cautiously progressive it offers a compromise between his-toricism and modernism. And as a background to all this, lying behind the 'high culture' of the time – the ideas and activities of those artists and designers whose names descend to posterity – we shall see again a classical element in the semi-popular culture of the age, sometimes in the broad tradition, sometimes coloured with a distinctly Hellenic tinge.

By way of transition to these new terrains, we may cast an eye upon the grand and lonely figure of G.F. Watts (1817–1904). 'England's Michelangelo',[1] a newspaper called him, though he pre-ferred to consider himself a pupil of Phidias; with the Elgin Marbles in London, he declared, it was not necessary to visit Italy.[2] The Parthenon sculptures were the abiding passion of his life; yet more than most English painters he also aspired to inherit the great tradition descending from the Italian Renaissance. *Ariadne on Naxos* (1875) combines these two influences (Plate 202). The myth told

how Ariadne was deserted by her lover Theseus; loneliness is at the heart of her distress in most treatments of the story. Watts, however, has allowed part of this effect to be lost by giving her a companion, and no doubt with a particular purpose; for he has modelled the draperies and the composition of the figures on a mirror image of the group from the Parthenon traditionally known as the Fates (Plate 203). But the treatment of the landscape and the rich coloration suggest rather the Italian high Renaissance – Titian and his like; the Greek inspiration has been merged with a rather different influence.

Here then is yet another kind of eclecticism. But *Ariadne* is perhaps not altogether typical of his work. For the most part his eclecticism is of a different sort: a blending of classic and romantic, the south of Europe and the north. A pair of paintings contrasting *The Genius of Greek Poetry* with *The Genius of Northern Poetry* suggests the cast of his thought. In the view of the tirelessly communicative Mrs Russell Barrington, he possessed 'the sense of noble Greek serenity emotionalized into passion by the temperament of the Celt',[3] and his paintings do indeed seem to strive after the virtues which she attributes to them. There seem to be Hellenic touches to *Time, Death and Judgement* (Plate 204): the triangular composition, like the apex of a pediment, the face of Time on the left, the style and sculptural handling of the draperies of Oblivion on the right; but in place of the Apolline clarity of the Greek gods and heroes is cloudy allegory, and the figures are blurred into a vague turbid grandeur suggestive of modern romanticism and a northern sensibility. The phrase 'Celtic twilight' drifts mistily through the mind.

Some of his paintings have nothing classical about them at all beyond the title and the barest outlines of the subject-matter: for example *Olympus on Ida*, a painting in which three fuzzy figures present themselves in poses of majestic nudity. We may suspect that for Watts Hellas answered a need that was as much emotional as purely aesthetic; he was one of those Victorians who found in Greece a source of formless spiritual feeling which one can hardly call religious or mystical without emptying the words of most of their meaning. He visited Athens in a mood of pilgrimage; there he reflected that great art and great nature were one, and contemplated the 'effect of sacredness' which the works of Phidias produced

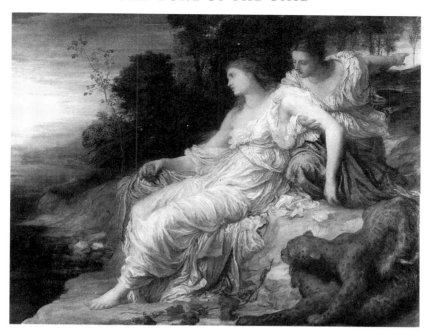

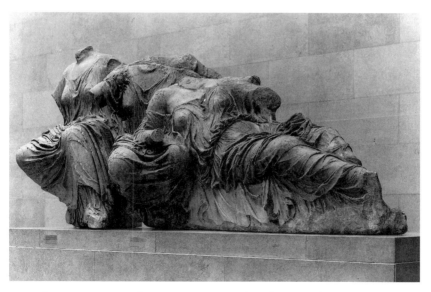

202 and 203 Watts, *Ariadne on Naxos*: colour and landscape are from Italian painting, but the composition derives from the Elgin Marbles.

in his mind. With the eye of faith he beheld the vanished statue of Athena: 'I sometimes feel as if I can see it. The fragments give one a great idea of what Pallas Athene was, probably most spiritual and exceedingly strange.'[4] In similar mood another painter, Sir William Blake Richmond, found himself carried still further by this religionless religion. He was on the island of Delos when he seemed to see a great mass of fire sweep over the heavens: 'It looked,' he wrote afterwards, 'as though the wheels of the chariot of Apollo had . . . wrapped themselves in tortuous spirals around about the empyrean', and as in a vision he believed he could see what was happening at that very moment in his London home.[5]

In Watts's case the grandeur of Greece had as strong an appeal as its spiritual glories. It comes perhaps as no great surprise that this creator of high allegory and titanic immensities was a mild old gentleman, whose life had been shaped or organized for him by a succession of strong-minded women, Lady Holland, Mrs Thoby

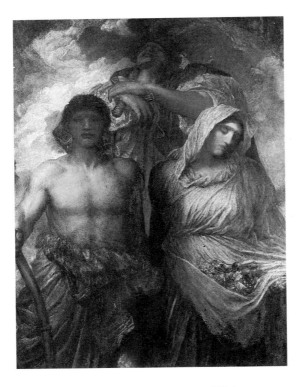

204 Clouded Hellenism: Watts, *Time, Death and Judgement*.

Prinsep, Mrs Barrington, his two wives. Mrs Prinsep was alleged to have pushed him into his first and foredoomed marriage with Ellen Terry, at a time when he was forty-six years old and his bride sixteen. After a few uneasy months they separated, and she then fell for the architect and designer E. W. Godwin (1833–86), with whom she lived, without benefit of clergy, in an ambience of progressive aestheticism. Godwin's beliefs about art and society were interwoven: not only did he support women's suffrage, but he sought to free them from the bondage of the corset; Greek dress should be the model for modern costume, since it was both rational and beautiful. Oscar Wilde tried to spread Godwin's idea: 'Over a substratum of pure wool,' he wrote, 'such as is supplied by Dr Jaeger under the modern German system, some modification of Greek costume is perfectly applicable to our climate, our country and our century.'[6] Wilde's own motives, one imagines, were more aesthetic than political; but indeed the reform of dress provided a pleasant field for moral indignation, allowing one the satisfaction of holding advanced views which posed no threat to the existing forms of society.

Watts himself, who might seem to have had little in common with Godwin beyond an interest in ancient Greece and Ellen Terry, was equally shocked by the corset and became a member of the Anti-Tight-Lacing Society. Indeed, he used Greek sculpture to argue about contemporary dress. It should teach the ladies not to point their fingernails or wear tightly pinching shoes (the female statues of Greece, he noticed, have rather large feet); high heels were to be eschewed on the same grounds.[7] Rather as Regent Street separates Mayfair from Soho without quite having the character of either, so it is tempting to see Watts as the point where the artistic establishment and bohemia met. And yet he seems in some respects an old-fashioned figure even in his own time: his portentous allegories hark back to the spirit of Regency titanism: to Byron in Promethean mood, to Keats dizzied by the rude grandeur of the Parthenon sculptures, to Shelley's cosmic Hellenism, in which vast abstractions scud cloudlike across the face of the void. The romantic poets did not inspire in the artists of their own time an adequate visual equivalent to these emotions; Watts seems belatedly to answer the call. In an odd way he resembles Leighton; not in the form of his art, which shows hardly any similarity beyond a

reverence for ancient Greece, but in his position among the other artists of the time. He stands solitary, and he was 'Olympian'; that is to say, his work was self-consciously lofty in aspiration, and official esteem ranked him among the great: he received the Order of Merit and twice declined a baronetcy. If public honours and the grand manner are necessary conditions for Olympian status, Leighton and Watts meet them alone among the artists of their time.

The Elgin Marbles were 'Watts's teachers', so Mrs Barrington maintained.[8] Like Leighton, he had a cast of the frieze around the walls of his studio; there were more casts above his chimney-piece, their large white monumentality strangely at odds with the informal mixture of Gothic fancy and arts-and-crafts homeliness about them (Plate 205). This curious combination of things represents the eclecticism of the age and suggests the persistence of Hellenism, its habit of intrusion into places where we might not expect it to be naturally at home. Yet perhaps the awkwardness of Watts's chimney-piece has another message as well, hinting that his high rhetoric, his straining after the sublime did not assort easily with the aesthetic temper of the time. Maybe it hints at some discomfort in his very Hellenism, provoking the suspicion that it was in part an attitude too consciously taken up, rather than the natural expression of his artistic bent. In more than one respect Watts is the man who fails to fit in: his involvement with new styles of life and art was not altogether happy, as we see from the sad story of his marriage to Ellen Terry, depicted in one of his most charming paintings, *Choosing*. In the event, she chose Godwin.

Godwin's development as an architect shows which way the wind was blowing. Perhaps that is the wrong metaphor, for he did not just drift with the current of his time but was one of those who helped to shape its aesthetic character. The chief work of his youth, Northampton Town Hall (1861–4), is in a vigorous, full-blooded Gothic style; one might take it for a building by Street or Scott. Startlingly different is a design for 44 Tite Street, Chelsea, made in 1878, which could pass for an early work of Frank Lloyd Wright; indeed it was so radical that the planning authorities insisted on a few concessions to convention. In this design he was not so much turning from Gothic back to the classical tradition as abandoning historicism altogether; and he said himself that he hoped the age of revivals was coming to an end. But as in the time of Soane the

boundary between Hellenism and modernism was blurred. In some respects the Hellenically tinged aestheticism of the late Victorian age looks like the Greek Revival revived; in others it leads on towards the twentieth century; Pater himself seems both timid and bold, a reactionary and a revolutionary all in one. Godwin is a more obviously radical figure than the Oxford don, but in him too there is something intriguingly equivocal about the use of the past to throw off the past.

His private existence was a picture by Albert Moore brought to life. Ellen Terry would dress either in Grecian robes or in a kimono; she and Godwin, anxious to form their daughter's taste upon the best principles, favoured the children's books illustrated by Walter Crane. The walls of their drawing-room in Bloomsbury were white; the hangings were of a grey-blue pattern repeated in the cushions lying on the wicker chairs. In the centre of the room was a cast of the Venus de Milo, before which stood a censer whence issued a few

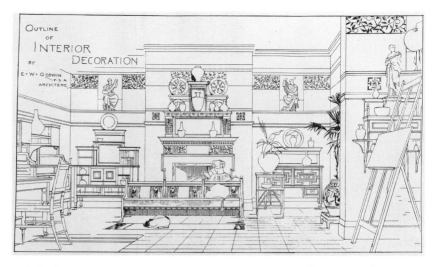

OUTLINE
OF
INTERIOR
BY
DECORATION
E·W·GODWIN
F.S.A
ARCHITECT

206 Godwin, 'Interior Decoration': the reaction against mid-Victorian clutter.

ribbons of blue, curling smoke.[9] His scheme of interior decoration, published in 1881 (Plate 206), reacting against the thickly coloured, patterned, cluttered rooms of the high Victorian age, recalls the cool, bare surfaces and spindly refinement of Thomas Hope's neo-classicism earlier in the century (Plate 207). Still, the differences are as clear as the likeness: though the influence of Greece is not denied – indeed it is asserted in the figures and in one or two of the vases – there are hints of the Orient, and a degree of styleless modernism. The pot on the right, from which a palm is growing, is much like the one in Moore's *Azaleas*. The 'Greek chair' (Plate 208) looks forward to the furniture designs of Charles Rennie Mackintosh, but it also draws upon the Elgin frieze. Though Godwin's interior is a little highbrow, a little bohemian (one wonders what volume the loosely clad lady in the drawing is perusing: some essays by Mr Pater, perhaps, or Swinburne's *Poems and Ballads*), it is humane and practicable, and something like it was to be realized in many middle-class Edwardian households.

Historians of art tend to keep grand company: they move more among easel-painters and sculptors than designers and decorative artists; they are better acquainted with the architects of churches and public buildings than with the journeymen builders who have made the settings in which most of us live. That is perhaps inevi-

table; yet the lesser men may do as much to form the taste of an age. Indeed, they may not necessarily be lesser men at all: today we are still too deferential to a hierarchy of genres; witness the fact that so many bad oil-painters fetch more in the sale-room than a water-colourist of genius like Cotman. In Godwin's case it is part of his originality that he moves between architecture, interior decoration and stage design. In fact, the late nineteenth century seems to be rather specially an age when the most brilliant talent is to be found in the less obvious places; perhaps because it was a time when old forms, old boundaries, old categories were coming under question. Which English artist of the period has the best claim to the title of genius? Surely Beardsley. And conversely Leighton's faults seem to stem from the desire to be an Old Master of an old-fashioned type. Literature tells a similar story; it was an age which did not know itself. Of this period it can be said, as of no other in English history, that its best poetry was produced by a man wholly unknown to his contemporaries; so much so that the name of Gerard Manley Hopkins does not figure in the *Dictionary of National Biography*. Wilde's poetry is mediocre, *Salome* absurd; but *The Importance of Being Earnest* is immortal. I suppose that in the last quarter of the century the four most memorable characters in English fiction are Mr Pooter, Mr Salteena, Long John Silver and

207 Thomas Hope's schemes of interior decoration (1809) have more in common with Godwin than with the style of the mid century.

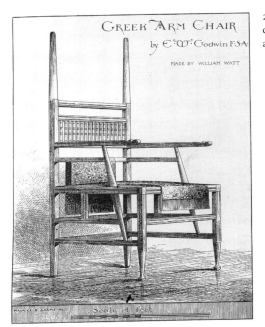

GREEK ARM CHAIR
by E·W·Godwin F.S.A.

MADE BY WILLIAM WATT

208 Godwin's 'Greek chair': the fifth century as a spur towards modernism.

Sherlock Holmes. The last two of these have gained a mythic status, so that it is hard to imagine there was a time before they existed; the first two are comic masterpieces, touched with an accidental pathos. None of them comes in an art novel, and none of their creators, one suspects, fully realized what a masterpiece he had made.

So while the 'minor art' of any age may be illuminating, that of the later nineteenth century is likely to be especially so. Let us go back for a moment to Owen Jones in the middle of the century. Lecturing on the Great Exhibition, he suggested that Stuart and Revett's *Antiquities of Athens* had 'generated a mania for Greek architecture, from which we are barely yet recovered'.[10] That observation reminds us of how long the Greek Revival persisted; but it also suggests that by the 1850s it had finally spent its force. Yet the broad classical tradition went on; and though the Greek Revival in architecture was effectively at an end, except in Scotland, in the decorative arts men like Jones kept alive not only the classical tradition in general but Greek forms in particular. Just as many devout churchgoers, from Queen Victoria downwards, were not

much disturbed by the issues that fiercely divided High-Churchmen, Broad-Churchmen and Evangelicals, so there were artists who went about their business little agitated by those fervours that seethed in the breasts of Pugin, Ruskin or the Pre-Raphaelite Brotherhood. Lacking the passionate exclusivity of such men, Jones was prepared to learn from almost any source: 'From the works of Egypt,' he said, 'we may learn how to symbolize; from those of Greece we may learn purity of form and grace of outline; from the Arabs and Indians, perfection of form . . .';[11] and in his sumptuous volume, *The Grammar of Ornament* (1856), he illustrated all kinds of decorative forms, Greek, Gothic and oriental, with a serene impartiality. As we know, he saw the importance of repetition in decorative art; and his principles were to prevail, in the long run, over Ruskin's heroic but doomed insistence on an endless variety of detail. Ruskin's ideal was a Gothic ideal, and the nineteenth century was to show that the full Gothic ideal could not be

209 Owen Jones illustrates *The Winter's Tale*: Shakespeare as a Greek vase-painter might have seen him.

brought back to life again. You could put up Gothic buildings, certainly; but with rare exceptions the minor craftsman was not able to recover the powers of fantasy and invention that the Middle Ages had given him.

Suppose that one were asked to guess the date and subject of the illustration shown in Plate 209. A well-informed judge would almost certainly guess wrongly; that is, unless he were very well informed indeed. It is one of Jones's illustrations to Shakespeare's *Winter's Tale*, published in 1866, a date not far from the zenith of the Gothic Revival. Of course, there is a touch of mischief in handling Shakespeare, of all people, in so purely Hellenic a fashion; but these pictures cannot be dismissed as merely an isolated oddity, for they are in a decorative tradition that looks back to Flaxman and on to Crane. We have already met Crane making fun of Albert Moore (or someone very like him) in *The Baby's Opera*; the illustration of 'The Four Presents' (Plate 210) in a second book of nursery rhymes, *The Baby's Bouquet*, seems more like a direct tribute to eclectic, aesthetic Hellenism: we observe the frieze composition, the classical columns, the Grecian costume of at least two of the figures, blended with the orientalism of the miniature cherry-tree and the garment of the youth carrying it, while the stool on which

210 Crane, 'The Four Presents' from *The Baby's Bouquet*: between imitation and parody.

the maiden is sitting would not be out of place in one of Godwin's
interiors. But indeed it is one of the charms of Crane's art that we
are left not quite sure where imitation ends and parody begins.
Such playful equivocation is characteristic of the decadent sensi-
bility, with its dandyism, elusiveness and shunning of high serious-
ness. This is not to say that Crane was decadent in a moral sense –
far from it: he was a devout guild-socialist who wrote earnest poems
in praise of Hellas, in which the glories of antiquity were contrasted
with the degeneracy of the modern, industrial world, and prose
works in which he argued that the city states of Greece, democratic
in constitution and humane in scale, offered a pattern for the ideal
society. Artist, designer, poet, socialist – a Hellenic William
Morris, we might call him, did not such works as *The Life and
Death of Jason* show that Morris himself had a Grecian tinge. Though
radical in politics, he was wholly respectable in his private life; his
wife forbade him to paint the female nude from the life, and for
The Renascence of Venus he was obliged to employ an Italian male,
making some rather unconvincing adjustments. 'Why,' said Leigh-
ton, when he saw the picture, 'that's Alessandro!'[12]

In 1887 Crane produced *Echoes of Hellas*, two sumptuous volumes
commemorating an adaptation of Aeschylus' *Oresteia* staged by Pro-
fessor G.C. Warr at the University of London in the previous year
(Plate 211).[13] The printing in black and red invites the reader to
think of Greek vase-painting, and indeed Crane's strong sense of
linear design and his ability to compose gracefully within borders
of any shape seem to owe much to Greek example. *Echoes of Hellas*
brings the aesthetic Hellenism of visual art into association with
theatre, literature and music. It includes translations of parts of
Homer's *Iliad* and *Odyssey* and Warr's abridged version of the *Ores-
teia*, while the second volume contains musical settings by four
different hands. There was in fact a fashion for classical productions
in the 1880s, and not only for Greek plays; for example, Fletcher's
Faithful Shepherdess, a work of the early seventeenth century, was
done in classical costume in 1885.[14] The most spectacular example
of this trend was Godwin's production of *Helena in Troas* in 1886,
the last year of his life. The play was a pastiche of Greek tragedy
by John Todhunter, an Anglo-Irish doctor and amateur folklorist
from Bedford Park, and it opened in the very week in which Warr
was presenting his *Oresteia*. The chorus was clad in chitons of

unbleached calico intended to suggest Pentelic marble; according to the *Morning Post*, the scene was 'like one of Mr Alma-Tadema's pictures magnified and turned into stone'.[15] That may make the production sound straightforwardly middlebrow; which it was not. To recover the spirit of Greek drama, the play was staged not in a conventional theatre with proscenium arch but at 'Hengler's Circus'. The audience included the Prince of Wales, who came with his wife to the first performance, and Oscar Wilde, representatives of two very different style of raffishness. Indeed, one of the fascinations of this Hellenic event was that it provided a common ground upon which aristocracy, middle-class culture and the aesthetic *avant-garde* could meet; as Yeats put it, *Helena* was 'an art product, the appeal of a scholar to the scholarly', and yet it 'filled the theatre with the ordinary run of theatre-goers'.[16]

Wilde attributed the verse form of the play 'more to the courtesy of the printer than the genius of the poet',[17] a remark which is unjust to Todhunter's impeccable scansion, though praise cannot

extend much further. However, he persuaded his wife to appear as one of Helena's attendants; she wore a sea-green chiton fringed with gold, her hair gathered in a knot and bound with a fillet.[18] And he was full of praise for the production itself, which he thought the best example of a 'Greek dramatic performance' ever seen in England.[19] Yeats was even more enthusiastic: in a number of articles written for American newspapers he kept coming back to it, calling it 'an immense success' and 'the talk of the London season'; as an older man he was to confess ruefully that he had 'over-rated Dr Todhunter's poetical importance'.[20] But to be sure, he recognized, then as later, that the piece owed much of its success 'to the wonderful stage — the only exact reproduction of the stage of ancient Athens seen in the world — and the no less wonderful stage management'.[21] Wilde, with the classical training of Dublin and Oxford behind him, put his approval in somewhat different terms: 'The performance was not intended to be an absolute reproduction of the Greek stage . . . : it was simply the presentation in Greek form of a poem conceived in the Greek spirit; and the secret of its beauty was the perfect correspondence of form and matter, the delicate equilibrium of spirit and sense.'[22]

Helena in Troas looked both forwards and back; it is one of those points where Victorianism and the modern movement have a common frontier. Todhunter's text was merely the latest in an uninspiring line of academic Grecian verse-dramas which includes Arnold's *Merope* and Swinburne's *Atalanta in Calydon* and *Erechtheus*; but Godwin's staging was adventurous. Despite his classical approach — or rather, because of it — he anticipated twentieth-century techniques in doing away with the proscenium arch, putting the chorus in the middle of the audience and paring down costume, scenery and movement to a bare simplicity. The stage work of Edward Gordon Craig, Godwin's son and Isadora Duncan's lover, owed something to his father's example. Stravinsky too could be said to have been following where Godwin had led when he demanded that the dancers in his *Apollo* should restrict themselves to 'strictly classical' movements and be dressed in monochrome. And why was Yeats so bowled over? The Yeats family, like Dr Todhunter, were cultivated Anglo-Irish from Bedford Park; but that cannot have been the only reason. The young poet was excited because he saw in *Helena* a way of escape from 'those two slatterns,

farce and melodrama', the staple of Victorian theatre: 'Its sonorous verse,' he wrote, 'united to the rhythmical motions of the white-robed chorus, and the solemnity of burning incense, produced a semi-religious effect new to the modern stage . . . Many people have said to me that the surroundings of *Helena* made them feel religious. Once get your audience in that mood, and you can do anything with it.'[23] In his own plays he sought to revivify the theatre with Irish mythology in the way that Godwin had done with Greek. Athenian drama, he said, had been both cultivated and popular; sanguinely, he seems to have thought that a new Irish drama could be the same.

However, it was not easy to follow in Godwin's footsteps. When Todhunter's next piece, *A Sicilian Idyll*, was given in Bedford Park in 1890, the amateurish imitation of Godwin reminded one critic of a Salvation Army rally, while according to another, Miss Linfield's Bacchic dance 'suggested that the can-can was thoroughly under-stood . . . in Arcadia'.[24] Still, imitation, however poor, is a tribute of a kind; so too is lampoon. Gilbert and Sullivan produced a couple of skits on cultural pretension, *Patience* (1881) and *The Grand Duke* (1896); the differences as well as the similarities between them are interesting. In the earlier piece the predominant tone of the 'fleshly poet' Bunthorne and his aesthetic maidens is a greenery-yallery medievalism, though in Burne-Jonesy spirit there is a light infusion of Hellenic flavouring: 'Oh, forgive her, Eros!' cries one character; and 'Oh, Chronos, Chronos, this is too bad of you!' cries another. Gilbert has also observed how some writers used Hellenism as a means of high-minded prurience: Bunthorne's fleshly poem alludes to 'the amorous colocynth' and

> The writhing maid, lithe-limbed,
> Quivering on amaranthine asphodel.

Only once in *Patience* does Hellenism appear pure and unmixed with Pre-Raphaelite taint, when Bunthorne enters garlanded, accompanied by maidens 'dancing classically and playing on cymbals, double pipes, and other archaic instruments':

> Let the merry cymbals sound,
> Gaily pipe Pandaean pleasure,

With a Daphnephoric bound
Tread a gay but classic measure.

Elsewhere Gilbert's main targets seem to be Rossetti, Burne-Jones, Swinburne and the young Wilde; here Leighton has made his mark: *The Daphnephoria*, one of his largest paintings, had been completed in 1878.[25]

Very similar is the scene in *The Grand Duke* where Ernest Dummkopf's theatrical company enter 'carrying garlands, playing on pipes, citharae, and cymbals',[26] but overall the aesthetic tone in this later work differs from *Patience* in being much more thoroughly Hellenic. Much of the plot is concerned with the duke's plan 'to revive the classic memories of Athens at its best' by recreating the Greek drama, and in one of his songs he gives a lecture about classical customs and costumes, including some fragments of the Greek language, before turning (it was inevitable) to Hellenism's risqué aspect:

Then came rather risky dances (under certain circumstances)
Which would shock that worthy gentleman, the Licenser of
 Plays,
Corybantian mani*ac* kick – Dionysiac or Bacchic –
And the Dithyrambic revels of those undecorous days . . .
Yes, on reconsideration, there are customs of that nation
Which are not in strict accordance with the habits of our day,
And when I come to codify, their rules I mean to modify,
Or Mrs Grundy, p'r'aps, may have a word or two to say . . .
They wore little underclothing – scarcely anything – or
 no-thing –
And their dress of Coan silk was quite transparent in design –
Well, in fact, in summer weather, something like the
 'altogether'
And it's *there*, I rather fancy, I shall have to draw the line.

But how accurately, we may wonder, do these burlesques reflect the tone of the time? Gilbert was sometimes slow off the mark, most startlingly with *Princess Ida* (1884), which made fun of women undergraduates when they had been established in Cambridge for more than a decade, and parodied Tennyson's *Princess*, written more

than thirty-five years before. In both these operettas Gilbert is inclined to mock things that had been the *dernier cri* ten years or so earlier: though Wilde was a new phenomenon when *Patience* was written, Swinburne's first series of *Poems and Ballads* had come out as long before as 1866 and Robert Buchanan's notorious article attacking 'The Fleshly School of Poetry' had appeared in 1871; as for *The Grand Duke*, Leighton's classicism was in full flower in the 1880s, and Godwin's theatrical experiments date from the same period. Yet essentially Gilbert reflects his times well enough; though his targets may not have been brand new, they were still there to be shot at. Besides, eclectic aestheticism had indeed made its mark rather earlier than the more emphatically Hellenic tone that we find, in different guises, in Leighton, Godwin and Crane; the shift from *Patience* to *The Grand Duke* does follow a shift in public taste. But the one style did not simply oust the other: the two continued side by side, sometimes intermingling their currents and gradually descending from the aesthetic heights to irrigate middle-class life; indeed Gilbert and Sullivan's middlebrow entertainments are part of that process. World-weary aestheticism itself became domesticated (that indeed is the burden of *Patience*: everyone is doing it now); and Crane's *Baby's Opera* brought sophistication into the middle-class nursery.

Advertisements provide another sign of the times: here are both the broad classical tradition and touches of the new Hellenism, both

212 'Gaily pipe Pandaean pleasure': Arcadia interpreted in the manner of Crane to sell Cocoatina.

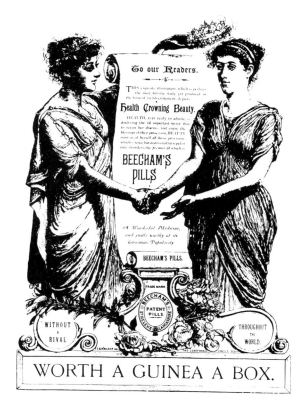

213 Hellas and sound digestion: an advertisement for Beecham's Pills.

vulgarity and some small pretension to culture; the spirit of Mrs Jarley meets aspirations to a new refinement. We find, for example, a design in Crane's manner showing Grecian damsels, just as in Gilbert's descriptions, playing on ancient musical instruments 'In praise of Schweitzer's Cocoatina' (Plate 212). Liberty's went for a Grecian pastoral idyll, as we have already seen (Plate 13). Harness' Electropathic Belt was promoted by a representation of the goddess Hygeia, while Vogeler's Curative Compound displayed a maiden in classical garb with a classical niche behind her standing beside a 'Fountain of Health' (one of her breasts is bare; it should not be thought that this advertising technique was invented in the 1960s). The Chancery Lane Safe Deposit recommended itself with a design of classical columns and pediment, before which stands a statue of 'Minerva, guardian and protectress of wisdom, art and commerce';

and Beecham's Pills showed that in 1890 there was still nothing to beat the Greeks for adding a touch of class (Plate 213): their superior qualities were demonstrated by a picture of two Hellenic ladies and the information that 'This exquisite illustration, which is perhaps the most artistic study yet produced in the form of an advertisement, depicts *Health Crowning Beauty*.'[27] Such are the faint echoes that the valleys return to the peaks of Parnassus.

Architecture, like the other arts, presents a varied and sometimes confusing picture in the later Victorian age. Some of its forms were not classical at all; others can only be called classical by stretching the term a long way. The Queen Anne Revival, so called, owes nothing of importance to the ancient world, least of all in the picturesque form in which it was taken up by Norman Shaw and his school. The Beaux-Arts school has its place in the broad classical tradition, but it owes so much more to the France of Louis XV that it need hardly concern us here. There are, however, a few classical strands which are worth tracing through the complex texture of late Victorian architecture and which show us continuity and change within the tradition. First, though, we need to travel north of the Border, and back some years in time. We have seen that by the 1850s the Greek Revival in England seemed to be at an end; but in Scotland it was still not quite over. And the last stages of the Greek Revival in Scotland are not simply the end of a story; in a curious way they look forward to the later Victorian age.

Now in several countries it seems that the great provincial cities, more sometimes than the national capitals, were the cradles of modernism. When new ideas are abroad, provincialism can sometimes be an asset to an expanding society; the blend of prosperity with a certain separateness can produce freshness and independence: one thinks of Edinburgh in the eighteenth and early nineteenth centuries, or of Dublin in the late Victorian and Edwardian period; in the first century BC it was wealthy and provincial Italy north of the River Po that produced many of the brightest literary talents. In architecture especially, a metropolis, freighted with tradition, conscious of the duty of national pomp, may sense some weight of conservatism imposed upon itself. Provinces have sometimes felt a greater freedom; particularly in the nineteenth century perhaps,

when the industrial revolution was shaking the old hierarchies. The Manchester feeling was in the air: the belief of the new industrial cities that in contrast to the old lazy aristocracies they were doing the work of today and thinking the thoughts of tomorrow.

Modern architecture in America begins in Chicago, metropolis of the mid west but provincial within the nation as a whole. Here the skyscraper was invented; it is no surprise to find Europe's first skyscraper in Antwerp, another provincial, mercantile city. Two buildings dominate its skyline, the tower of the medieval cathedral and the Torengebouw of 1930, and ugly though the latter is, there is something fine in these visible tokens of a continuing bourgeois tradition of sober pride and self-confident progress. Elsewhere in Europe too the great provincial cities were engines of fresh invention. It was in Barcelona, not in royal, rectangular Madrid, that Gaudí built his bizarre fantasies; in Barcelona that the young Picasso, an Andalusian from the far south of Spain, took his first steps as a painter. The boldest flights of art nouveau were in Brussels not Paris, and Brussels in the nineteenth century must be considered a provincial offshoot of French culture. Perhaps even Vienna, home of the Jugendstil and the Sezession, of Mahler, Klimt and Freud, fits the pattern, for though it was the capital of an empire, on another view it had become the second city of the German-speaking world, the artistic and intellectual capital of a culture in which the centre of political power now lay elsewhere, in Berlin.

Britain's second city – the second city of the empire, it was said – was Glasgow. Now those other cradles of modernism were often not only provincial cities but capitals of 'nations within a nation': areas linguistically, politically or racially separated from one of the high metropolitan cultures of Europe. Brussels was a French city, but also the Flemish capital and a seat of government; Prague – another home of new cultural adventure – was a centre of Czech nationalism; Barcelona is capital of Catalonia, and Catalan was claimed to be an independent language. In Glasgow, for its part, the language is identifiably English (except perhaps on Saturday nights); but England it certainly is not. Besides, in the nineteenth century it had not only grown into a great manufacturing city, it was also exporting people: all over the world were Glaswegian engineers, doctors, businessmen, and this efflux of people seems to have been a source of pride, not as in Ireland of grief, perhaps

because so many of the expatriates were not penniless refugees but men on the make. Moreover, Glasgow's sense of provincial, mercantile pride was sharpened by a closer, keener rivalry: with Edinburgh a mere forty miles away. Edinburgh was old and beautiful, both picturesque and elegant, its tone polite, intellectual, a little staid. Glasgow was not beautiful, but it was industrial, energetic, and immensely expanding. Its people were not the sober Saxons of eastern Scotland but the Celts of the west, now mingled with a huge Irish immigration; staidness was not a danger. The likenesses and unlikenesses between the two cities have their visual expression, as we shall see.

We have seen the provinces sometimes clinging to old styles which had gone out of fashion in the metropolis; and yet some great provincial cities can be found in the vanguard of progress in the later nineteenth century. The case of Glasgow suggests the paradox that these two opposites could almost become the same. If Scotland kept to the Greek Revival after it had faded in England, we can attribute this in part to the 'provincial retardation' which we found, for example, in Bristol. But there were other reasons for the Greek Revival to persist which were distinctively Scottish. One of these was negative. Much of the impetus behind the Gothic Revival was Catholic or High Church; the less reason therefore, for Calvinist Scotland to join the party. True, the Church of Scotland would for a while go Gothic, and Walter Scott's influence led to a crop of castles in the Scottish baronial style; but the faint whiff of popery, or of Englishness, that clung to the Gothic style may have prolonged the life of classicism in public buildings. And the Scots also had positive reasons for sticking to Greek forms. An energetic people in a poor land, they knew the value of schooling and had long taken pride in their tradition of classical education, while the fact that they were at the edge of Europe made them cling the more tightly to Europe's central culture. To this day in Britain the names Hector and Alexander have a slightly Scottish flavour (and at one time the name Aeneas was sometimes adopted as a classical version of Angus). Furthermore, eighteenth-century facetiousness had christened the Scots dialect 'Doric', in allusion to the Dorians of ancient Greece, regarded as rude highlanders in contrast to the quicker-witted and more cultivated Ionians. The Scots retorted by taking the name as a compliment; so that when the Greek Revival came, it was easy

to feel that Doric architecture was a fittingly Scots style, its austerity reflecting the frugal, spartan virtues of the national character. Two views could be taken: on one, a stern architecture was the proper match for a stern climate. To Hippolyte Taine's Gallic eye, however, Doric Edinburgh was an absurdity:[28]

> Calton Hill, with its colonnades and two or three little temples, is trying to be an Acropolis; and this city, learned, lettered and philosophical, calls itself the Athens of the North. But what an incongruity here is the architecture of classical antiquity! Whipped by the wind, a pale mist drifts and spreads all over the city . . . A wisp of fog or cloud hangs upon the green slope of Calton Hill, winding in and out of the columns. The very climate seems to revolt against the shapes proper to a dry, hot country; and the needs, tastes and ways of northern man are even more hostile to them.

Taine ought to be right, one feels; but after all, few buildings look entertaining in a Scotch mist, and the sheer success of Edinburgh as an urban whole gives the Scots the better of the argument.

So Edinburgh and Glasgow were akin in their attachment to the puritan simplicities of the Greek style. But in the works of the Glaswegian architect Alexander Thomson (1817–75) – Greek Thomson, he was nicknamed – we find a character that differentiates them from the lingering classicism of Bristol, Newcastle and Edinburgh alike. His Caledonia Road Free Church is a remarkable blend of the romantic and the austere (Plate 214); its asymmetry is picturesque, but the geometrical clarity of the interlocking shapes seems nearly modernistic; almost we seem to be looking forward to the buildings designed by Dudok in Holland in the 1920s and 30s. The classical forms seem to be shrinking towards insignificance: the temple façade, deprived of sculptural ornament, is only one element in a composition made largely of bare, flat, undecorated surfaces; otherwise, Greek allusions remain only in the two porches, in the very simple band of key pattern above the windows in the tower and in a few other small details. Yet as with Soane, so with Thomson: these surviving classical forms cannot in the end be dismissed as inessential, mere vestiges of a Grecianism which has been

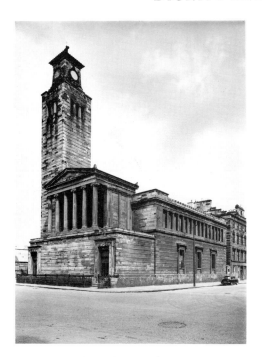

214 Ionic order and Scots idiosyncrasy:
Thomson's Caledonia Road Church, Glasgow
(1856–7) looks back to Soane's play with
Greek elements, forward to modernism.

215 Disciplined eccentricity: Thomson's
St Vincent Street Church, Glasgow (1859)

abandoned in all but name. For it is the combination of plain shapes
and surfaces with pure Greek incidents which produces the effect.
A sense of nicety, of sharpness of mind and execution, is created by
the contrast between the strong geometry of the main shapes and
the little projections of capitals and acroteria, between large areas of
bold, bare surface and small areas of precise Greek detail. Thomson's
church may seem far indeed from the baroque style, but it has
this in common, that it manipulates the classical vocabulary of
architecture, so that without some knowledge of that tradition the
building cannot be fully enjoyed. We do not understand Thomson
if we do not appreciate that it is an Ionic portico – a pure historical
form – which has been jacked up from its traditional position on
the ground to command the bare masonry beneath, like an eagle
upon a crag. It is a paradox of the birth of modernism, and one not

restricted to architecture alone, that just before the old conventional forms are swept away, they become more important than ever. The opening phrases of *Tristan and Isolde* seem to prepare the way for the dissolution of tonality, yet they require the full western tradition of harmonic progression for their effect. The augmented sixth so long suspended that it seems to lose its identity, the dominant seventh never resolved — the sense of formless, fluid yearning which the music creates comes out of our previous experience of the conventions which Wagner is teasing out of shape. You cannot stretch or crack a framework unless you have a framework to begin with. Painting, too, offers a similar phenomenon: impressionism leads on to the anti-realistic movements of the twentieth century, but in itself aims at a higher realism: to convey the appearance of things as it truly is, and not in the conventional forms which tradition has fooled us into believing true.

Thomson was an architect of varied resource. In his church on St Vincent Street the sloping site allowed him to perch his Ionic portico still more dramatically high upon a cliff of masonry (Plate 215). The tower, fantastical and a little coarse, differs from the

216 Thomson, Moray Place: Greek motifs within a scheme of high originality.

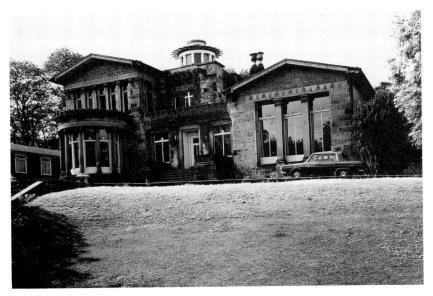

217 Thomson, Holmwood House (1856–8): harbinger of a domestic architecture that will abandon historicism.

ordered coolness of the Caledonia Road Church, faithful to no known style, though touches of Greece and Egypt can be seen in it; the top is as much Hindu as anything. The sources of the details hardly matter in so eccentric a composition; yet we still feel this tower to be historically allusive in a loose way. The total effect is almost Hollywood-Babylonian, and the contrast of this barbarism with the proper Greek portico is telling, dignity and ferocity combined.

Some of his domestic buildings are more obviously in a belated neo-classical tradition. Moray Place (1859) is not hugely different from things that can be seen in Bristol, though it has a tightness and strength, on a very modest scale, which few neo-classical designs can match (Plate 216); and it was built at a date when even the most 'retarded' of English cities had left the Greek Revival behind. He may seem to have been at the end of a road which could lead no further. The architectural writer Robert Kerr said of Thomson in the year before his death that he had 'carried the Hellenic motive back to meet the Egyptian, and modernised both with much pains-taking of detail. He hoped to be the founder of a new school, but

that was impossible.'[29] Greek Thomson seems to end the story which Athenian Stuart began. Yet he also looks forward: some people have even seen resemblances between his work and the early Frank Lloyd Wright. The broad projecting gables of Thomson's Holmwood House, for example, crowning and unifying the composition, anticipate one of Wright's techniques (Plate 217); Thomson's porch at Arran View and his Double Villa, Mansion House Drive, with its deep narrow windows, compressed and severe, bear some likeness to Wright's Unity Church (Plates 218 and 219).

Thomson is a Victorian architect: his career did not even begin until Victoria had reached the throne, and it penetrates well into the second half of her reign. He has been a great favourite of architectural historians; so it should be said that there was no one

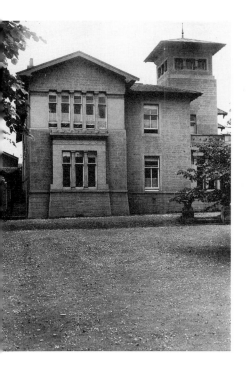

218 and 219 Thomson's Arran View (1867) and Double Villa, Mansion House Drive (1856): prefigurings of twentieth-century experiment.

else quite like him in Glasgow (or anywhere else). Yet we need not regard him purely as a lone prophet, anticipating by sheer individuality of imagination later architects who would know nothing of him. A mixture of Greece and Greek Thomson can be detected in the St Andrew's Halls by James Sellars (1873–7); he uses historical forms, but he also seems to foreshadow the much larger blocks which were soon to go up in Chicago. And meanwhile the broader classical tradition continued on its way. The career of the accomplished and pliable John Burnet is instructive. An early work, the Fine Art Institute in Glasgow, is smoothly and conventionally classical in a style influenced by the Beaux-Arts school; gradually he evolved a more vigorous manner. In the course of time he was chosen to design the King Edward VII Galleries at the British Museum (we now move south again, along with Burnet himself); they make an interesting comparison with Smirke's original building of some sixty years earlier (Plates 220 and 221). Burnet continues the classical tradition by echoing Smirke's remorseless march of giant Ionic columns, but in place of the older architect's purism, he hints at a new rhetoric. There are discreet touches of pomp-and-circumstantial Edwardian baroque: the columns are incorporated into the mass of the building instead of standing free, the bare space above the cornice is massive and ponderous, the doorway is toughly chunky, the windows have heavy, block-like tops. Front and back, the Museum illustrates the classical tradition at either end of Victoria's reign; a continuing tradition, yet one which adapts itself to changing tastes.

When he designed the Kodak Building in Kingsway, London (1910–11), Burnet abandoned classical forms altogether. This ugly structure is historically interesting as a case of a classical architect moving on to create a wholly 'modern' building. It does not bother to hide the fact that it is steel-framed; but often architects found classical forms a useful way of making the new technology respectable. Department stores are a good example; after all, one must not frighten the customers. Sometimes the classical elements became vestigial merely, vanishing into modernism; a handsome example

OPPOSITE: 220 and 221 Greek Revival and Greek Re-Revival at the British Museum: Smirke's frontage (built 1842–7) is purist in conception, while Burnet's King Edward VII Galleries (completed 1914) incorporates Ionic columns into a composition of Edwardian weightiness.

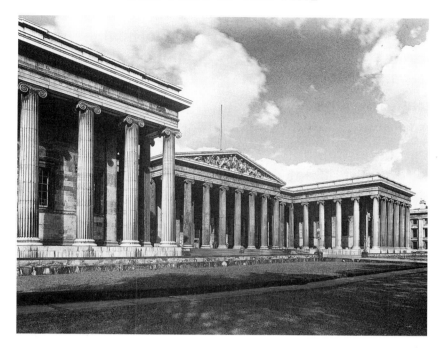

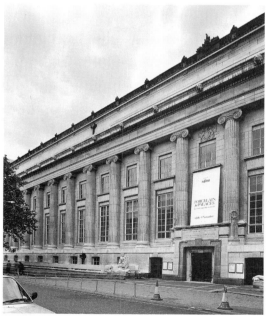

is Heal's department store of 1916, by Smith and Brewer (Plate 222).

The late nineteenth century was an age of eclecticism; more unkindly, it might be said to be a time when many of the arts had lost their direction. In an atmosphere of experiment or uncertainty, other forms of the classical tradition came back. A version of the Greek Revival reappeared, sometimes called 'Neo-Grec'; it remained quite popular even after the First World War, and examples can be found in most large cities. This was merely an architecture of tame compromise, the odd detail harsh or pared away to give traditional forms a mild flavour of modernity; and the compromise was assisted by the idea that the Hellenic spirit was progressive. That could not be claimed for Gothic architecture or the style of Wren. In 1906 the architect Voysey thought this new Grecianism such a threat that he wrote a pamphlet, *Reason as a basis of art*, to attack it. 'Pretend that you are a Greek,' he said, 'with Grecian taste, in a Grecian climate, and faithfully follow like an

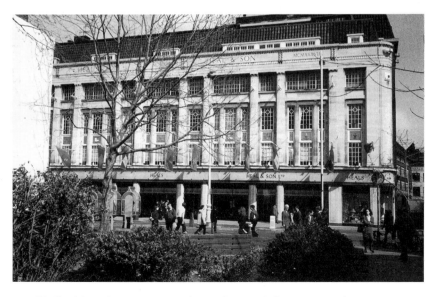

222 Heal's, Tottenham Court Road (1916; extended 1937): 'the best commercial façade of its date in London' (Pevsner). Historical forms have almost disappeared, but the frontage is still articulated by square pilasters of different sizes; compare Plate 107.

ape the expression your splendid education has given you to copy and you will be patted on the back and much honoured.' His tone was Ruskinian in its moralistic colour, but more defensive: unlike Ruskin he had now to allow that people liked classical forms: 'No doubt what you build will be a true expression of your taste, that is, what you like . . . But the question remains; is such a "liking" founded on reason, conscience, and love. Is it an honest expression?'[30] Voysey wanted an end to historicism altogether, but he paid this tribute to Hellas: it was on the Greek principle of reason that he urged the abandonment of Greek forms, and he ended with a long quotation from Plato.

But not everything in this revival of a revival was merely timid. Late in the century there was a renewal of interest in Cockerell, who can be seen like Soane and Thomson both as representing the end of a road and as looking onward to the future. The Scots architect J.M. Brydon, whose own work, though in a classical tradition, was very different from Cockerell's, gave a lecture in his praise in 1900; a few months later another architect, Beresford Pite, was writing that 'Erstwhile ardent Gothic Revivalists now acclaim the wonder of Professor Cockerell's works'.[31] In 1911 the arts-and-crafts architect Lethaby was still complaining of the 'endeavour to bring about a Renaissance of Professor Cockerell's Greek'.[32] Pite himself displayed his debt to Cockerell undisguisedly in his building for the London, Edinburgh and Glasgow Assurance Society, Euston Road (1907): we see it in the Bassae capitals, the rusticated corners, the massive attic stories above the Greek pediment and the emphatic bracketed cornice (Plate 223).

Pite's article of 1900, though tortuously written, is quite revealing. He foresaw the possibility of a new Greek architecture: 'It may be yet that some not far distant day in an eclectic hour may reproduce its bygone Greek music from its long-forgotten scores.' This was because Greek architecture 'died a school' with its rules and principles worked out and written down; not so the Gothic Revival.[33] Pugin and Ruskin would have retorted that this was just a way of saying that Grecians designed buildings mechanically, by rote; another view of the matter would be that the Greek rules helped decent, run-of-the-mill architects to design decent, well-mannered buildings. From either point of view it could be said that the Gothic style needed more individual thought if it were to be

223 Beresford Pite's London, Edinburgh and Glasgow Assurance Society office, Euston Road, London: an Edwardian revival of Cockerell's eclectic Hellenism.

used successfully; and that made it harder for it to survive once the original impetus had spent its force. The Gothic Revival was too ambitious, too morally impassioned even, to be as durable for ordinary purposes.

Pite was not interested simply in revivalism. He wrote sympathetically of the 'revolt against style' and the 'attempt to oust affectation of style by an unaffected stylelessness of difficult simplicity'. And he kept his warmest praise for Godwin, maintaining that 'present-day aestheticism' had not yet got beyond the point that he had reached twenty years earlier. In Godwin's case, Pite explained, 'the steps of tendency move simply and illustratively onwards from the starting point of scholastic tradition to the direction upon which the greatest promise of our Modern School is at present travelling.'[34]

Some of this may seem confusing. Pite looks forward to the possibility of another Greek Revival, and apparently with pleasure; after all, he was to play a small part in it himself. On the other hand he sympathizes with the revolt against style, and applauds Godwin for breaking away from historicism. Perhaps his jumbled

ideas and clotted, laboured prose reflect the age's puzzlement about the direction that architecture should take. But there is a key to his argument, and that is Greece. The most advanced pattern available for a styleless architecture was Godwin, and his later work had grown naturally, so Pite argued, out of 'scholastic tradition'. Now Godwin, as we have seen, had been both a conventional Goth and an idiosyncratic Grecian; it was his Greek experiments that led him to a kind of styleless modernism, and that is surely what Pite has in mind. A second Greek Revival was one prospect, stylelessness was another; in either case Hellas provided a meeting-point, a common ground on which the search for a style could be worked out.

Meanwhile, in more conservative circles, another classical style had seized the patriotic ground once occupied by the Goths; this was the Renaissance or baroque manner derived from Sir Christopher Wren and his school. Despite Wren's debt to Italy, it could be claimed as a national style; for had he not been the best of English architects? It is so common in late-Victorian Britain that it needs no illustration; it can be seen on an ample scale in Whitehall, where it bears witness also to the conquest of England by the Scots: both William Young, who designed the War Office, and J.M. Brydon, architect of the Treasury, hailed from north of the Border. This style seemed a fitting embodiment of the imperial idea; Sir William Emerson added some oriental flourishes to it in his flamboyant if undisciplined Victoria Memorial at Calcutta, the half-caste offspring of a Sir Christopher gone native (Plate 224).

Wren had derived his style from Roman baroque, which in turn owed a distant debt to ancient Rome. It is natural to wonder, therefore, if there is a double historical allusion in the Wren revival of the later nineteenth century: not only to an English past but also to Rome's imperial glory, now reincarnated. Comparison between the British and Roman empires was inevitable, and often enough made; it was implicit in Disraeli's phrase, 'imperium et libertas'. But it was a comparison with which the British were not entirely happy; the Roman Empire seemed too military and despotic, and some people felt uncomfortably that the British Empire had 'Greek' and 'Roman' aspects: on the one hand, the half-independent settlement colonies, like Canada and Australia, on the other the African and Indian empires, autocratically controlled. Napoleon's Paris and

Mussolini's Rome present themselves plainly as inheritors of ancient Roman glories; it is not easy to find the like in Britain. Perhaps, after Napoleon, a specifically Roman architecture would have had too Continental or tyrannous a flavour; perhaps the Roman empire itself was too ambiguous a pattern for a liberal modern state; at all events, given the obviousness of the comparison between the Roman and British empires, the general absence of such allusion in British architecture is striking. Probably the most that can be said of the Wren revival in this regard is that it had the right kind of imperial swagger. In an age of national pride this species of classical style became attractive because it was distinctively English; a nice irony.

The renewed popularity of the Hellenic and broad-classical styles was in part both the effect and the cause of the retreat from Gothic. To some degree the move away from Gothic may merely show fashion's pendulum at work; each generation wants something new, and the medieval revival had simply had its day. But Gothic shapes were also expensive or inconvenient for many modern purposes, as we have seen; despite Ruskin's eloquence, it was not really plausible to claim that Gothic was the most practical style for the present time. Moreover, the ideology of the Gothic revival, if it was remembered at all, had lost its charm. Pugin had been a kind of moral blackmailer: resist me, he had said, and you show yourself to be no true patriot and no good Christian. To the culture of the late century, whether we think of its tone as florid imperialism or a delicate eclectic sophistication, this aesthetic terrorism no longer seemed so coercive. The early Victorian period is an age of earnestness, the late century an age of worldliness — it is crude to stick these simple moral labels on whole generations, as we know, but there is a truth in them none the less. How far does an architectural style reflect the society from which it springs? We have seen how rash it may be to suppose a simple relationship. Still, when all is said and done, the muscular, sometimes uncomfortable Gothic of the mid century does seem to correspond to the moral energy and the religious wrestlings of the time; and the various classical styles of the late century, imperial baroque, Greek-eclectic and 'styleless' aestheticism, may likewise represent a period of pomp and etiolation, pride and uncertainty. The very variety of styles may itself be a symptom of a loss of direction; it is true that the Gothic and broad-classical traditions march together right through Victoria's

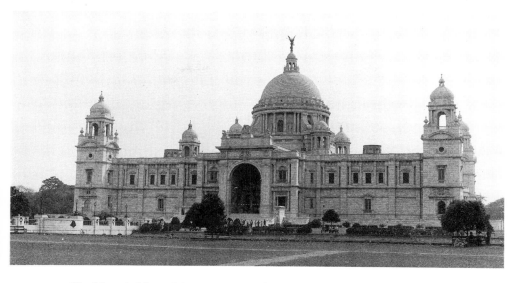

224 The Victoria Memorial, Calcutta (1906–21): Edwardian baroque with Moghul touches.

reign, but in her last years the diversity of styles was greater. Even the bluster of Edwardian baroque may reflect a half-hidden uncertainty: it seems to protest its confidence too much. It is often supposed that imperial rhetoric was complacent; that was not universally true. Political fear of Russia and Germany, economic fear of Germany and America haunted the imperialists in their very hey-day; sometimes there is a hint of eschatological tone in their writings: could the empire last? Besides, it may be that imperial style tends to be ripest just before it rots: the grandest part of the Hofburg in Vienna was completed in 1913, a mere five years before the Austro-Hungarian Empire ended for ever; and New Delhi, the most expansive work of city planning ever attempted by the British, was going up even as they were passing the Government of India Act (1935), which made the end of the British Raj inevitable.

The Gothic Revival was effectively over by 1880 except for churches and a number of schools and universities. This is not to say that it had lost all vitality: some of its best products were designed late in the century and even after. Some of it became more 'classical' in conformity with the temper of the age. G.F. Bodley's cool refinement and J.L. Pearson's austere, devotional Early English

are no less wholeheartedly Gothic than the work of the mid century; but they are less tense, urgent, spiky. William Burges, though a Goth of a knobbly sort himself, became willing to allow that French architecture of the thirteenth century was 'very like what the Greeks might have produced if they had had to work in a different material and different climate, with the advantage of the knowledge of the pointed arch'.[35] Godwin, more radically, thought that Gothic architecture could become the means of its own abolition: 'The best work of the thirteenth century . . . approximates in feeling to Greek art; earnest studies of the best Gothic work . . . will lead us, step by step, back to Greek work.'[36]

In a short story, *Apollo in Picardy*, Pater made the supposed kinship between Greek and early Gothic style the basis of a supernatural fable. The god Apollo is reincarnated in medieval France, and his presence affects the architecture. A barn is being built, and though Gothic, it acquires 'a sort of classical harmony'. The stone 'has the fine, close-grained texture of antique marble. The great northern gable is almost a classic pediment'. In *Plato and Platonism* Pater inverts this idea, fancying an affinity with the Middle Ages in 'the hieratic Dorian architecture' of ancient Greece:[37]

> Compare it . . . to Gothic building, to the Cistercian Gothic, if you will, when Saint Bernard had purged it of a still barbaric superfluity of ornament. It seems a long way from the Parthenon to Saint Ouen, 'of the aisles and arches', or *Notre-Dame de Bourges*; yet they illustrate almost equally the direction of the Platonic aesthetics. Those churches of the Middle Age have, as we all feel, their loveliness, yet of a stern sort . . .

This description would fit Bodley's St Augustine, Pendlebury, or Pearson's St Michael, Croydon, well enough; better, indeed, than it fits Pater's own examples from France. Bodley himself was warm in praise of 'that marvellous time when Greece . . . brought order out of the chaos of barbaric work, and, suddenly, became the land of all that was beautiful in art'. And most significantly, he admired Greek architecture for 'the delicate beauty of carved ornament and artistic detail'.[38] He remained a pure Goth, so far as his own work was concerned; but Ruskin's hostility to Greek ornament was now a thing of the past.

It was not only the austerer mode of Gothic that kept some vitality; Bodley himself had a sumptuous manner as well as a chaste one. The John Rylands Library in Manchester (1890–99), by Basil Champneys, is a masterpiece, imaginative in its use of space, very rich but also very refined; and ripely Gothic. Giles Gilbert Scott's Liverpool Cathedral, though designed shortly after Victoria's death, can in a sense be called the largest of all Victorian churches (it is indeed the largest church in northern Europe). It, too, is in a wholehearted if idiosyncratic Gothic, though the spatial scheme is closer to Wren's St Paul's than to any medieval English cathedral. The early twentieth century also produced one or two powerful churches in a modernist Gothic springing from the arts-and-crafts school, such as Lethaby's Brockhampton in Herefordshire, a remarkably strong design on a very modest scale. It was only when it started to compromise that Gothic began to look feeble. Between the wars, and even after, a style often chosen for churches was 'symbolic reductionism', which meant that an already tame modernity was further watered down by the use of a few vestigially Gothic shapes. Half-heartedness is better managed in the classical manner.

However, the Wren style so popular at the turn of the century was anything but half-hearted. It was a revival, like so many of the styles that had gone before it; yet it may also be seen as the reassertion of a durable tradition. We sense the persistence of a tradition, both sacred and secular, as we look down St Martin's Lane in the heart of London (Plate 225). The steeple of Gibbs's St-Martin-in-the-Fields (1722–6) develops one of the types of classical spire invented by Wren for his City churches; the tower of Frank Matcham's Coliseum (1904) is a coarse but enjoyable variation on the western towers of St Paul's Cathedral: a church and a theatre, Georgian refinement and Edwardian hearty good fun; but both inheritors of the Wren tradition.

We have been looking at Britain; but some forms of the classical tradition proved very exportable also. Broadly speaking, we can class the exports under two heads, a style and a symbolism. A simple, serviceable classicism is adaptable to many climes and purposes. Singapore may stand as an example: the Anglican cathedral sits in the middle of the city, colonial Gothic in white painted wood, like King's College Chapel crossed with a wedding cake.

Enjoyably quaint, it is both obviously English and obviously colonial; like the solar topee, created for a tropical clime by a race which feels out of place there. But the Roman Catholic cathedral and the city's oldest mosque both use an order of plain Tuscan columns, and the cathedral in particular is a work of some dignity; this classical style adapts itself to a testing climate and the needs of two different faiths without fuss or embarrassment.

In such a case the very lack of symbolism is an advantage of the classical style: Perpendicular Gothic is laden with too specific a significance. But all over the English-speaking world we can also find Victorian and even later buildings in which the classical style seems to have, in part at least, a symbolic function. The dome of St Paul's has spawned many offspring: the Capitol in Washington provides one instance, and there are others on public buildings in

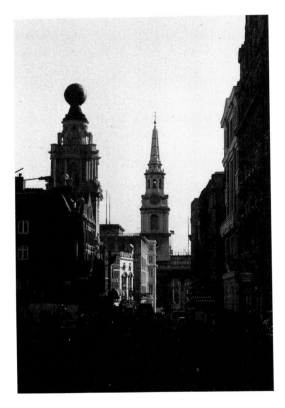

225 Wren's progeny: the Coliseum (1904) and St Martin-in-the-Fields (1722–6), seen from St Martin's Lane.

(for example) Utah, Texas, Manitoba, Buenos Aires; in Singapore too, for that matter. Why are such domes found on so many seats of administration? Surely the cause is not aesthetic alone. These domes seem fitting because they speak of dignity and security, and they speak of these things because they latch on to a tradition. A copy of Magna Carta is displayed beside the Declaration of Independence in Washington (and in a building whose florid Renaissance style seems to body forth a kind of religious secularism). Much of the American myth speaks of a young and lusty nation shaking off the enfeebling trammels of the Old World, but it has always needed, as a counterpoise, a belief in roots, a sense of tradition and continuity, perhaps most vividly expressed in visual terms by the fact that the nation's chief contribution to the world's repertoire of architectural forms, the skyscraper, is kept out of the national capital. The classical sobriety, the European pomp of Washington assert that the New World can inherit the slow accreted civilization of the Old.

Even the pure Hellenic style seems at times to acquire an instinctive emotional force. The most austere of the Greek orders was felt to be fitting for war memorials. Gallipoli brought to the peaceable antipodes the knowledge of tragedy; the sacrifices of the Great War demanded lapidary acknowledgement. The National War Memorial in Auckland, chief city of New Zealand, uses a Doric order (Plate 226), as does the Anzac Memorial in Melbourne, Australia's largest city at the time of its construction (Plate 227). One might think the Parthenon a suitable model for such a monument; or perhaps the Mausoleum of Halicarnassus. The expansive Australian spirit decided to have both at once (with results that are not altogether happy). The most accomplished of these modern Doric shrines is the Lincoln Memorial in Washington (1917), and this too is really a war memorial, a remembrance of the American Civil War, which in its tragic and heroic quality is perhaps the nearest thing in the American story to the place of the Great War in the British national memory. If we look along the Mall in Washington, we see a classical monument at either end: the Capitol and the Lincoln Memorial, the broad English tradition and Hellenic purism. And even in the Greek simplicity of the Memorial, which seems so plain, so stripped of any significance outside itself, there are two allusions: not only to democratic Athens and the pure well-springs of western civiliz-

226 and 227 Doric columns commemorate the Great War in the Antipodes: the National War Memorial, Auckland, and the Anzac Memorial, Melbourne.

ation but to an earlier America also, in which the Greek Revival had seemed the apt expression of frugal, republican virtue. It is only a little fanciful to see these two buildings as embodying two styles of patriotism, which one might represent by the terms comedy and tragedy. The Capitol issues the trumpet call of national pride, and for all its clumsiness of design, it has proved a symbol adequate for a superpower; the Memorial commemorates the most sombre period in American history and its austere hero. Together they display the resilience and variety of the classical tradition.

The study of the past is a study of ourselves — that is a half truth but perhaps truer than usual of the Victorian age, partly because so much of the twentieth century has roots in the nineteenth century, partly because we have been more changeable in our view of the Victorians than of any other period. That shift in taste, from mockery to admiration, is part of the story of our time.

One reason for the Victorians' new popularity is that modernism

this way of using the past. Men like Poynter and Alma-Tadema were traders in fantasy; their recovered popularity has been impelled by fantasy of a double kind. 'Let's pretend to be ancient Romans,' these painters implied; and 'Let's pretend to be Victorians pretending to be Romans,' their present-day admirers answer.

Given its subject, it has been natural for this book to have dwelt at times upon the escapist element in the Victorians' culture; but an injustice is done to them if we stress this aspect only of an expansive and dynamic society. Indeed, the energy that plunged itself into the work of today and the fastidiousness that recoiled from the ugliness and materialism of the new age were two sides of a single coin, for both were consequences of the industrial revolution, which inspired new confidences and new doubts. Recent historians have argued that the industrial revolution had smaller political and economic effects than used to be thought, but some great changes there certainly were: a technological transformation, an expansion of the middle class and specifically of an urban middle class, the spread through all classes of the essentially bourgeois values of respectability. The paradox of the bourgeois triumph was that in the short run it may have brought in new forms of stuffiness and over-delicacy (particularly in the treatment of young women) while in the longer term it was breaking down walls that had stood firm for centuries; the spirit of invention and enquiry that had created the industrial revolution and given the bourgeois their opportunity was bound to extend itself into every department of life. Energy and anxiety thus walk hand in hand, and there is a peculiar tension in the age between ebullience and repression. We find it, for example, in their treatment of erotic themes, and as we have seen, this combination of reticence with a curious freedom from inhibition has stirred a kind of envy in the late twentieth century, deprived as it is of the pleasure of taking risks against a background of moral certitude. The side-effects of this enthusiasm have sometimes been ironic; in 1974, when a photograph based on Waterhouse's nymphs (Plate 200) was used to promote a bubble bath in women's magazines, the picture was referred to the Advertising Standards Authority on the grounds of indecency. Waterhouse had been spared such awkwardness in the 1890s. In 1990 another of his classical paintings, *Echo and Narcissus*, was used in similar style to commend American cotton to the British public (Plate 228).

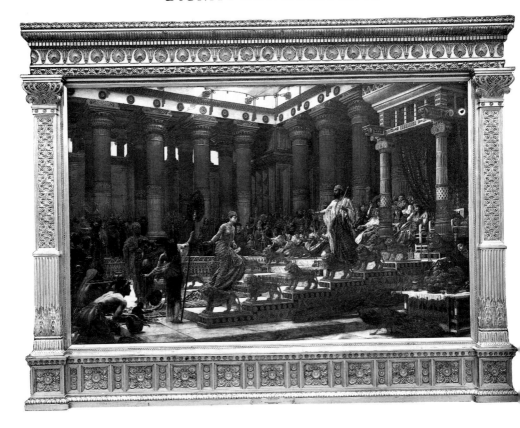

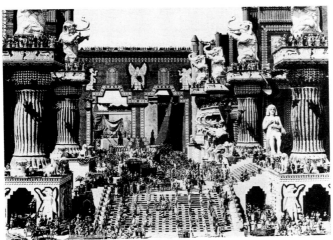

229 and 230 Poynter, *The Visit of the Queen of Sheba*, and Babylon in Griffith's *Intolerance*: epic evocations of the ancient Near East.

This is just one example of how mockery of the Victorians has modulated into a humorous appreciation of period charm. Humour is indeed the key: Sir John Betjeman became a national institution partly because his readers could remain undecided whether they were laughing at the Victorian age or admiring it. But now we scarcely bother to conceal our envy. The Victorians appeal to our time by being grand and glorious, yet also vulnerable and accessible to our imaginations: they mingle nostalgia and self-confidence, inhibition and extravagance, ordinariness and the consciousness of

231 A Roman procession: Alma-Tadema's *Spring* (1894), the Getty Museum's most popular exhibit.

335

belonging to a heroic age – a complex of attitudes to which they gave expression, in part, by their various means of exploiting the ancient world. Some of these were carried over into the twentieth century by the cinema: we can see a community of spirit between D.W. Griffith's Babylon and (say) Poynter's *Solomon and the Queen of Sheba* (Plates 229 and 230), and we have seen that Griffith modelled one of his scenes directly on Long's *Babylonian Marriage-Market* (Plate 77). It is also known that Cecil B. De Mille based some of his scenes on paintings by Alma-Tadema. And now the Getty Museum has discovered from surveys that Alma-Tadema's *Spring* is its most popular exhibit, preferred by visitors to the old masters and classical sculptures which it has so much more expensively acquired (Plate 231). But as we say goodbye to the Victorians we may note this difference from ourselves, that in the last century the

232 and 233 The Roman baths recreated on canvas: Alma-Tadema, *The Baths of Caracalla* (1899). And in three dimensions: Thermal Establishment at Le Mont Dore, Puy-de-Dôme (by Emile Camute, 1890–3).

336

234 Interior of
St George's Hall,
Liverpool (by C.R.
Cockerell, 1850s); the
design and pillars of red
stone are inspired by
the Baths of Caracalla.

vanished splendours of the past might seem possible, almost, of
recovery. Griffith's Babylon shrinks into insignificance compared to
the coarse, crushing gigantism of the Palais de Justice in Brussels;
an Edwardian extravagance like the old Imperial Hotel in London
makes Disneyland seem flimsier than ever. On canvas Alma-Tadema
could restore the Baths of Caracalla, putting in the foreground what
we recognize as three modern ladies in Roman dress (Plate 232).
But such fancies did not have to remain two-dimensional: taking
the waters in the Massif Central, one could lounge in a room
modelled on the Roman baths (Plate 233). And the Baths of Cara-
calla also inspired much larger and finer works: the noble interior
of St George's Hall, Liverpool (Plate 234), where imitation extended
even to the columns of polished red granite, and, fifty years later,
Penn Central Station in New York, perhaps the most impres-
sive railway station ever built (Plate 235). The glory that was
Rome might be the object of nostalgic reverie, but it could also

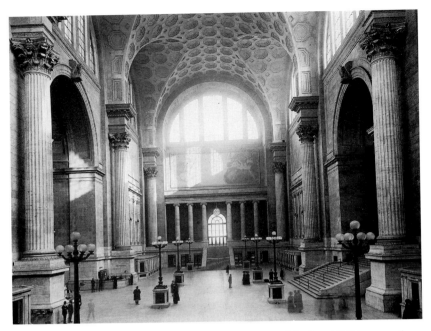

235 At Pennsylvania Station, New York (by McKim, Mead and White, 1906–10; demolished), the Baths of Caracalla are recreated on a scale even larger than the original.

be re-embodied in a way that is impossible today; as the wags say, nostalgia isn't what it used to be.

The Victorian sages were fond of saying that they lived in a transitional age; or as Tennyson put it, 'All ages are ages of transition; but this is an awful moment of transition.'[39] In the nineteenth century the taste of the elite and the taste of the people began to diverge as never before; yet with the embourgeoisement of culture came also the growth of a middlebrow art and architecture which happily played to the gallery. Paintings and buildings are among the means by which the Victorians expressed the change and continuity in their society, the conservative tendency and the radical impulse. The Victorian age maintains a tradition descended from the Renaissance and it prepares the way for modernism; and classical myths, ideas and patterns play their part in both processes.

NOTES

CHAPTER ONE: THE VICTORIAN
SETTING

1. 'Eton Reform' (1861) quoted in
 [John Carter], *William Johnson
 Cory* (1959) and in Carter's
 preface to Cory, *On the Education
 of the Reasoning Faculties* (1964).
2. S. Bayley, *The Albert Memorial:
 the Monument in its Social and
 Architectural Context* (1981),
 p. 30ff.
3. On Scott and Palmerston see
 Kenneth Clark, *The Gothic
 Revival: An Essay in the History of
 Taste* (revised edn, 1962), ch. 9.
4. See pp. 159–61.
5. See pp. 308–10.
6. *David Copperfield*, ch. 11.
7. *The Old Curiosity Shop*, ch. 27.
8. See p. 127.
9. See p. 247.
10. Preface to 1862 edn of *Alton
 Locke*.
11. *Taine's Notes on England*, tr.
 E. Hyams (1957), p. 105.
12. *The Collected Works of John Stuart
 Mill*, ed. J. M. Robson, etc,
 Vol. 11, p. 303.
13. Ruskin, *The Crown of Wild Olive*,
 142.

CHAPTER TWO: THE ARCHITECTURAL
INHERITANCE

1. C. Campbell, *Vitruvius
 Britannicus* (1715),
 Introduction.

2. L. Cust, *History of the Society of
 Dilettanti* (1914), p. 265 etc.
3. Stuart and Revett, *The
 Antiquities of Athens*, Vol. 1
 (1762), p. ii. Stuart could have
 added that the Roman treatment
 of the Ionic capital differs
 considerably from what he found
 in Athens.
4. T. Spencer, *Fair Greece, Sad Relic*
 (1954), p. 195.
5. Stuart and Revett, Vol. 3
 (1794), p. xii.
6. Ib., p. xiii.
7. Ib., p. xiv f.
8. Cowper's *Iliad* (1791), pp. vi f.,
 x.
9. In the volume on Hampshire in
 his series 'The Buildings of
 England', s.v. 'The Grange'.
10. See especially pp. 177, 179f.
11. D. Watkin, *The Life and Work of
 C. R. Cockerell RA* (1974),
 pp. 69–71.
12. See p. 161f.
13. See p. 313f.
14. Watkin, pp. 9, 7.
15. See p. 186.
16. Pugin, *Contrasts* (2nd edn,
 1841), pp. 17, 9.
17. *The Letters and Diaries of John
 Henry Newman*, Vol. 12, ed. C.
 S. Dessain (1962), pp. 221, 326.
18. *Contrasts*, p. 34.
19. P. Stanton, *Pugin* (1971), p. 7.

20. *Contrasts*, p. 12.
21. K. Clark, *The Gothic Revival* (revised edn, 1962), ch. 7.
22. Wilde, *The Critic as Artist*.
23. Arnold, 'The Function of Criticism at the Present Time'.
24. See p. 322.

CHAPTER THREE: THE IDEA OF SCULPTURE

1. Schlegel, *Lectures on the Drama*, lecture 1.
2. *TLS*, 1974, p. 767.
3. A. H. Smith, *Journal of Hellenic Studies* XXXVI (1916), p. 306.
4. B. R. Haydon, *Autobiography*, ch. 6.
5. J. M. Crook, *The Greek Revival* (1972), p. 39. But Flaxman was later to take a cooler view.
6. Hazlitt, 'Flaxman's Lectures on Sculpture'.
7. Hazlitt, 'A Journey through France and Italy'.
8. Hazlitt, 'Flaxman's Lectures. . . .'
9. Hazlitt, 'Flaxman's Lectures. . . .'
10. Symonds, *Studies of the Greek Poets* (3rd edn, 1893), ch. 5.
11. Hazlitt, 'Flaxman's Lectures. . . .'
12. Ruskin, *Aratra Pentelici* § 15.
13. *Aratra Pentelici* § 21.
14. Pater, *Studies in the History of the Renaissance*, 'Winckelmann'.
15. Dickens, *The Old Curiosity Shop*, ch. 27.
16. Byron, *Don Juan* 13. 110.
17. *The Old Curiosity Shop*, ch. 1.
18. *The Old Curiosity Shop*, ch. 28.
19. *The Old Curiosity Shop*, ch. 32.

20. George Eliot, *Felix Holt. . .*, ch. 43.
21. Dickens, *Little Dorrit*, bk 2, ch. 9.
22. George Eliot, *Middlemarch*, ch. 9.
23. Alford, *Chapters on the Poets of Ancient Greece* (1841), p. 5f.
24. Ruskin, *Aratra Pentelici* § 61.
25. *Aratra Pentelici* § 181.
26. *Aratra Pentelici* § 31.
27. *Aratra Pentelici* § 122.
28. Byron, *Childe Harold's Pilgrimage*, 4. 160ff, 49ff.
29. Ruskin, *Modern Painters*, Vol. 3 (part 4). 5. 8.
30. James, *Roderick Hudson*, ch. 18.
31. James, *The Portrait of a Lady*, ch. 28.
32. *Roderick Hudson*, ch. 20.
33. *Roderick Hudson*, ch. 2.
34. *Roderick Hudson*, chs. 10, 15.
35. *Roderick Hudson*, ch. 11.
36. *Roderick Hudson*, ch. 2.
37. *Roderick Hudson*, ch. 6.
38. *Roderick Hudson*, ch. 6.
39. Wilde, *The Picture of Dorian Gray*, ch. 2.
40. See p. 235ff.
41. Dickens, *Our Mutual Friend*, ch. 17.
42. Dowson, *Epigram*.
43. Helen H. Law, *Classical Journal* 22 (1932), 337–342.
44. See p. 27.
45. E. B. Browning, *Hiram Powers' Greek Slave*.
46. *The Letters of Elizabeth Barrett Browning*, ed. F. G. Kenyon (1897), Vol. 2, pp. 148, 155.
47. M. Girouard, *The Return to Camelot: Chivalry and the English Gentleman* (1981), p. 159.
48. Herodotus 1. 196.

49. Thackeray, *The Newcomes*, ch. 32, ch. 43.
50. Mallock, *The New Republic*, bk. 3, ch. 2.
51. *Roderick Hudson*, ch. 9.
52. J. Chapel, *Victorian Taste: the Complete Catalogue of Paintings at the Royal Holloway College* (1982), p. 109.
53. A. Stirling, *The Richmond Papers* (1926), p. 63.
54. Zimmern, L. *Alma-Tadema, Royal Academician: His Life and Work* (1886), p. 20.
55. Standing, *Sir Lawrence Alma-Tadema* (1905), p. 58.
56. K. Clark, *The Nude* (1956), p. 67.
57. *The Complete Works of . . . Swinburne*, ed. E. Gosse and T. J. Wise (1925–7), Vol. 15, p. 197.
58. Byron, *Don Juan*, canto 6, line 43.
59. Kingsley, *Alton Locke*, ch. 6.
60. Pater, *Marius the Epicurean*, ch. 21.
61. George Eliot, *Middlemarch*, ch. 19.
62. Pater, *Studies in the History of the Renaissance*, 'Winckelmann'.
63. Tennyson, *The Beggar Maid*.
64. Mantegna's *Madonna della Vittoria* (in the Louvre) is illustrated next to a sketch for *King Cophetua* in M. Harrison and Bill Waters, *Burne-Jones* (1973), p. 139.
65. Vernon Lee, *Miss Brown* (1884), Vol. 1, p. 121f.
66. *Miss Brown*, Vol. 2, p. 310f.
67. Davidson, *Earl Lavender*, p. 129.
68. Mackenzie, *Carnival*, ch. 22.
69. These are the last words of Shaw's postscript to the play.
70. Thackeray, *The Newcomes*, ch. 25.
71. Wilde, *The Picture of Dorian Gray*, ch. 3.

CHAPTER FOUR: RUSKIN'S DILEMMA

1. K. Clark, *Ruskin Today* (1964), p. 13.
2. *Lectures on Art* ∫ 111.
3. *Aratra Pentelici* ∫ 78.
4. *Aratra Pentelici* ∫ 136 and pl. VIII.
5. *Aratra Pentelici* ∫ 203 and pl. XX.
6. *Aratra Pentelici* ∫ 181.
7. *Aratra Pentelici* ∫ 21; compare p. 96.
8. *The Seven Lamps of Architecture* 4.41.
9. *The Seven Lamps of Architecture* 3.14.
10. *The Seven Lamps of Architecture* 3.15.
11. *The Seven Lamps of Architecture* 3.15.
12. *The Seven Lamps of Architecture* 3.21.
13. *The Seven Lamps of Architecture* 3.21.
14. *The Seven Lamps of Architecture* 4.4.
15. *The Seven Lamps of Architecture* 4.5.
16. *The Seven Lamps of Architecture* 4.2.
17. *The Stones of Venice* 1.27.18.
18. Plate 16 in *The Stones of Venice*.
19. *The Stones of Venice* 1.27.21.
20. *The Seven Lamps of Architecture* 4.2.
21. *The Seven Lamps of Architecture* 4.12.

22. *The Seven Lamps of Architecture* 4.
19.
23. *The Seven Lamps of Architecture*
7.7.
24. *The Seven Lamps of Architecture*
7.7.
25. *The Seven Lamps of Architecture*
7.7.
26. *The Seven Lamps of Architecture*
7.7.
27. *The Seven Lamps of Architecture*
3.13.
28. *The Seven Lamps of Architecture*
6.16.
29. *The Seven Lamps of Architecture*
3.8.
30. Clark, *Ruskin Today*, p. 125.
31. *The Stones of Venice* preface.
32. *The Stones of Venice* 1.1.17.
33. *The Stones of Venice* 1.1.19.
34. *The Stones of Venice* 1.30.1.
35. *The Stones of Venice* 1.30.3.
36. *The Stones of Venice* 1.26.2,
together with Ruskin's plate 13.
37. *The Stones of Venice* 3.4.35.
38. *Apologia pro Vita Sua*, ch. 5.
39. *The Stones of Venice* 2.6.88f.
40. *The Stones of Venice* 1.14.5;
1.26.17; 1.26.18.
41. *The Stones of Venice* 1.25.5.
42. *The Stones of Venice* 1.25.8.
43. *The Stones of Venice* 1.14.15.
44. *The Stones of Venice* 1.16.2.
45. See p. 52.
46. *The Stones of Venice* 1.7.8.
47. *The Stones of Venice* 1.7.9.
48. *The Stones of Venice* 1.7.9 and
1.13.7.
49. *The Stones of Venice* 1.13.8.
50. *The Stones of Venice* 1.13.7.
51. *The Stones of Venice* 1.1.17.
52. *The Stones of Venice* 1.6.6.
53. *The Stones of Venice* 1.8.8.
54. *The Stones of Venice* 2.6.8.

55. *The Stones of Venice* 1.2.12.
56. *Lectures on Architecture and
Painting* ∫ 24.
57. *The Stones of Venice* 2.6.6.
58. *Lectures on Architecture and
Painting* ∫ 3.
59. *Lectures on Architecture and
Painting* ∫ 4.
60. *The Seven Lamps of Architecture*
4.4 is a very clear expression of
this view.
61. The bridge was completed after
Brunel's death, with the design
of the pylons altered.
62. Clark, *The Gothic Revival* (revised
edn, 1962), ch. 10.
63. Day, *Instances of Accessory Art*
(1880) (no pagination).
64. See p. 23.
65. J. M. Crook, *The Greek Revival*
(1972), p. 129.
66. Day, *Instances of Accessory Art*.
67. Jones, *Lectures . . . on the Great
Exhibition*, p. 290.

CHAPTER FIVE: HELLENE HIGH
WATER
1. See p. 89.
2. Haydon, *Autobiography*, ch. 9.
3. *Adam Bede*, ch. 17.
4. *The Newcomes*, ch. 31.
5. *The Newcomes*, ch. 17.
6. See pl. 60.
7. *Taine's Notes on England*, tr. E.
Hyams (1957), p. 258.
8. Ruskin, *Lectures on Architecture
and Painting*, 130f.
9. *Lectures on Architecture and
Painting*, 129.
10. The Pre-Raphaelite Brotherhood
was formed in 1848. Holman
Hunt was born in 1827, D. G.
Rossetti in 1828, Millais in 1829.
11. See p. 104.

12. See p. 96.
13. Rhys, *Frederic Lord Leighton* (3rd edn, London, 1900), p. 37.
14. Sidney, *Apology for Poetry*.
15. *Odyssey* 8.457–68; tr. S. H. Butcher and Andrew Lang (1879).
16. Barrington, *The Life, Letters and Work of Frederic Leighton* (1906), Vol. 2, p. 262; Leighton, *Addresses Delivered to the Students of the Royal Academy* (1896), p. 89.
17. *Iliad* 6. 447–65, from the version by Walter Leaf, Andrew Lang and Ernest Myers (1882). This passage is translated by Leaf.
18. *The Complete Works of . . . Swinburne*, ed. E. Gosse and T. Wise (1925–7), Vol. 15, p. 198.
19. J. Harlaw, *The Charm of Leighton* (1913), p. 38.
20. Barrington, *Essays on the Purpose of Art* (1911), p. 322.
21. Frances Elliot, *Roman Gossip* (1894), p. 291.
22. Zimmern, L. *Alma-Tadema Royal Academician: His Life and Work* (1886), p. 12.
23. W. Gaunt, *Victorian Olympus* (1952), p. 142.
24. Bayliss, *Five Great Painters of the Victorian Era* (1902), p. 31.
25. Barrington, *The Life . . . of Frederic Leighton*, Vol. 1, p. 24f.
26. L. and R. Ormond, *Lord Leighton* (1975), p. 101.
27. Fraser Harrison, *The Dark Angel: Aspects of Victorian Sexuality* (1977), p. 81f.
28. L. and R. Ormond reproduce the two pictures on facing pages.

In their text (p. 34) Cabanel's painting is compared to *Venus Disrobing*, presumably a slip.
29. Harlaw, p. 29.
30. See p. 86.
31. Gaunt, p. 171.
32. R. Ash, *Alma-Tadema* (1973), p. 24.
33. P. C. Standing, *Sir Lawrence Alma-Tadema* (1905), p. 56.
34. It was probably William Gaunt who started this with *Victorian Olympus* (1952); compare Christopher Wood, *Olympian Dreamers* (1983).
35. *Lothair*, ch. 29.
36. Ib.

CHAPTER SIX: THE AESTHETIC MOOD
1. Beerbohm, *The Works of Max Beerbohm* (1896), 'Diminuendo'.
2. Pater, *Studies in the History of the Renaissance*, preface.
3. Pater, *Studies in the History of the Renaissance*, 'Sandro Botticelli'.
4. Pater, 'Coleridge'. An expanded version of the essay can be found in his *Appreciations*.
5. Mallock, *The New Republic*, bk. 1, ch. 2; bk. 4, ch. 1.
6. *The New Republic*, bk. 3, ch. 1. The Greek quotation ('both doomed to an early death and miserable beyond all men') is Thetis' description of her son Achilles in Homer's *Iliad* 1. 417.
7. Pater, *Studies in the History of the Renaissance*, preface.
8. The essay can be found in his *Greek Studies*.
9. Pater, *Studies in the History of the Renaissance*, 'Winckelmann'.
10. See further below, p. 326.

11. Wilde, 'Pen, Pencil and Poison'.
12. *The Complete Works of . . . Swinburne*, ed. E. Gosse and T. J. Wise (1935–7), Vol. 15, p. 198.
13. F. Spalding. *Whistler* (1979), p. 43f. There is more on the relations between Moore and Whistler in the exhibition catalogue *Albert Moore and his Contemporaries* (Laing Art Gallery, Newcastle upon Tyne, 1972).
14. There are brief but telling remarks by Robert Blake, *Disraeli* (1966), p. 78.
15. Grahame, *The Wind in the Willows*, ch. 7 ('The Piper at the Gates of Dawn'). Cf. Flecker, *Oak and Olive* and *The Ballad of Hampstead Heath*; Saki, *The Music on the Hill*. Forster makes Rickie, the hero of his novel, *The Longest Journey*, write stories of this type, and his own tale, *The Story of a Panic*, applies the theme to the English in Italy. Beerbohm's *Hilary Maltby and Stephen Braxton* satirizes the genre.
16. See pp. 264ff, 255.

CHAPTER SEVEN: THE TONE OF THE TIME

1. W. Blunt, *England's Michelangelo: a Biography of George Frederic Watts, OM, RA* (1975), p. 228.
2. W. Gaunt, *Victorian Olympus* (1952), p. 86.
3. Barrington, *Essays on the Purpose of Art* (1911), p. 368.
4. M. S. Watts, *George Frederic Watts* (1912), Vol. 2, p. 81.
5. A. Stirling (ed.), *The Richmond Papers* (1926), p. 301.
6. D. Harbron, *The Conscious Stone* (1949), p. 165.
7. M. S. Watts, *G. F. Watts*, Vol. 3, p. 202ff.
8. Barrington, *G. F. Watts: Reminiscences* (1905), title of plate following p. 48.
9. Harbron, *The Conscious Stone*, pp. 75, 95.
10. Jones, *Lectures . . . on the Great Exhibition* (1854), p. 290.
11. Jones, *Lectures . . .* , p. 297.
12. Gaunt, *Victorian Olympus*, p. 126.
13. J. Stokes, *Resistible Theatres: Enterprise and Experiment in the Late Nineteenth Century* (1972), p. 52.
14. Stokes, p. 50.
15. Stokes, p. 54.
16. Yeats, *Letters to the New Island*, ed. H. Reynolds (1934), pp. 175, 132.
17. Harbron, p. 178.
18. Stokes, p. 54.
19. Harbron, p. 180.
20. *Letters to the New Island*, pp. 132, 113, viii.
21. *Letters to the New Island*, p. 132.
22. Stokes, p. 55.
23. *Letters to the New Island*, pp. 114, 113, 134.
24. Stokes, p. 67.
25. All the quotations from *Patience* in this paragraph come from Act 1.
26. *The Grand Duke*, Act 2.
27. L. de Vries, *Victorian Advertisements*, pp. 130, 15, 21, 86, 26.
28. Taine's *Notes on England*, tr. E. Hyams (1957), p. 286.

29. J. M. Crook, *The Greek Revival* (1972), p. 151.
30. Voysey, *Reason. . .* , p. 9.
31. *Journal RIBA* (1901), p. 80.
32. D. Watkin, *The Life and Work of C. R. Cockerell, RA* (1974), p. 246.
33. *Journal RIBA* 8 (1901), p. 78.
34. Ib, pp. 81–4.
35. J. M. Crook, *William Burges and the High Victorian Dream* (1981), p. 350.
36. Crook, *William Burges. . .* , p. 350f.
37. Pater, *Plato and Platonism*, ch. 10.
38. Bodley's paper, written in 1885, was published in *Journal RIBA* 7 (1900); the quotations are from p. 131.
39. H. Tennyson, *Alfred Lord Tennyson* (1897), Vol. 2, p. 337.

PHOTOGRAPHIC CREDITS

INDEX

INDEX

DATE DUE